Selected Works

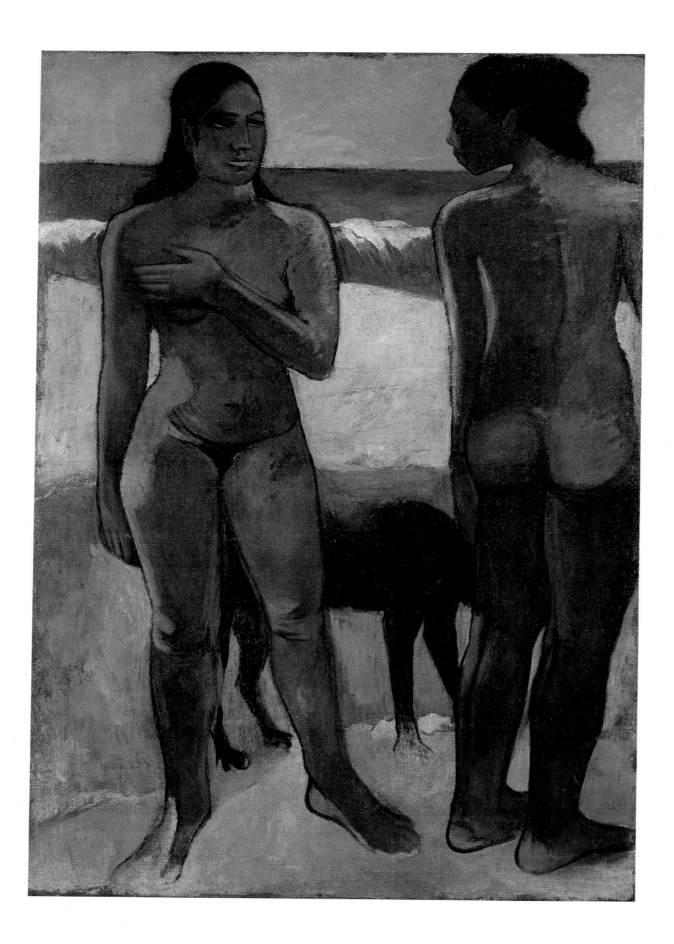

Honolulu Academy of Arts

Selected Works

Honolulu, Hawaii
1990

To all the special friends of the Academy whose support and generosity have resulted in the formation of the museum's permanent collection.

This catalogue has been made possible by generous grants from the National Endowment for the Arts, the Andrew W. Mellon Foundation, the Atherton Family Foundation, the Samuel N. and Mary Castle Foundation, the William Randolph Hearst Foundation, and the Samuel H. Kress Foundation.

Cover: Robert Delaunay, *Rainbow*, 1913 (page 196)
Frontispiece: Paul Gauguin, *Two Nudes on a Tahitian Beach*, 1891/94 (page 192)
Page 6: Large pitcher (oenochoe), Roman, 2nd–4th century (page 143)

Printed in Japan

Library of Congress Cataloging-in-Publication Data
Honolulu Academy of Arts
 Honolulu Academy of Arts: selected works
ISBN 0-937426-10-5
1. Honolulu Academy of Arts—Catalogs. 2. Art—Hawaii—Honolulu—Catalogs.
I. Title
N576.H6A66 1989 89-15376
708.8969'31—dc20

Design and production: Ed Marquand Book Design
Typesetting: Centerpoint/Type Gallery, Inc., Seattle
Printing: Dai Nippon Printing Co., Ltd., Tokyo

Editor's note: Entries generally are arranged in chronological order within their geographical area. Dimensions are given in inches and centimeters; height precedes width and depth. Chinese and Japanese names are traditionally rendered with the last name first.

This book is a publication of the Honolulu Academy of Arts.

Contents

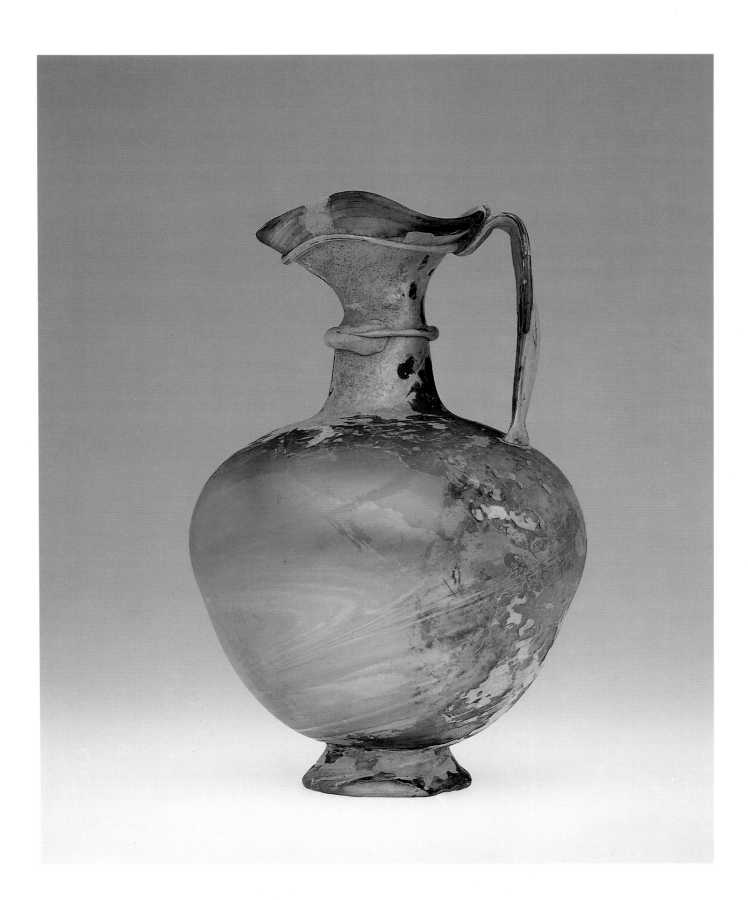

Acknowledgments

This publication provides an overview of the nature and scope of the Honolulu Academy of Arts' collections. We have attempted to present our holdings in a balanced and representative fashion, but it has been impossible to include hundreds of other works of equal importance. The last general catalogue of the Academy's holdings appeared in 1968 and highlighted approximately 140 works. A substantial number of these pieces appear in this new volume, but we have, as much as possible, attempted to present works not then included, as well as many works acquired since that date. The total number of pieces in this publication is almost double that of the previous volume, many being reproduced in color as well.

We hope that this small sampling of the museum's growing collection, which now encompasses over 24,000 pieces, will not only stimulate and educate but entice our readers to visit the museum. Firsthand experience cannot be duplicated through illustrations, no matter how good they might be.

Most museum collections result from the generosity of many individuals, both through direct gifts of works of art and through the donation of funds for their acquisition. The Academy is no exception to this rule, and its collection is a reflection of the generosity of hundreds of individuals over the sixty-two years the museum has served the people of Hawaii. To all of our patrons I extend my profound thanks for their contributions to the development of our holdings. While not every donor can be individually acknowledged, each one is responsible for the strength and quality of our collection.

The informative entries in this catalogue were written by members of the Academy's staff and are identified in the text by the contributor's initials. The authors are Reiko M. Brandon, curator of textiles; Roger A. Dell, curator of gallery education; Sanna S. Deutsch, registrar; George R. Ellis, director; Linda Le Geyt, instructor, gallery education; James F. Jensen, curator of Western art; Howard A. Link, senior curator of Asian art; Jennifer Saville, assistant curator of Western art; Bernice Thomas, former instructor, gallery education; and Selden Washington, assistant director. Several entries, identified by the initials "LM," are the work of a number of researchers over the years. Nancy Kwok, the museum's editor of publications, served as the overall editor of the volume. We thank each one for a job well done.

Robert L. Andrus, Marion Campbell, Litheia Hall, Hilde Randolph, Karen Lum, Stella MacGowan, Cathy Ng, Pamela Wilk Sapienza, and Betty Shigemitsu lent invaluable aid in various aspects of the preparation of the manuscript. Academy librarian Anne Seaman provided unfailing reference assistance. Franklyn Donahue carefully moved many of the objects to be photographed. Robert White, Evelyn Ishida, and Glen Nakamura coordinated various behind-the-scenes activities related to the project.

The work of four photographers is represented in this volume. Three former staff members—Raymond Sato (the Academy photographer for forty-two years), Robert Chinn, and James de la Torre—and our current photographer, Tibor Franyo, have all used their talents to record the beauty of these works. Special thanks are due to Ed Marquand Book Design. Ed Marquand conceived the design of this handsome publication; Tomarra LeRoy assisted in its production; Suzanne Kotz, aided by Lorna Price, John Pierce, and Patricia Draher, managed the final copyediting; and Marie Weiler acted as skillful proofreader.

We are particularly indebted to several organizations for their generous financial support of this effort; without their special assistance, the project would not have been possible: the Atherton Family Foundation, the Samuel N. and Mary Castle Foundation, the William Randolph Hearst Foundation, the Samuel H. Kress Foundation, the Andrew W. Mellon Foundation, and the National Endowment for the Arts.

George R. Ellis
Director

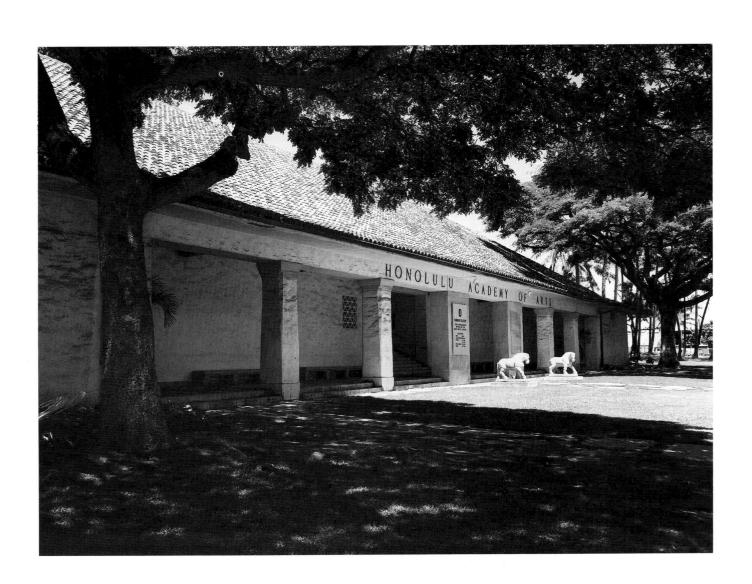

Introduction

The Museum

One of the most repeated questions asked by our visitors is "How did the Academy come into being?" Mainland, European, and Asian guests are as curious as they are delighted to find a fully professional general art museum in Hawaii.

The Academy story is similar to that of other institutions throughout the world: a single individual founded the museum in order to provide cultural opportunity for fellow citizens. What is unique, however, is that this occurred in the mid-Pacific, far from other significant population centers. How it happened is a fascinating episode in museum history, one flavored by a strong humanitarian spirit and resolve.

A charter of incorporation was issued to the "Honolulu Art Museum" in 1922 for "the promotion of the study of and advancement of education in matters of art, the encouragement of artists, the acquisition and public exhibition of pictures, statuary and other works and things of art and the extension and use thereof to artists and others interested in the study of art." The family home of Anna C. Cooke, the Academy's founder, was the initial location for these activities, her collection being housed there until 1925. Mrs. Cooke's home was later demolished to provide the site for the present museum building, which was formally dedicated in the spring of 1927.

A more specific vision of the proposed new museum's mission emerged, between 1922 and 1927, as Mrs. Cooke discussed her plans with family and friends. The museum's treasures would be available to the connoisseur, but they would also be used to educate and inspire all citizens of Hawaii, especially children. In keeping with this concept, the name of the museum was officially changed to the Honolulu Academy of Arts, and the charter was amended to include a much broader educational program. The revised charter read as follows:

WHEREAS it is deemed desirable that the Charter of Incorporation of the Honolulu Museum of Art be amended to authorize the enlargement of the scope of the purposes and objects of the Corporation, and its corporate name changed to correspond therewith, as herein provided.

BE IT RESOLVED by the Trustees of said Corporation in a special meeting duly assembled for the purpose this 12th day of January, 1925, that the Charter of the Corporation be amended by amending the preamble thereof so that the same will read in full as follows:

WHEREAS, ANNA C. COOKE, ALICE C. SPALDING, MARY A. RICHARDS, C. M. COOKE AND L. J. WARREN, all being residents of Honolulu, in the City and County of Honolulu, Territory of Hawaii, have made application to me to grant to them and their associates and successors, a Charter of Incorporation under the corporate name of "HONOLULU MUSEUM OF ART," as a body corporate, to have for its purposes the promotion of study and advancement of the liberal arts, the encouragement of artists, the acquisition, exhibition and disposition of pictures, statuary and other works and things of art and objects relating to and illustrative of the same; the carrying on of educational work in matters of art, including schools or classes for instruction, study and training; to provide for the delivery and holding of lectures, concerts, dramatic productions, exhibitions, meetings, classes and conferences, in the interest of or in connection with the liberal arts, whether general or technical; to collect, preserve and own or care for books, manuscripts, and other forms of writings, literature, records and papers of historical or educational value pertaining to art in any form, ancient or modern, and establish and maintain a library thereof, for study and reference; all of which objects and purposes are to be served and controlled conformably with law, under such rules and regulations as the governing board and officials of the Corporation shall in their entire discretion from time to time make, pro-

vide and promulgate and all without profit or gain to its members.

AND BE IT FURTHER RESOLVED, that the name of said Corporation be changed from "Honolulu Museum of Art" to "HONOLULU ACADEMY OF ARTS," and the Charter further amended to conform thereto wherever the name of said Corporation therein appears.

Thus the Honolulu Academy of Arts was formally opened to the public in 1927 with a gala celebration featuring a dedicatory speech incorporating the spirit, ideals, and inspirations of the founder:

That our children of many nationalities and races, being far from the centres of Art, may receive an intimation of their own cultural legacy, and wake to the ideals embodied in the arts of their neighbors.

... That Hawaiians, Americans, Chinese, Japanese, Koreans, Filipinos, Northern Europeans and all other people living here, contacting through the channel of art those deep intuitions common to all, may perceive a foundation on which a new culture, enriched by the old strains, may be built in these islands.

As Honolulu prospered, the Academy's collection and physical plant grew in size and quality. Today's collection, built on the initial gifts of its founder, is internationally recognized for its excellence and diversity. Important holdings from throughout the world are anchored by one of the finest Asian collections found in the United States.

The physical plant has also been expanded to meet increasing community needs and priorities. The Robert Allerton Library wing was constructed in 1956, followed by an educational center in 1960. A café opened in 1969, and the Clare Boothe Luce wing—incorporating a large contemporary gallery, a 296-seat theater, and administrative offices—was dedicated in 1977. In 1989 the renovation of Linekona School was completed; this facility contains our Lending Center and studio classrooms for adults and children. Space freed in the education wing is to be converted to galleries for the expanded display of the permanent collection and to areas for volunteer activities.

The expansion of the collection and physical facilities has been accompanied by increased programming of special exhibitions, art classes, films, lectures, musical performances, festivals, and a wide range of other cultural opportunities.

Today's Academy would please Mrs. Cooke. It clearly reflects her vision of its role and function in this community, always retaining its educational emphasis while adapting to changing social and economic circumstances.

The Permanent Collection

Developed from the founder's initial gift of approximately 4,500 works of art, the Academy's collection of approximately 24,000 pieces is today internationally recognized for its quality and diversity. The Academy is Hawaii's only general art museum, and its holdings, almost equally divided between Western and Asian art, are encyclopedic in nature and scope.

The Western collections consist of approximately 12,000 paintings, sculptures, works on paper, and decorative arts objects. Encompassing ancient to contemporary times, the collection ranges from Cycladic, Greek, Roman, and Egyptian works from as early as the third millennium B.C. to American and European arts of the 1980s. Particularly noted for their quality and significance are the Academy's Luristan bronzes; European paintings (including a Samuel H. Kress Foundation collection of Italian paintings), sculpture, drawings, and decorative arts; eighteenth- and nineteenth-century American paintings, sculpture, and decorative arts including the work of John Singleton Copley, Thomas Sully, Gilbert Stuart, Charles Willson Peale, George Inness, Mary Cassatt, James Peale, Thomas Eakins, Albert Bierstadt, Thomas Moran, and James McNeill Whistler; and a distinguished group of nineteenth- and twentieth-century European paintings and sculpture highlighted by the works of Vincent van Gogh, Paul Gauguin, Paul Cézanne, Pablo Picasso,

Amedeo Modigliani, Camille Pissarro, Pierre Bonnard, Odilon Redon, Eugène Delacroix, Gustave Courbet, Claude Monet, Henri Matisse, Auguste Rodin, Giorgio de Chirico, and Émile-Antoine Bourdelle. The Academy's twentieth-century American collection includes works by Morris Louis, Hans Hofmann, Helen Frankenthaler, Louise Nevelson, Isamu Noguchi, Stuart Davis, Alexander Calder, Gaston Lachaise, Richard Diebenkorn, David Smith, Francis Bacon, Georgia O'Keeffe, Arthur Dove, Manuel Neri, and others.

Because of space limitations, several aspects of the museum's Western collection are not represented here. Among these are approximately 10,000 prints, comprising a survey of the history of the graphic arts from the late fifteenth century to the present with particular strength in American and European works of the nineteenth and twentieth centuries. In addition, there is a small but representative collection of photographs, as well as a substantial assemblage of historical and contemporary works by artists of Hawaii.

The collection of Asian art, numbering over 12,000 works, is one of the principal strengths of the museum's holdings and is generally considered to be among the most important assemblages of its kind in American museums. The collection is particularly noted for its extensive and excellent representation of Chinese, Japanese, and Korean art.

The Chinese holdings include masterworks of painting by such outstanding Ming-dynasty artists as Chou Ch'en, Shen Chou, Wen Cheng-ming, Ch'en Shun, Hsü Wei, Hsüeh Wu, Lu Chih, and Wu Pin, as well as numerous Ch'ing-dynasty masters including Yün Shou-p'ing, Hung-jen, Wang Wei, and Ch'en Hung-shou. The richness of the Chinese collection is further revealed in its impressive groupings of Shang-dynasty bronze ritual vessels and jade objects, and in its examples of Yang-shao pottery, porcelaneous stoneware, T'ang-dynasty pottery figures, tenth-century white porcelain, Liao-dynasty amber pottery, and superb Ming blue-and-white porcelain pieces. Yüan and Ming lacquer pieces, Ming furniture, and a variety of stone and wood sculpture, including Northern Wei limestone buddhas, bodhisattvas, and apsarases, as well as an impressive Sung-dynasty Kuan-yin bodhisattva further represent the art of China.

The Japanese collection features screens by Kanō Eitoku, Kanō Ryōkei, Tawaraya Sōtatsu, Maruyama Ōkyo, Ike no Taiga, and Suzuki Kiitsu's acknowledged masterpiece, *Flowering Plum and Camellia*. In other painting formats there are masterworks by Sesson Shūkei, Hōsetsu Tōzen, Kanō Motohide, Kanō Naonobu, Sakai Hōitsu, Tsubaki Chinzan, and Shibata Zeshin. In the applied arts, the collection includes a range of lacquerware from the Kamakura through Edo periods, and an especially good assemblage of Edo-period ceramics. Among the unsigned treasures of medieval Japan is a twelfth-century gold and silver flower tray, a fourteenth-century portrait of the priest Son'en and a fourteenth-century handscroll featuring the life of Kōbō Daishi; these three works would be Registered Cultural Properties if in Japan today. The museum is also the permanent home of the James A. Michener collection of 5,400 Japanese *ukiyo-e* prints, which contains the largest single grouping of prints in the world by Utagawa Hiroshige, as well as hundreds of other *ukiyo-e* masterworks.

The Academy's collection also includes one of the few comprehensive assemblages of Korean ceramics of the Koryō dynasty outside Korea, in-depth holdings of Silla and Paekche pottery, and a small but fine grouping of Koryō Buddhist paintings. Other significant components include a select group of Islamic ceramics; more than 2,000 textiles, with a special emphasis on Japan and China; and a growing Indian sculpture collection. In addition, the traditional arts of Africa, the Pacific, and the Americas are well represented.

The permanent collection serves as the primary resource of its kind for the one million residents of Hawaii and for the millions of visitors who travel from around the world to the islands.

G.R.E.

East Asian Art

VESSEL (p'ing)

Chinese, Neolithic period, 5th millennium B.C.

Yang-shao; red pottery with impressed string pattern

14¹/₂ × 6 in. (36.8 × 15.2 cm.)

Gift of the Honorable Edgar Bromberger, 1956 (2164.1)

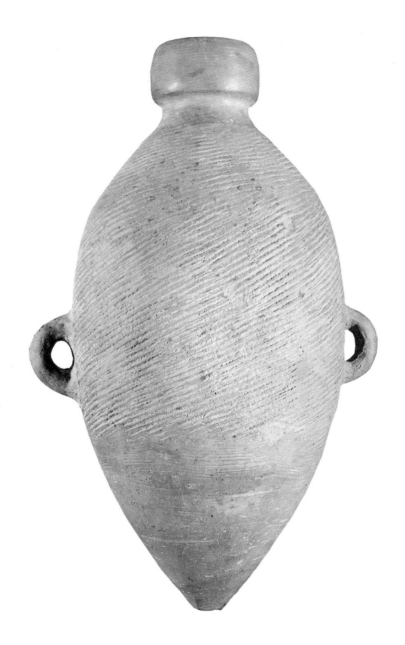

Unpainted vessels in the shape of the Greek amphora are found alongside a variety of hand-painted wares throughout the range of the Yang-shao culture in northern China (one of the first basic cultural horizons of the Neolithic period), but the particular shape of this example is apparently limited to the area of Shensi province. The vessel, with its pointed bottom, continuous convex contour, and lug handles, is similar to those recently excavated near Pan-p'o Ts'un in Shensi. One vessel, identified as a *p'ing* and found in a burial pit with a child's corpse adorned with a body-band of beads, is nearly identical with this example. Both vessels have been dated to the fifth millennium B.C., the period of the excavated site, and are thought to be water jars, since their shape, lug handles, and balance make them ideal for lowering into a stream. This *p'ing* has been judged to be one of the oldest known Chinese water jars in the West. HAL

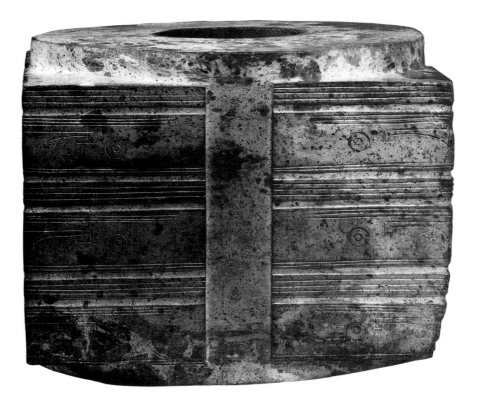

The most respected thesis regarding the identification and meaning of the term *ts'ung* and its cousin, *pi*, equates the names (first noted in the Chou dynasty *Book of Rites*) with certain burial jades recovered from the graves of neolithic and early dynastic China. Square jades of varying height but always perforated by a tubular hole in the center have been identified as *ts'ung* symbolizing the earth; such jades are said to have been placed on the abdomen of the corpse in ritual burials. In contrast, jade discs, also perforated by a hole in the middle, have been equated with *pi* symbolizing heaven; such jades were placed beneath the corpse. The few scientifically excavated burials do not provide a further key to the meaning of these curious jade forms.

Scientific excavations, however, are just now producing evidence that suggests a date for this form. The only previously known neolithic examples of the *ts'ung* were confined to flat faceted rings. This example was ascribed to the later Eastern Chou period (771–256 B.C.); its form is similar to a *ts'ung* in the Royal Ontario Museum traditionally dated to this time. Excavations undertaken in Kiangsu between 1973 and 1978, however, have revealed jade *ts'ung* of a type similar to both the Academy and Royal Ontario examples. Since the excavated *ts'ung* from the Liang-chu culture are dated to the third millennium B.C., the Academy example has been redated to this time.

HAL

RITUAL OBJECT (ts'ung)

Chinese, Neolithic period, probably 3rd millennium B.C.

Calcified dark green nephrite

6 1/8 × 7 1/2 in. (15.6 × 19 cm.)

Acquired through gifts of Mrs. Charles C. Spalding,

J. Lionberger Davis, and Arthur Wiesenberger, 1967 (3503.1)

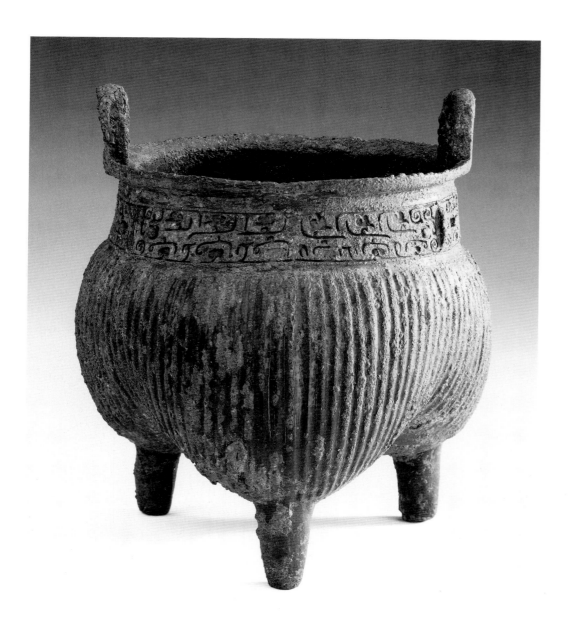

RITUAL FOOD VESSEL (li-ting)

Chinese, Shang dynasty, ca. 1300 B.C.

Bronze; 6⅝ × 6 in. (16.8 × 15.2 cm.)

Exchange, 1969 (3607.1)

The three-lobed body of this bronze vessel, supported by solid tapering legs, was inspired by the hollow-legged ancient pottery vessel of the type known as *li*. Even the vertical ribs on the surface find a counterpart in early pottery forms. Of particular interest is the early style of the *t'ao-t'ieh* (ogre mask) in the neck zone. The naive treatment of the decor, coupled with the hesitant proportions of the piece, tentatively suggests the early date of ca. 1300 B.C. As with most early bronzes discovered at the site of An-yang, identified as the last capital of the Shang dynasty, there is no inscription. Most surviving *li-ting* date to a later period within the Shang, making this vessel a particularly rare and valuable art-historical example. HAL

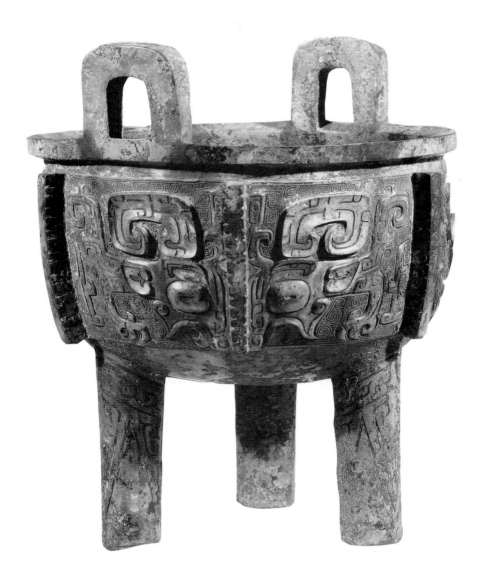

This superb tripod, with harmoniously balanced form and crisply articulated *t'ao-t'ieh* motif, perfectly illustrates the salient characteristics of the bronze caster's art at its very best. The style and technique is associated with the later years of the Shang dynasty. The *t'ao-t'ieh*, or ogre mask, seen here is a classic example of the motif in its fully developed phase. No explanation for the meaning of the *t'ao-t'ieh* nor the sources of its form have yet been convincingly offered. The two-character inscription on the inner wall of this vessel has been translated by Robert J. Poor as ''[dedicated to] Son i or Clan-sign i.'' HAL

RITUAL FOOD VESSEL (ting)

Chinese, Shang dynasty, ca. 1200–1000 B.C.
Bronze; 9¹/₂ × 7³/₄ in. (24.1 × 19.7 cm.)
Purchase, 1940 (4838)

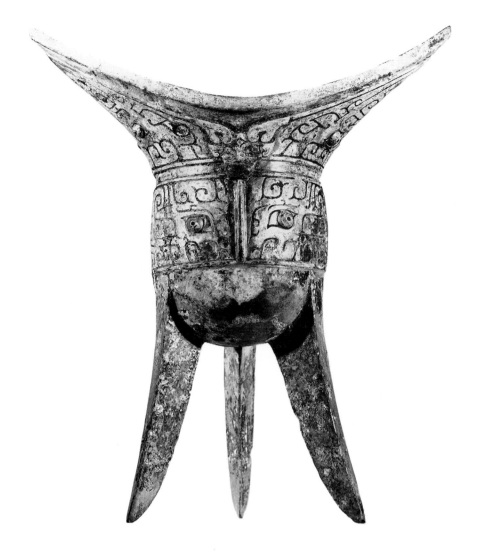

RITUAL WINE VESSEL (chiao)

Chinese, Shang dynasty, ca. 1300 B.C.

Bronze; 8¼ × 6¹¹⁄₁₆ in. (21 × 17 cm.)

Gift of Wilhelmina Tenney Memorial Collection, 1966

(3414.1)

This rare tripod vessel, classified as a *chiao*, resembles the more common type of tripod identified as *chüeh*, except that the *chiao* lacks a spout and rim posts. An example in the collection of the Metropolitan Museum of Art, New York, said to have come from an altar set discovered at Pao-chi-hsien, dated to the Western Chou dynasty, reveals similar decoration, although the method of articulation differs. The Academy work, despite the absence of a lid, relates to the style associated with Pao-chi-hsien, although the character of the decoration supports an earlier dating. HAL

Examples of the Shang sculptor's art are seldom encountered outside of archaeological collections, and few large sculptures in hard materials seem to have survived from the Bronze Age. This specimen is tentatively identified as the shoulder of a vessel of the *hu* type. Its motifs are presented in a manner peculiar to late Shang stone carving. This combination of incised lines and thin raised ones is not normally found on bronze vessels but is found on marble sculptures at the ancient city of An-yang. The soft modeling of the features of the animal head are also in keeping with the An-yang sculptural style. HAL

SCULPTURAL FRAGMENT

Chinese, Shang dynasty, ca. 1300–1050 B.C.
Gray marble; 9⅝ × 10⅝ in. (24.5 × 27 cm.)
Purchase, 1953 (1846.1)

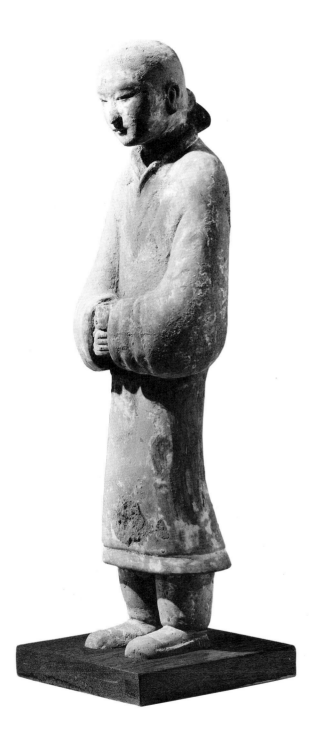

STANDING FIGURE

Chinese, Han dynasty, ca. 140–85 B.C.

Pottery; h. 21 ⅛ in. (53.7 cm.)

Bequest of Theodore A. Cooke, 1973 (4168.1)

This pottery figure, probably of a female mourner, is identical with those uncovered in 1966 at the site of Jen-chia-p'o at Sian in Shensi province. The excavation yielded forty-two earthenware sculptures, which were scattered over thirty-seven different pits for funerary objects. The pits are associated with the tomb of Empress Tou (d. 135 B.C.), wife of Wen-ti (reigned 180–157 B.C.). The Academy figure measures the same height as all the sculptures recovered from this site and is composed of a relatively high-fired clay with traces of polychrome. The figure makes a ringing sound when tapped and offers the same iconography and style as the other figures. The dress and demeanor of the Academy figure identify it as a court attendant; its half-closed hands, one aligned above the other, must have held a vertical pole in connection with its function as an attendant for the deceased. HAL

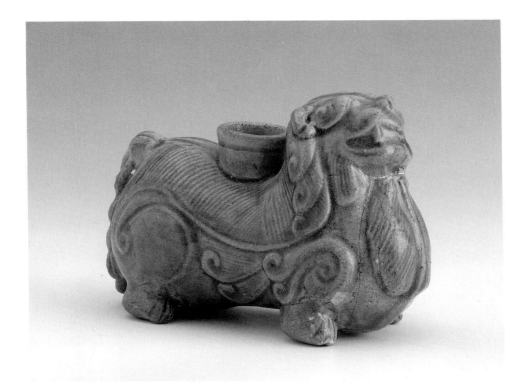

Greenish-glazed wares that presaged the celadons of the Sung dynasty were formerly referred to as Yüeh ware and were thought to have been primarily produced at Yüeh-chou in Chekiang province. Such wares are now classified as proto-Yüeh if they predate the T'ang dynasty (618–906), and as Yüeh-type if they date to the T'ang or later but cannot be assigned with certainty to the Yüeh-chou kilns. Yüeh ware is confined to examples from the Yüeh-chou kilns.

The proto-Yüeh kilns produced a great variety of shapes: bowls, vases, dishes, and cups. The chimera shown here probably functioned as a small holder or stand. An identical example found in 1953 at Yangchow in Kiangsu province from a site dated to the Western Chin dynasty suggests its date. Proto-Yüeh and Yüeh-type wares were exported as far away as Fostat in Egypt, Samarra in Mesopotamia, Brahminabad in India, and Nara in Japan. Their glazes descended from Han-dynasty glazed stonewares.

HAL

CHIMERA

Chinese, Western Chin dynasty (265–316)

Proto-Yüeh ware; stoneware with olive green glaze

h. 5¹/₂ in. (14 cm.)

Gift of the Honorable Edgar Bromberger, 1953 (1900.1)

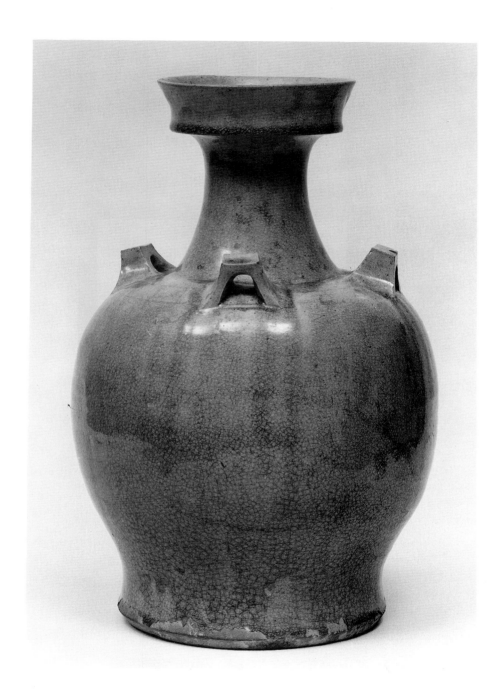

LARGE STONEWARE JAR

Chinese, Southern Ch'i dynasty (479–502)

Proto-Yüeh ware; stoneware with olive green glaze

h. 16¾ in. (42.5 cm.)

Purchase, 1972 (4039.1)

As proto-Yüeh glaze ingredients and methods of firing improved, a more even glaze and richer color became possible. Surface decoration, common to proto-Yüeh ware, was minimized in favor of a more controlled glazed surface, as seen on this large jar. The high neck, cup-shaped mouth, and four squared lugs luted onto its shoulder are identical to those of a jar, now in the Shanghai Museum, that was excavated in 1975 in Chi-an, Kiangsi province, and dated to the Southern Ch'i dynasty. HAL

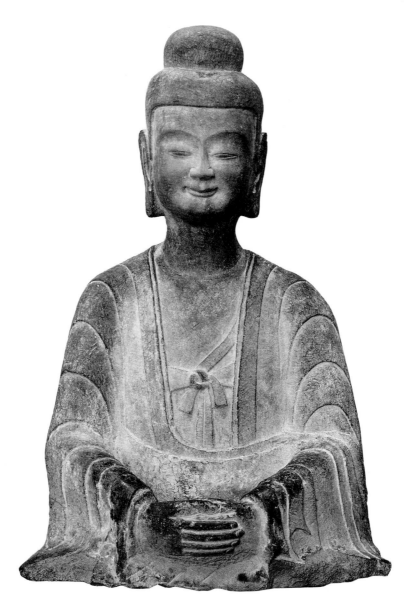

During the Northern Wei dynasty, nomadic tribes from the north and the west occupied the Yellow River basin, bringing with them the cultural traditions of Central Asia. One result of nomadic influence was a particularly elegant style of Buddhist sculpture, which is documented by the Academy's limestone Buddha. The lower part of the statue is now missing, but we can safely surmise that the image was seated meditatively in a *dhyana mudra* (gesture of concentration). The *ushnisha* (knowledge bump) on the head identifies the image as Buddha; the archaic smile, elongated body, front girdle knot, and the simplified folds of the robe are characteristics associated with the mature style of Wei sculpture. This image originally came from the cave of Shih K'u Ssu at Kung-hsien, a Buddhist cave site near the Yellow River in Honan province, where much sculpture of a similar type can still be seen. HAL

BUDDHA

Chinese, Northern Wei dynasty (386–535),
Kung-hsien site
Gray limestone; h. 37 1/2 in. (95.3 cm.)
Gift of Mrs. Charles M. Cooke, 1930 (3468)

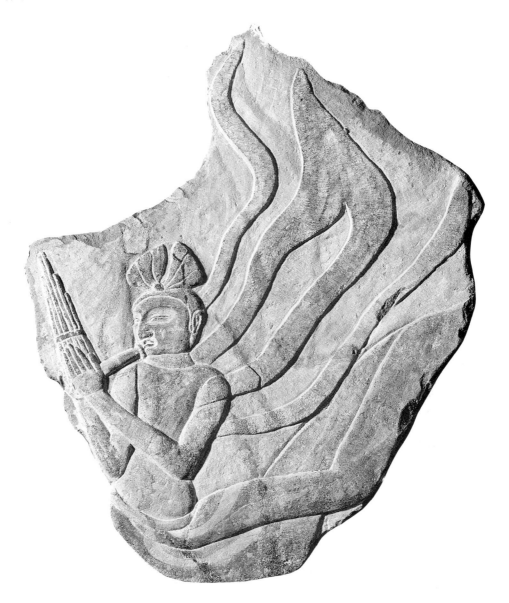

APSARAS PLAYING A SHENG

Chinese, Northern Ch'i dynasty (550–77),
T'ien-lung-shan site
Limestone with traces of polychrome
42¹/₂ × 32¹/₂ in. (108 × 82.5 cm.)
Gift of Mrs. Charles M. Cooke, 1932 (3087)

The Academy owns two limestone apsarases (flying female figures from the Buddhist paradises), one playing a *sheng* (bamboo pipes) and the other playing a *p'i-pa* (lute). The imagery came to China from India via Central Asia. Both reliefs, in excellent condition, were originally carved on the ceiling of Cave XVI at the Buddhist site of T'ien-lung-shan (Heavenly Dragon Mountain) in the northern part of China. The reliefs have been dated to the Northern Ch'i dynasty. Four of them were originally arranged at the four corners of the ceiling with a large lotus flower in the middle. Traces of light green, red, and black pigment indicate that the reliefs were originally painted. HAL

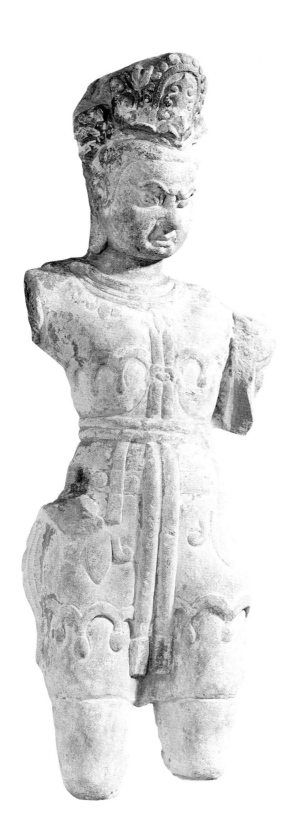

GUARDIAN FIGURE

Chinese, late 6th century,
T'ien-lung-shan site, ca. 584
Limestone; h. 39½ in. (100.3 cm.)
Purchase, 1956 (2241.1)

This guardian figure is a documented example from the caves of T'ien-lung-shan (Heavenly Dragon Mountain) in Honan province. Identification of the sculpture as a guardian figure is based on the headdress, facial type—curved eyebrows, round protruding eyes, and long ears—and the armorlike chest of the torso. Studies published in 1964 indicate that the body of this sculpture came from Cave VIII at T'ien-lung-shan, and the head came from a guardian figure outside Cave XVI at the same site. The latter cave is dated 584. The excavation photographs, however, show that the body of the Academy sculpture was loose and not part of the cave materials. The original location of the form, therefore, is not certain. The torso fragment is appropriate to a guardian figure, although it is unlikely that this head and torso originally belonged together.

HAL

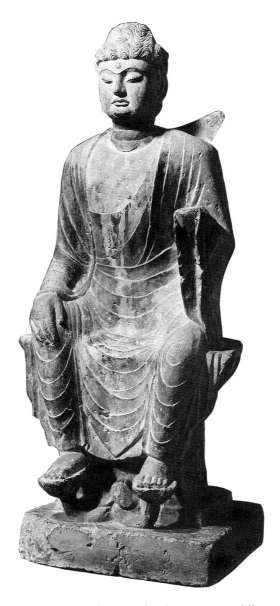

SAKYAMUNI BUDDHA

Chinese, T'ang dynasty, 7th century
Limestone; h. (including base) 59½ in. (151.1 cm.)
Gift of Robert Allerton, 1959 (2564.1)

This large figure of Sakyamuni Buddha is depicted in the relatively rare enthroned posture. The material is gray limestone of the type used by sculptors of Honan and eastern Shensi provinces. The iconography includes a lotus throne, *bhumisparsa mudra* (gesture of touching the ground), and perhaps the *adhaya mudra* (the calming of fear gesture). The latter cannot be determined with certainty since the left arm is missing below the elbow.

The connecting curved eyebrows of the face are considered rare in Chinese sculpture and are in sharp contrast to the typical Chinese characteristics of full face and slanting eyes. Only a fragment remains of the halo behind the statue. The petals of the lotus throne still show red pigment. The square stand under the seat includes a variant of the *t'ao-t'ieh* mask, a lion and tiger in relief.

Sculptures of the early decades of the T'ang dynasty are rare, and this Sakyamuni possesses both the typical features of the early style and an artistic excellence seldom encountered in stone sculpture. HAL

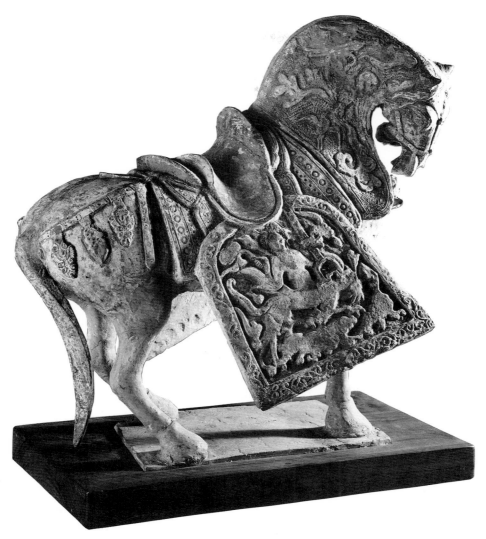

The clay tomb figurines of the Six Dynasties period form an imposing battery of fine statuary. Most are made of gray earthenware painted with slip colors, usually red, green, or yellow. Along with chimeras, dogs, lions, and camels, the most commonly encountered form is the horse figurine, regarded by many connoisseurs as the finest of all Chinese animal sculptures. Wei-dynasty mortuary horses are prized for their linearity of form and detail, which is quintessentially Chinese in feeling. The Academy owns two superb examples with elaborate molded designs on the saddle panniers. Although still linear in character and possessing the peculiar charm typical of Wei sculpture, the Academy examples project a greater sense of movement and realism than encountered elsewhere, suggesting a date on the very threshold of the T'ang dynasty. HAL

HORSE

Chinese, Northern Wei dynasty, ca. 6th century
Pottery, one of a pair
14¼ × 14½ in. (36.2 × 36.8 cm.)
Gift of Wook Moon, 1951 (1165.1)

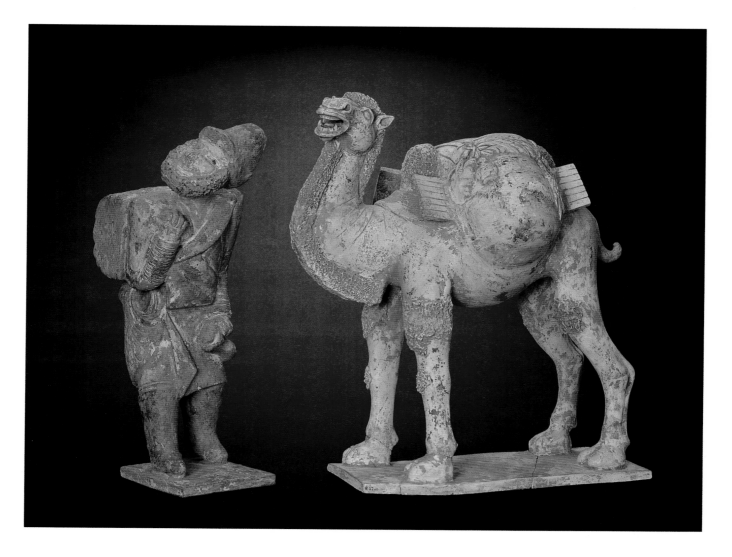

CAMEL AND OLD MAN

Chinese, T'ang dynasty (618–906)

Low-fired pottery; camel: 18½ × 17 in.

(47 × 43.2 cm.), figure: h. 17 in. (43.2 cm.)

Gift of Charles M. and Anna C. Cooke Trust,

1929 (2782, 2781)

The custom of burying with the dead low-fired pottery models of people and animals that might usefully serve in afterlife began at least as early as the Ch'in dynasty (221–206 B.C.), but greatly expanded in the T'ang dynasty. Servants, guards, dwarfs, horses (sometimes with riders), camels, and all paraphernalia of T'ang life were mirrored in the clay burial miniatures. Although cheaply produced by the thousands, a surprising proportion are small masterpieces of sensitive modeling and accurate observation that give a rich picture of the life of well-to-do T'ang society. The dynamic figure of the Academy's camel, standing with raised head, carrying a full load of cargo, is typical of the quality of this genre. The work is finely articulated and realistically portrayed. The old man, bent under his pack and carrying a pitcher, is vividly characterized as well. He might represent a foreigner of Armenoid type, employed in T'ang times to look after horses and camels. HAL

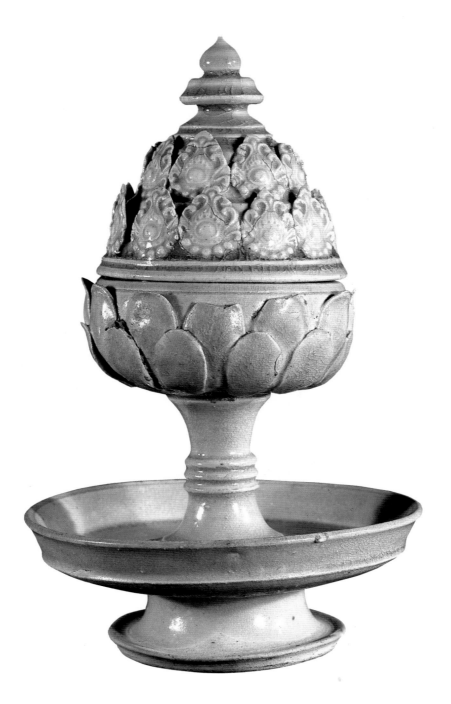

Decorated in tiers of lotus petals and medallions and topped with a pagoda-like knob, this rare incense burner may have been associated with Buddhism. In glaze and form it relates to a distinctive white ware thought to come from South China. The feldspathic glaze shows a faint, green tinge where it has pooled or piled thickly; in this respect it presages similar effects achieved in Ying-ch'ing (Ch'ing-pai) ware of the Sung dynasty. The wide flaring foot of the stand and the density of the bisque reflect Yüeh-type ware of the early T'ang dynasty and suggest a seventh-century date. Fragments of this ware uncovered at datable sites in Central Asia confirm the present dating. HAL

INCENSE BURNER

Chinese, T'ang dynasty, 7th century
Stoneware with cracked, pale greenish glaze
9³/₄ × 5¹/₂ in. (24.8 × 14 cm.)
Gift of the Honorable Edgar Bromberger, 1954 (1993.1)

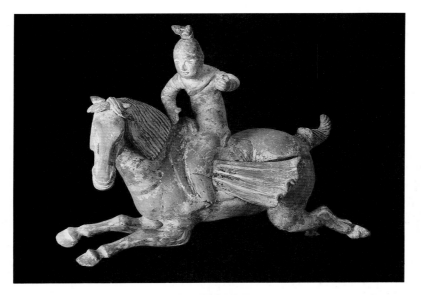

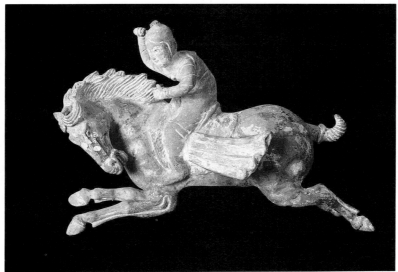

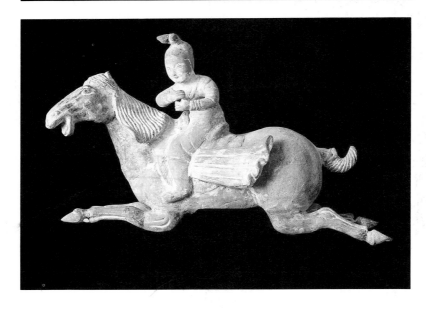

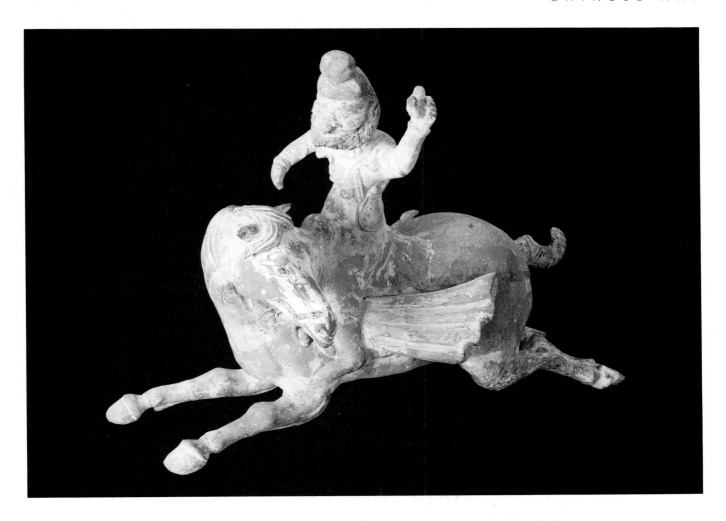

Among the most striking and rare subjects encountered in T'ang pottery tomb sculpture are figures on horseback, such as the Academy's extraordinary group of four equestrians. This sculpture group, documented by scientific analysis to be 1,350 years old (plus or minus 300 years), is not only dynamic and detailed but surprisingly cosmopolitan in its rendering, inferring an artistic product of the eighth century. Three of the figures represent women playing polo, which was introduced to the Chinese by the Persians and played on large horses imported from Bactria in Asia Minor. The women's hair is dressed in "butterfly" topknots, a fashion that originated in the Near East; they wear men's clothing, a fitted tunic over trousers and high boots, a popular fashion in the T'ang capital city of Ch'ang-an.

The beaklike nose, heavy beard, thick eyebrows, and wide eyes identify the fourth rider as an Armenoid male, a people who inhabited the region west of the Caspian Sea in Central Asia. Portraits of foreigners are not unusual among T'ang tomb furnishings (see p. 28), but their depiction as riders is quite rare. HAL

THREE FEMALE POLO PLAYERS AND A FOREIGNER ON HORSEBACK

Chinese, T'ang dynasty, ca. 8th century
Low-fired pottery; each figure: 6⅞ × 13 in.
(17.5 × 33 cm.)
Bequest of Renee Halbedl, 1981 (4911.1–4)

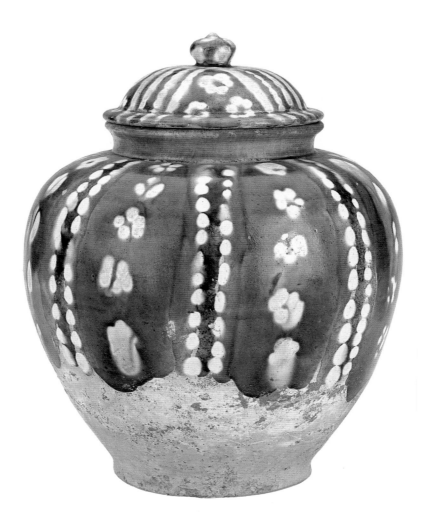

COVERED JAR

Chinese, T'ang dynasty (618–906)
Pottery with three-color glaze; h. 14 in. (35.6 cm.)
Gift of Mrs. Charles M. Cooke, 1931 (3009)

Made primarily for burial purposes, three-color pottery of the T'ang dynasty is admired throughout the world. The glaze colors were derived from oxides of copper, iron, and cobalt. Sometimes a white slip was applied to the body before the glazes were added. Although most were made in northern China, polychrome wares were imitated elsewhere. This covered jar of buff earthenware is decorated with vertical bands of flowers and dots in green, yellow, and blue. Its unsophisticated charm and vigor reflect the rich and robust taste of the T'ang period. The piece ranks with the best surviving examples of its kind. HAL

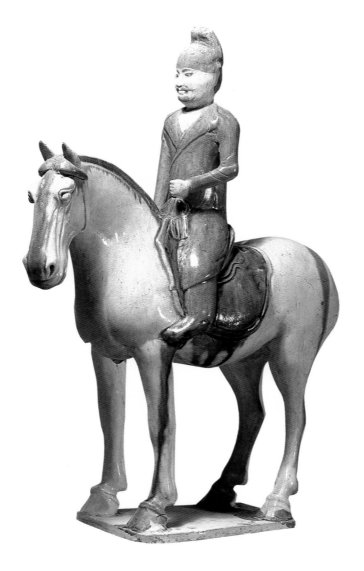

This T'ang dynasty three-color pottery figure of a horse and rider is of superb quality. The rider's unglazed head with features finely drawn in black pigment is particularly noteworthy. The figure wears a soft black cap tied in front and a chestnut-glazed coat open at the neck. His boots are similarly glazed in chestnut. The handsome steed is covered with a cream glaze of greenish tint, which contrasts with the chestnut-glazed hogged mane, forelock and blaze, and docked tail. The saddle is covered with a rich olive green, and the same green runs in streaks down the front legs of the horse. The elegant lyricism of the pottery figure sets it apart from the many other pottery figures made in the period.

This figure comes from a well-known group of sixteen equestrian models, all of which are in unusually fine condition. Made of a particularly hard, whitish clay, they were excavated before 1943 near Loyang, Honan province. Other figures from the group now in public collections include two each at the Freer Gallery of Art and the Nelson-Atkins Museum of Art, and one each at the Royal Ontario Museum, the Fogg Art Museum, the Yale University Art Gallery, Oberlin College, and the Musée Guimet. HAL

EQUESTRIAN FIGURE

Chinese, T'ang dynasty (618–906)
Pottery with three-color glaze; h. 14 in. (35.6 cm.)
Gift of Mrs. L. Drew Betz, 1984 (5232.1)

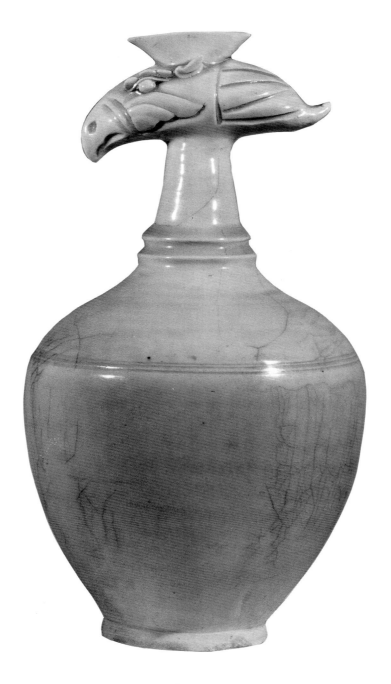

BIRD-HEADED EWER

Chinese, Five Dynasties period, ca. 10th century

White porcelain with bluish white glaze

h. 13³/₈ in. (34 cm.)

Gift of Miss Helen Kimball, 1963 (3031.1)

By the close of the T'ang dynasty, North China was producing a pure white porcelain known as *hsing* ware. The most extraordinary surviving example is an extremely rare bird-headed ewer in the British Museum, formerly part of the Eumorfopolous collection. The Academy's ewer shares a similar bird's-head lip and robust shape but not the incised floral arabesques found on the body of the British Museum's piece. The entire surface of the Academy work is covered with a bluish white glaze. In this respect it presages the Ying-ch'ing glaze of the Sung dynasty and is therefore dated to a period slightly later than the close of the T'ang dynasty. This ewer was found in Surabaya, Indonesia, in 1959, and similar examples are in the collection of the Tokyo National Museum. All are dated to the tenth century. HAL

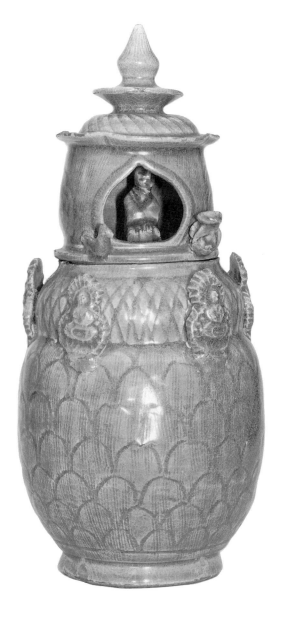

BURIAL JAR

Chinese, Sung dynasty (960–1279)

Yüeh-type ware; stoneware with olive green glaze

12½ × 5¼ in. (31.8 × 13.3 cm.)

Gift of the Honorable Edgar Bromberger, 1953 (1895.1)

The body of this rare burial jar is decorated with incised leaf petals, which ascend to a bulbous shoulder covered with an incised criss-cross diaper pattern. The shoulder is interrupted by five leaf-shaped plaquettes, which serve as nimbus backgrounds for five seated Buddhist divinities. The cover is in the form of a shrine, in which a seated figure of a Buddhist deity is modeled in the round. The form can be viewed through a leaf-shaped opening flanked by a bird and a dog. The top of the shrine is surmounted by a tiered petal ending in a pointed finial. The entire surface of the jar is covered with an olive-green celadon glaze.

A somewhat earlier jar of the same type in the collection of the Seattle Art Museum is dated to the late T'ang dynasty on the basis of its widely splayed foot. Proto-Yüeh ware was produced as early as the Han period and gained its full identity during the Six Dynasties period (220–580); see pp. 21–22. This high-fired stoneware burial jar with transparent olive or gray-green feldspathic glaze is here designated as Yüeh-type ware after Yüeh-chou in Chekiang province, where true Yüeh ware was first produced. Yüeh and Yüeh-type ware are important links in the development of the later celadons, and this jar is clearly on the threshold of the celadon era. The Buddhist iconography and shrine-cover are apparently unique for this ware.

HAL

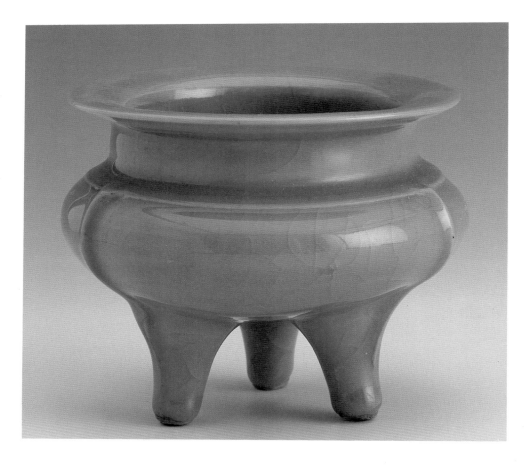

INCENSE BURNER

Chinese, Southern Sung dynasty (1127–1279)

Lung-ch'üan ware; porcelaneous stoneware with

blue-green glaze; 4¼ × 5¼ in. (10.8 × 13.3 cm.)

Gift of the Honorable Edgar Bromberger, 1950 (1032.1)

Following the collapse of the Northern Sung court and its subsequent move south, a change occurred in the design and glaze of ceramics. Southern Sung celadon or Lung-ch'üan ware, with bluish green glaze and molded decoration, soon became the most pervasive Southern Sung ware, replacing the typical Northern Sung celadons altogether. This transition has been attributed to the differing tastes of the two periods, but studies point to technical factors as well. The coal used for firing in the north imparted a yellowish tint, resulting in the olive-gray glaze of the northern ware. In the south, pinewood was preferred, and this gave the glaze a bluish tint.

This small tripod recalls the archaic bronze *li* of ancient times. Its blue-green glazed surface has the unctuous texture of jade and is indicative of the cultivated antiquarian taste that dominated the period. HAL

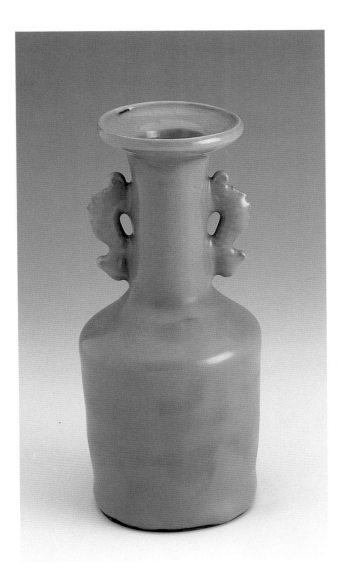

This superb vase in perfect condition is of a type known by the Japanese term *kinuta*, meaning "mallet-shaped," which has come to be applied to any celadon of this blue-green color, regardless of its shape. Considered the standard of excellence in Lung-ch'üan ware, *kinuta* represents the finest of all celadon colors.

The ware in general has a white-gray porcelain body, which burns to a sugary brown where exposed to the kiln flame, is covered by a thick glaze with many small bubbles beneath the surface, and ranges in color from a celadon sea green to olive green, blue-green, and a blue that approaches the blue of another Sung ware called Chün. The best examples rival the superlative quality of jade.

The proportion and relationship of the two fish-handles to the neck and body of this vase are beautifully calculated. Said to have once been part of the famous collection of Lord Cunliffe, the vase is as excellent but not as large as the Lung-ch'üan *kinuta* in the Freer Gallery of Art, long a textbook classic. HAL

"MALLET" VASE

Chinese, Southern Sung dynasty. 12th–13th century

Lung-ch'üan ware; porcelaneous stoneware with

blue-green glaze; 6⁷⁄₈ × 3¹⁄₄ in. (17.5 × 8.3 cm.)

Gift of the Honorable Edgar Bromberger, 1953 (1890.1)

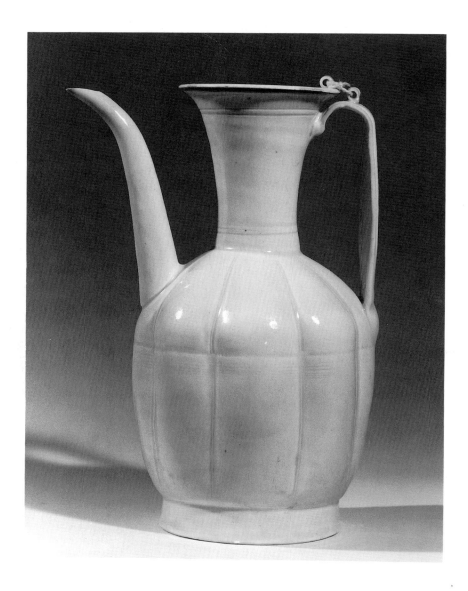

EWER

Chinese, Sung dynasty, 10th–11th century

Ying-ch'ing ware, white porcelain with pale bluish glaze

h. 9½ in. (24.1 cm.)

Gift of Mrs. Charles M. Cooke, 1927 (112)

Not highly regarded in its own time, and without even a contemporary name, the ware known as Ying-ch'ing (literally, shadow blue) proved to be a favorite with later collectors. A pervasive export ware, it was an important white ware in the development of the blue-and-whites of later Chinese porcelain. The principal center for the production of Ying-ch'ing ware was Ching-te-chen in Kiangsi province. Other sites have been excavated in Fukien province. In the fifth and sixth centuries these kilns were controlled by the needs of the Kiangsi farmers, but by the late tenth or early eleventh century the kilns began production on a regular basis with skilled potters. A myriad of shapes ranging from ewers (such as this fine example), vases, incense burners, and bowls appeared. The ware, which was not imperial, continued to be manufactured until the fourteenth century. It was then modified for use in the Yüan-dynasty imperial kilns and referred to as Shu-fu (see p. 45).

Ying-ch'ing or Ch'ing-pai ware, as it is sometimes called, was exported in large numbers all over Asia and even to the Near East. Examples have been uncovered in Japan from twelfth-century sutra mounds.

This example is believed to have been produced during the Northern Sung dynasty, possibly in the late tenth or early eleventh century at the Ching-te-chen kilns. The dating is based on the melon form of the lobed body, the high neck with flared legs, the slender, gracefully curved spout, and the flat "ribbon" handle. The work is a splendid example in fine condition and complete with its original cover. HAL

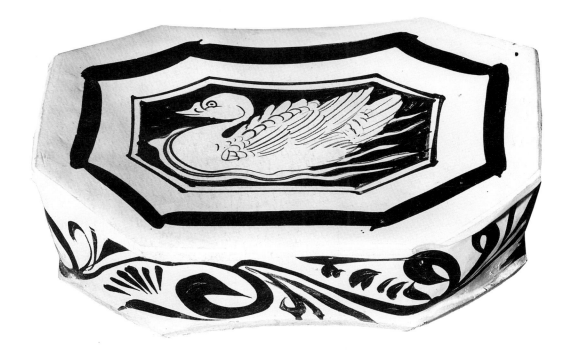

Tz'u-chou is a generic term encompassing a group of related wares with either painted, incised, or carved decoration and produced over a large area of northern China. The painted ware was by far the most successful of the Tz'u-chou types, having a more fluid, vibrant quality seldom encountered in the incised or carved examples. The surface and sides of this pillow are decorated with dynamic scrolling foliage, and the top includes a design of a goose floating in water. The result is a work of distinctive grace and elegance. The Tz'u-chou wares from the kilns of southern Hopei province represent one of the largest and most important groups of Sung ceramics. This pillow may have emanated from that area. HAL

PILLOW

Chinese, Chin dynasty, ca. 12th–13th century
Tz'u-chou ware; porcelaneous stoneware with white
slip and painted decoration in underglaze iron
4 × 12 × 7½ in. (10.2 × 30.5 × 19.1 cm.)
Potter's three-character mark: Chang-chia tsao
Gift of the Honorable Edgar Bromberger, 1952 (1599.1)

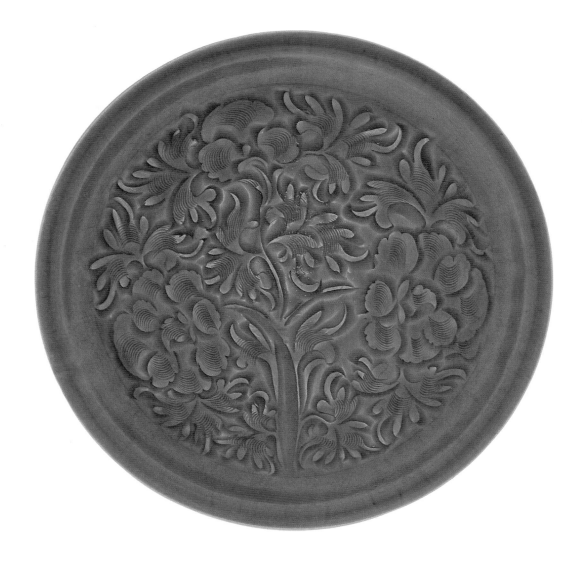

BOWL

Chinese, Northern Sung dynasty, 11th or 12th century

Porcelaneous pottery with celadon glaze

2⅞ × 11⅞ in. (7.3 × 30.2 cm.)

Exchange, 1971 (3823.1)

Celadon ware of the Northern Sung dynasty was widely distributed throughout Honan province and other parts of northern China and reflects a further development of Yüeh-type ware techniques. Designs were either molded or carved on the body of the northern ware. This bowl is distinguished by a gray porcelaneous body covered with a transparent olive-green glaze. A peony design has been sharply carved into the surface along with swirling leaf forms. The fineness of this carving, in combination with the application of glaze, has resulted in rich accretions of the glaze which, where settled into recessed areas, create a sense of chiaroscuro. Large bowls such as this one are rare in Northern Sung celadon and, when encountered, are seldom of such high quality. HAL

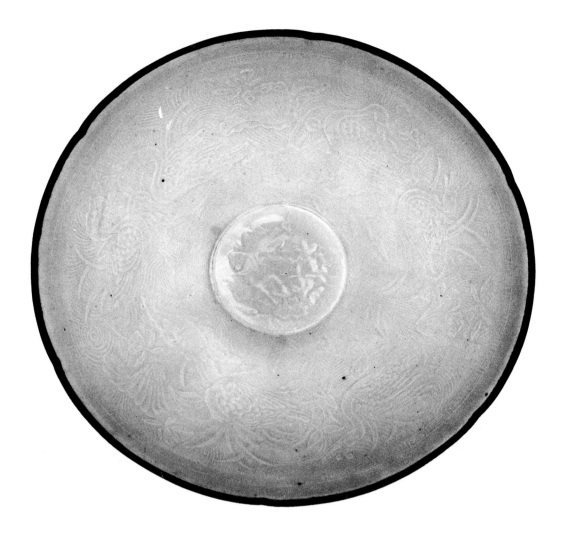

This deep bowl, with its thinly potted form and neatly impressed design featuring three mandarin ducks, lotus leaves, and flowers, represents one of the characteristic types of Chin Ting ware. The bowl is made of porcelain and covered with a clear glaze. Waves indicated by comb marks complete the design. The underside shows the "tear-stain" effect (straw-colored glaze drops) that is mentioned as typical of Ting ware in Chinese literature on ceramics. The term porcelain is used here in the Chinese definition: a high-fired ware in which the glaze coalesces with the body and which, when struck, produces a clear, resonant tone. Translucency is not a requirement of Chinese porcelain, as it is in the West, although this particularly thin example would qualify under either definition.

Ting ware was fired upside down in the sagger, which required that the lip be wiped clean of glaze before firing. Later the unglazed lip was covered with a copper rim, observed in this example. These rims were sometimes gilded in silver or gold. HAL

BOWL

Chinese, Chin dynasty, 10th–11th century
Ting ware; porcelain with molded decoration and
clear glaze; 2³/₄ × 7³/₄ in. (7 × 19.7 cm.)
Gift of Lt. Gen. Oliver S. Picher, USAF (Ret.), 1956
(2235.1)

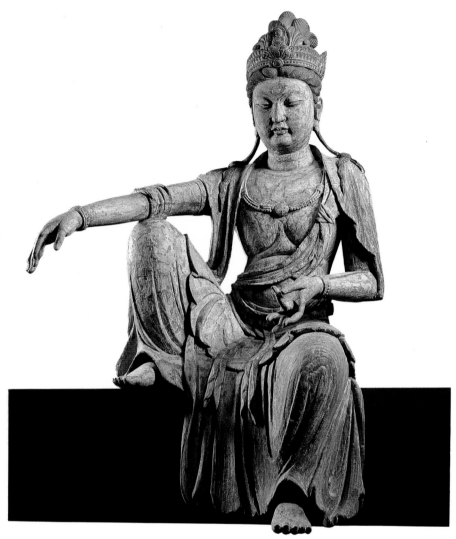

KUAN-YIN BODHISATTVA

Chinese, Northern Sung dynasty, ca. 1025

Wood; h. 67 in. (170.2 cm.)

Purchase, 1927 (2400)

This Kuan-yin bodhisattva figure sits frontally in a complex pose called the *maharaja lalitasana*. This pose, with left leg pendant and the right leg raised onto the top of the throne seat, the bent knee supporting the tensely stretched right arm, is known in Indian art from the fifth century, as evidenced by works in the Ajanta caves. The pose is documented by a bronze image discovered in a tomb in Chekiang province containing a variety of materials dated to the Five Dynasties period (909–960). This Kuan-yin is tentatively identified as Kuan-yin P'u-sa (Avalokitesvara Bodhisattva), the god-goddess of mercy and compassion, because of the representation of a small Buddha figure (thought to be the deity's parent, Buddha Amitabha) in the crown of the image.

Stylistically, the form possesses a lifelike reality and inner strength that convey an impression of alertness typical of early Northern Sung sculpture of the eleventh century. The ornamentation, not elaborately treated, is also consistent with eleventh-century sculptural style. The particular division of the form's torso prevails in most images from the first half of the century; by the middle of the century the divisions acquire a stronger and sharper linearity than observed here. This evolution of sculptural form and detailing can be documented in a group of images, one dated 1012 (or 1020) and others dated 1038, all from the main Shrine Hall of the Fen-kuo Ssu in I-hsien, Manchuria, suggesting the possibility of a Liao origin for the Academy image. Its crown with rows of tiny petal-forms is apparently unique in surviving Chinese sculpture, but it occurs frequently in Japanese sculpture in the second half of the eleventh century.

This Kuan-yin dates stylistically and iconographically to about 1025, and, as such, is one of the earliest of its type to survive in a long line of similar images that are a dominant feature of Sung and Yüan Buddhist art. HAL

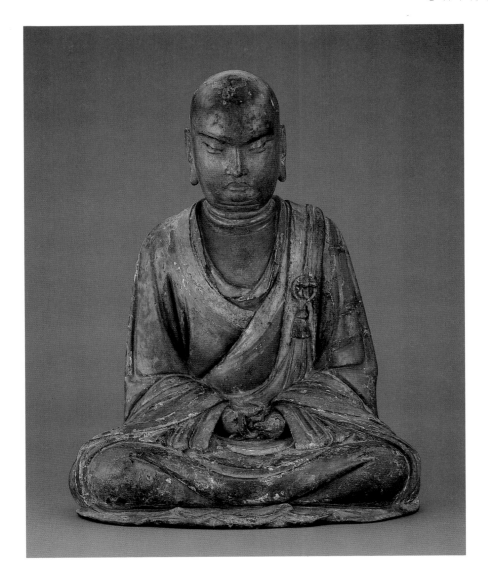

One of the best-preserved Chinese sculptures in the dry-lacquer medium, this seated image of a lohan (arhat) bears a rare authentic inscription that dates the work to the second year (1099) of the Yüan-fu period. It also names the donor as Chiang-sheng and identifies the artist as Liu-yün. The figure, in monk's garb and with shaven head, is seated with legs folded under his robe and his hands in the *dhyana mudra*, connoting contemplation; similar images in pottery from I-chou, Hopei province, have been identified as lohans on the basis of the *mudra*. The Academy statue is made of layers of lacquer-soaked cloth, which is hard, durable, and lightweight when dry. Although this technique was known for centuries, relatively few examples survive in Buddhist sculpture, adding to the importance of the Academy's dated treasure.

Stylistically, the lohan reveals the consolidation or formalization of features common to the eleventh century; the sense of settled calm and the degree of naturalism are characteristic of Chinese sculpture of this time. HAL

LOHAN

Chinese, Northern Sung dynasty, dated 1099

Dry lacquer; h. 17½ in. (44.5 cm.)

Purchase, 1939 (4818)

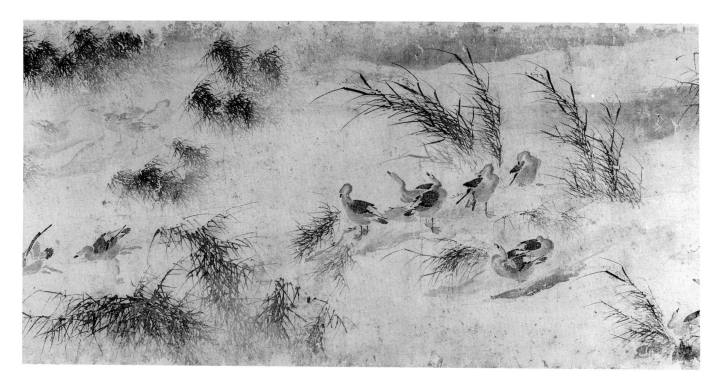

THE HUNDRED GEESE (detail)

Traditionally attributed to Ma Fen, act. 12th century

Chinese, late Southern Song or Yüan dynasty

Ink on paper, mounted as a handscroll

13¾ in. × 15 ft. 10⅞ in. (34.9 cm. × 4.85 m.)

Signature: Ho-chung Ma Fen

Gift of Mrs. Charles M. Cooke, 1927 (2121)

A long river and marshland together with a misty sky constitute a background for reeds, bending grasses, and above all, a plethora of dynamic birds—the hundred geese of the scroll's title. The birds form a wavy chain, sometimes in groups, sometimes in a thin string. With swift touches of the brush and in a virtuoso performance of ink gradation and rhythmic spacing, the artist has captured a seemingly infinite variety of positions—the birds soar through the air, dive in the water, gather in flocks on the shore, fight, even brood.

In recent years the traditional attribution of this work to Ma Fen has been challenged on two counts: first, the signature, "Ho-chung Ma Fen," at the end of the scroll is not by the same hand as the painting and has been judged a spurious addition; second, the scroll contains no collector or owner seal earlier than the Yung-lo period (1403–24), two centuries later than the time of Ma Fen. Its style, however, is distinguished by a subtle pictorial quality associated with a number of Chinese ink paintings in Japan and also traditionally attributed to the late Sung dynasty. Based on style and brush characteristics, the scroll seems to date to the late thirteenth or early fourteenth century and is one of the most beautiful bird paintings of its type in existence. HAL

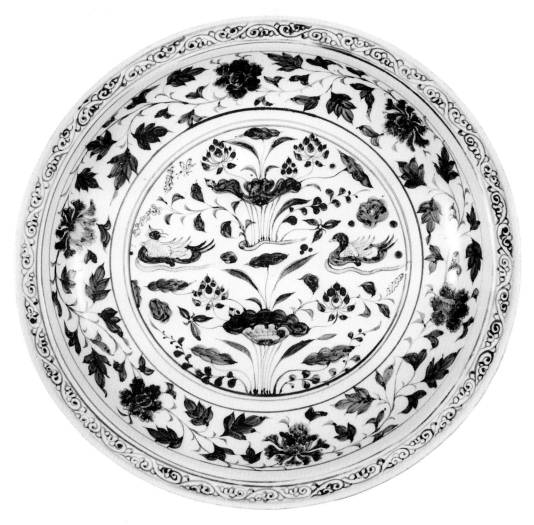

It has been suggested that the key to the development of Chinese porcelains from the Yüan dynasty to recent times lies in a combination of two particular styles: the thin porcelain with pale blue glaze known as Ying-ch'ing ware (see p. 38) and the robust underglaze cobalt-blue decoration that satisfied the new Mongol ruling class. The Yüan court adopted Ying-ch'ing ware to its own foreign traditions and called it by the euphonious title Shu-fu. This late thirteenth-century ware was more refined, homogeneous, and stronger than Ying-ch'ing, with a more cohesive bond between glaze and body. The slightly thick, milky quality of the glaze and the heavier body provided the perfect form and surface for the addition of underglaze cobalt-blue decoration, ushering in the beginnings of the great Chinese tradition of blue-and-white in the early fourteenth century.

This large dish typifies the perfection of blue-and-white wares made during Yüan times. The underglaze cobalt-blue pigment is darker in color, and the decoration is tighter and more crowded than in later examples (see pp. 47 and 48). The pattern includes lyrically conceived mandarin ducks and water plants in a central design of great charm, surrounded by bands of peony and scroll decoration. The exterior, with typical fourteenth-century lotus decor, helps to date this example. HAL

DISH

Chinese, Yüan dynasty, early 14th century

Porcelain with underglaze blue; $2^{1}/_{2}$ × $14^{7}/_{8}$ in.

(6.4 × 37.8 cm.)

Purchase, Marjorie Lewis Griffing Fund, 1970 (3713.1)

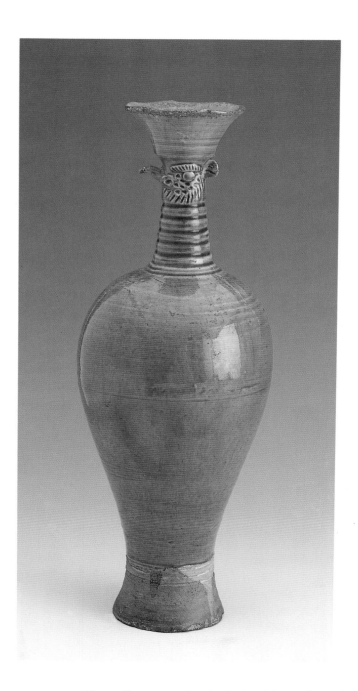

EWER

Chinese, Liao dynasty, 11th–12th century

Pottery with amber glaze on white slip

h. 16 in. (40.6 cm.)

Gift of Lt. Gen. Oliver S. Picher, USAF (Ret.), 1972

(4027.1)

This tall ewer with a high shoulder and an elongated, slender, ribbed neck ends in a bird's-head motif and cup-shaped mouth with foliate lip (see p. 34). The form is exquisite, as is the robust amber-orange glaze. Recent excavations indicate that this example should be assigned to the Liao dynasty of the late eleventh or early twelfth centuries. Identical examples have been uncovered in Liao-period tombs. Liao ceramics continued the earlier T'ang traditions in both glaze and form in an appealing although provincial manner, often borrowing elements of contemporary Sung style as well. The shape of this work, for example, is an attenuation of T'ang bird-headed ewers observed in three-color ware and Hsing ware. The high shoulder, however, is more characteristic of Sung ware. HAL

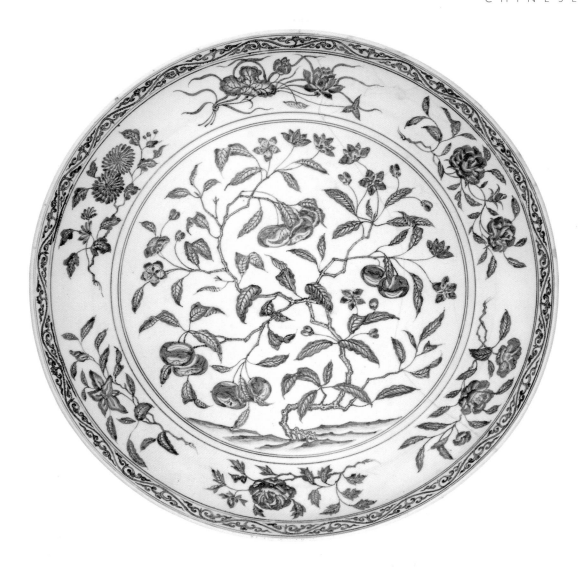

The Yung-lo period of the Ming dynasty is known primarily for its mono-chrome white porcelains, but other wares, including some superlative blue-and-white examples, should not be overlooked. Among the classic Yung-lo productions is this blue-and-white dish, one of the larger plates of this type to survive. The dish is thought to be unique among the underglaze-blue porcelains of the early fifteenth century because of its painted design; the realistically depicted flowers and plants in the center can be identified as loquat, surrounded by sprays of lotus, rose, camellia, peony, gardenia, and chrysanthemum. The bright blue color of these patterns is the result of using imported cobalt pigments. Perhaps the supersaturation of the imported cobalt ore was the cause of areas of bluish black and brownish black, including dots along the lines of the design.

The dish has been hailed by Chinese ceramic expert Margaret Medley, former curator of the Percival David collection, as the single most important piece of all blue-and-white porcelains of the early fifteenth century. HAL

DISH

Chinese, Ming dynasty, Yung-lo period (1403–24)
Porcelain with underglaze blue; diam. 23 in. (58.4 cm.)
Purchase, Academy funds and partial gift of Robert P.
Griffing, Jr., 1976 (4398.1)

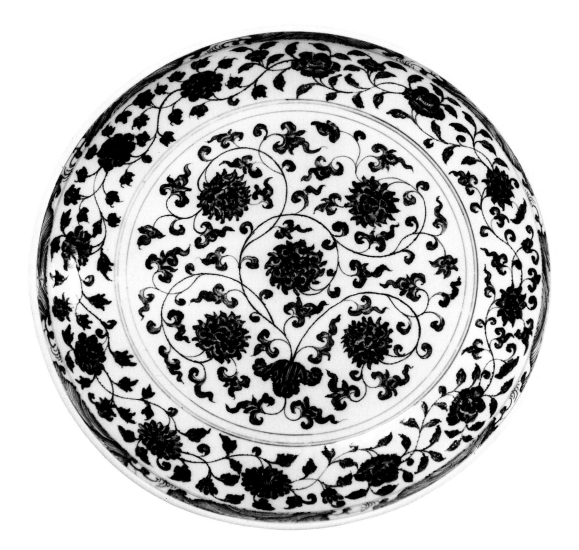

DISH

Chinese, Ming dynasty, Hsüan-te period (1426–35)

Porcelain with underglaze blue

diam. 15⅛ in. (38.4 cm.)

Purchase, 1961 (2907.1)

In contrast to the Yung-lo piece (p. 47), with its large size and loosely conceived design, is this blue-and-white porcelain of the Hsüan-te era. Most, if not all, of the clearly dated underglazed-blue porcelains of the Hsüan-te reign offer a more tightly conceived decoration than do the earlier Yung-lo examples. The Hsüan-te reign is considered by many authorities to be the classic period for blue-and-white ware due to improved materials and methods, and corresponding refinement in painting technique. During this era, objects such as this dish, with a central design of lotus scroll and peony scroll on the cavetto, display a notable richness of color resulting in a greater impression of strength. HAL

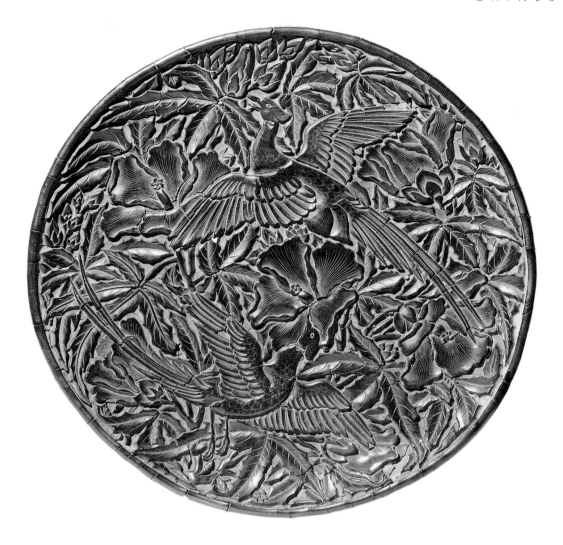

TRAY

Chinese, Yüan dynasty, late 14th century

Lacquer; diam. 12½ in. (31.7 cm.)

Purchase, 1955 (2118.1)

The lacquer medium was employed as early as the Warring States period of the late Chou dynasty, when it was used for painted designs, and lacquer dishes and utensils, miraculously preserved, have been recovered in recent years from Han-dynasty tombs. By the Yüan dynasty, the same imperial patronage that demanded the great blue-and-white porcelains required carved lacquer dishes with similarly robust designs. Numerous lacquer techniques developed in this long history, but the most involved, and perhaps most evolved, is that of building up innumerable layers of lacquer lamination over a base (most often of wood) and then carving or incising through them. Although the dating of Chinese lacquerware is still tentative, it is believed by some scholars that the layering technique was developed during the Yüan dynasty.

This lacquer tray deserves special attention because it reflects design elements similar to those found in other media of the Yüan dynasty, suggesting a late fourteenth-century date. A remarkable example of carving, the tray has on its face a design of two birds among peonies. Its deeply carved, precise design and refined detail are also criteria for suggesting a date at the threshold of the Ming dynasty. HAL

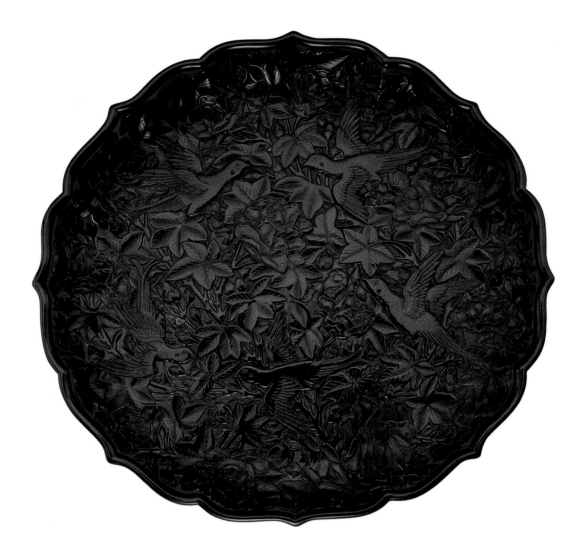

LACQUER TRAY WITH FOLIATE RIM

Chinese, Ming dynasty, ca. 15th century

Carved lacquer; 2⅛ × 16⅜ in. (5.4 × 41.6 cm.)

Purchase, 1973 (4177.1)

This tray with foliate rim and decoration of five birds set against a design of flowering peonies is a superb example of carved lacquerware. It reveals the use of a technique in which alternating colors are used for the laminated layers; incisions made through them reveal the order, like geologic strata. The background layer of this tray is of red lacquer. In an excellent state of preservation, the dish was included in the grand exhibition of Asian art celebrating the opening in 1968 of the Toyōkan of the Tokyo National Museum, where it was assigned to the fifteenth century in the official catalogue. Compare this tray with a carved tray in the Academy's collection that is dated to the late Yüan dynasty (p. 49). The cutting on this fifteenth-century example is less deep and angular than in trays assigned to the fourteenth century.　　HAL

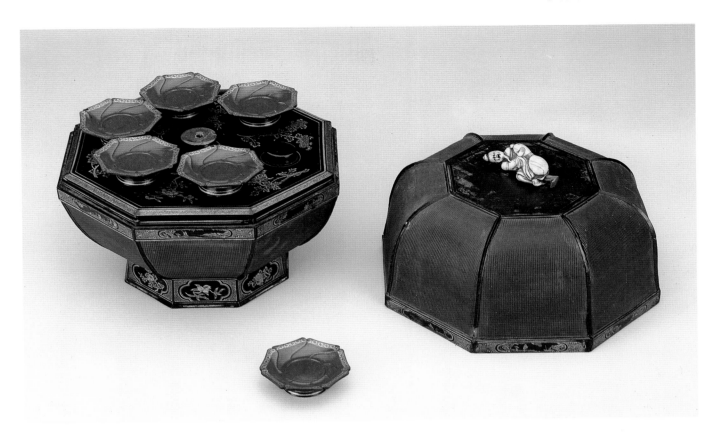

Fitted with particularly fine basketry panels on all eight sides, this deep octagonal box was made to hold a set of six cups. The flat surface of the top is decorated with a painted landscape on a black lacquer ground and is surmounted by an ivory figure of a Taoist immortal lying on his side. A filled tray inside the box has six recesses for holding cups, and the center is fitted with a malachite disc and a coral knob by which the tray can be lifted. This inset is decorated with six floral sprays on branches painted in gold. The cups, of red lacquer, are modeled in the form of overlapping petals. The exterior borders of the box, cover, and foot are decorated with miniature landscape scenes as well as with floral sprays.

The box bears on its base an inscription giving the year *Wan-li chia-yin*, which corresponds to 1614. This early inscription, followed by the character *ju* (to acquire for use), has been partly obliterated, perhaps to provide space for the owner's name, Chan Shang-p'ei, which was added at a later date. The six cups bear the owner's mark as well, suggesting that no replacements have been added since the time of his ownership.

Boxes for holding cups such as this were known in the Han dynasty as *lo*. Very early references indicate that this term defines a basket for holding cups. Excavation reports from China indicate that lacquer boxes holding five or ten lacquer cups have been found in early Western Han tombs in the southern province of Hupei, but it is unclear whether these lacquer boxes are of wood or of bamboo basketry. This example is not only a rare dated example, but it reflects a tradition dating back to the early dynastic history of China. HAL

OCTAGONAL BOX

Chinese, Ming dynasty, Wan-li period,
dated by inscription to 1614
Fitted basketry panels with lacquer top; 9 1/2 × 10 in.
(24.1 × 25.4 cm.)
Gift of Mrs. Charles M. Cooke, 1927 (1501)

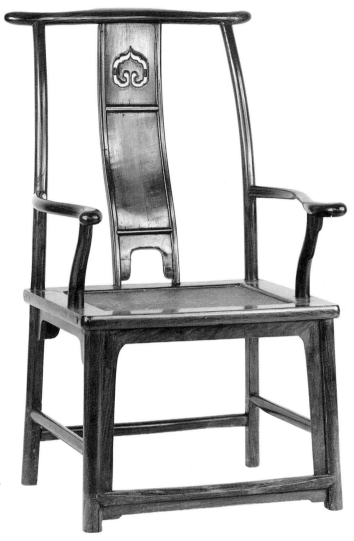

HIGH YOKE-BACK ARMCHAIR

Chinese, Ming dynasty, 16th century

Huang hua-li wood, one of a pair; 45 × 23 × 19 in.

(114.3 × 58.4 × 48.2 cm.)

Purchase, 1973 (4170.1a)

This classic example of a high yoke-back armchair demonstrates many of the criteria and virtues of early Ming furniture. The play of forms achieved by the curve in the posts and the concave splat, combined with the sweep of the arms and the splay of the legs, produces an object that is as much sculptural as it is functional. Quality wood was lavishly employed to create a work of well-proportioned vigor.

The criteria for dating this chair to the early sixteenth century include: the flattened yoke, well-laid back; a slight splay and strong curvature of the rear stiles; a strong curvature to the arm rails; the substantial heft of the arm posts; the thickness of the unmolded slab seat frame; the height (four inches) from the floor of the side stretchers and their ovate shape; the heavy flanges and aprons, all fashioned from one solid piece of wood, observable only in this thickness in early examples of *huang hua-li*; and finally, the substantial wear of the foot rail, suggesting great age. These same characteristics, resulting in an architectonic vigor, can be observed in other yoke-back chairs assigned to the same period.

A variety of miniature furniture, including the yoke-back chair, from tombs ranging in date from the twelfth to sixteenth centuries shows that furniture design fol-

lowed the same basic form century after century with few modifications. Stylistic dating to an earlier period, therefore, is difficult at best, although the possibility cannot be eliminated.

The fine wood of this chair, called *hua-li*, or *huang hua-li*, is mentioned in writings of the thirteenth century. The term describes woods from the island of Hainan and other similar species imported from Indochina and India. *Hua-li* belongs to the family of *Leguminosae*, which includes more than seven thousand species. The word *Lü* refers to a group of people living on the islands of Hainan or Southern Islands, whence came the wood called *hua-lü* that was sent to Canton in the eighth century. Today, in the West, all of these woods are generally called rosewood and have a fine, close grain and color ranging from yellow to various hues of reddish brown. HAL

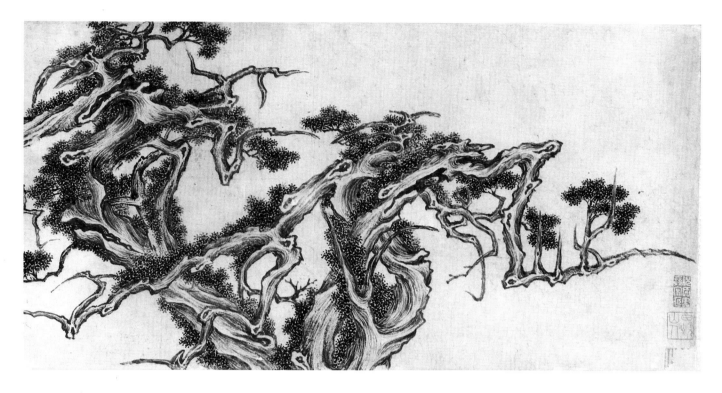

The southern-style painting of the early Ming dynasty is dominated by two great masters, Shen Chou (1427–1509), the founder of the Wu school, and his immediate successor and pupil, Wen Cheng-ming. Drawing on the traditions of the Four Great Masters of the Yüan dynasty, these artists set the standard for scholarly painting until the end of the sixteenth century.

Wen's fully developed style, however, is all his own and is characterized by a complex treatment of landscapes that is a departure from all that had gone before. His interest in grotesque trees and tortured, convoluted composition reached its climax in this handscroll featuring the Seven Junipers of Ch'ang-shu, dated in an accompanying colophon to the summer of 1532. Years earlier, Shen Chou had painted the famous trees, hallowed by a history that went back to the year 500. Shen's work, or a close copy, survives to this day in China and offers a similarly gnarled and convoluted composition.

HAL

WEN CHENG-MING

Chinese, Ming dynasty, 1470–1559

The Seven Junipers (detail), dated summer 1532

Ink on paper, mounted as a handscroll

11 1/2 in. × 11 ft. 10 1/2 in. (29.2 cm. × 3.62 m.)

Inscriptions and seals of the artist

Gift of Mrs. Carter Galt, 1952 (1666.1)

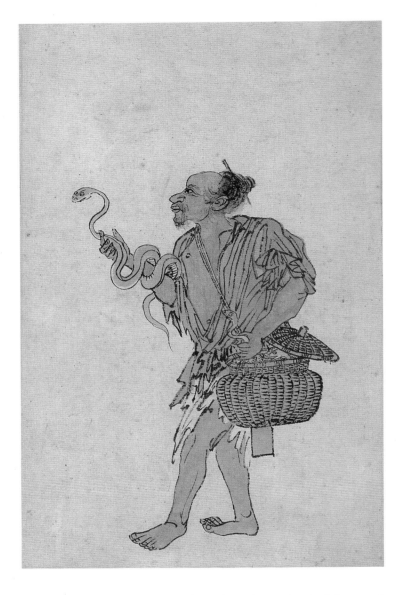

CHOU CH'EN

Chinese, Ming dynasty, act. ca. 1500–35

The Unfortunates (detail), dated 1516

Ink and slight color on paper, mounted as a handscroll;

painting only: 12⅜ in. × 8 ft. ½ in. (31.4 cm. × 2.45 m.)

Gift of Mrs. Carter Galt, 1956 (2239.1)

In 1516 Chou Ch'en, a professional artist from Soochow who worked in the style of Li T'ang (act. ca. 1050–1130) and Liu Sung-nien (act. 1174–1224), painted a set of twenty-four album leaves depicting Chinese street characters. The work was painted with such expressive power that had the artist done nothing else his name would still be remembered today.

The album has been mounted as a long handscroll with a colophon. Part of the scroll, including the artist's colophon (which securely dates and attributes the work), is in the collection of the Cleveland Museum of Art. The Academy owns the remainder, which depicts ten street urchins who run the gamut of physical types from plain to repulsive. One eats a turnip, another carries a basket of snakes; still another toils under a heavy load of firewood on his back. There is no indication of surroundings and little, if any, interaction between figures. Each is an independent study delineated with angular, choppy strokes and a dry brush that leaves ragged edges. The physical and social types have an individuality bordering on caricature—some are eccentric, some pitiful, some proud. There is little precedent in the history of Chinese painting for such interest in a poor beggar or mendicant of grotesque appearance, except perhaps in the secondary part of Buddhist icons representing scenes of hell. Ch'en's interest seems almost sociological, if dispassionate, and represents an interesting footnote of great originality in the history of Chinese painting. HAL

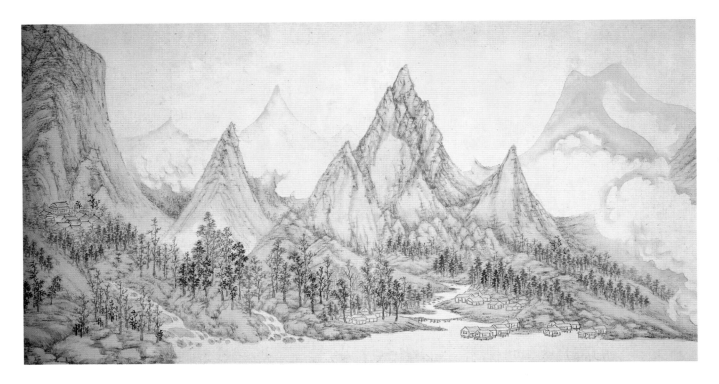

Wu Pin, a master of fine-line (*pai-miao*) figure painting, created a number of detailed landscapes that express the twisted aspects of nature. In the fifth month of 1601, Wu painted a small handscroll of mountains and clouds for a friend whose name is unknown, but whose style name was Chiu Hua. The still-intact work is signed "Chih-yin-an Chu Wu Pin" (Wu Pin, Lord of the Hiding Branch Studio) and bears three seals associated with the artist as well as two collector's seals. The accompanying colophon is a long poem by Wu telling of the beauty of the landscape.

The composition of this subtly beautiful and lyrical painting features tall, sharp, conical mountains, deep valleys, and massive white clouds; nowhere in the scene does one encounter the miniature treatment of human figures or the nearly grotesque natural forms found in Wu's later works. His technique is unique: the paper acts as the opaque of the clouds; the mountains and valleys were created with light washes and then textured with brown and blue brushstrokes. These effects are all departures from traditional methods and document Wu's experimental period in the early 1600s. The result is a panoramic landscape of great simplicity. Although this painting style was not picked up by other artists, and knew no further development within Wu's own stylistic evolution, his personal use of colors was one of the major contributions of the individualists of the succeeding Ch'ing dynasty. HAL

WU PIN

Chinese, Ming dynasty, act. 1568–1621

Landscape (detail), 1601

Ink and slight color on paper, mounted as a handscroll;

painting only: 13¼ in. × 6 ft. ¾ in. (34 cm. × 1.85 m.)

Signature and seals: Chih-yin-an Chu Wu Pin;

three seals of the artist

Purchase, 1967 (3519.1)

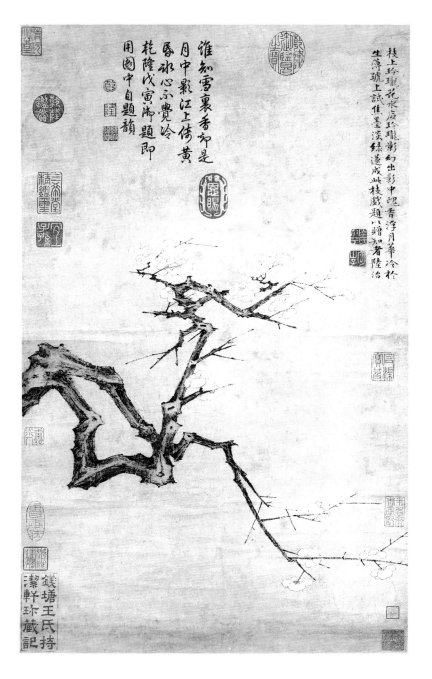

LU CHIH

Chinese, Ming dynasty, 1496–1576
Blossoming Plum Branch
Ink and light color on paper, mounted as a
hanging scroll; 23½ × 13¾ in. (60 × 35 cm.)
Signature and seals: Lu Chih; two seals of the artist
Gift of Mrs. Frank Gerbode in memory of Mr. and Mrs.
Wallace Alexander, 1956 (2261.1)

Among the Academy's treasures is this painting signed by Lu Chih, the Soochow artist and follower of Wen Cheng-ming. Lu's landscapes often employ a sharp crystalline brushwork in compositions that stress overall patterning, but his flower paintings (for which he was most famous) are more in the style of Hsü Hsi or Huang Ch'üan. The silhouetted plum branches of this painting reveal the delicate brushwork and refined use of color typical of Lu's art at its very best.

Various seals added to the scroll by later owners over the years provide interesting documentation of provenance. The painting was once the property of Emperor Ch'ien-lung, whose seal it bears. An inscription on the painting by Ch'ien-lung indicates that the work was in his collection as early as 1758. It probably left the palace as a gift to a distinguished dignitary. Other seals show that the scroll once belonged to several generations of the Lu family, including the maternal grandfather of Chiang Er-shih, the last owner of the scroll before the Academy obtained the work. HAL

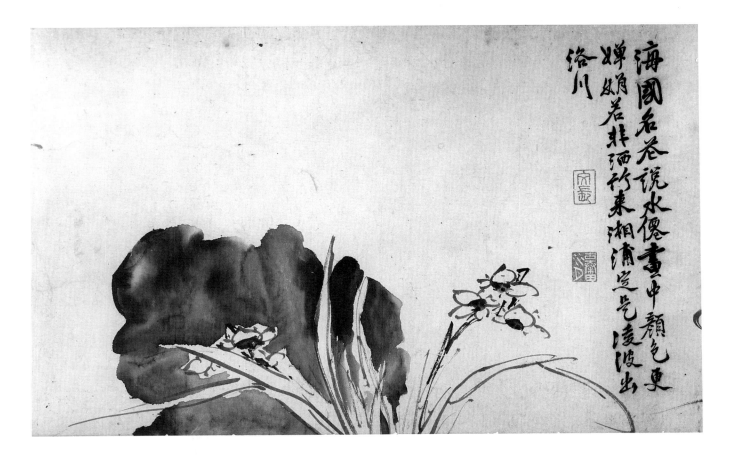

Twelve flowering plants, each rendered with a spontaneous, uninhibited brush, are separated by poems done in *hsing-shu* (running script). Both painting and calligraphy are by the artist Hsü Wei, who was also noted as a poet and dramatist. From Shan-yin, Chekiang province, Hsü Wei was the son of his father's concubine. In 1547, after failing provincial examinations for a government position, he settled in Shao-hsing in a studio called I-chih-t'ang (Twig Hall), where he wrote plays, poems, and sociopolitical essays. In 1566 he was sentenced to seven years imprisonment for beating his wife to death.

Hsü judged his calligraphy to be better than his painting—a free style that was to influence and inspire a number of Ch'ing flower painters. This scroll seems to support his view, for the calligraphy is exceptionally fine. HAL

HSÜ WEI

Chinese, Ming dynasty, 1521–93

Twelve Plants and Twelve Calligraphies (detail), after 1573

Ink on paper, mounted as a handscroll

12¹⁄₂ in. × 17 ft. 1⁵⁄₈ in. (31.8 cm. × 5.22 m.)

Unsigned; sealed Hsü Wei and several alternate names

Purchase, Martha Cooke Steadman Fund, 1960 (2710.1)

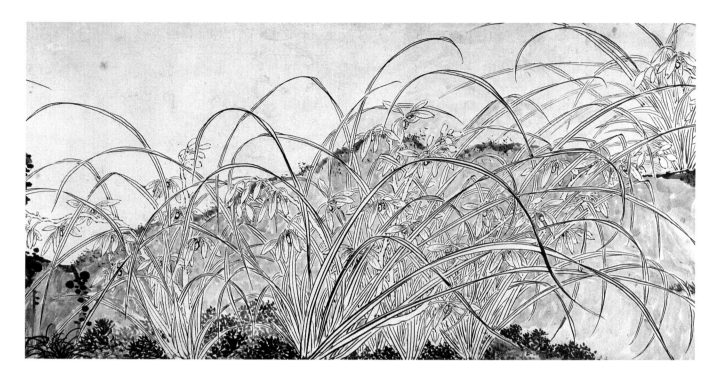

HSÜEH WU

Chinese, Ming dynasty, 1564–ca. 1637

Wild Orchids (detail), dated 1601

Ink on paper, mounted as a handscroll

12½ in. × 19 ft. 6 in. (31.8 cm. × 5.94 m.)

Signature and seal: Hsüeh Wu

Purchase, 1952 (1667.1)

Hsüeh Wu was a famous courtesan of the Ming dynasty who was equally renowned for her archery and horsemanship as she was for her love of poetry and her originality. "Beside the bed," declared Hu Ying-lin in a poem written for her, "she is awaiting the lute of jade." This same admirer and man of letters said that "she looked amiable and beautiful. Her conversation is refined and her manner of moving lovely." He particularly mentioned her paintings of bamboo and orchids. "Her brush dashes rapidly; all her paintings are full of spirit." This judgment is fully documented in *Wild Orchids*, in which subtlety, elegance, spontaneity, and controlled vitality are all blended in a delightful virtuoso demonstration. HAL

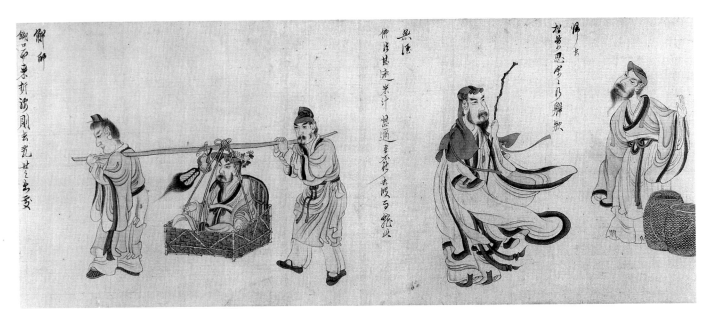

Ch'en Hung-shou, from Chekiang province, started to paint during his boyhood and developed a distinctive style that was probably borrowed from early pictorial stone engravings. He is best known for his figure paintings drawn from historic and religious subjects. The famous philosopher-hermit T'ao Ch'ien (372–430) must have been especially important to Ch'en, for he based several of his paintings on T'ao's life. Perhaps the most famous of these works is this long handscroll in ink and light color on silk, dated in the colophon to 1650. The scroll survives intact and consists of eleven scenes; each scene is framed by two rhythmic phrases by the artist.

The colophons accompanying this scroll give us a great deal of information. Ch'en painted the scroll for his friend Chou Li-yuan. An inscription by this friend noted that "the master became inspired on a bridge at West Lake (Hangchow) and silk was rushed to him. A singer stood at the rail of the bridge and sang to him. After eleven days of work—at the bridge, a (nearby) house, a houseboat, and in a (nearby) temple—he had completed forty-two paintings, large and small, including this one."

Ch'en deliberately affected the archaic quality of earlier painters such as that of the fourth-century master Ku K'ai-chih, using a drapery style of thin flowing lines in the delineation of his figures. The rocks are based on T'ang-dynasty rock elements, and Ch'en shaded these and the draperies of his figures accordingly. Where secondary figures are present, they are depicted smaller in scale than the central protagonist, another pictorial device that dates as far back as the fifth century.

CH'EN HUNG-SHOU

Chinese, Ch'ing dynasty, 1598–1652
Episodes from the Life of T'ao Ch'ien (detail), 1650
Ink and slight color on silk; 12 in. × 10 ft. 1¼ in.
(30.5 cm. × 3.08 m.)
Signed and sealed Ch'en Hung-shou in colophon
Purchase, 1954 (1912.1)

In this section of the scroll, Ch'en's technical virtuosity is fully apparent. To the right, the poet disdainfully holds up his hand (to a woman at his right, not in view). The scene is identified as "Planting Rice" and carries the explanation, "Men are fighting for food from rice barrels to gain raw strength. I am a man of stimulants and need not feed on rice." The second figure is T'ao holding a staff and gazing into the distance while the wind whips at his clothing. The title of this section is "Returning Home" and is accompanied by the verse, "The pine and chrysanthemum are longing for me, so I'll return." The last illustration, entitled "No Virtue," shows the famous poet-sage being carried in a sedan chair. The humorous inscription reads, "Buddhism is far, but the rice wine is close. I cannot reach far, therefore, I embrace what is close." Light transparent colors augment this linear masterpiece, but a colophon tells us that they were applied by Ch'en's fourth son, Ming-ju.

The Academy also owns an album of eight landscapes and figure paintings of fine quality by Ch'en Hung-shou. HAL

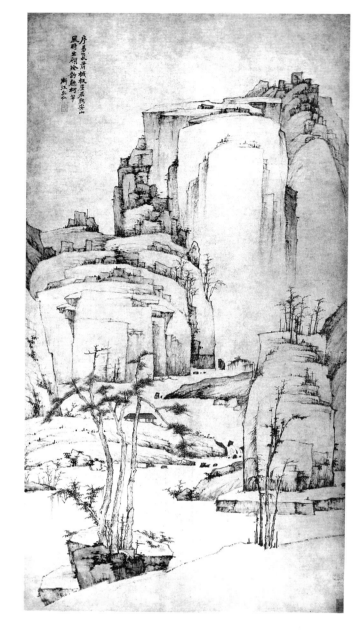

HUNG-JEN

Chinese, Ch'ing dynasty, 1610–63

The Coming of Autumn, ca. 1658–61

Ink on paper, mounted as a hanging scroll

48 1/8 × 24 3/4 in. (122.2 × 62.9 cm.)

Signature: Chien-chiang Hung-jen; seal: Hung-jen

Gift of Wilhelmina Tenney Memorial Collection, 1955

(2045.1)

Among the Anhui individualists of the Ch'ing dynasty was Hung-jen, an artist who took the skeletal painting style of the great Yüan master Ni Ts'an (1301–74) and created a new and original variation. One of the finest Hung-jen paintings to survive is *The Coming of Autumn*. Painted on paper with light, dry brushstrokes, blocky, angular forms overlap with flat planes. The painting is sparse, crystalline, and extremely sensitive. The rhythmical repetition of shapes, which result in a feeling of vastness, recall the style of Hung-jen's contemporary and teacher, Hsiao Yun-ts'ung (1596–1673). The single lonely hut in the mid- dle ground is given verbal expression in a poem accom- panying the work: "At the changing of the seasons, my emotions become sad and lonely. In my wooden hut I dwell in peace. The winds of the mountain sometimes come. And in the coolness and harmony I hear the sound of the branches and trunks."

The scroll is signed "Chien-chiang [courtesy name] Hung-jen" and sealed "Hung-jen." There can be no doubt of the work's singular importance in the study of this mas- ter's brief career. HAL

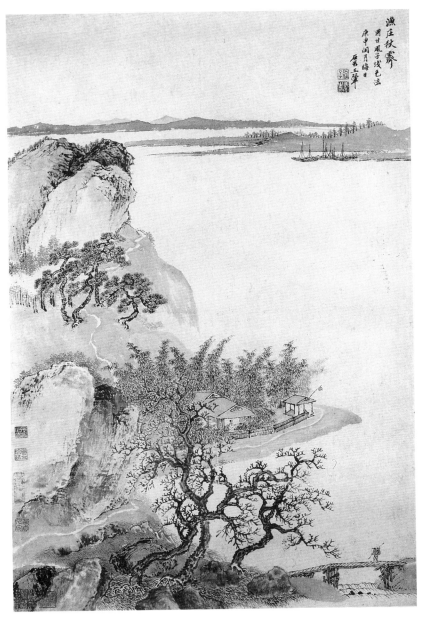

WANG HUI

Chinese, Ch'ing dynasty, 1632–1717
Fishing Village on a Clear Day in Autumn, 1680
Ink and color on paper, mounted as a hanging scroll
24½ × 15⅝ in. (62.2 × 39.7 cm.)
Signature: Shih Ku Wang Hui; seal: Wang Hui
Purchase, 1955 (2031.1)

Wang Hui, one of the Four Wangs of the Ch'ing dynasty, was famous for paintings in the style of earlier masters. As a youth his virtuoso abilities permitted him to make exacting copies—so much so that even in his mature works it is possible to detect the style of various earlier artists combined into one painting. Such works are not uncommon, and truly synthesized treatments in which his individual manner can be observed are relatively rare. The small hanging scroll illustrated here is one of his individual efforts. The work, signed "Shih Ku [style name] Wang Hui," followed by two artist's seals and several collector's seals, is dated by inscription to 1680, when the artist was

forty-eight years old. The painting is original in its use of space and washes, despite the inscription by Wang announcing his debt for the painting's light coloring to the Sung-dynasty painter Kan Feng-tzu.

The finely articulated grasses in the foreground and the fineness of the thick bamboo grove in the middle ground should be noted; here the artist has effectively used the white of the paper as a path that meanders from the foreground into the distance. Above all else, this small painting is a logically conceived landscape reflecting total mastery of Chinese technique. HAL

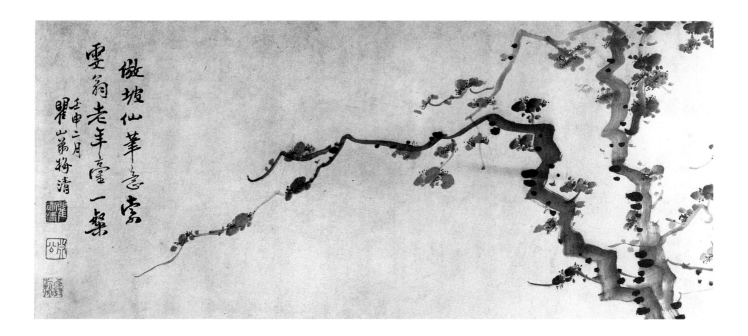

MEI CH'ING

Chinese, Ch'ing dynasty, 1623–97
Plum Branches and Blossoms (detail), dated 1692
Ink on paper, mounted as a handscroll
11 3/8 in. × 6 ft. 2 5/8 in. (28.9 cm. × 1.9 m.)
Signature and seal: Mei Ch'ing
Purchase, 1953 (1668.1)

A superlative example of the individualist Anhui school, *Plum Branches and Blossoms* is by the youngest and perhaps the most gifted of the Anhui painters, Mei Ch'ing.

Mei was born in Hsüan-ch'eng, Anhui province. His family was apparently artistic, and two of his brothers also became painters. Mei called himself by various appellations, including Ch'u-shan, Hsüeh-lu, Mei-ch'ih, and Lao-ch'u fan-fu. In this he exhibited the same taste for fanciful seals and signatures as his friend, the eccentric painter Shih-t'ao.

Mei spent most of his life in Anhui, where he studied the fantastic formations about Huang-shan, enchanted with the landscape and the stirring scenes it provided. It is said that he was a precocious youth with unusual gifts in poetry and painting. "When not occupied in singing or writing poems, he did ink paintings; moving the brush in coiled-up patterns all strange and unrestrained." This statement accurately describes Mei's approach to his paintings of the early 1690s, toward the close of his life. In the case of this scroll, the plum blossoms and twisted branches are freely distorted with a loose wet brush and treated as a continuous stretch of "landscape." His forms are abbreviated, and his composition dependent on repetitive rhythms. In his use of the brush, Mei owes something to Shih-t'ao, who was addicted to an extremely bold use of the brush and delicate washes. One of Mei's seals reads Mei-ch'ih (the Plum-blossoms' Fool), and this predilection for the plum tree may have been conditioned by his association with Shih-t'ao, who often painted the subject.

Most of Mei's published work is landscape, either album leaf or hanging scroll, making comparative material limited. In 1693, however, he painted a lovely album, one leaf of which, *Winding Water Between Cloudlike Rocks on Huang-shan*, offers parallel brushwork and the same curious compositional eccentricity as observed in the Academy handscroll. HAL

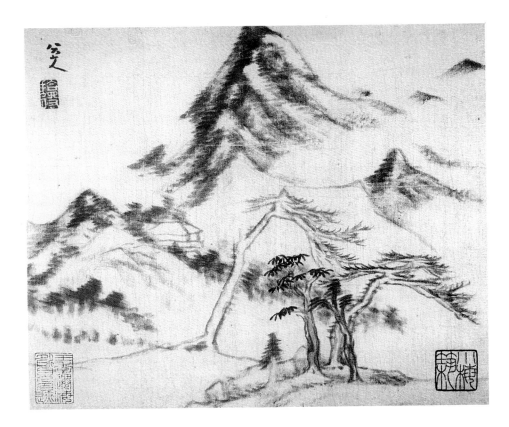

Chu Ta is best remembered for his eccentric painting style, which is extremely abbreviated, brilliantly conceived, and executed with great ease and rapidity. In China he is better known by his actual name, Pa-ta Shan-jen; Chu Ta is his Buddhist name. His eccentric and uncouth life matched much of his wildly conceived art. He was subject to uncontrollable fits of laughter and sobbing, preferred strong spirits, and entered a delirious state while painting—splashing and smearing ink on paper as he sang and shouted.

Chu's primary style was indebted to the artist and theoretician Tung Ch'i-ch'ang (1555–1636), who codified the tenets of literati painting. Chu Ta, unlike other artists of the day, adopted the more radical aspects of Tung's art, producing a style that is quite his own. He constructed pictures by means of a series of tentative brushstrokes, searching for final forms rather than a fully realized delineation. There is a sense of the form growing beneath the brush, and the feeling that the picture is still being completed.

The Academy's album of eight leaves conforms to the criteria of Chu's primary style. It also reveals a debt to Mi Fu (1052–1109) and Mi Yu-jen (1086–1165) in five of the eight leaves; elsewhere there are echoes of Huang Kung-

LANDSCAPE IN THE MI STYLE

Attributed to Chu Ta, ca. 1626–1705

Chinese, Ch'ing dynasty

Ink and light color on satin, the eighth leaf from an album of eight leaves; 13⅜ × 22⅞ in. (34 × 58.1 cm.)

Signature and seals of the artist on all eight leaves

Gift of Robert Allerton, 1959 (2561.1)

wang (1269–1357) and even subtle traces of Wu Chen (1280–1354) and Wang Meng (ca. 1309–85). That the Mi style dominates the album leaves comes as no surprise, for Chu's grandfather was skilled in its practice, and Chu's preference may stem from family tradition.

Most scholars who have studied this Chu Ta album date the work very late (ca. 1700–1705) and accept it as a genuine late work, noting that it conforms stylistically to other late landscapes by the master. HAL

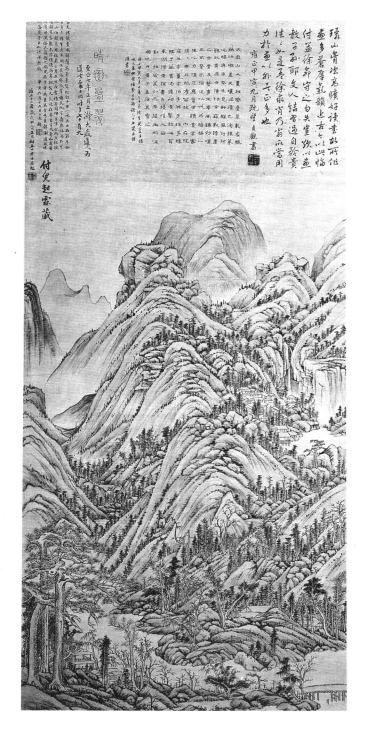

FANG SHIH-SHU

Chinese, Ch'ing dynasty, 1692–1751

Sunny Mountains in an Assembly of Greens, 1734

Ink and light color on silk, mounted as a hanging scroll

58¾ × 26 in. (149.2 × 66 cm.)

Signature: Fang Shih-shu copied; seal: Fang Shih-shu

Gift of Mr. and Mrs. Mitchell Hutchinson, 1988 (5733.1)

A member of the orthodox Lou-tung school, Fang Shih-shu found inspiration for this painting in one of the same title by the early Yüan master Huang Kung-wang (1269–1354). An inscription on the painting indicates that Fang's interpretation was based on a written record of Huang's version. In Fang's painting, the crystalline formations are symbolic of Huang's style as reinterpreted in the seventeenth and eighteenth centuries, but Fang's intellectualized painting is an improvisation that remains all his own. The "assembly of greens" mentioned in the original title is here only dashes of color; the repeated slopes and lumps of rock are rhythmically formulated. The painting obviously pleased Fang, as he added an inscription indicating that he gave it to his son for safekeeping. In still another inscription, the painting is dated to the ninth lunar month, the fifteenth day of 1734. The scroll also includes a poem written by Fang's younger brother, Shih-chieh, which says in part that the painting is a family heirloom and must never be neglected—a treasure that must be kept safe for future generations. Three other inscriptions, two by later collectors, are included.

Fang Shih-shu, a native of Hsin-an, Anhwei province, eventually settled in Chiang-tu, Kiangsu province. He studied first with his father and then with Huang Ting (1660–1730). Both teachers derived their painting style from the leader of the Lou-tung school, Wang Yüan-ch'i (1642–1715). As were other literati artists, Fang Shih-shu was a poet and writer of prose. At least two compendiums of his writings are well known. HAL

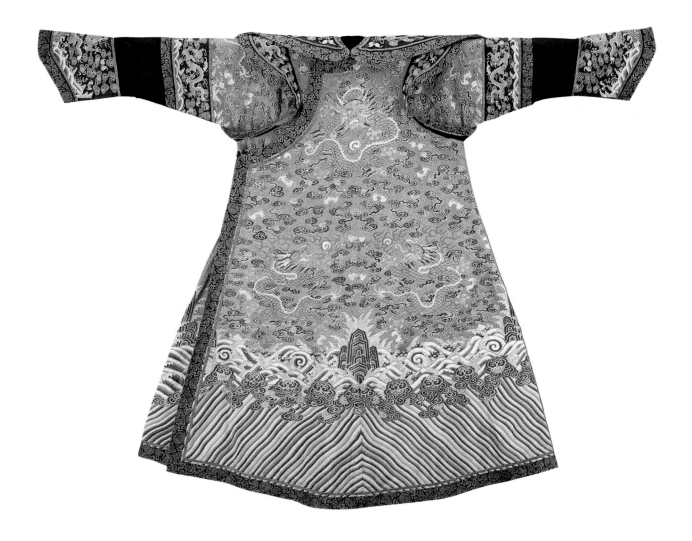

This garment is a dragon robe (*lung p'ao*) of the type worn by the Chinese empress and imperial consorts in the later part of the Ch'ing dynasty. Derived from the costumes of an earlier period, when Manchu noblewomen dressed like their husbands, the robe is distinguished by its epaulettes and wide, detachable bib collar (few such robes survive accompanied by their original collars). This garment lacks only a vest or sleeveless jacket; otherwise it serves as a complete example of high-ranking Chinese women's court costume of the nineteenth century.

The pattern on the robe includes many imperial and other symbols (five-clawed dragon, mountains, rainbow stripe, waves, clouds, and bats, some of which hold in their mouths the red reversed swastika symbolizing infinite virtue) woven in red, blue, black, gold, and white in the Chinese tapestry technique called *k'o-ssu*, which originated as early as the T'ang dynasty (619–906). The background is further embellished with an interlocking fret-work pattern embroidered in light brown and dark reddish-orange silk, giving the fabric an especially rich and appealing surface texture. R B

COURT ROBE FOR AN IMPERIAL CONSORT

Chinese, Ch'ing dynasty, 19th century

Silk and gilt yarns, *k'o-ssu* weave, embroidered with silk

yarns and trimmed with brocaded silk; 55½ × 35 in.

(141 × 88.9 cm.)

Gift of Mrs. Charles M. Cooke, 1927 (1063)

HANIWA

Japanese, Kōfun period, 6th century
Reddish pottery; h. 29¼ in. (74.3 cm.)
Purchase, donations from Academy docents,
1979 (4751.1)

The most interesting works of prehistoric Japan are the cylindrical grave figures known as *haniwa* (literally "clay cylinder"). These reddish-brown earthenware objects were placed on the terraced slopes of tumuli, the massive royal burial mounds of the Kōfun period. *Haniwa* functioned in a practical manner, draining soil and inhibiting erosion. Many were surmounted by elaborate sculptural images that were visible symbols of the power and grandeur of the dead ruler. The earliest *haniwa* from the Kyoto/Nara centers emphasized models of contemporary houses, weapons, armor, and ceremonial paraphernalia; later *haniwa* focused on popular themes from daily life and included warriors, horses with elaborate saddles, musicians, priestess types, and other figures of women.

Representational *haniwa*, such as this example of a standing woman, were apparently set up at places of special funerary significance. Their attire, often with jewelry, perhaps relates to their various duties in the ceremony. The ceremonial functions of such *haniwa* are as yet imperfectly understood.

This figure was excavated in Gumma prefecture, in the Kantō district of Honshū in eastern Japan. The figure has had some restoration, particularly to the right hand. Her hair is dressed in a conventionalized mortarboardlike coiffure known as *shimada*. She wears a simple skirted costume without front folds, which is characteristic of sixth-century works, along with a necklace of round beads and elaborate earrings. This figural style is in keeping with other examples excavated from the Kantō regions of the later Tumulus period. HAL

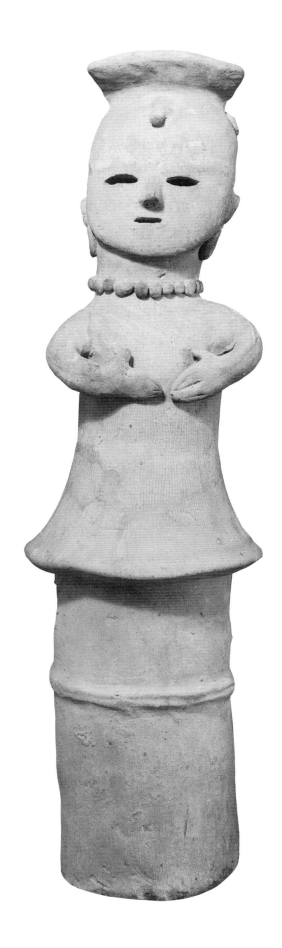

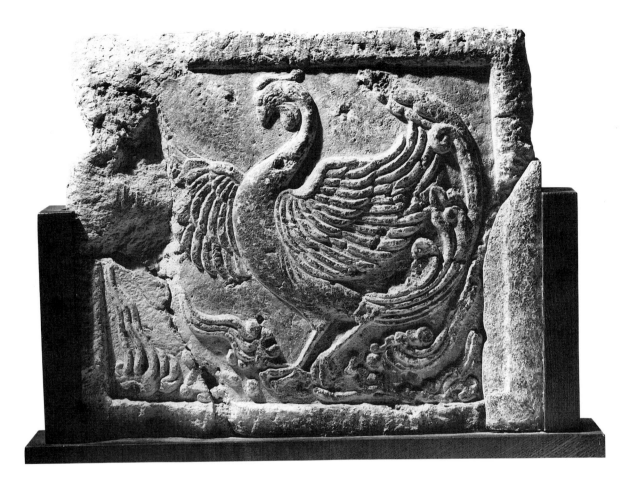

Reportedly from the Minami Hōkkei-ji (temple) in Nara, the design of this clay tile reveals a Chinese T'ang style. The phoenix is the symbol of the southern regions and is therefore an appropriate decorative theme for the Minami (southern) Hōkkei-ji, founded in the early eighth century. The vitality of the design, with the reversing arcs of the bird's neck and arching body extending to the long sweep of its majestic tail, is repeated in two other tiles of a similar type. An example in the Seattle Art Museum was also reportedly excavated from Minami Hōkkei-ji, and the third, kept at Tsubosakadera, Nara, is classified as a National Treasure. HAL

TILE WITH PHOENIX MOTIF

Japanese, Nara period, Tempyō era, mid-8th century
Clay pottery; 10 1/2 × 11 1/4 × 1 3/4 in.
(26.7 × 28.6 × 4.4 cm.)
Anonymous gift, 1965 (3356.1)

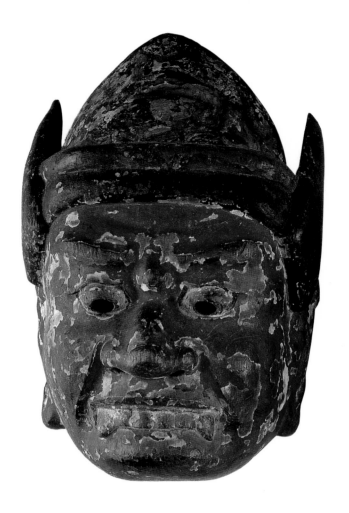
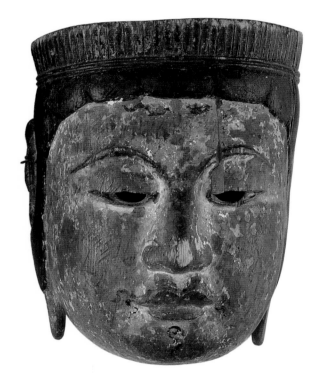

PROCESSIONAL MASKS

Japanese, Heian period, late 10th–early 11th century

Wood with traces of lacquer and gold

bodhisattva mask: 8¼ × 6⅝ in. (21 × 16.8 cm.)

guardian mask: 11 × 6¾ in. (27.9 × 17.1 cm.)

Gifts of Arnold M. Grant, 1961 (2999.1, 2998.1)

Both of these processional masks bear inscriptions indicating that they were repaired in 1186 and again in 1334. These inscriptions place them as part of a set of Jūni-Ten, the twelve guardian deities, once kept at Tōji, Kyoto. Seven other masks to survive from this temple have identical inscriptions and are registered in Japan as Important Cultural Properties. Temple records indicate that the Academy masks and those still in Japan may have been in the Tōji collection at the beginning of the eleventh century. The Academy masks agree closely in style with the seven guardian masks in Japan, down to the inclusion of identical inscriptions.

One of the Academy masks has been identified as the guardian deity Rasetsu-Ten (Rakshasa), based on its bulging eyes and protruding teeth; the other remains unidentified, although its resemblance to bodhisattva masks has prompted some scholars to suggest that it belongs to another group of nineteen bodhisattva masks, also once kept at Tōji. The identical repair inscriptions of 1186 and 1334 found on the back of the mask, however, argue against such speculation, and Japanese authorities refer to the mask as one of the twelve guardian deities without attempting a closer identification.

Masks such as these, generally known as Gyōdō masks, were worn in Buddhist processions. Priests chanted sutras while others, wearing masks and special robes, took the part of various guardians of Buddha's law. HAL

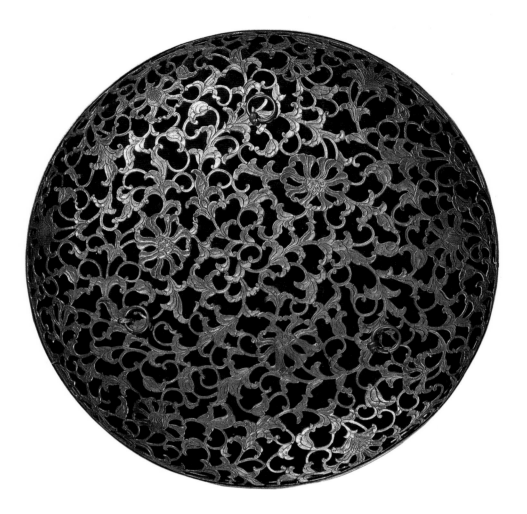

This gilded bronze *keko* (ceremonial flower tray) is unsurpassed for its sumptuous refinement. The practice of strewing flower petals—usually lotus—at memorial services in Buddhist temples goes back to the Nara period (645–794). The more than eight hundred bamboo flower-baskets preserved at the eighth-century Shōsōin Imperial Repository at Nara, for example, testify to their common use at the time. Although twenty such *keko* are known to exist, sixteen of which are at the Jinshi-ji in Shiga prefecture, where they are registered as National Treasures, this *keko* is of singular beauty and the only one outside Japan. Shaped like a shallow bowl with a surface decoration of reticulated peonylike *hosoge* flowers and tendrils, the pattern calls to mind the richness of the gold and silver work of T'ang dynasty China. By gilding, silvering, and incising the fine details of the legendary flowering plant into the metal, the artist has created a three-dimensional richness and a feeling of movement. HAL

CEREMONIAL FLOWER TRAY

Japanese, Kamakura period, 12th century
Reticulated gold- and silver-plated bronze
diam. 11 3/8 in. (28.9 cm.)
Gift of Wilhelmina Tenney Memorial Fund, 1955 (2114.1)

SHINTŌ DEITY

Japanese, Kamakura period, 12th–13th century
Wood; h. 44½ in. (113 cm.)
Gift of Robert Allerton, 1964 (3311.1)

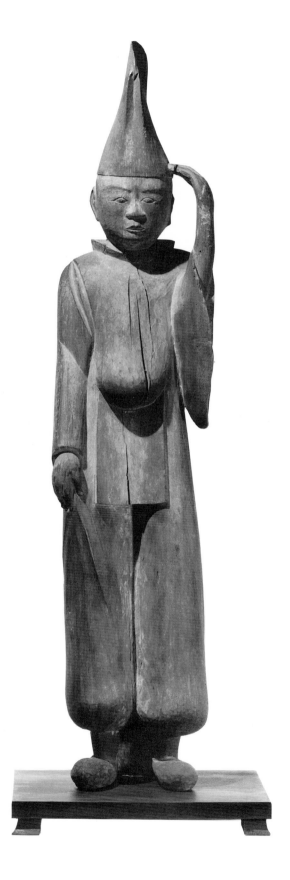

Shintō, meaning "way of the gods," is the native religion of Japan. Its gods (*kami*) were thought of as unseen presences, or simply, as the divinity of things. Elements in nature, such as an ancient tree or a mighty waterfall, could become objects of veneration. The dead were also numbered among the *kami*, and the ancestors of the imperial, or Yamato clan, were given high positions in the Shintō pantheon.

It was only under the influence of Buddhism, in which images were calculated to inspire the viewer directly, that Shintō sculpture emerged. (Many shrines, even now, exist without images.) The earliest depictions of Shintō gods seem to date to the Heian period (ca. ninth and tenth centuries). The simplicity of Shintō imagery, compared to the complexity of Buddhist iconography, makes it difficult, if not impossible, to distinguish one god from the other on the basis of attributes. Most are decorous images clad in court robes, their faces devoid of emotion. The courtly dress of these figures points to their relationship with the emperor, the earthly descendant of the sun goddess. Most Shintō sculpture is carved from a single block of wood in the *ichiboku* technique, which was first introduced by Buddhist sculptors but which continued in use by Shintō artists long after it was abandoned in Buddhism.

This superb Shintō deity reflects many of the above stylistic characteristics, including the single-block carving method. The costume, with tall peaked cap (*eboshi*) and full pantaloons (*hakama*), follows typical court dress; it has been suggested that the posture of the figure is appropriate to a retainer. The strong columnar profile of the piece almost seems to suggest that the sculptor was hesitant to tamper with the basic nature of the wood.

HAL

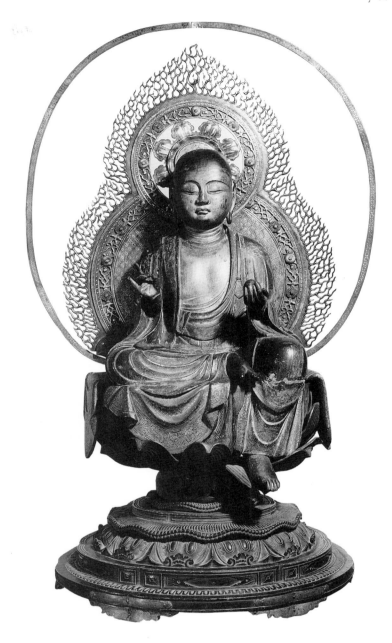

The cult of Jizō reached Japan during the mid-eighth century, and even today he is worshiped as the helper of all in trouble, especially the weak or suffering. His blessings are beseeched for expectant mothers, young children, travelers, soldiers, and those doomed to an existence in hell.

This example shows a seated figure; one bare foot rests on a pedestal, the other is pendant. Jizō holds in his left hand the burning jewel (*nyoi-shu*), which responds to all wishes and illuminates the darkness of hell. The right hand once held a long pilgrim's staff (*shakujō*). The figure itself can be dated to the middle Kamakura period, but the metal mandala and lotus base are probably of Muromachi age (1392–1573). The beautiful image, classically formulated, is imbued with the gentle idealism typical of Kamakura sculpture. HAL

JIZŌ

Japanese, Kamakura period, 13th century

Lacquered wood with traces of gold

h. (to top of halo) 34 in. (86.4 cm.)

Gift of Yozo Nomura on his 60th birthday, 1930 (2865)

ELEVEN-HEADED KANNON

Japanese, Kamakura period, ca. 13th century
Painted and lacquered wood with halo
and decorations of cut and gilded metal
h. (to top of halo) 25¾ in. (65.4 cm.)
Gift of Robert Allerton, 1963 (3153.1)

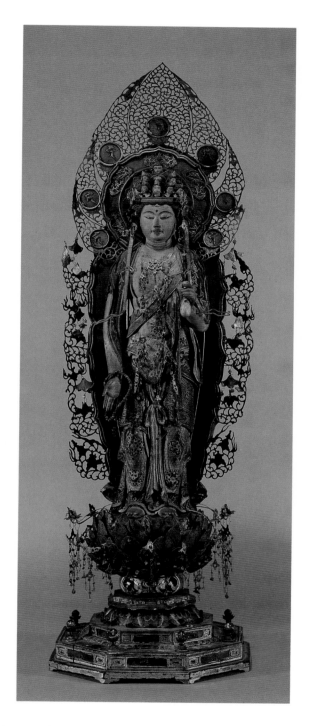

This fine thirteenth-century sculpture of the eleven-headed deity Kannon (Jūichimon Kannon) is of such realistic detail and serenity of mood that scholars have tentatively attributed the figure to the Kamakura master Tankei (1173–1254), an identification altogether in keeping with its style and quality. The charm of this small lacquered religious image depends on the intricacy and cleverness of the modulation of the draperies. It possesses all the realism and sculptural directness necessary to illustrate the Kamakura ideal in sculpture at its very best. HAL

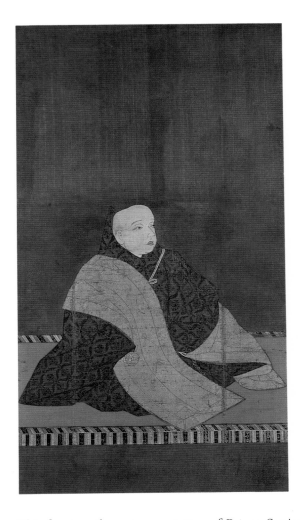

PORTRAIT OF IMPERIAL PRINCE ABBOT SON'EN AS A BUDDHIST PRIEST

Attributed to Gōshin, act. mid-14th century

Japanese, Muromachi period, ca. 1350

Color on silk, mounted as a hanging scroll

36⅝ × 20⁷/₁₆ in. (93 × 51.9 cm.)

Gift of Mrs. Carter Galt, 1959 (2600.1)

This fourteenth-century painting of Prince Son'en is one of several surviving works based on the *nise-e* portrait tradition of China, first introduced in Japan by Fujiwara Takanobu in the twelfth century. The work once belonged to the Shōren-in, Enryaku-ji, a subtemple in Kyoto that Son'en made into the primary training center for aristocratic calligraphers. The painting can be regarded as a rare example of court portraiture related to but independent from the Chin-zō tradition. It may have been shown on ceremonial occasions to the hundreds of calligraphy students who came for instruction there. Prince Son'en was the sixth son of Emperor Fushimi and rose to high positions in Japanese religious circles. Along with his appointments to Enryaku-ji, the Tendai headquarters on the summit of Mount Hiei, he was also appointed as an exorcist to emperors Go-Kagon and Sukō.

In this painting Son'en is shown robed as a Tendai Buddhist prelate. By a simplified use of thin subtle lines the artist convincingly rendered the personality of the prince, resplendent in his ecclesiastical garb of embroidered circular floral patterns. His robes are enhanced by a scarf of stiff golden brocade with traces of a delicate design. Seated on a tatami mat with a multicolored border, he faces to the right and in his left hand holds a rosary half hidden by his robes. A three-pronged *vajra* (Japanese: *sankosho*) is held in his right hand.

Studies suggest that the artist of this portrait may have been the court painter Gōshin, who in 1338 painted a portrait, now in a temple collection in Kyoto, of Son'en's half-brother, the retired emperor Hanazono. Gōshin was the son of Fujiwara no Tanenobu and belonged to a line of court painters, beginning with Takanobu and Nobuzane, who specialized in portrait sketches from life (*nise-e*). Gōshin is recorded to have painted a portrait of the Shōren-in monk Jichin on which Son'en wrote an inscription.

Sometime before 1825, the Edo-period Rimpa painter Sakai Hōitsu (1761–1828) made a copy of this painting. His later and inferior version was traditionally said to be a portrait of Abbot Son'en, an identification questioned in 1952 by the editors of *Kokka*. They were apparently unaware of the Muromachi painting (removed from Japan after World War II) upon which Hōitsu's version was based. HAL

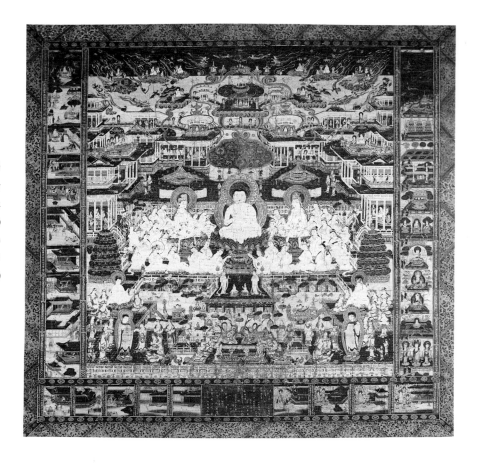

TAIMA MANDARA (Paradise of Amida Buddha)

Japanese, Kamakura period, second half 13th century

Gold, ink, and color on dark purple silk, mounted as a

hanging scroll; 42¹/₂ × 42 in. (107.9 × 106.7 cm.)

Gift of Robert Allerton in honor of the 50th

wedding anniversary of Mr. and Mrs. Walter F.

Dillingham, 1960 (2726.1)

This *Taima Mandara* (Paradise of Amida Buddha) may be regarded as a fine representative example of its type. *Mandara* (Sanskrit: mandala), in esoteric Buddhism a schematized arrangement of deities, is here inaccurate; the actual prototype for this painting is the *Western Paradise of Amida Buddha*, still to be seen at the Taimadera, a Buddhist temple near Nara.

The form of the work was apparently imported from China to Japan by the eighth century. According to tradition, the entire panorama of Amida's Western Paradise was revealed by Buddha to a certain Princess Chūjō Hime (753–781) as a reward for her piety while a nun at the Taimadera monastery. The *Taima Mandara* refers to this miraculous vision, showing the formalized assemblage of deities and celestial beings centered on Amida, who is seated on his lotus throne in his Western Paradise. Palaces with pillared halls and towered pavilions are linked by bridges and open verandas, and are organized according to a type of one-point perspective peculiar to these images.

This particular painting is based on the *Kanmuryōku-*

kyō (Pure Land Sutra); a narrative frieze around the perimeter relates the story of Prince Ajatashatru and the sixteen meditations. This narrative frieze is referred to as the Six Series of Cause and Effect and, although generally standardized, is flexible enough to include related pictures of interesting detail.

On the basis of style and technical matters, scholars date this painting to the second half of the thirteenth century and regard it as an important monument of the Kamakura period. The painting occupies a position of interest in the history of Buddhist painting not only because of its association with Chinese prototypes, as seen in the caves at Tun-huang and in the famous eighth-century *Taima Mandara*, but also because it reflects a change in Buddhism from the meditative practices of the Shingon and Tendai sects to the simple belief in Amida as the way to salvation. HAL

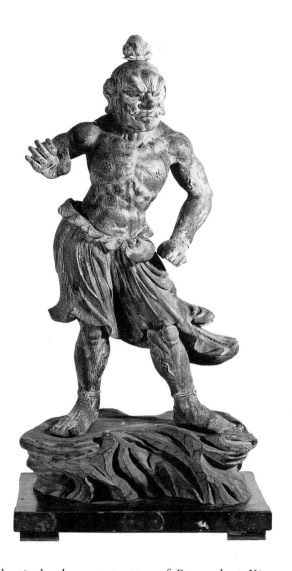
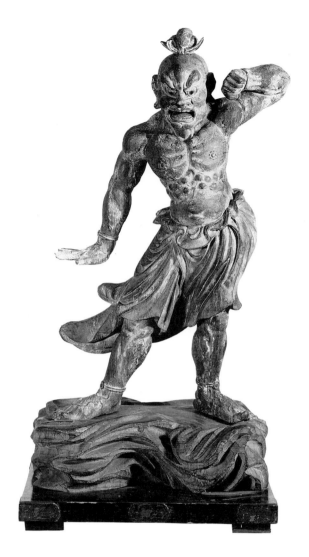

Collectively these statuettes of Benevolent Kings are referred to as Niō, or Kongō-rikishi. Mishiku Kongō can be distinguished by his open mouth and bared teeth; Naraen Kongō is always depicted with his mouth closed in a fierce grimace. The former signifies overt power, the latter latent might. Full-sized Niō were placed as guardians at temple gates to ward off danger and evil forces. The best-known pair of carved Niō to survive stand at the Nandaimon (south main gate) of the famed Tōdai-ji, Nara. Enormous in size (measuring just over eight meters), these colossal figures were the joint effort of the great Kamakura sculptors Unkei and Kaikei.

Niō are generally represented as powerful figures with exaggerated muscles and bulging veins. The style reached its height during the Kamakura period, when a taste for baroque treatment developed. The Academy's examples fully explore the dramatic possibilities offered by their

TWO BENEVOLENT KINGS

Japanese, Kamakura period, ca. 13th century
Wood, traces of gesso and polychrome
Mishiku Kongō: h. 29¼ in. (74.3 cm.); Naraen Kongō:
h. 29½ in. (74.9 cm.)
Gifts of Robert Allerton, 1952 (1690.1, 1691.1)

exaggerated poses. The works are powerful, intense, and frightful. In some examples the heads are entirely shaven; others, as here, include a neatly tied chignon at the top. The menacing faces are particularly well done: their fierce countenances, swollen temples, knitted brows, bulging eyes, and scowling expressions underline their function as protectors of the faith. Judging by their reduced size, the Academy Niō were probably used within a temple in association with an altar. HAL

KŌBŌ DAISHI GYŌJŌ EMAKI (detail)

(Events in the Life of Kōbō Daishi)

Japanese, Kamakura period

late 13th–early 14th century

Ink and color on paper, mounted as a handscroll

13 in. × 24 ft. 1⅝ in. (33 cm. × 7.36 m.)

Purchase, 1952 (1689.1)

In the ateliers of Buddhist monasteries, artists produced *yamato-e* (Japanese painting) handscrolls that narrated the origin of the sect or the life of its venerable founder. Most of the artists were monks as well as painters. An important example of Buddhist painting within this tradition is this handscroll, *Kōbō Daishi Gyōjō Emaki* (Events in the Life of Kōbō Daishi), which relates events in the life of Kōbō Daishi (Kūkai), who founded the Shingon sect of Buddhism in Japan in the ninth century.

The narrative organization of this scroll follows a conventional format established in earlier handscrolls in which scenes are preceded and followed by text. The style of coloring known as *tsukuri-e* (sketches overpainted with opaque color and then finished with ink lines) is also traceable to the Heian period. This painting combines *tsukuri-e* with *horinuri*, a technique first used in handscrolls in the second half of the twelfth century. In *horinuri* the opaque pigments are more carefully applied, permitting the original *sumi* (ink) lines to serve as the outline.

The secondary figures of this scroll represent particularly well the fully developed, animated figural tradition of the Kamakura period. Their vivid characterization and interaction, set against the usual conventions of scrolls of the time (e.g., diagonal architectural elements and clouds of mist), along with the more static *onna-e* renderings reserved for the central characters, produce a human drama of curious vigor and technical dexterity.

The Academy's *Kōbō Daishi Gyōjō Emaki*, documenting three episodes, is incomplete. Scholars have concluded that the scroll originally consisted of at least ten episodes, and that it is quite independent from other surviving versions, both pictorially and textually. As such, the work occupies an extremely important position in the history of Kōbō Daishi narratives and is a major monument of the *yamato-e* tradition in a Western collection.

HAL

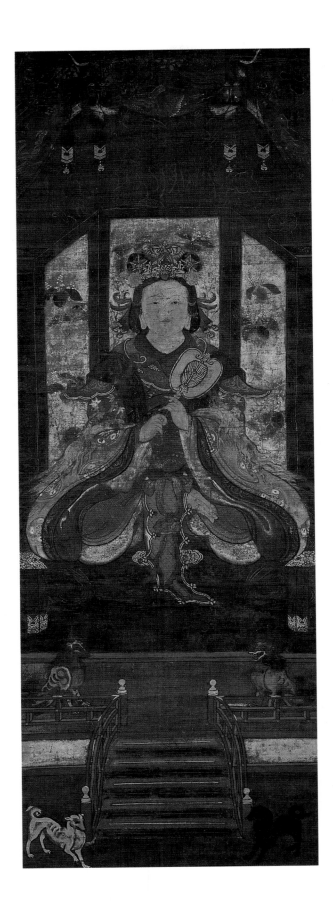

NIU MYŌJIN (Goddess of Mount Kōya)

Japanese, Kamakura period,

ca. first half 14th century

Color on silk, mounted as a hanging scroll

42 × 15 in. (106.7 × 38.1 cm.)

Purchase, 1986 (5604.1)

The Shintō goddess Niu along with her son Kōya, who is generally rendered in the guise of a hunter, were adopted as special guardians of the monastic center founded by Kōbō Daishi on Mount Kōya; they are regarded to this day as the tutelary deities of the Kōya monastery. Niu Myōjin images are extremely rare, and this painting, with the goddess in a formal setting that includes not only the ubiquitous lion-dogs of Shintō but the dogs who guided Kūkai to Mount Kōya, may be the only surviving example of this particular iconographic treatment. As such, it is an art-historical treasure of the first order. The scroll is dated to the first half of the fourteenth century on the basis of stylistic and technical evidence: a drawing of Niu with Kōya, dated 1335 (Shirayana Hide Shrine, Ishikawa prefecture), offers an image of Niu that is both stylistically and iconographically similar to the one depicted in this rare painting.

The character *niu* is used throughout Japan as a place name associated with the mining of mercury, and studies suggest that the goddess Niu may originally have been a *kami* (spirit) worshiped by clans associated with this industry. HAL

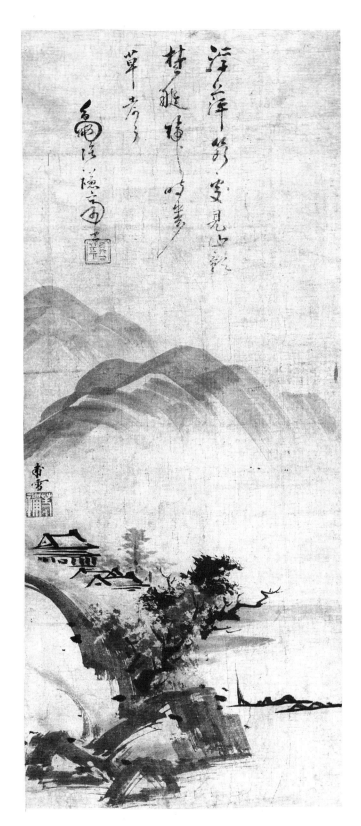

LANDSCAPE

Japanese, Muromachi period, ca. 1547–79

Ink on paper, mounted as a hanging scroll

36 × 14¼ in. (91.4 × 36.2 cm.)

Signature: Hōsetsu; seal: Tōzen

Gift of A. E. Steadman (Martha Cooke Steadman
Acquisition Fund), 1962 (3099.1)

The composition of this fine ink painting, done in a semi-cursive brush style, is close to the one-corner view of mid fifteenth-century Japanese landscapes, but the background mountains stretching the full width of the composition suggest that the work should be dated to the second half of the sixteenth century. During the transitional years at the close of the Muromachi period, paintings tended to exhibit the two-dimensional decorative style documented here. The concise composition, however, is clearly the work of an exceptional painter.

The inscription above the mountain translates: "Where duckweed ends, one sees mountains reflected in the water; when boats of the Chu River return, it is so still one can hear the grass grow. Written from the Kun Ken Studio." Kun Ken was a Zen priest who visited Ming dynasty China in 1547 and again in 1555. He died in 1579. This inscription and the painting were probably brushed at about the same time, as was the general practice in those days. On this basis it is possible to date the Academy painting to sometime after 1547 but before 1579.

Hōsetsu Tōzen studied under the great master Sesshū and acquired a deep understanding of painting techniques. He also studied Sung and Yüan paintings as well. Since none of Tōzen's surviving works, which number only a very few, offer an inscribed date, the length of Tōzen's activity has always been a matter of conjecture.

HAL

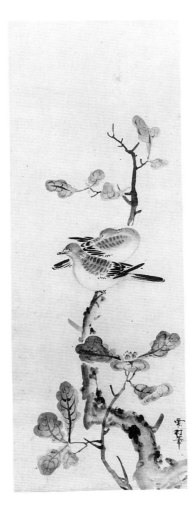

SESSON SHŪKEI

Japanese, Muromachi period

Mynah Birds and *Pigeons*, ca. 1555–60

Ink on paper, mounted as a pair of hanging scrolls

39 × 13 in. (99 × 33 cm.)

Purchase, Marjorie Lewis Griffing Fund, 1985 (5326.2)

In the right scroll two gray-and-white-bellied pigeons roost on the branch of an oak tree, rendered with a soft, wet brush, that suggests tranquility. In the lower right corner appear the signature "Sesson hitsu" (Sesson painted this) and the master's seal, "Shūkei."

The left scroll depicts two aggressive, crested black-and-white birds alighting on a tree branch with pointed leaves and tufted pods. The squawking birds are expressively rendered with a vigorous brush and intense black washes that suit the angular forms and sharper textures of the tree branch. In the lower left corner appear the same signature and seal.

Although born shortly after the death of Sesshū, the most illustrious ink painter of the Muromachi period, Sesson Shūkei claimed to be Sesshū's spiritual successor and added his predecessor's epithet, "Setsu" (Snow), to his name. Studies show that Sesson, a descendant of the famous Satake family, was born in Hitachi province, living first at Hitari and later in Aizen in Iwashiro district. Sesson avoided the Zen centers in Kyoto and Kamakura, and was largely self-taught, studying Chinese ink paintings of the Sung and Yüan dynasties as well as the art of Sesshū. He is said to have written a short treatise on painting in 1562. By 1546 Sesson was instructing the local daimyo of Aizen in the care and handling of paintings. It is also known that in 1573 he was in Tamura in Iwashiro, where he lived a solitary existence as a Zen monk until his death.

The Academy paintings represent the quintessence of Sesson's elegant, decorative, and graceful brush style in the bird-and-flower genre, a Chinese style Sesson adapted to express a more emotional Japanese outlook. His talent lay in the rhythmic and deft movement of the brush rather than in the placement of elements of composition. Accompanying the scrolls are three testimonials by famous tea masters of the past, indicating the importance of the scrolls in the Momoyama and Edo periods. HAL

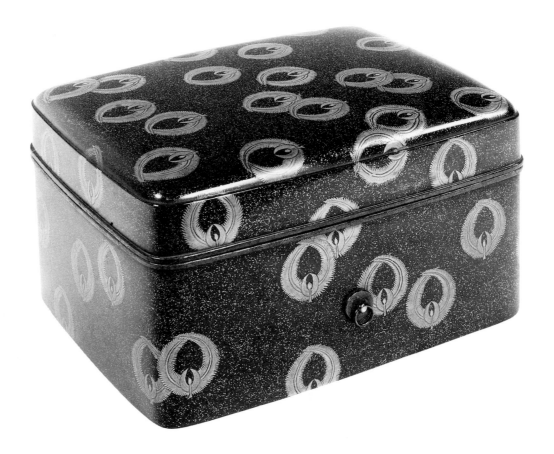

TOILETRIES CASE

Japanese, Kamakura period, 13th century

Wood with *maki-e* (sprinkled gold lacquer)

6 × 10 × 8 in. (15.2 × 25.4 × 20.3 cm.)

Purchase, 1966 (3418.1)

Elaborately decorated *tebako* (toiletries case), revered treasures of wealthy families, were considered worthy religious offerings. They were a popular presentation gift to shrines and temples in the Heian and Kamakura periods.

Tebako of the Kamakura period are particularly admired for their taut surface contours and high profiles. This example is decorated with a design of peacock crests and an overall sprinkling of gold powder. The crests themselves stand out in low relief. The interior is lined with a floral pattern of olive green brocade.

The *maki-e* technique used here involves the sprinkling of powdered gold on a wet lacquer ground. The process, first developed in the Nara period (645–794), reached its zenith in the thirteenth and fourteenth centuries. Early examples used gold and silver dust, but Kamakura-period pieces are almost always decorated with gold alone because of a scarcity of silver.

HAL

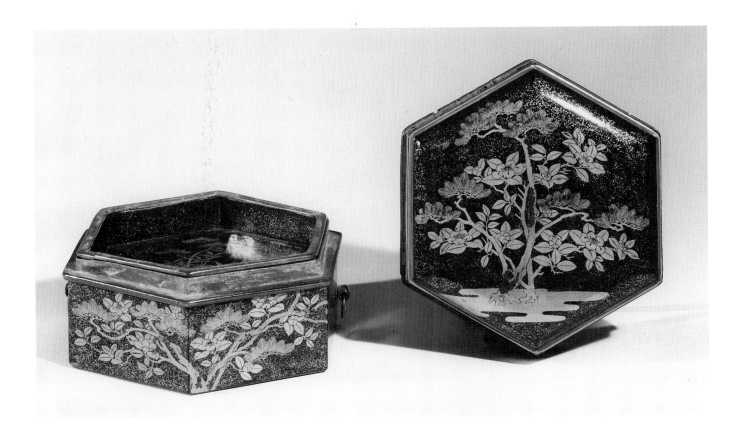

This hexagonal box, with lid and tray insert, is a splendid example of *maki-e* lacquer decorated in the *togidashi* technique. The wooden body of the form was first covered with black lacquer, on which gold dust was sprinkled to form a ground design. Several more layers of black lacquer were then applied, completely covering the sprinkled decoration. Finally, the top layers of lacquer were polished with charcoal, revealing the motifs underneath. In this way the final design—in this case pine and camellia motifs on the exterior, and bamboo and pine designs on the interior—appears in exactly the same plane as the surrounding lacquer ground. The hexagonal shape is a typical form of Muromachi lacquer, as is the technique. This example is dated on stylistic and technical evidence only. HAL

SIX-SIDED BLACK LACQUER BOX

Japanese, Muromachi period (1392–1573)
Wood, lacquered with *maki-e* design
2³/₄ (with lid) × 4¹/₂ in. (7 × 11.4 cm.)
Gift of Mrs. Theodore A. Cooke in memory
of Mrs. Philip E. Spalding, 1968 (3528.1)

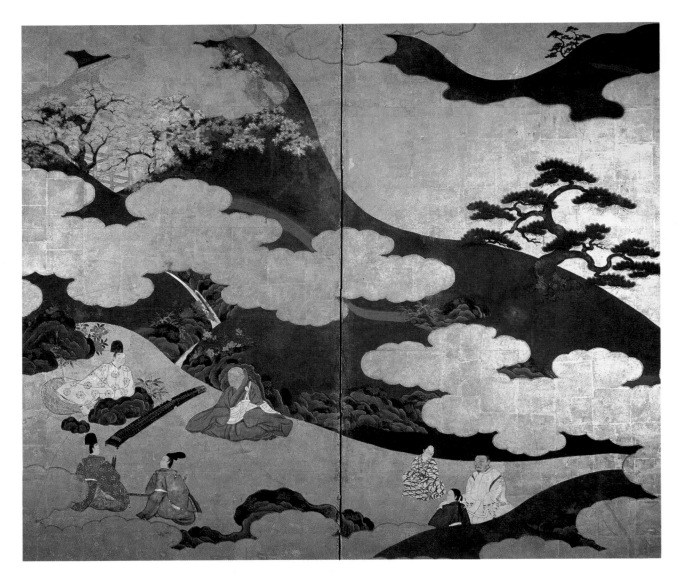

GENJI MONOGATARI (Tale of Genji)

Attributed to Tosa Mitsuyoshi, 1539–1613

Japanese, Momoyama period

Ink and color on gold paper, mounted as a two-panel
screen; 64¹/₂ × 72¹/₂ in. (163.8 × 184.2 cm.)

Gift of Dr. and Mrs. Ray R. Reeves, 1960 (2785.1)

The Tosa painters, who dominated court circles from the late fourteenth century onward, painted their *yamato-e* narratives in scroll and album format, but in the late Ashikaga and early Momoyama periods, they turned to large folding screens to produce some of the most important conservative works of the period. Countless themes from the literary classics in particular received a fresh interpretation in this larger format. Among the Tosa artists to paint *Genji Monogatari* (Tale of Genji) was Tosa Mitsuyoshi, who lived in Kyoto and became the head of the Tosa school in 1569.

Although no signed screens by Mitsuyoshi survive, attribution to him on stylistic grounds is confirmed by the overall painting line and characteristic details, including the ribbonlike stretches of light green landscape, the contours of the rolling hills, and the shape and method of painting the numerous rock formations. These same style markers can be observed in at least three other works generally accepted as authentic Mitsuyoshi paintings, all scenes from the great novel *Genji Monogatari*. HAL

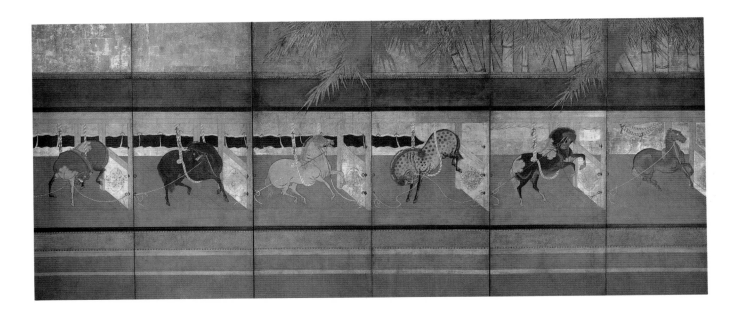

In the late Muromachi period (1392–1573), Chinese-inspired pictures known as *uma-ya-zu* (stable pictures) became prominent among themes intimately connected with the daily lives of samurai. Stable painting in the form of handscrolls can be traced back to the fifteenth century and no doubt provided an important source for such screens. In the folding-screen format, the stable and horse theme was conceived in a simple repetitive formula intended to produce a decorative effect.

Scholars divide stable screens into two categories according to the handling of subject matter. The more common genre-type stable screens include spectators and guests engaged in a variety of activities; the earliest date to the beginning of the Momoyama period. Non-genre screens, following an archaic format, are part of a portrait tradition (*nise-e*) of famous horses and oxen but are expanded to monumental size.

This screen, the left half of a pair of six-fold screens of the non-genre type (the other half is not owned by the Academy), is one of several recorded examples based on the early format. A large stable covers the entire length of the screen. On each panel a different horse is depicted, but all are sturdy, high-spirited, finely bred, and dynamically posed. This screen repeats, in its essentials, the left half of a pair of six-fold screens of the Muromachi period by a Tosa-school artist and now in the Imperial Household Collection. This early screen served as a model for a number of later paintings, including the Academy example. The hardness of the brush line in the delineation of the horses in the Academy screen suggests a Kanō school work of the late Momoyama period. As such, the screen may be regarded as a rare example of an archaic *yamato-e* tradition borrowed by Kanō decorators in their search for themes that would delight the warrior class of Momoyama times.

HAL

STABLE (uma-ya)

Unknown artist of the Kanō school

Japanese, Momoyama period

Ink and color on paper with gold leaf, mounted as a six-fold screen: 5 ft. × 11 ft. 8³/₄ in. (1.52 × 3.56 m.)

Purchase, 1975 (4279.1)

OLD PINE AND CHERRY TREE BY ROCKS

Attributed to Kanō Eitoku, 1543–90, or a close follower

Japanese, Momoyama period, ca. 1590

Ink and color with gold leaf on paper, mounted as·a six-

fold screen: 5 ft. 3 in. × 11 ft. 8¾ in. (1.6 × 3.57 m.)

Gift of Mrs. L. Drew Betz in memory of her husband,

1982 (5039.1)

A boldly executed close-up of a huge pine tree forms the main focus of this composition. In the middle ground, to the right, appear gray rocks executed with a swift, bold brushstroke in black ink. Additional trees of flowering white cherry and red camellias are glimpsed in the background. The work embodies the stylistic characteristics known as *taiga*, first introduced by Kanō Eitoku to enhance the monumental dimensions of Momoyama castles. The magnified forms and bold brushwork suited the dimly lit rooms of daimyo residences. Gold backgrounds, here signifying stream and sky, brightened the filtered light of the tenebrous rooms.

A number of Japanese art historians have attributed this screen to Kanō Eitoku and his circle. Studies have revealed that the painting was either done by Eitoku himself at the close of his life or by another artist who worked closely with him.

The screen was once the back panel of a large alcove (*tokōnoma*). Its style is close to the "Cypress Tree" screen in the Tokyo National Museum, which is attributed to Eitoku and dated to the close of his life. One historian, Kanō Eino, writing in 1653, offered some valuable comments on the master. He indicated that Eitoku painted splendidly detailed landscapes, figures, flowers, and birds in his youth, but that in his mature years he filled the dark rooms of daimyo mansions with large-scale *taiga* paintings. Eino described the brushwork of these later works as having the forcefulness of flying cranes and dashing serpents and asserts that one pine and plum tree design done in exaggerated *taiga* style was ten to twenty feet high, covering the walls and transom area of a residence in a single spectacular composition. The Academy screen fits Eino's description particularly well, offering additional support for attributing the work to Eitoku. HAL

Rarely does one encounter early genre paintings that can be securely assigned to a known artist. This is particularly true of *rakuchū-rakugai-zu* (pictures in and around Kyoto), which first appeared in the sixteenth century. The development of this theme, which anticipated the appearance of seventeenth-century *ukiyo-e* (pictures of the floating world), came in the wake of the emergence of the nascent *machishū* (merchant elite) and their delight in the rebuilding of Kyoto as a commercial entity after the Ōnin Civil War (1467–77).

Paving the way for the splendor of the genre movement and *rakuchū-rakugai* screens was the depiction of famous Kyoto sites in fan format. The view of the Gion-Sha in Kyoto shown here is one of ten such fans in the Academy's collection painted by the deft brush of Kanō Motohide. It is thought that Motohide painted a total of sixty-one fans, to be mounted on a pair of screens. To date twenty-two have been uncovered in public and private collections, all bearing Motohide's genuine seal. One of them, in the Kobe Municipal Museum, depicts a Christian church that existed for only eleven years, from 1578 to 1588, making possible the close dating offered here. Each of the fans represents a famous place in Kyoto and offers a stereotypical view of the people and their social customs. The aesthetic value of the paintings lies in Motohide's ability to unify the diverse elements of landscape, architecture, and human figures into a decorative whole. HAL

KANŌ MOTOHIDE

Japanese, Momoyama period, act. late 16th century

A View of Kyoto, ca. 1578–88

Color on gold paper, mounted as a folding fan

7³/₄ × 19¹/₂ in. (19.7 × 49.5 cm.)

Purchase, 1927 (2384)

ROUND FOOD BOX WITH COVER

Japanese, Momoyama period, Keichō era (1596–1615)

Black lacquer with low-relief metallic gold lacquer

5 × 8¼ in. (12.7 × 21 cm.)

Purchase, Marjorie Lewis Griffing Fund, 1980 (4842.1)

This squat, round container with ring foot and shallow circular cover is decorated with gold *maki-e* designs set against black lacquer. The motifs include such autumn flowers as chrysanthemum, maple leaves, pampas grass, and bush clover. The style of lacquer is associated with Kōdai-ji, a late Momoyama- to early Edo-period Zen temple located in the foothills of Kyoto. The interior of the ancestral hall at this temple houses portrait statues enclosed in lacquer shrine boxes, and the room itself is ornamented with lacquer balustrades and other fittings. The date of 1596 and signatures of artists of the Kōami family of lacquerers have been found scratched on the furnishings.

The term Kōdai-ji *maki-e* originally referred to the objects from this temple but came to designate any lacquerware of similar artistry from the late Momoyama and early Edo periods. Three different styles survive: flat gold decoration, high relief decoration, and low relief decoration. Technically, such lacquerware shows a simple but effective use of the medium. The designs are rendered boldly with leaves and flowers appearing as if pressed flat to the surface. Regarded by scholars as extremely fine, the Academy food box with cover displays a flat gold decoration called *hiramaki-e*. HAL

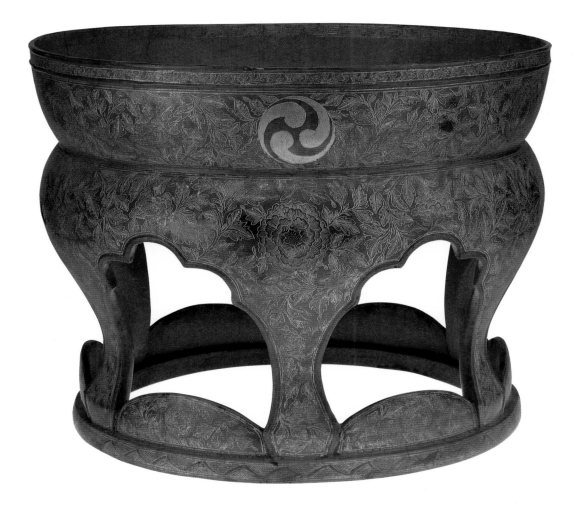

This offering stand consists of a deep circular tray supported on six shaped feet connected at the bottom by a ring foot. Made of wood, the form was completely covered with red lacquer and its incised decoration filled with gold lacquer, a technique referred to as *ch'iang-chin*. The inside bottom of the tray is decorated with a peony spray at the center and a key-fret border around the rim. The outside of the tray is decorated with a broad peony scroll and three crests of the royal Okinawan Shō family.

Evidence of the *ch'iang-chin* technique suggests that the stand was made in the late seventeenth century; an example from the late seventeenth century in the Shuri Museum uses the same technique and displays the Shō family crest. The only other recorded example of the royal Shō family crest is an offering dish in the Tokugawa collection, Kamakura, Japan. All three pieces can be dated to the late seventeenth or early eighteenth century on the basis of the presence of this family crest. The *ch'iang-chin* technique was described by Okinawan lacquer scholar Ishizawa Hyogo in 1887 in connection with a piece of furniture dated to 1775. The *ch'iang-chin* process, however, was used until recent times, making it difficult to date a work on the basis of the technique alone. HAL

OFFERING STAND

Okinawan, late 17th–early 18th century

Red lacquer with incised designs filled with gold

16⅝ × 21³⁄₈ in. (42.2 × 54.3 cm.)

Gift of Helen Lewis Knudsen, 1970 (3799.1)

RAKUCHŪ-RAKUGAI-ZU (detail)

(Pictures in and around Kyoto)

Japanese, Momoyama period, early 17th century

Ink and color on gold paper; one of a pair of six-fold

screens, each panel: 61 × 23¾ in. (155 × 60.3 cm.)

Gift of Mrs. Charles M. Cooke, 1932 (3455)

The theme of *rakuchū-rakugai* was a favorite among genre painters of both the classic Kanō school and the purely Japanese Tosa school. This pair of screens represents a final compositional development in this important native theme, which was first conceived by Tosa Mitsunobu (d. 1522) in the early sixteenth century. The left screen presents west Kyoto, with Nijō Castle in the center and the Nishiyama hills rising in the background. The right screen features east Kyoto and shows the Imperial Palace and the great Buddha Hall of Hōkō-ji. The heart of the composition, however, is the Gion festival commemorating the deliverance of Kyoto from the terrible pestilence of 874.

These screens, probably by a Tosa-school artist, are not of the stereotypical variety common to the decadent phase of this theme. Over half of the extant *rakuchū-rakugai-zu* belong to the east-west arrangement observed here, but only a few, including those at the Okayama Art Museum and Shoko-ji, can be regarded as exceptional. The majority were probably mass produced as practice paintings (*shikomi-e*) and are thought to date after 1650. The Academy screens, offering an exciting panorama of life in Kyoto, are painted with great skill and affection. The view of the city is maplike, with pasted *tanzaku* labels identifying famous landmarks.

Screens depicting east and west Kyoto first appeared in 1603, when Nijō Castle was completed. The Academy screens can be dated to a period before the renovation of the castle in preparation for a visit of Emperor Gomiezuno-o in 1626, for the work does not show the addition of a large tower or the enlarged principal compound common to later screens. The screens also include a view of Yodo Castle before it was rebuilt using Nijō Castle's own smaller tower. No Kyoto screen remains in Japan showing Yodo Castle in its original form. Moreover, the vermilion used on the horses was replaced by gold in later examples of this style. A date, therefore, in the late Keichō or early Genna era (1611–15) is appropriate for this screen. As such, the work is an important document of life in Kyoto during the late Momoyama period. HAL

Tawaraya Sōtatsu, along with the great calligrapher, potter, and painter, Hon'ami Kōetsu (1558–1637), was responsible for a revival of *yamato-e*, the traditional Japanese painting style, beginning in the late Momoyama period (1573–1615). *Yamato-e*, which flourished from the twelfth through the fourteenth century, had declined during a resurgence of interest in Chinese ink painting but was restored to popularity by these remarkable artists. They adapted the *yamato-e* style according to the spirit of the times. Kōetsu and Sōtatsu selected themes from Japanese literary classics and subjects from nature, arranged them in bold compositions, and painted them in vivid colors unequaled in the art of *yamato-e*. The new and unprecedented view of Japanese beauty they created, known by later critics as the Rimpa (Precious Gem) school, was to persist throughout Japanese painting thereafter. Many consider it to be the highest manifestation of the search for sensual delights and beauty in the art of premodern Japan.

The Academy's screens, *Plowing* and *Planting*, attributed to Tawaraya Sōtatsu but generally thought to be Tawaraya atelier works of the 1630s, provide the essentials

PLOWING

Attributed to Tawaraya Sōtatsu, act. late 16th–
early 17th century
Japanese, Edo period, ca. 1630s
Ink and color on paper, one of a pair of six-fold screens
58¼ in. (148 cm.)
Signature: each screen, Sōtatsu hokkyō; seal: Taisei ken
Gift of Mrs. Charles M. Cooke, 1934 (3470)

of this *yamato-e* revival for which Sōtatsu and Kōetsu are credited. The painting technique even includes suggestions of *tarashikomi* (color pools), which was to become the hallmark of the school. Five workmen in a rice field, one driving a white horse and a plow, and another, a black-and-white bullock, are the focus of the screens, along with pine trees and a farmhouse with thatched roof. All of these pictorial elements can be found in other works of art signed or attributed to Tawaraya Sōtatsu. In turn, these borrowings can be traced back to earlier *yamato-e* handscrolls that served as inspiration for the new sensuous art form. HAL

HON'AMI KŌETSU

Japanese, Edo period, 1558–1637

Wakan Roeishu (detail), 1630

Ink with gold underdecoration on silk

12 in. × 35 ft. 4 in. (30.5 cm. × 10.8 m.)

Signature: "by the retired hermit of Takagamunie

Mountain, Taikyo-an, at the age of 72"; seal: Kōetsu

Gift of Mr. and Mrs. Theodore A. Cooke in memory of

Elizabeth Cooke Rice, 1967 (3502.1)

This long handscroll of calligraphy, based on poems from the anthology *Wakan Roeishu*, is a masterwork of the decorative art of the Rimpa school. The colophon of the scroll indicates that the calligraphy was done in the seventh month of the sixth year of Kan'ei (1630) by Taikyo-an (Kōetsu's residence and studio name), at the age of seventy-two. This conforms with the known history of Kōetsu's life. The inscription is followed by a square black seal reading "Kōetsu." The colophon, the silk ground, the controlled calligraphy, and the quality of the underpainting all indicate that this is an authentic calligraphic painting by Hon'ami Kōetsu. The work is the culmination of years of painting calligraphic scrolls (*e-maki*) and poem cards in both square (*shikishi*) and vertical (*tanzaku*) formats.

Kōetsu is known for reviving the purely Japanese aesthetic of the Heian period (794–1185). He produced several important paintings inspired by a famous Heian prototype, the poem anthology *San-ju-roku ninshu*, noted for its beautiful calligraphy and delicate underpainting (*shita-e*). Kōetsu's work relies on the predominant use of classical syllabic writing (*kana*), but is revitalized by his infusion of the decorative taste of the Momoyama period.

Under all of Kōetsu's brushwriting were luxurious designs done in a technique called *kingindei-e* (painting with gold-silver paints). Until this century these designs were thought to be the art of Kōetsu himself. It has been discovered, however, that some of the best examples were done in collaboration with Tawaraya Sōtatsu: Kōetsu did the calligraphy and Sōtatsu the underpainting.

Because of the quality of the gold *shita-e* found on the *Wakan Roeishu* scroll (which was printed from woodblock and actual leaves) and the obvious Sōtatsu flavor of the motifs, authorities in the past have attributed the underpainting of the scroll to Sōtatsu. But comparison of this work with a number of Sōtatsu/Kōetsu masterpieces executed between 1605 and 1624, including the famous *Deer Scroll* (MOA and Seattle Art Museum) and the *Lotus Scroll* (Tokyo National Museum), offers considerable support for the opinion that neither Sōtatsu nor Kōetsu was responsible for the gold designs. The artist of the Academy scroll approached the delightful interplay of calligraphy and decorative forms in his own special way. To be sure, the scroll's gold *shita-e* is a mixture of Sōtatsu-like elements, such as Japanese cypress, ivy, pine, pampas grass, and black pine. Yet the results are less powerfully organized and more whimsically arranged in relation to the calligraphy. In fact, the delicate renderings can be equated with certain other unattributed examples of the period, including the *kingindei-e* of Kōetsu's *Kyofu no ji* and a number of works merely sealed "Ito in." HAL

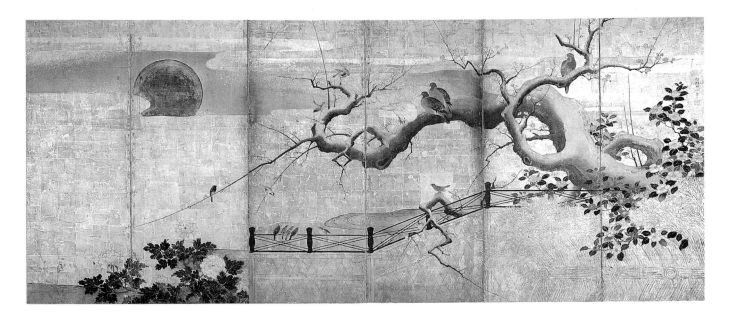

Paintings of birds and flowers, of tigers and bamboo, and of flowering trees and plants, known collectively as *kacho-ga*, were the leading subject of decorative painters in the Momoyama and early Edo periods and the special property of the Kanō school. This pair of screens is a splendid example of the genre. A weakly written signature reading "Kanō Koi hitsu" occurs on both screens; only one of the pair carries a seal. Most scholars agree that the signature and seal are spurious. Nevertheless, the screens represent one of the last gems of Momoyama-style art. Calculated with an almost geometrical composition of rocks and twisted trees, they betray a virtually static and abstract beauty. The agreeable rhythm of these well-balanced screens is brought about by the bold but harmonious colors of the flowers, leaves, and birds. The birds, purposefully perched on the top of the tree trunks on both screens, reflect a style favored by Kanō Sanraku (1559–1635) and Kanō Sansetsu (1589–1651) in the early 1630s. HAL

BIRDS AND FLOWERS (detail)

Japanese, Edo period, Kan'ei era (1624–44)

Ink and color on paper with gold leaf, one of a pair of six-fold screens; 5 ft. 2 in. × 11 ft. 11 in. (1.58 × 3.63 m.)

Gift of Mrs. Charles M. Cooke, 1929 (4150)

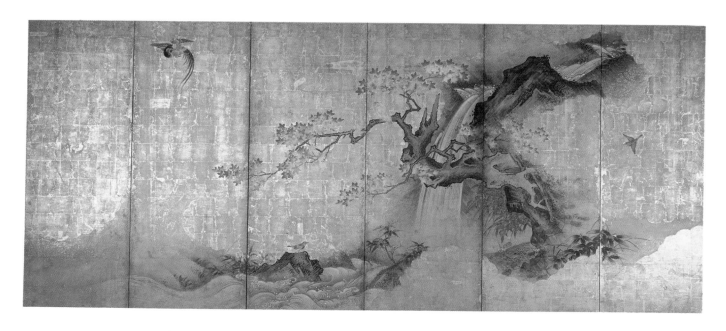

MAPLE TREES, WATERFALL, AND BIRDS

Attributed to Kanō Ryōkei, d. 1645

Japanese, Kan'ei era (1624–44)

Ink and color on paper with gold leaf, mounted as a six-
fold screen; 5 ft. 2 in. × 12 ft. 6 in. (1.59 × 3.81 m.)

Gift of Wilhelmina Tenney Memorial Collection, 1970

(3700.1)

A waterfall cascades behind a red- and gold-leafed maple tree, at the base of which are bamboo stalks and clusters of pink flowers. A white bird perches on one of the gnarled branches silhouetted against the gold-leaf background. Other birds are depicted in flight. Below, a stream, swirling and foaming around a boulder, is skillfully rendered.

According to tradition, this screen and three others were originally mounted as *fusuma* (sliding doors) in Nishi Hongan-ji, Kyoto. The doors, which in sequence dealt with the four seasons, have long been attributed to the Kanō school artist Kanō Ryōkei (Watanabe Ryōkei), who died in 1645. The Academy screen (autumn) clearly reveals evidence of having once been *fusuma*, as do its companions, *Pheasant under Cherry and Willow Tree* (spring) and *Iris and Mist* (early summer), in a private collection. Scholars note, however, that the style of these screens follows a more orthodox Kanō manner than is generally seen in Ryōkei's work. Nevertheless, the paintings are of superb quality and can be soundly dated to the Kan'ei era. All have a provenance traceable to the Nishi Hongan-ji temple.　HAL

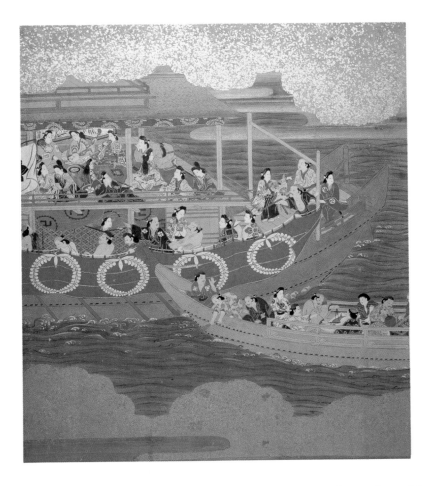

SCENES OF COMMON PLEASURE (detail)

Japanese, Edo period, third quarter 17th century

Ink and color on paper with gold accents, one panel

from a pair of six-fold screens; each screen:

4 ft. 1 in. × 12 ft. 6 in. (1.25 × 3.81 m.)

Gift of Mrs. L. Drew Betz, 1981 (4891.1)

This fine pair of genre screens in *oshie-bari* format (individual panel paintings) depicts scenes of common pleasure (*shonin yūraku-zu*). They were painted by an anonymous *machi-eshi* (town artist) in the old capital of Kyoto perhaps as early as the 1630s. Historical materials dealing with the subject of *wakashū* (young male dandies), *wakashū kabuki* (young male popular theater), and the brothel district of old Kyoto, Ryokujō Misujimachi, are scarce; the Academy screens, therefore, are an art historical document of the first order.

Each panel contains a different scene and can be described as follows: (right screen, right to left) samurai, priest, blind musician, and a group of *wakashū* at a brothel house; *wakashū kabuki*, its stage, and audience; *wakashū* and warriors' outdoor pleasure trip; *kabuki-nō* stage and audience; single *wakashū* dancing on stage and the audience; the stage of a *wakashū kabuki* theater, with four *wakashū* playing samisens sitting on tiger-skin-covered Chinese-style chairs; (left screen, right to left) viewing *wakashū kabuki* by invitation at the house of a samurai; the *nō* play of *Tsunahiki* (Rope Pulling) per-

formed by *wakashū kabuki*; the stage of *wakashū kabuki* and the audience; a group of court nobles playing *kemari* at the estate of a samurai, where they are assembled by invitation; *wakashū* and courtesans enjoying boating (illustrated); and a scene of the pleasure quarters at Ryokujō Misujimachi.

Studies in Japan have dated these screens to between Kan'ei 7 (1630) and Kan'ei 8 (1631) based on evidence of the *kabuki* and *nō* theaters, historical data relating to the prostitute district of Ryokujō Misujimachi, and the kimono fashions, as well as the *hyōgomage* coiffure worn by the courtesans. The stereotyped rendering of figures and face types as well as compositional borrowings from late seventeenth-century genre handscrolls, however, support a somewhat later date in this writer's opinion.

Of particular note is a pleasure boat with courtesans entertaining guests, shown here. The form of this boat and even the oars are done in a style characteristic of the Kan'ei period. This particular painting has been referred to by scholars as the finest drawing of the subject ever seen in an early genre painting.　HAL

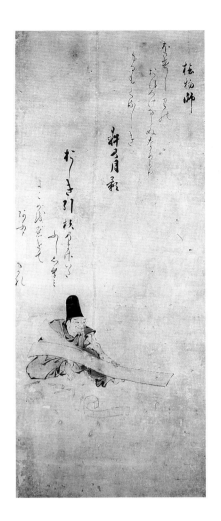

KANŌ NAONOBU

Japanese, Edo period, 1607–50

Temple Artisans at Work, ca. 1630

Ink and light color on paper, two panels from a pair of
six-fold screens; each panel: 51 3/8 × 19 1/4 in.
(130.5 × 49 cm.)

Seal: Kanō Naonobu

Gift of Joseph Brotherton in memory of
Robert P. Griffing, Jr., 1981 (4892.1a)

Purchase, Marjorie Lewis Griffing Fund, 1981 (4892.1b)

This pair of screens in the *oshie-bari* format (individual panel paintings) pictures twelve craftsmen whose occupations are associated with temple life and maintenance. They were painted by a distinguished follower of Kanō Tan'yū (1602–74), Kanō Naonobu, using a deft ink brush line and light color. The occupations have been identified as follows: (right screen, left to right) polishing a needle, making wood veneer, boiling ocean water to make salt, carrying charcoal, binding a mat, drilling holes in rosary beads; (left screen, left to right) squaring wood to prepare it for carving, forging metal to make a machete, a blind musician with helper carrying a stringed instrument (*biwa*), making a bow, chiseling a *kannon* and preparing paper for handscrolls and album leaves. These identifications are based not only on the illustrations themselves but on the poems that occur above, inscribed by the great calligrapher Shōkadō Shōjō (1584–1639). The joint work of such distinguished artists suggests that these paintings were highly regarded during the Kan'ei era, when they were painted.

In 1623 Kanō Naonobu was appointed Goyō Eishi (a master painter employed by the court or military government under the shogun) to the shogun's court, and in 1626 he worked with his master, Tan'yū, for Tokugawa Iemitsu in Nijō Castle. He was summoned in 1630 to Edo, where he helped Tan'yū found the Kobikicho branch of the Kanō family. His association with Shōkadō Shōjō dates from this period; these paintings are a rare product of their collaboration.

Naonobu painted in ink, using a broad free brush and light color washes in compositions of considerable elegance. His style is clearly evident in these screens, despite the fact that the subjects themselves are unique in the Kanō school. Paintings of craftsmen can be traced back to *yamato-e* and Tosa-school scrolls as early as the Kamakura period (1185–1333). The Academy's screens, however, suggest that a tradition for this subject existed in the *suiboku* ink-painting style of the Kanō school. The screens are therefore historically as well as aesthetically important. HAL

Ko-Imari, or old Imari ware, refers to the early under-glaze-blue porcelains that emanated from the Hizen kilns. Porcelain first appeared during the early Edo period (1615–68), and its origins can be traced to innovations from Korea. In 1616 a Korean living in Japan discovered kaolin, a porcelain clay, at Izumiyama, not far from the village of Arita in the ancient Hizen province of Kyūshū. The Korean, Ri Sampei, established Japan's first true porcelain kiln at Tengudani near Arita. His success soon proliferated, and kilns in the vicinity of Arita were converted from Karatsu-type stoneware to porcelain manufacture.

The underglaze-blue painting on the best of these early wares rises above mere decoration, and the brushwork, sometimes highly refined and sometimes loose and primitive, is always vital and vibrant. Underglaze-blue wares were the only porcelains produced in Japan between 1600 and 1640. This example can be dated to the last of three stages in the development of this ware.

Around 1630, Chinese styles of the Ch'ung-cheng era of the Ming dynasty (1628–44) began to influence the design of this ware. The *ju-i* repeat pattern occurring

LARGE BOWL WITH LANDSCAPE DESIGN

Japanese, Edo period, ca. 1630–40
Ko-Imari, porcelain; 4¼ × 15¾ in. (10.8 × 40 cm.)
Purchase, 1969 (3662.1)

around the wide rim of this bowl is a typical Chinese motif and reoccurred in later overglaze enamel wares. The landscape painting of the dish is extremely abstract, particularly when compared to examples borrowed from late Ming motifs (T'ien-ch'i era, 1621–27). As with all early Imari wares, the foot is relatively small in relation to the large diameter of the piece. In appreciating Ko-Imari ware, priority must be given to the ornamental designs. In this case, the painter's skilled brushwork moves freely and unhesitatingly. The thin glaze sweeps over the surface, on occasion almost giving the effect of a shadow. The landscape design is free and abstract yet retains a refinement, poetry, and warm intimacy that is typical of Imari ware at its best. Similar examples are designated as having emanated from the Kuromute kiln. HAL

WOMAN PLAYING A SAMISEN

Japanese, Edo period, late 17th century

Ink and color on paper

32¾ × 16¾ in. (83.2 × 42.5 cm.)

Gift of Mrs. Robert P. Griffing, Jr., in memory

of Robert Allerton, 1965 (3333.1)

The Academy collection, particularly rich in genre and *ukiyo-e* material, contains no finer example than the hanging scroll *Woman Playing a Samisen*, dated to the third quarter of the seventeenth century. Relatively muted, soft patterns of color in the figure's robes and confident brushwork set this painting apart from other genre works of the same period. The position of the figure is similar to those of the *nise-e* (likeness) tradition of China, a popular style in Japan from medieval times (see p. 73), and suggests that the unknown artist may have worked with a live model. But, in contrast to the Chinese style, she is depicted within the tradition of *bijin-ga* (pictures of beautiful women), which was popular during the Kambun era (1661–72). As such, the work is of particular interest. HAL

In the late 1830s Utagawa Hiroshige completed the series "Sixty-nine Stations on the Kisokaidō," a reference to a route connecting Edo and Kyoto. Eisen (1790–1848), a *ukiyo-e* artist and editor of early histories of *ukiyo-e*, had begun the series. The result is one of the great *ukiyo-e* collaborations. The station Nagakubo is shown here in a particularly fine impression, with rich vibrant colors and in pristine condition.

Hiroshige was a master of poetic landscapes, as this superb print clearly demonstrates. Born in Edo, Hiroshige entered the studio of Utagawa Toyohiro in 1811 and soon received the art name Hiroshige, which he used throughout his life. His first published work, an illustrated book, is dated 1818. It was not until 1831, however, that he turned to landscape prints. His "Fifty-three Stations of Tōkaidō" and "Sixty-nine Stations of the Kaikaidō" are among his masterpieces. He consolidated the landscape form and adapted it to popular taste. At their best, his landscapes are imbued with a poetic quality unmatched in the history of Japanese landscape prints.
HAL

UTAGAWA HIROSHIGE

Japanese, Edo period, 1797–1858
Nagakubo, no. 28 in the series "Sixty-nine Stations on the Kisokaidō," late 1830s
Full-color woodblock print; 9 × 14 in. (22.9 × 35.6 cm.)
Signature: Hiroshige ga; seal: Ichiryūsai
James A. Michener Collection (15,618)

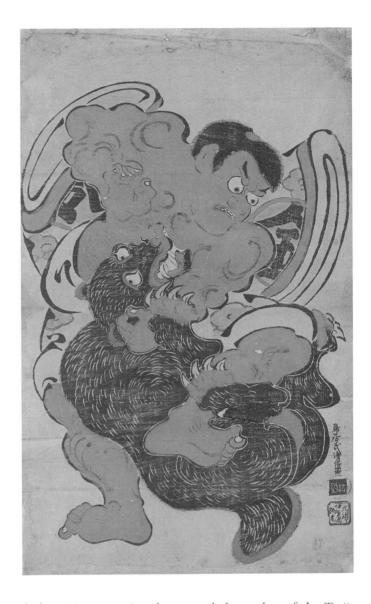

TORII KIYOMASU I

Japanese, Edo period, act. 1697 to mid-1720s

Kintoki Wrestling with a Black Bear, ca. 1700

Hand-colored woodblock print

21³/₄ × 12¹/₂ in. (55.3 × 31.8 cm.)

Signature: Torii Uji Kiyomasu zu; seal: Kiyomasu

James A. Michener Collection (16,576)

This powerful design of Kintoki wrestling with a black bear is the only recorded impression of this Torii print, one of the finest in existence. On the basis of style, signature, technical matters, and the use of vivid *tan* (orange), it is dated to around 1700. The print, along with others dated 1697, 1701, and 1704, defines Torii Kiyomasu's early bombastic style and suggests that Kiyomasu was a mature, active artist during the first years of the Torii school.

Torii Kiyomasu I was a *ukiyo-e* printmaker specializing in Edo *kabuki* theatrical prints. Despite sharing the same surname, no firm genealogical connection has been proven between Kiyomasu and Torii Kiyonobu I, the traditional founder of the Torii school. According to one theory, these artists are one and the same person; according to others Kiyomasu is a brother or son of Kiyonobu I. Until the discovery of some incontrovertible evidence directly linking Kiyomasu I with a recorded member of the Torii family, all suppositions must be approached with caution. It is possible that Kiyomasu I and his direct namesake, Kiyomasu II, originally represented an Edo branch of the Torii family distinct from, but contemporary with, the Kamigata branch (Kyoto/Osaka) headed by Kiyonobu and Kiyomoto. This theory is supported by the recent discovery of the veteran Edo artist Torii Kiyotaka, who possibly headed the Edo school, and by prints, such as the Academy's example, signed "Kiyomasu" and dated to the early 1700s. The absence of either the Kiyotaka or Kiyomasu name in the earliest Torii genealogy devoted to the Kiyonobu lineage, as well as significant differences of a regional character in Kiyonobu and Kiyomasu's primary art styles, offers additional support. HAL

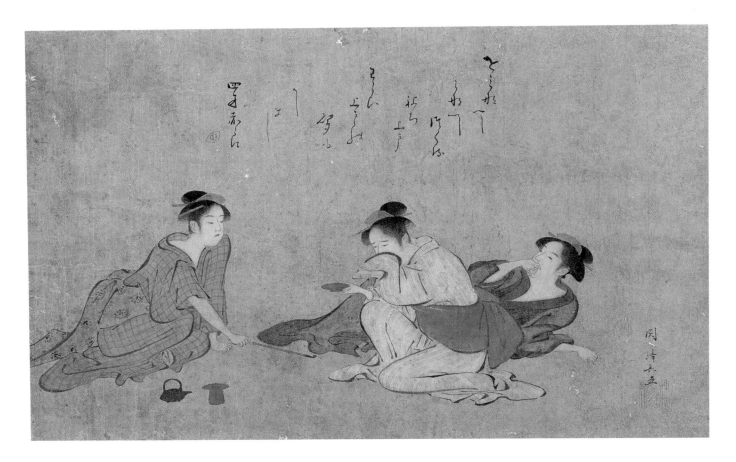

A married woman in blue-and-white striped *yukata* (summer kimono), apparently in tears, is seated between two women. She holds a sake cup in her right hand and covers part of her face with her left sleeve. Another woman, seated opposite her, points with a pipe and talks angrily to her. A third woman seems amused at the situation. The inscription above translates: "How boisterous are those intoxicated women! One is merrily laughing and another is bullying the others. [by] Yomo no Abara." The author of the inscription was one of the best comic poets and writers during the Edo period and went by the pen name Ota Naojirō (1749–1823), or as he is sometimes known, Shokusanjin or Nanpo.

This painting falls into the category of *nikuhitsu* (heavy pigment brush genre paintings of the floating world). The artist, Torii Kiyonaga, identified by signature and seal, was a leading *ukiyo-e* painter, print artist, and illustrator of the day. Fourth titular head of the Torii school, he produced posters, playbills, programs, and prints depicting leading actors and plays for the *kabuki* theaters. His genius, however, went far beyond the portrayal of *kabuki* actors. He specialized in the depiction of elegant young men and women on a grand scale with solid, realistic draftsmanship. His poetic and evocative style formed the basis of Utamaro's art in the early 1790s. HAL

TORII KIYONAGA

Japanese, Edo period, 1752–1815

Three Drunken Women, ca. 1787

Ink and color on paper, mounted as a hanging scroll

25³/₈ × 50¹/₂ in. (64.5 × 128.3 cm.)

Signature: Seki Kiyonaga ga; seal: Seki Kiyonaga

Gift of Robert Allerton, 1957 (2389.1)

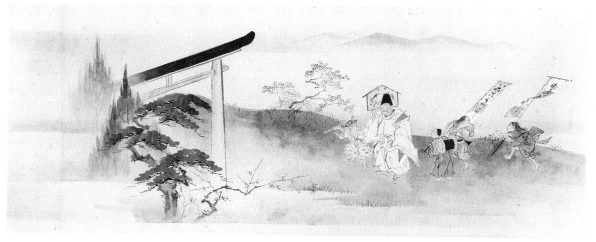

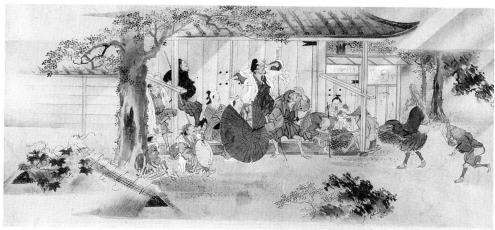

**FASHIONS AND MANNERS OF
THE TWELVE MONTHS** (details)

Attributed to Hanabusa Itcho II, act. 1677–1737
Japanese, Edo period, ca. first half of the 18th century
Ink and color on paper, mounted as a handscroll
10½ in. × 12 ft. (26.7 cm. × 3.66 m.)
Signature: Itcho; seal: Hanabusa
Gift of the Hui Manaolana Foundation, 1967 (3491.1)

This fine painting in handscroll format features twelve genre scenes representing the twelve months of the year, done with the deft brush and technical fluency of a true master. The scenes include men digging trees, townsmen carrying baskets of fish and fruit on long poles, musicians, children playing at games, a man rolling a cask, a group of townsmen reading a poster before a *kabuki* theater, domestic interior scenes with people talking and maids serving a meal, a priest carrying a horse painting (*ema*) passing near a torii gate, a procession of dancing men wearing masks, and women washing clothes inside a house.

The painting is justly famous, and although specialists have sometimes questioned its signature, there has never been any doubt of the quality of the painting nor its attribution to Hanabusa Itchō. It has been noted that a banner carried by a man in the scene with the priest includes the name of a famous banner maker who worked in the second quarter of the eighteenth century. This dating is significant, for it suggests that the work is not by Hanabusa Itchō I, as previously thought, but by Hanabusa Itchō II, who worked from 1677 to 1737. Little is known of this gifted master. He was perhaps the adopted son but more likely the student of Hanabusa Itchō I. His documented style is less sketchy than that of the first artist and is typical, in fact, of the Academy scroll. HAL

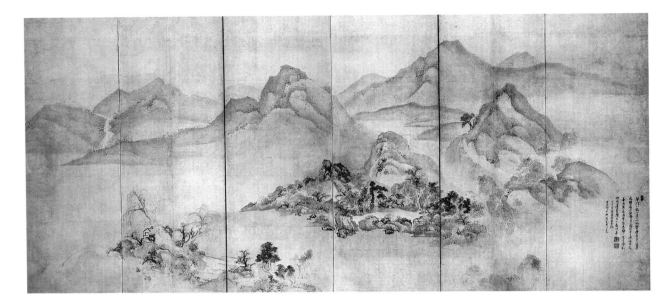

During the eighteenth and nineteenth centuries a number of Japanese painters based their style on the work of Chinese landscape artists. Their paintings were called *nanga* (southern-style paintings), after the southern-style *nan-p'ai* (painters of China), or *bunjin-ga* (painting of literati), after the Chinese *wen-jen hua*. The majority of these painters depended on woodblock manuals of Chinese painting for their inspiration rather than on any direct study of originals. As a result, Japanese artists composed and borrowed elements from various ancient artists to produce a unique and eclectic art suited to Japanese taste.

Ike no Taiga was a prolific painter and calligrapher who experimented outside the limits of Chinese painting as set forth in the woodblock manuals. He developed special brush mannerisms in the delineation of foliage that became his trademark. Taiga was, moreover, one of the wittiest and most original of all the *nanga* artists, particularly in his depictions of the humans that populated his vast landscape studies. Whether his paintings remained faithful to Chinese ideals or took on the rolling, rollicking rhythms of his more Japanese style, the results were always of the highest quality. This work of a more conservative nature is unquestionably a masterpiece.

In the early spring of 1762 Taiga produced a *sumi* (ink) landscape comprised of eight sliding doors, which, when placed together, created a panoramic mural that was probably three and one-half meters in width. On this huge surface Taiga painted his vision of a Chinese landscape, intended to give a sense of revisitation to the observer but not based on any real acquaintance with the scenery of China. The resulting display shows off Ike no Taiga's vir-

IKE NO TAIGA

Japanese, Edo period, 1723–76
Landscape, 1762
Ink on paper, one of a pair of six-fold screens;
each screen: 5 ft. 7 in. × 11 ft. 10½ in. (1.7 × 3.62 m.)
Wilhelmina Tenney Memorial Collection, 1964 (3299.1)

tuosity with the brush and is a classic example of his pointillist texturing. The landscape is painted with soft, subtly modulated ink textures in a dreamlike composition of vast space. The configurations blur and fade on the light, airy surface, dazzling the eye. All the standard elements are included in the composition: mountains, trees, mists, foliage, and small human figures that emphasize the vastness of the scene.

The work has been reassembled and remounted as a pair of six-fold screens. One bears Taiga's seals, and the other includes a long inscription of authentication and the seal of Shukei Imei, a Zen priest and painter (act. 1804–17) who apparently was Taiga's friend. The inscription translates in part: "This is a monoscenic eight-panel landscape, painted by the deceased Ike no Taiga in the early spring of 1776. . . . This screen is executed in *sumi* and is of superior quality. Recorded by Shukei Imei, in April 1807." Careful inspection confirms that the screens were originally divided into eight separate panels, adding further support to the overwhelming evidence that this work is an authentic masterwork of Ike no Taiga done in the prime of his life. HAL

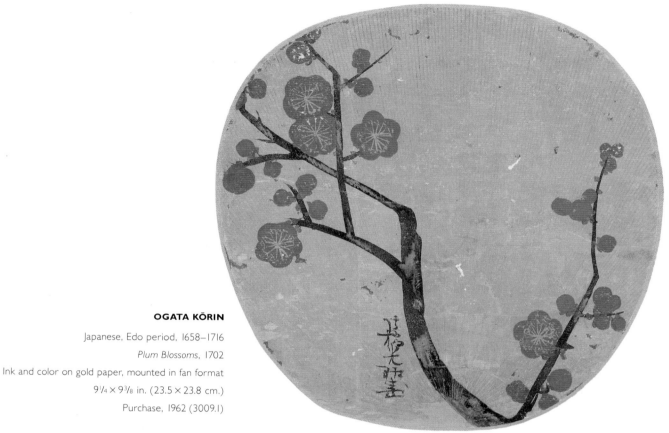

OGATA KŌRIN

Japanese, Edo period, 1658–1716

Plum Blossoms, 1702

Ink and color on gold paper, mounted in fan format

9¼ × 9⅜ in. (23.5 × 23.8 cm.)

Purchase, 1962 (3009.1)

Although Ogata Kōrin was born about ten years after the death of Tawaraya Sōtatsu, he continued the decorative tradition established by the great master, even making copies of Sōtatsu's most celebrated paintings in order to explore the secrets of his art. Kōrin was not merely an imitator, however, for his brilliant sense of bold design, use of opulent materials, and dramatic compositional arrangements dazzled the Edo art world, ensuring him an enduring position in the history of Japanese painting. In fact, before the rediscovery of Sōtatsu in this century, Kōrin was generally thought to be the founder of the Rimpa school. Even the school's name borrowed the second character ("rim") of the master's art name, Kōrin.

This small fan painting has within the confines of its round, flat surface all the essentials of Kōrin's decorative style. The asymmetrical disposition of the plum branch, the bright red blossoms with gold stamens, and the textured treatment of the branch utilizing a technique peculiar to the school known as *tarashikomi* (where green pigments were blurred on a still-wet surface) confirm the fan's authenticity.

Kōrin concentrated on painting as a profession from 1697 to the end of his life, in 1716, and he achieved the honorary status of "Hokkyō" in 1701. This fan, signed "Hokkyō Kōrin," must, therefore, date sometime between 1701 and 1716. Three other works by Kōrin help to date this small fan more closely. The famous *Kōhaku Bai-zu*, in the Atami Art Museum, includes an identical treatment of red plum blossoms with gold stamens and use of *tarashikomi* in the branches of the tree. A second fan, *Hakubai-zu*, from a private Japanese collection, is sealed "Kōrin" and offers a similar composition utilizing white plum-cherry. Like the Academy's fan, the composition is divided into two nearly equal portions. Scholars date both works to the last eight years of Kōrin's life, suggesting that the Academy's fan probably dates within this same period. In addition, the writing of the signature "Hokkyō Kōrin" on this fan is nearly identical to one on a late Kōrin screen, *Take Ume-zu*. We therefore may regard the fan as a minor glory of the Rimpa school—a dramatic distillation of Kōrin's mature decorative style painted at the height of his short career. HAL

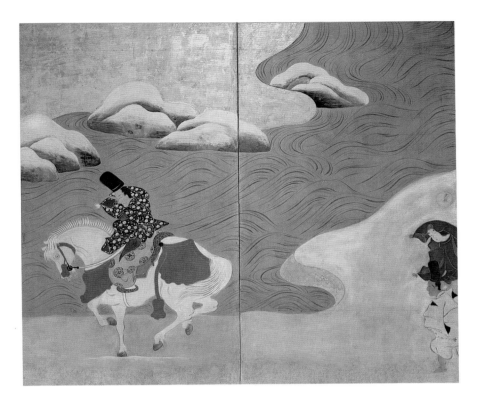

CROSSING TO SANO

Unknown artist

Japanese, Edo period, 18th century

Ink and color on paper with gold leaf, mounted

as a two-panel screen; 60½ × 70¼ in.

(153.6 × 178.4 cm.)

Gift of the estate of John Gregg Allerton, 1986 (5624.1)

This fine screen illustrates a poem that first appeared in the *Man'yōshū* of the eighth century. The sentiment of the poem was recaptured by Fujiwara Sadare in *Shin-Kokin-shū* of the thirteenth century: "At dusk, I stop my horse to shake the snow off my sleeves at the crossing to Sano."

The painting features a nobleman riding a white steed and followed by two attendants; they make their way slowly along the snowy shore of a churning river, yet to be crossed to reach the town of Sano. Located near Nikko in Tochigi prefecture, Sano was famous for its natural beauty. In this two-panel screen, the artist combines compositional elements of earlier Japanese *yamato-e*, but the results are more structured and richly transparent, following the Rimpa tradition of Ogata Kōrin and his predecessors Sōtatsu and Sōsetsu. Broad expressive lines emphasize the flat surface, and the coloration (with considerable later repainting) creates a subdued, though brilliant, harmony.

The same configuration is recorded in Sakai Hōitsu's woodblock compendium of 1815, *Kōrin Hyakuzu* (One Hundred Works by Kōrin), in which the original Ogata Kōrin screen shows both the master's signature and seal positioned to the left of the rider. An attribution of the Academy's screen to Kōrin is unlikely, however, since only a Masatoki (Hōshoku) seal occurs on it.

Attribution to the enigmatic artist Tatebayashi Kagei (act. first half of the eighteenth century) has also been suggested, based on the closeness of the brushwork to an undisputed painting by Kagei bearing his full signature and a Masatoki seal similar to the one on the Academy screen. A number of Rimpa paintings, however, survive with Masatoki seals that are clearly not by the same hand. Attribution of this screen, therefore, is uncertain. Nevertheless, despite some later repainting and late pigments, the work is regarded as a fine eighteenth-century Rimpa-school painting. HAL

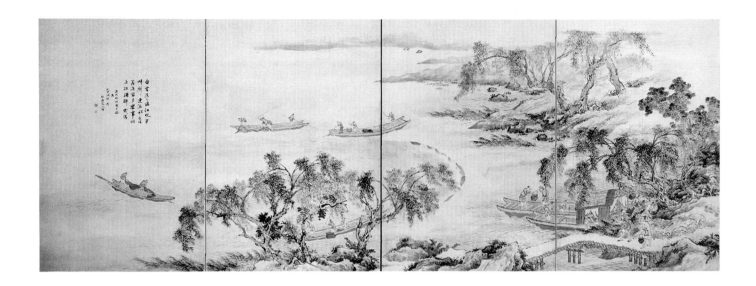

TSUBAKI CHINZAN

Japanese, Edo period, 1801–54

Landscape with Fishermen, 1850

Ink and light color on paper, mounted as a four-fold

screen; 5 ft. 8¾ in. × 14 ft. 3 in. (1.75 × 4.34 m.)

Signature and date: "Painted by Kyuan-Itsujin

[pseudonym of Chinzan] in the late fall of 1850"

Purchase, 1972 (4081.1)

Originally painted as four *fusuma* (sliding doors), this screen focuses on a Chinese fishing village. *Nanga* artist Tsubaki Chinzan invigorated the entire composition with color and a pervasive restlessness of moving forms. Particularly convincing are the turbulence of the river's current and the movement and gestures of the fishermen.

This rural scene, a common theme in both Chinese and Japanese painting, is described in the poem inscribed by Chinzan himself: "The evening view of the fishing village where white clouds float low in the sky and a long horizontal shadow streaks the grassy beach disappearing in the water. Now the fisherman leads an enviable life and exchanges his catch for wine, enjoying the intoxication. Like the gods, the fisherman enjoys his happy and simple life."

Although the fishermen are dressed in Chinese clothes, the detailed drawing of individual features and gestures conveys the same affectionate reportage as seen in traditional Japanese scroll paintings. The work may be thought of as a transformation of Chinese-style painting to suit Japanese taste. HAL

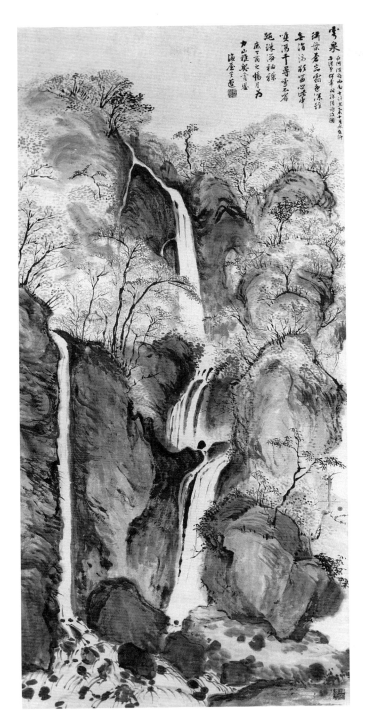

NUKINA KAIOKU

Japanese, Edo period, 1778–1863

Mount Unzen in Autumn, 1837

Ink and color on paper; 52³/₈ × 24⁷/₈ in.

(133 × 63.2 cm.)

Gift of Mrs. Robert P. Griffing, Jr., 1967 (3495.1)

Although Nukina Kaioku, the *nanga* master and theorist, urged a faithful submission to Chinese ideals, *Mount Unzen in Autumn*, executed when the artist was fifty-five years old, combines the Chinese ink tradition with the more robust traits of Japanese art. The painter took obvious delight in the use of bright opaque colors and in the inexhaustible range of expression possible in ink painting, here blending them in a new and original statement that is purely Japanese.

Both the seal and the signature are those of Kaioku, and the accompanying inscription describes the work and dates it to 1837. Studies note the similarity in composition to the thirteenth-century Japanese painting *Nachi Waterfall*, a symbolic landscape that is really an icon representing a Shintō deity. Whether or not this composition alludes to the classic native painting, it is undeniably the ultimate expression of *nanga* painting and a true masterpiece of Japanese landscape ink painting. HAL

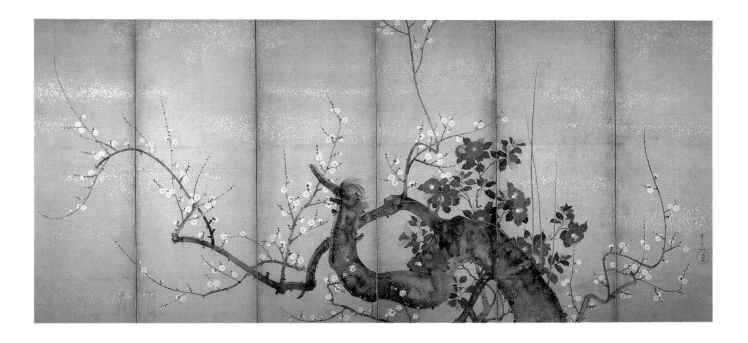

SUZUKI KIITSU

Japanese, Edo period, 1796–1858

Flowering Plum and Camellia, ca. 1850s

Ink and color on paper, mounted as a six-fold screen

4 ft. 7¼ in. × 10 ft. 9 in. (1.61 × 3.28 m.)

Wilhelmina Tenney Memorial Collection, 1966 (3378.1)

Of all the Rimpa paintings in the Academy's collection, none surpasses the screen *Flowering Plum and Camellia*, regarded by many as Suzuki Kiitsu's greatest masterpiece. Stimulated by his father's trade as a textile dyer, Kiitsu became a student of the Rimpa master Sakai Hōitsu at the age of eighteen. Because of the boy's great artistic ability, the celebrated decorative painter arranged a marriage for Kiitsu, and his adoption into the Suzuki family (retainers of the Sakai family), thus making Kiitsu a samurai in the service of Lord Sakai of Himeji Castle. As chamberlain, Kiitsu was permitted to continue his art, poetry, and tea ceremony studies under the great Hōitsu. After Hōitsu's death in 1828, the devoted student remained with the Sakai family until his death in 1858.

Kiitsu was the last important Rimpa school artist, and the Academy's six-fold screen serves as a standard by which all other works purporting to be his must be judged. Boldly conceived with generous brushwork, the gnarled branches of a plum tree with a camellia bush nestled among them provide Kiitsu with an ideal subject to display his virtuosity. Each thin branch is but a single spontaneous brushstroke, while the thick trunk was rendered with a few quick strokes of a wide brush and then enhanced by demonstration of spectacular *tarashikomi* (see p. 102). This, in combination with the white and red blossoms, creates splendid patterns and textures. Kiitsu's style is so similar to that of Hōitsu that some specialists believe that he sometimes painted for his teacher under the Hōitsu signature and seal. This theory is documented by a group of letters written by Hōitsu to his students assigning specific painting projects in the atelier. Nevertheless, Kiitsu brought a breath of fresh air to the somewhat mannered style of his mentor. Based on a study of Kiitsu's signature and seals, this painting probably dates to the last phase of the master's career in the mid-nineteenth century. HAL

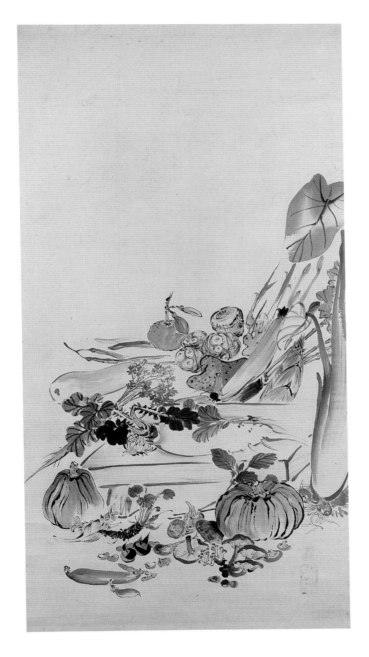

SHIBATA ZESHIN

Japanese, Edo period, 1807–91
The Death of Buddha, ca. 1840s
Ink and color on paper, mounted as a hanging scroll;
54 1/8 × 27 1/4 in. (137.5 × 69.2 cm.)
Seal: Tairyūkyo, Zeshin no In
James Edward and Mary Louise O'Brien Collection
(4598.1)

The novelty of Zeshin's subjects was in part derived from his training in haiku, with its qualities of surprise and suggestion. This painting, masterfully conceived and executed, combines elements of humor with an indirect approach (*rusu-moyō*) in which an object or subject, by virtue of association, stands in place of that it is intended to represent. In this work, vegetables are placed in positions that recall the nirvana scene (*nehan-zu*, or death of Buddha) common in Japanese art. The large white radish laid flat on a cutting board represents Sakyamuni, who has just died in a grove of sacred *sala* trees (here replaced by a tall leafy root), lying on his death bed surrounded by his many mourners (pumpkins, mushrooms, eggplant, etc.). The effect is one of surprise and delight, and it is the artist's intention to stir our interest in exploring the smallest details for additional visual puns. The brushwork of this painting is superb and stands as strong testimony of Zeshin's thorough assimilation of Shijō's pictorial techniques.

The work has been tentatively dated to Zeshin's middle period on the basis of the "Zeshin no In" seal, used until around 1845. Both this seal and the "Tairyūkyo" seal noted above are identical with other known impressions. Accompanying this fine painting is an official document from Count Tanaka, chairman of Zeshin's memorial exhibition in Tokyo in 1907, noting that this work was accepted as genuine. HAL

Shibata Zeshin was a member of the Shijō school and was a painter, printmaker, and lacquerer. He lived in Edo for all his life, studying painting under Suzuki Nanrei (1775–1844) and briefly under Okamoto Toyohiko (1773–1844) in Kyoto. He studied lacquer techniques under Koma Kansai II. He is regarded as the greatest lacquerer of the nineteenth century in Japan, being particularly skilled in *urushi-e*. His paintings have gained great acclaim in recent years as delightful works full of charm and urbane Edo wit.

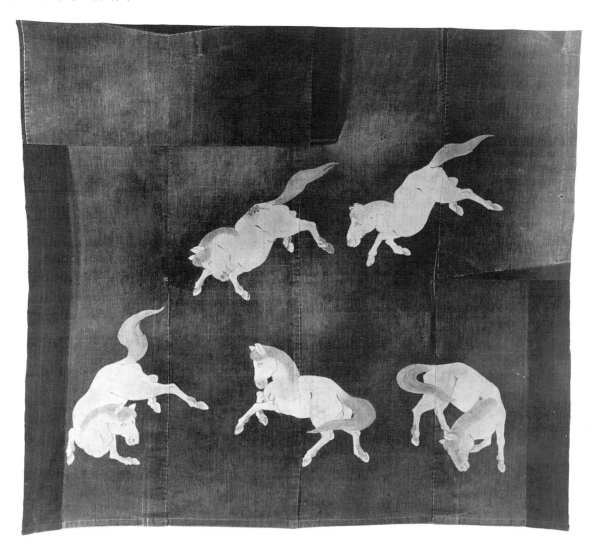

HANGING MADE FROM A JACKET

Japanese, probably 17th century

Cotton, hand spun, hand woven, plain weave, rice-paste resist, painted with pigments, dip-dyed in indigo; ochre, gray, and light brown on indigo blue

Irregular four-panel construction; 13 in. panel, 46½ × 48 in. (33, 118 × 122 cm.)

Purchase, 1937 (4296)

This remarkable and rare piece was originally a short jacket, the six panels of which were resewn into a four-panel cloth. A horizontal seam, just above the tail of the horse in the center, indicates where the collar of the jacket once was sewn. A slanting seam in the right panel probably shows the bottom of a sleeve; another sleeve section, running horizontally, finishes the upper left of the cloth. Five wonderfully alert horses were painted directly on the jacket in pigments and then covered with rice paste, using a *tsutsu* (cone-shaped paper tube), prior to dip-dyeing in indigo. The horses are portrayed realistically in varied poses. Their expressive faces and large eyes, and the skillful, rhythmic composition suggest a painting prototype may have been used. Horses have been associated with warriors in Japan since prehistoric times, as baked clay *haniwa* horse figures (ca. 200–400) witness. The animal's vitality, strength, courage, and faithfulness were treasured by the samurai. In feudal times a prized horse was a valued offering to a Shintō shrine, where it would become a sacred mount for a deity. Painted horses (*ema*) are still presented to shrines as a less expensive substitute gift. The jacket originally may have been worn by a servant of a samurai. RB

108

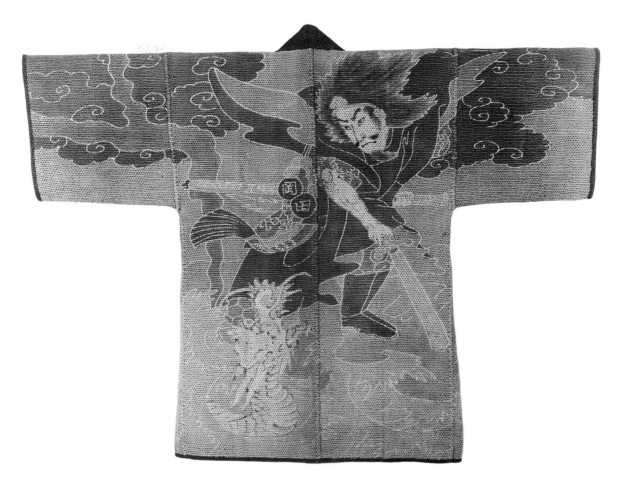

During the Edo and Meiji periods many devastating fires raged through the streets of urban areas. The daring and athletic ability of volunteer firemen was much admired and respected. The colorful costumes worn by these firemen were always an exciting attraction for the town's spectators. The fireman's outfit consisted of a jacket, tightly fit trousers, a hood, and an arm cover. They were carefully constructed from layers of hand-woven cotton cloth, sewn together, and meticulously quilted to provide thickness and strength to protect the wearer against the fire's heat and falling debris. The outside of the jacket was usually simple, depicting only a large crest or seal of the fireman's company, while the inside was decorated with elaborate pictorial images.

The inner surface of this example, probably worn by a high-ranking fireman, is embellished with an image of Prince Susanoo, a legendary god of prehistoric Japan who conquered a fire-breathing eight-headed dragon, an obvious inspiration for the brave fireman. This motif was probably taken from a print of Kuniteru III, a rather obscure printmaker active around 1893. His two seals, Kuniteru and Okada (his real name), appear on the garment at the back and at the right front respectively. Once a fire was out, the fireman visited victims and residents of the neighborhood to pay his condolences, and he customarily turned his jacket inside out to show off such fabulous designs as the one seen on this example. RB

FIREMAN'S JACKET (hikeshi banten)

Japanese, Tokyo, 19th century

Cotton, *tsutsugaki* (paste resist, hand drawn), indigo dye and pigments, quilted; 49 × 38 in. (124.5 × 96.5 cm.)

Purchase, 1985 (5331.1)

BOWL WITH CHRYSANTHEMUM DESIGN

Korean, Koryŏ period, late 11th–early 12th century

Porcelaneous ware with transparent blue-green glaze

2¼ × 7¹/₁₆ in. (5.7 × 17.9 cm.)

Purchase, Marjorie Lewis Griffing Fund and partial gift
of Harry Shupak, 1984 (5248.1)

Related to Chinese celadons are those made in Korea during the Koryŏ period. The earliest Korean celadon wares were often based on the shapes and decorations associated with Chinese Yüeh wares (pp. 21, 22, 29, 35). The thin glazing of Yüeh-type wares was used by the early Koryŏ potter, but the color of the glaze was modified to a distinctive watery blue-green, not unlike Lung-ch'üan ware (pp. 36, 37).

Thinly applied blue-green glazing is evident in this foliate celadon bowl, which is in nearly perfect condition. The exquisite shape, ribbed into six equal petallike forms and focusing on a floral design in the center, seems not to be derived from Yüeh ware, but from Sung dynasty (960–1279) porcelains, particularly Ying-ch'ing, with their dis-

tinctive small foot. The interior space of the foot ring is filled in and thick, as in the manner of Ying-ch'ing ware. The central chrysanthemum design, however, is prevalent only in Korean art and testifies to the vessel's Korean origin; the motif is based on the small wild chrysanthemum found all over Korea in the autumn. Accretions of glaze that have collected around the raised chrysanthemum design are particularly lovely.

The combination of the chrysanthemum design and the Chinese-inspired form is rare. Recent studies of this particular type of chrysanthemum motif support a date in the mid to late eleventh century. The shape of the foot ring and the method of firing of spurs also confirm the early Koryŏ origin of the piece.

Although other wares emulate Sung forms, this particular shape is not known to survive with this design. The shape can be observed in two molded-design bowls, both in the National Museum of Korea, Seoul, but the chrysanthemum design has not been discovered in conjunction with this form, making the Academy bowl an important and rare example of Korean celadon. HAL

This low-footed wine cup is beautifully decorated both inside and out with incised designs of lotus flowers and leaves, and the rim is banded by a scroll motif. The celadon glaze with secondary crackle is a stunning green-blue. Design elements and shape indicate an early twelfth-century date.

The wine cup is paired with an extremely important and rare celadon stand of the same date and coloration. Four carved scroll-feet support an incised platform with a rim carved in lotus form. Wine cups and stands of this type were rarely made to match each other, and only one other example of this type exists in an American collection. No other examples of similar quality are known in either the West or in Japanese collections.

The twelfth-century date for this celadon stand is further supported by comparison with other examples assigned to this period. The stand bears a resemblance to a five-footed example with an inlaid chrysanthemum design of the mid-twelfth century in the Kanson Art Museum, Seoul. A nearly identical example, but not as fine, is in a private collection in Oregon.

HAL

WINE CUP AND STAND

Korean, Koryŏ period, 12th century
Porcelaneous ware with transparent blue-green glaze
Cup: 1³/₄ × 4 in. (4.4 × 10.2 cm.)
Gift of W. Damon Giffard, 1961 (1235.1)
Stand: 1³/₈ × 4¹/₈ in. (3.5 × 10.5 cm.)
Purchase, 1972 (4087.1)

BOWL

Korean, Koryŏ period, early 12th century
Porcelaneous ware with transparent blue-green glaze
3³/₈ × 5¹/₈ in. (8.6 × 13 cm.)
Gift of Lt. Gen. Oliver S. Picher, USAF (Ret.), 1955
(2053.1)

One of the usual forms in celadon bowls is the lotus-petal shape, in which a repeat design of lotus petals is sharply defined on the exterior of the bowl. A particularly fine example of this form is illustrated here. This deep bowl features a sharply molded lotus-petal design in two registers on the exterior. The loveliness of the design itself is enhanced by the rich accretions of blue-green glaze that have collected in the recesses of the design. The glazed foot reveals three spur-marks, common to ware of this period. HAL

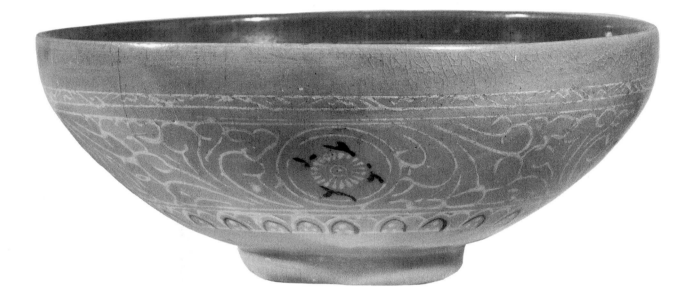

This fine celadon bowl is decorated with incised designs that have been filled with either white or brown slip and covered with a blue-green celadon glaze. The three chalky-white spur marks on the ring foot can be compared with shards from the thirteenth-century kiln near Kang-jin, thirty miles west of Seoul. This example, in nearly perfect condition, is dated accordingly.

Chrysanthemum medallions amid foliate scrolls decorate the exterior. Three clusters of pomegranates alternating with three full-blown chrysanthemums surround a *jui-i* (a symbol signifying "in harmony with the desire of your heart") motif set in a central circlet on the interior. These designs conform to the thirteenth-century date. HAL

INCISED BOWL

Korean, Koryŏ period, 13th century
Porcelaneous ware with transparent blue-green glaze
incised and filled with brown and white slip
3½ × 8 in. (9 × 20.3 cm.)
Gift of Lt. Gen. Oliver S. Picher, USAF (Ret.), 1982
(5037.1)

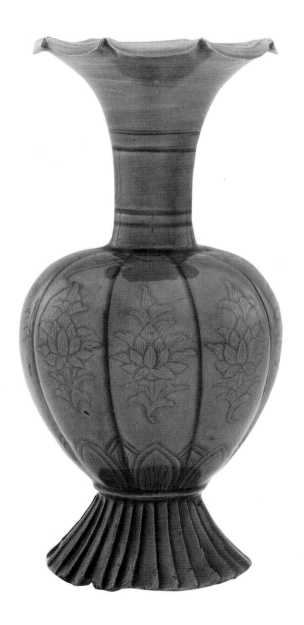

VASE

Korean, Koryŏ period, early 12th century
Porcelaneous ware with transparent blue-green glaze
8¼ × (body) 4 in. (21 × 10.2 cm.)
Purchase, 1967 (3520.1)

This superb celadon vase is particularly noteworthy for its fine, evenly coated, blue-green glaze. Supported by a pleated foot, the low body, divided into eight sections, is in the form of a muskmelon; the mouth is in the shape of a melon flower.

This celadon resembles an example excavated from the tomb of King Injong of Koryŏ, north of Seoul. The tomb is generally dated to around 1146. Fragments of similar celadons have also been discovered at the twelfth-century kiln site at Kang-jin. The similarity of form and glaze to early twelfth-century tomb examples helps to date the Academy vase, which is in nearly perfect condition except for a slight kiln crack on the rim. HAL

One rarely encounters a celadon piece of such perfect proportion and simplicity of design. The saucer has six double scallops around the edge, the curving lines of which continue down on the saucer top to meet the bottom of the bowl, much as the petals of a flower. The bowl itself is undecorated but finely formed. The saucer and bowl rest on a high, slightly concave foot. The elegance of the form is enhanced by an even application of rich blue-green glaze. HAL

BOWL WITH ATTACHED STAND

Korean, Koryŏ period, early 12th century

Porcelaneous ware with transparent blue-green glaze

2³/₄ × 7¹/₄ in. (7 × 18.4 cm.)

Gift of Mrs. Robert P. Griffing, Jr., in memory of W. Damon Giffard, 1966 (3434.1)

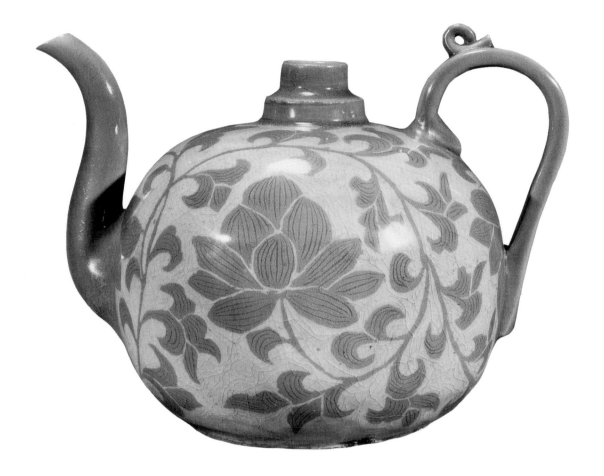

WINE JAR

Korean, Koryŏ period, 12th century

Porcelaneous ware with transparent gray-green glaze

inlaid with lotus and arabesque designs

6 × 6 in. (15.2 × 15.2 cm.)

Mrs. Charles M. Cooke, 1927 (101)

The slip-decorated stonewares of northern China, particularly the boldly decorated Tz'u-chou ware (p. 39), were a major influence on the Koryŏ potter. The difficult slip-inlay techniques of this ware were borrowed and enlarged to produce a rich style unique to Korean celadons.

The lotus and arabesque designs on this fine wine jar are expressed in reverse inlay. The veins of the lotus flower, leaves, and arabesque designs are painted; the area outside the patterns is inlaid. Reticulated crackles can be observed in the lustrous grayish-green glaze. Parts of the handle and the loop have been repaired.

This pot, nearly identical to one in the National Museum of Korea, Seoul, once had a lid featuring a fanciful bird. Like the Seoul example there are six spur marks and sand on the bottom. Both pots no doubt came from the same kiln and date to the same period. HAL

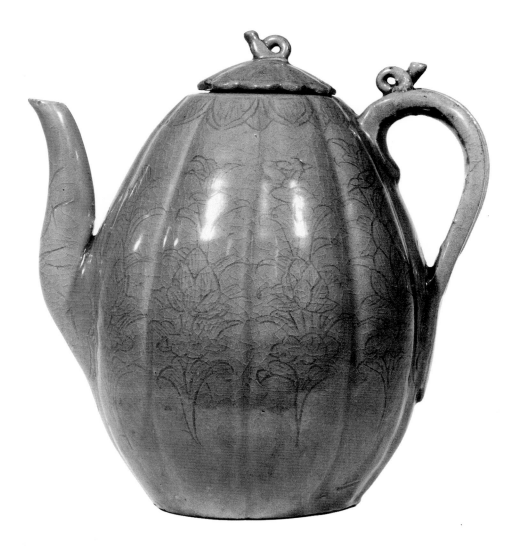

This lobed wine jar is shaped like a muskmelon, its original cover like the end of a melon. Each lobe of the body is ornamented with incised floral designs over which there is an even coat of blue-green celadon glaze. This type of form is more commonly decorated with white slip designs. Both inlaid and incised fragments found at a kiln site in Kang-jin help place the date of this example. HAL

WINE JAR

Korean, Koryŏ period, mid-12th century
Porcelaneous ware with transparent blue-green glaze
9³/₄ × 6¹/₄ in. (24.8 × 15.9 cm.)
Gift of Lt. Gen. Oliver S. Picher, USAF (Ret.), 1966
(3380.1)

PUN CH'ONG FLAT BOTTLE

Korean, Yi dynasty, 15th century
Porcelain with Pun Ch'ong glaze over white slip with
incised fish design; h. 9 in. (22.9 cm.)
Gift of Lt. Gen. Oliver S. Picher, USAF (Ret.), 1958
(2522.1)

Flat bottles such as this example are typical of the Yi-dynasty Pun Ch'ong porcelains. Yi potters took a free hand in modeling the shape and creating the designs for these vessels, leaving much to chance. The essence of Yi craftsmanship is revealed in this spontaneous and unpretentious design of a fish with conventional lines incised on the sides. The entire form was dipped in white clay pigment and then the fish design drawn with a bamboo knife, after which the Pun Ch'ong glaze was applied. HAL

Southeast Asian, South Asian,

and Middle Eastern Art

ANCESTOR FIGURE (adu zatus)

Indonesian, Nias, 19th–20th century

Wood; h. 26³⁄₄ in. (68 cm.)

The Christensen Fund Collection, 1989

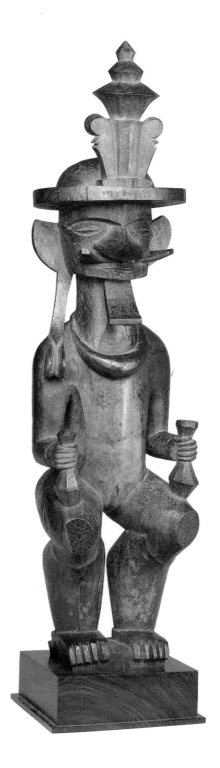

Ancestor traditions constitute the core of the belief systems of Nias, an island lying approximately one hundred kilometers off the northwest coast of Sumatra. Ancestors are represented by wooden figures (*adu*), which are placed in the houses of the wealthy to serve a protective function. Carved by some of Indonesia's most talented sculptors, these images are found throughout the island, although the greater percentage are from the north and central regions. The most impressive of these images are highly polished and finely carved human figures wearing the elaborate gold ornaments reserved for the highest nobility, as shown in this example.

This male figure with mustache and beard, one of the finest examples of Nias sculpture known, is most likely from the central area. Here wood sculpture of varying size is generally more geometric in treatment than the more rounded forms of the north. Figures are depicted standing, supported by flexed legs with massive calves. Pegs, possibly representing betel-nut pestles, are held in each hand and rest upon the knees. Joints are marked by flat facets. Several small sculptures that appear to be by the same carver are in the Royal Ethnological Museum, Leiden. Collected from Idana Mola village, they were catalogued in 1907. GRE

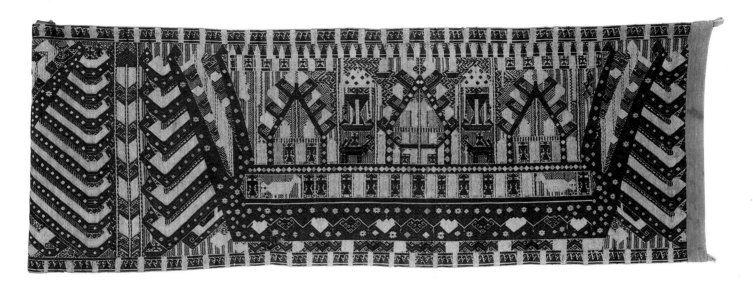

Ship designs appear in many Indonesian textiles. The ship is believed to symbolize the transition in human life from one condition to another. Thus the motif is often used in ceremonial textiles known as *palepai*, which commemorate rites of passage, such as marriage and death. Once woven along the south coast of Sumatra, they depict the ship design in a most remarkable and spectacular manner. Exceptionally long (often three meters or more) and narrow, *palepai* are usually woven in plain beige, on which an enormous ship—or sometimes a pair, as in this example—carrying various passengers is depicted with intricate supplementary weft yarns, usually in shades of yellow, reddish brown, and blue-black. Metallic thread may be used to add a glittering effect.

Palepai were used to provide a backdrop for a principal figure in rituals reserved for the aristocratic stratum of society. In wedding rituals, the bride and sometimes the bridegroom sat in front of a *palepai* displayed on a wall. A *palepai* was also hung for name-giving ceremonies for infants, circumcisions, funerals, and other rituals. Several *palepai* might be hung alongside the central one, each representing the social rank and authority of the owner seated in front of it. The hanging arrangement of *palepai* mirrored the strict hierarchy of Sumatran communities. The textiles were usually passed on vertically within clans, from father to son.

This excellent example depicts a pair of red ships, on which appear three houses that have decorative projections on their sides (probably representations of traditional dwellings) and rows of small, highly stylized animals and human figures, some astride animals and some wearing large headgear. The figures are depicted in warm red-brown, blue, and yellow. The metallic thread, unfortunately, has tarnished and lost its sheen. The incredible craftsmanship of this *palepai* represents the peak of Indonesian textile art. This weaving skill is now completely lost; no new *palepai* have been made for more than fifty years. RB

CEREMONIAL HANGING (palepai) (detail)

Indonesian, South Sumatra, Lampung, 19th century

Hand-spun cotton, silk, metallic thread,

supplementary weft on plain weave

2 ft. 9 in. × 12 ft. 10½ in.

(.84 × 3.92 m.)

Gift of Dr. and Mrs. Robert Kuhn, 1981 (4997.1)

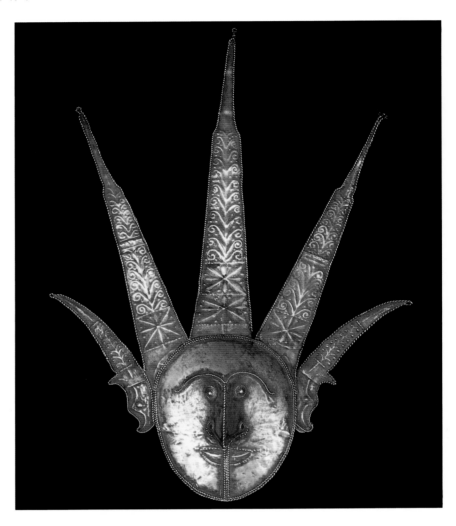

HEADDRESS

Indonesian, Luang, 19th century

Gold; h. 11 1/2 in. (29.2 cm.)

The Christensen Fund Collection, 1989

Collected on the small island of Luang, this headdress is one of only two known examples of this particular style and form. Located at the eastern end of the Indonesian archipelago, Luang is surrounded by a wide reef and has no anchorage for deep-draft vessels. There is little land for cultivation and only one well. In the mid-nineteenth century Luang is reported to have been an active commercial center, trading *tripang* and turtle shell for cloth, metals, pottery, arms, and other items. Smithing and weaving were once important crafts, and the island products were well known and widely traded throughout the region, one example being gold dishes, which were used as bride price on the island of Leti.

This beautiful piece displays stylistic affinities with the wood sculpture of surrounding islands, including Leti, but specific information regarding its function and use is not available. A field photograph by La Roux taken in 1922 shows the headdress being worn. Two individuals are depicted, the second wearing a headdress of a considerably different style. Each individual is bedecked with gold dishes and plates with repoussé work that relates to the decoration of the headdress.

Although lacking functional documentation, this headdress is aesthetically one of the finest examples of Indonesian metal art in the world. GRE

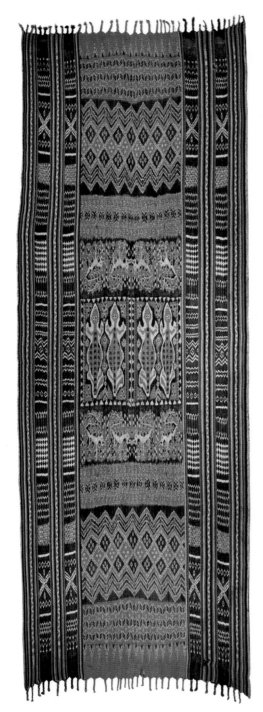

FUNERAL SHROUD OR HANGING (porilonjong)

Indonesian, Central Sulawesi (Celebes),

Rongkong, Toraja, ca. 1910

Hand-spun cotton, natural dyes, warp-faced plain

weave with warp ikat patterns

16 ft. 4 in. × 5 ft. 6 in. (4.98 × 1.68 m.)

Purchase, 1983 (5100.1)

Toraja groups inhabit the rugged mountainous area of Central Sulawesi. In sharp contrast to the international seagoing people of the surrounding coastal regions, the Torajas, secluded in their isolated natural environment, remained virtually untouched by outside influences until the Dutch gained control of the area in the twentieth century. As a part of the Toraja animistic religion, based on the worship of their ancestors' spirits, funerals were critical communal rituals. Textiles were important in the funeral rites, along with the sacrifice of water buffaloes and feasting. Magnificent hand-spun cotton ikat textiles woven by two Toraja groups (the Rongkong and the Karataun) are particularly known for their roles as funeral shrouds. A cloth was used to wrap or cover the body of the deceased, or if the deceased was highly respected, several ikat cloths were used.

This spectacular and gigantic piece is an early and rare example of an ikat shroud or ceremonial hanging produced by the Rongkong. Portions of the hand-spun cotton warp threads were painstakingly tied before dyeing, according to predetermined patterns, to resist dye penetration. The threads were then dip-dyed in baths of natural indigo and brown dye. After this, the threads were woven into fabric on a primitive backstrap loom. The bold and dramatic ikat patterns of this piece include four large crocodiles at the center, flanked by zoomorphic figures on both sides. Various geometric motifs, probably suggestive of the spiritual world of the Toraja, in the center field and the side borders add an energetic rhythm and mysterious feeling. As in many other Indonesian textiles, the true meaning of the Toraja motifs has been lost during the long process of using ancient ornamentation in extremely stylized forms. The crocodile, believed to be a powerful deity, however, is here depicted in a fairly realistic rendering. The dynamism of the patterns, the subtle hues of natural brown, red-brown, and light blue, and the tactile texture of the hand-spun cotton create a splendid visual presence. RB

CHARIOT ORNAMENT

Cambodian, Khmer, ca. 1200

Solid cast bronze; 8 1/8 × 5 3/4 in. (20.6 × 14.6 cm.)

Purchase, Academy Volunteers' Fund, 1989 (5804.1)

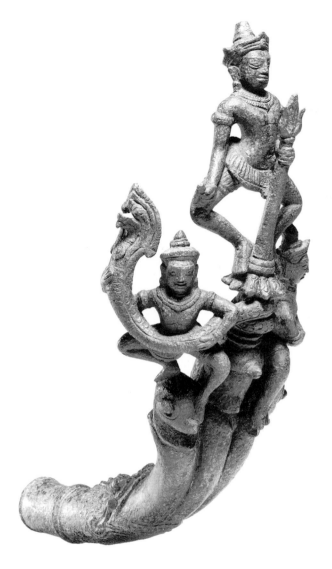

Chariot ornaments can be seen in bas-reliefs depicting sacred and secular battles and in scenes of court life in the temple-fortress-palace complexes at Angkor. Typically they have a tubular, elongated S-shaped body with an opening at one end, which fits over an upright staff or axle, a configuration that lent itself to the representation of *nagas*, or snake gods, with flexed upper bodies and multiple rearing plumed hoods. This finial, with its open form comprising a central male deity flanked by attendant deities holding a *naga*, is a rarity. Each figure wears the traditional *sampot* (waistcloth) as well as the tiara and jeweled chignon cover of a king or god.

The complex iconography of the finial draws the viewer into the heart of Khmer syncretic religious beliefs. The central image has two identifiable attributes of Shiva the Destroyer: the fire-producing third eye in the center of the forehead and the trident in the left hand, but he also carries a conch shell and stands on a tortoise, attributes of Vishnu the Creator/Preserver in the symbolism of the Hindu trinity. The smiling miens of the central figure and the deity on the right reflect the benign aspects of Vishnu, while the figure on the left has the protruding eyes and frowning brows of Shiva's terrifying aspects.

Moreover, the positioning of the figures and the twisting of the *naga* around the central post suggest the myth of the Churning of the Ocean of Milk, which successive Hindu and Buddhist Khmer kings used as the conceptual basis for the designs of their capitals. The main towers of Angkor Wat and Angkor Thom represent the Cosmic Mountain of the Universe as a pivoting, churning rod. Their major approaches have *naga* balustrades, which symbolize Vasuki, the Cosmic Naga. Coiled around the churning rod, Vasuki appears as a turning rope tugged at opposite ends by gods and demons. Their concerted efforts to draw forth the *amrita*, the elixir of immortality, from the Ocean of Milk are comparable to the king's exertion of power to procure the everlasting welfare of his subjects. In the myth, it is Vishnu's tortoise incarnation that supports the churning process, but Shiva, too, is incorporated, for at the crucial moment he intervenes to help, swallowing poison ejected by Vasuki before it can pollute the elixir. Thus the symbolism of the finial appears to glorify the supremacy of Shiva as Lord of the Universe, balanced on the axis of the universe above all polarities. SSD

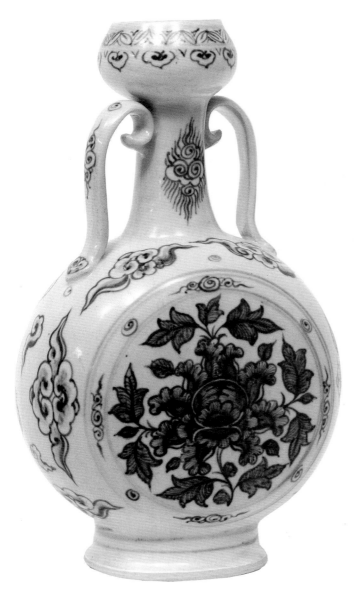

PILGRIM BOTTLE

Vietnamese, Annam, late 14th–early 15th century

Glazed stoneware with underglaze-blue design

h. 10¼ in. (26 cm.)

Purchase, Marjorie Lewis Griffing Fund, 1983 (5214.1)

This rare pilgrim flask with compressed globular body, tapered neck, cup-shaped mouth, and curled slab handles spanning its neck and shoulders is representative of the Annamese potter's art. It is finely painted with full-blown tree-peony designs surrounded by scattered clouds. Lappets and a band of petals decorate the restored lip.

The vase is regarded as a transitional piece. Whereas earlier porcelains include a central medallion decorated with a wide variety of motifs (fish with water plants, mythological animals, landscape elements in addition to a simple peony spray), the more naturalistic peony observed here, with prominent veining and shading, is almost universally encountered in medallions of the fifteenth century. Although this classic pilgrim bottle demonstrates many qualities common to the fifteenth century, it also hearkens back to some qualities associated with the fourteenth century, particularly its loose linear execution. Dating of these wares is based on the fact that they echo the evolution of Chinese blue-and-white wares of the fourteenth and fifteenth centuries. A number of the same motifs appear, change, and disappear in Annamese blue-and-whites in much the same manner as in their Chinese counterparts.

Annamese blue-and-white ceramics have increasingly attracted the attention of collectors and art historians over the past three decades. For many years the term Annamese was an appellation of convenience, for no archaeological evidence had pinpointed specific places of manufacture. Recently, however, a kiln site in Vietnam has been uncovered that establishes once and for all the origin of this classic ware. Nevertheless, most of what we know about Annamese blue-and-white comes from examples excavated from unscientific digs in the Indonesian archipelago. The great quantity of the blue-and-white wares found in Indonesia is thought to have been imported originally from Annam. Scientifically organized excavations have been conducted in the Philippines in recent years, testifying to a larger distribution area for the ware and providing some chronological comparisons for stylistic dating. HAL

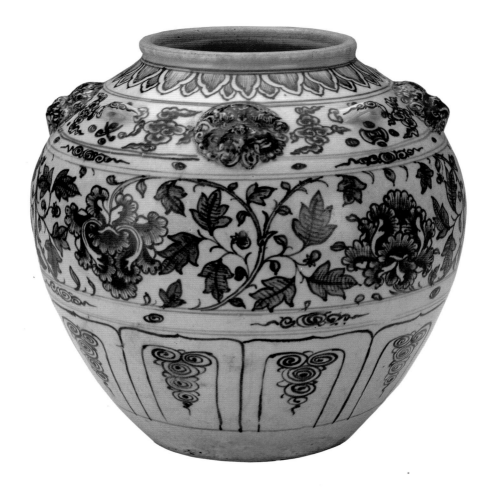

JAR

Vietnamese, Annam, early 15th century

Glazed stoneware with underglaze-blue design

h. 10¼ in. (26 cm.)

Purchase, Marjorie Lewis Griffing Fund, 1983 (5213.1)

This solidly potted, bulbous jar (*kuan*) is molded high on the shoulder with four blue-stippled bird-dragon masks separated by simple blue handles. Depictions of these masks are unusual and help to establish this fine jar as a unique surviving example of early Annamese blue-and-white porcelain. The central body is painted in a vivid dark underglaze-blue with a wide band of scrolling, blossoming tree-peony. The base is adorned with outlined jewel-lappets, and a design of overlapping stiff leaves decorates the lip.

Overtones of a style peculiar to the first half of the fifteenth century are revealed when this superb jar is compared with the only known inscribed Annamese ceramic, a bottle dated to 1450 in the collection of the Topkapi Saray, Istanbul. On both pieces the main decorative scheme is a central band of peony blossoms and leafy stems confined between narrow borders below and a richly ornamented shoulder above. HAL

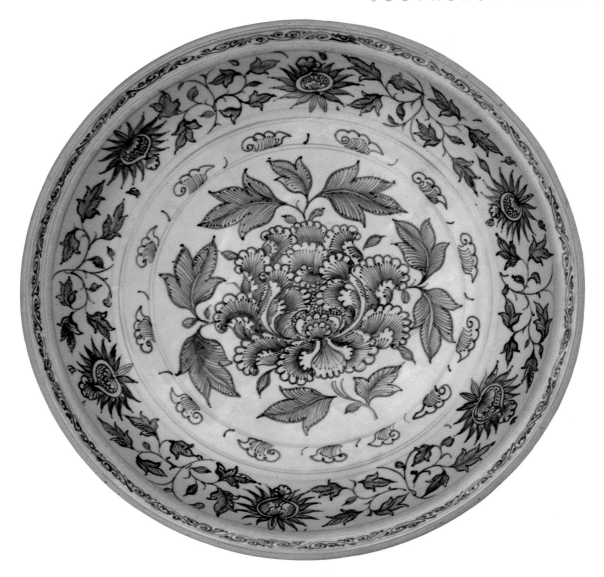

This fine Annamese blue-and-white dish is noteworthy for its central decoration of full-blown tree-peony designs with leaves. Two bands surround and complete the design: one with stylized clouds and a second in the cavetto with fanciful lotus designs. A narrow band of classic scrolls can be seen beneath the rim. This is a particularly fine example of classic fifteenth-century Chinese blue-and-white ware as adapted by Annamese craftsmen.

The increased naturalism of the flowers in the cavetto suggests a fifteenth-century date for this dish. Both petals and leaves are given prominent veining, and the individual elements are shaded. The rim is reduced in width, an innovation that constricted any decorative motif applied there. The work is particularly vitreous and resonant, matching any porcelain made in China. Again, the 1450 Topaki Saray bottle (see p. 126) provided a significant comparison for the dating of this dish. HAL

DISH

Vietnamese, Annam, 15th century
Stoneware with underglaze-blue design
2³/₄ × 14¹/₂ in. (7 × 36.8 cm.)
Purchase, Marjorie Lewis Griffing Fund, 1983 (5216.1)

DVARAPALA (Protector of the Door)

South Indian, Chola period, 9th–10th century

Green granite; h. 36 in. (91.4 cm.)

Gift of Mrs. Charles M. Cooke, 1930 (3017)

Authorities have tentatively identified this graceful figure as Dvarapala, a Shivite door guardian who warded off evil from the sacred interior of a Shiva sanctuary, and they agree on a ninth- to tenth-century date. Even in its fragmentary condition, the figure, with slender torso, heavy necklaces, and high headdress, is full of life and a sense of movement. According to documentation from the first owner, the work originally came from South India near Madras. HAL

This paunchy, seated elephant-headed god is a favored cult figure through-out India. Ganesha has been "Hinduized" as the son of Shiva and Parvati. Here he appears as the affable Destroyer of Obstacles and Bestower of Success. He is the indulgent dispenser of health and all bounty, the discriminating patron of cultural and intellectual enterprises, and the earthy "divine commoner," who is specially venerated by traders and merchants.

The elegantly bejeweled Ganesha is rich in iconography. He wears the sacred thread made of a serpent and carries four attributes, one in each hand: a hatchet, a radish or other bulbous root, a pot of sweetmeats, and his own tusk (legend recounts that he broke off this tusk to hurl it at the moon). Ganesha's mount, the rat, crouches on the base beneath his feet; two diminutive worshipers adore him on either side. Above his head appears a mask known as *kirttimukha*, which wards off evil and protects the devotee.
HAL

GANESHA

Indian, Rajasthan, Gurjara-Pratihara period,
10th century
Pink sandstone; h. 22 in. (55.9 cm.)
Purchase, 1975 (4310.1)

STELE DEPICTING SHIVA AND PARVATI

Central Indian, ca. 12th century

Pink sandstone; h. 52 in. (132.1 cm.)

Purchase, Jhamandas Watumull Endowment Fund, 1987

(5650.1)

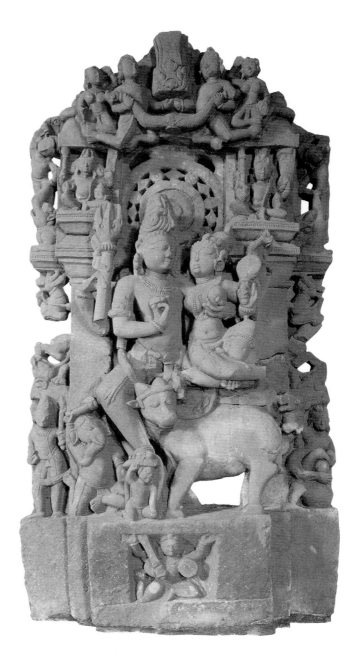

The divine couple, Shiva and Parvati, are seated in postures of ease and loving intimacy on Nandi, Shiva's bull. Shiva's right hands hold a lotus and a trident. One left hand touches the breast of his consort and the other clutches a many-headed cobra. Parvati's right arm embraces Shiva's shoulders, while her left hand holds a mirror, which symbolizes truth. Behind their heads is a shared nimbus. Flanking them are small images of their two sons. At the left is the elder, the elephant-headed auspicious god, Ganesha, who is dancing; at the right is the younger son, Skanda or Kartteyakea, god of war, with his peacock vehicle. Above, on either side, are the other deities of the Hindu trinity, who complement the destructive/regenerative powers of Shiva: to the left, Brahma, the Creator; to the right, Vishnu, the Preserver.

At the pinnacle of the stele are apsarases (celestial beings) holding a garland of flowers symbolizing their sensuous pleasures. The architectural tiers of the framing panels teem with energetic images: warriors grappling with *vyali* (leonine creatures), who stomp on elephants, lesser deities, and attendants. The whole forms the towering peak of Mount Kailasha, abode of the gods.

At the base of the stele, isolated in a cavelike enclosure, is a figure with a sword who has been identified as Ravana, the demonic king of Lanka. Many different legends recount Ravana's schemes to usurp the immortal powers and privileges of the manifestations of the trinity for himself; in some stories he even attempts to capture Mount Kailasha. Eventually he is always thwarted. In this stele, neither Ravana's threatening presence nor the *vyali*'s aggressive energies, not even the provocative merrymaking of the apsarases, disturb the serene and tender mood of Shiva and Parvati's perfect love incarnate. SSD

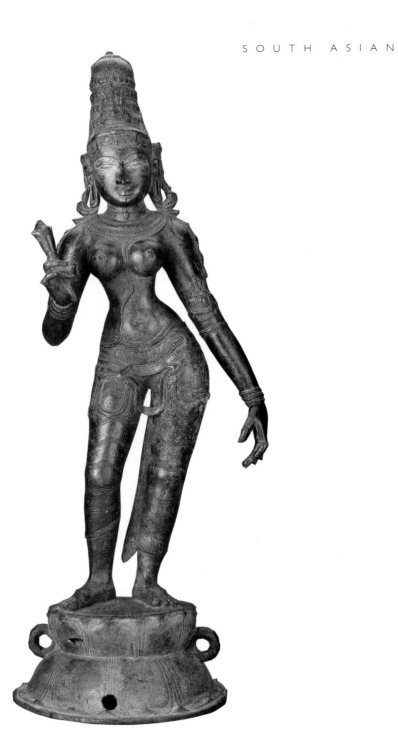

Parvati, the consort of Shiva, is the most powerful goddess in the Hindu pantheon. She is sculpted, with smiling countenance, as the manifestation of feminine beauty. Her head, full breasts, pinched waist, and swelling hips are sinuously aligned in the *tribhanga*, or triple flexion, standing pose. She wears a richly patterned skirt and ornamental jewelry; her coiffure is composed of the matted locks of an ascetic, twined together to form a crown. The rigidity of the back suggests that this bronze, done by the lost-wax technique of casting, is a Chola-period product of the late thirteenth century. The double lotus base, as in most bronzes of this period, has two loops to aid in carrying the image in ceremonial processions. HAL

PARVATI

South Indian, Chola period, late 13th century
Bronze; h. 31 in. (78.7 cm.)
Purchase, 1975 (4313.1)

COWRIE SHAWL (rehuke khim)

Indian, Nagaland, Yimchunger, early 20th century

Cotton, plain weave, embellished with cowrie shells

39 × 60 in. (99.1 × 152.4 cm.)

Gift of Mrs. W. Thomas Davis, 1989 (5898.1)

The Nagas comprise more than a dozen major groups of Indo-Mongoloid origin who reside in the isolated northeastern hills of India, today known as Nagaland. In the past, the Naga groups were known for their warlike nature. Their practice of headhunting, which continued well into the twentieth century until suppressed by the British, was in part a spiritual ritual. According to Naga belief, a vital essence of great power resided in the human head, so that taking an enemy's head brought the victors new energy and fertility. Headhunting inspired and stimulated many aspects of Naga artistic life, including the making of textiles. Unique and elaborate costumes were created for successful warriors and their relations, and of particular interest are the black cotton shawls decorated with cowrie shells. Worn at the waist by warriors of the Yimchunger tribe, the shawl strengthened the wearer when going to war. In later times, it became a ceremonial costume for important occasions and sometimes was used as a dance costume.

The typical shawl is made of black cotton decorated with red squares and circles of cowrie shells, as seen in this superb example. The red squares are said to symbolize the blood of the enemy. The cowrie circles represent the warrior's power and wealth, and the number of them on a textile is proportionate to the status and wealth of the wearer. It is said that as many as ninety-four circles were stitched to the shawl of a wealthy man. The human figures made of cowrie shells (there are two in this shawl) are believed to specify that the wearer was indeed a warrior. RB

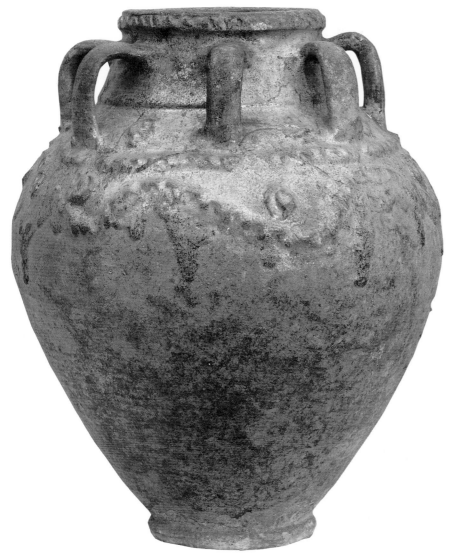

SEVEN-HANDLED STORAGE JAR

Iranian, Sassanian/Islamic, ca. 8th century

Buff clay with applied ornamentation, blue alkaline
glaze; 16½ × (mouth) 6 in. (41.9 × 15.2 cm.)

Purchase, 1956 (2197.1)

This rare vessel, from an unknown archaeological site, is
believed to date from the century after the Hejira,
Muhammad's famous flight from Mecca in 622. Thus, it is
a transitional piece bridging the late Sassanian and early
Islamic periods. Its antique form resembles storage jars
excavated at Susa in southern Iran, which were part of an
uninterrupted tradition of domestic wares hearkening
back over two millennia to the most ancient Mediterra-
nean antecedents. The jar has a rolled rim with raised
diagonal textures, a conical neck defined by circumvent-
ing grooves, seven strap handles rising from a sloping
shoulder, and an inverted pear-shaped body tapering to a
small foot. Neither the ropelike molding below the han-
dles nor the classical festooned bands and rosettes (ancient
sun symbols) on the shoulder are well defined, due in part
to the thickness of the deep blue-green glaze on the neck
and shoulder, which obscures the applied ornamentation.
Excessive amounts of glaze were poured on to give a
"spilled-liquid" effect running down the sides. The rich
silvery iridescence of these heavy deposits, and the flicker-
ings of the very thin coating on the body below, however,
produce the ethereal quality that ennobles the utilitarian
vessel as a precious object. SSD

BOWL

Iranian, Kurdistan, 10th–11th century

Red clay, carved white slip, emerald green glaze on

exterior, brown and yellow glazes on interior

2¼ × 6⅜ in. (5.7 × 16.2 cm.)

Wilhelmina Tenney Memorial Collection.

Gift of Renee Halbedl, 1962 (3070.1)

In the province of Kurdistan, remote from court-style centers, a crude but spirited ware developed that used a technique related to metalwork and stone carving (known in Europe as champlevé). Made with thick walls, this ware was covered with a white slip, on which a pattern was first engraved and then cut around, creating a flat relief. Transparent, thin colored glazes, such as the emerald green on the exterior and the earth tones on the interior, were applied to enhance the imagery and to enrich the surface with variegated pools of intense color. The somewhat random tri-hued effects achieved in this example are reminiscent of earlier Persian efforts to emulate Chinese three-color wares of the T'ang dynasty. The rendering of the lion motif is, however, indigenous to the Kurdistan region, for it combines not only the traditional pre-Islamic Iranian associations of the lion as symbol of the sun and royal power, but the reality of the powerful lions that the potters encountered in the wild mountains surrounding their homes. The animal's body, adapted to the concave surface with energetic, twisted movements, fills the whole field with the force of its trapped vitality. The design is an early example of the Islamic ornamentation termed arabesque. In this subtle but highly intellectual style of decoration, naturalistic forms are abstracted into an unbroken flow of lines that rhythmically interact; a dynamic balance is achieved by complex repetitions and variations of thematic elements.

SSD

The Turkish peoples of Central Asia ruled a large part of the Islamic world and influenced the development of its collective tastes and artistic traditions. This was particularly true after the Ottoman conquest of Constantinople in the mid-fifteenth century. As the Turks transformed the old Byzantine city into their capital, new styles of architecture and decorative arts began to emerge. The ceramic tiles created for their massive building program and the vessels used as domestic wares were all produced by the same designers and workmen. Ceramic production centered at Iznik, where the kilns were renowned for their hard, white porcelainlike paste; clear, brilliant finishing glaze; and vitreous colors. A rich tomato-red, so thick that it stood in relief, was their special pride, and may have been achieved by a process involving double firing. Their decorative vocabulary came to consist primarily of identifiable garden flowers, blossoming branches, and elegant trees.

In this deep dish with flaring rim, the tulip, the favorite flower of the Turks, is flanked by carnations with feathery

PLATE

Turkish, Ottoman Empire,
Later Iznik style, 17th century
Fine white paste; blue, blue-green, red, and black
polychrome covered by transparent glaze
2¹⁄₈ × 10¹⁄₈ in. (5.4 × 25.7 cm.)
Purchase, 1963 (3136.1)

leaves and buds. Conventional mirrored symmetry is ruffled in the somewhat windblown arrangement, which infuses the design with a slightly skewed, unexpected liveliness. The "cloud scrolls" and lotiform leaves in the border and the related calligraphic motifs on the exterior sides are reminders that Chinese porcelains of the Yüan and Ming dynasties were avidly collected by Turkish sultans and were a decided influence on the development of Asian Minor pottery. High-quality Iznik export ware was in great demand not only in the Near East but throughout Europe; it in turn was widely copied, especially in Italy and England. SSD

YOUTH PLUCKING FRUIT

Attributed to Riza-y 'Abbasi, d. 1635

Iranian, Isfahan, Safavid period, ca. 1587–1605

Ink and light wash on paper with gold illumination;

drawing only: 7¼ × 4¾ in. (18.4 × 12.1 cm.)

Purchase, C. Montague Cooke, Jr., Fund, 1962 (14,851)

MU'IN MUSAVVIR

Iranian, Isfahan, Safavid period, act. 1635–1705

Head of a Youth in Portuguese Costume, 1673

Ink on paper; drawing only: 3⅜ × 1¾ in.

(8.6 × 4.4 cm.)

Gift of Edwin Binney III, 1972 (4108.1)

These two drawings represent the effervescence of the aestheticism embraced both during and after the reign of Shah 'Abbas I. Called "The Great" by his people, he restored their fortunes and spirits and left a lasting monument to his achievements in the magnificent capital he built at Isfahan. The exquisite *Youth Plucking Fruit* is attributed to Riza-yi 'Abassi, an artist held to exemplify the canons of taste during his lifetime. This depiction is very similar to a drawing, *Seated Youth*, in the collection of Prince Sadruddin Aga Khan, that has been attributed to Sadiqi Bek, an older and much esteemed artist who came under the influence of the precocious genius of the younger Riza. The smaller portrait of a youth in Portuguese costume is signed by Riza's celebrated pupil, Mu'in Musavvir, who had a long and exceptional career. He was the favored recipient of court patronage and the most brilliant of teachers during the second half of the seventeenth century, just as his master had been during the first.

There is in Riza's drawing a delightful affinity between the plump, sensuous youth and the ripe fruit he plucks. Although his introspective pose is as stereotyped as the fantastic clouds and the burgeoning vegetation surrounding him, an obviously sure hand sketched the tapering and swelling outlines that suggest the languid, well-rounded volumes of his body. Staccato strokes enliven his swirled turban, sash, and hem folds. The border, illuminated with gold scrolling leaves, full-blown blossoms, and phoenixes, enhances the sense of the ephemeral beauty of ideal youth.

Mu'in chose to adhere to the refined Safavid calligraphic tradition. When he inscribed his painting with his signature, "Mu'in, the Painter," and a statement about the young man he depicted, "On the 13th of the beautiful month of Saval 1084 [1673] nobler than all strings of pearls," reminding us not only of the technical relationship between fine script and sensitive, spare draftsmanship but of this artist's use of art for self-expression. Despite depicting the sitter in a soft, wide-brimmed hat, scarf, and beads, with the loosely flowing hair of European fashion so in vogue at court, stylistically Mu'in never succumbed to Western influences, a tendency of his contemporaries.　SSD

Ancient Mediterranean Art

FEMALE FIGURE

Cycladic, ca. 2500–2400 B.C.

White marble with traces of polychrome

h. 26⅝ in. (67.6 cm.)

Purchase, Frank C. Atherton Memorial Fund, 1976

(4386.1)

The Cycladic archipelago, composed of thirty-one islands and many islets and reefs, lies in the center of the Aegean Sea. The marble-rich Cyclades, like stepping stones, link the mainland of Greece with Crete, Turkey, and the north Aegean. The Cyclades were so called because it was thought they formed a circle (Greek: *kyklos*) around the tiny island of Delos, sacred birthplace of the goddess Artemis and the god Apollo.

During the Early Bronze Age (ca. 2900–2200 B.C.), the people of the Cyclades developed a culture marked by skilled navigation and overseas trade. Much of what we today know about this culture is inferred from grave goods. Cycladic cemeteries, located in close proximity to settlements, are composed of boxlike graves in which jewelry, bronze daggers, obsidian blades, marble and pottery vases, and male and female figures have been found. The Academy's impressive and unusually large figure is an example of the late Spedos Variety, which is named after the location of an important cemetery on Naxos, and is a class exclusively made up of female, folded-arm figures. The figure has a lyre-shaped head and relatively straight profile; its arms are formed by both relief modeling and incision. The gentle curving abdominal groove completes the top part of the V-shaped pubic area. At the end of the unperforated leg cleft, the feet are separated and slightly splayed, the toes pointing downward.

Traces of paint appear on the figure's face. Red color can be seen on the nose, over the cheeks in double rows of dots, and across the top of the forehead, creating a kind of fringe. Faint almond-shaped designs that originally may have been blue can be distinguished in the eye region. A single curled lock was painted in a dark color on the right side of the narrow head: apparently sidelocks appear only on Spedos Variety images.

Occasionally small clay pots containing lumps of coloring matter, palettes, and bowl-mortars for grinding pigments are discovered in Cycladic graves, and some have inferred that ritual face painting was an important part of the religious rites observed by Cycladic people. Although the meaning of these images remains unclear, their calm dignity and perfect harmony is readily apparent. RAD

MALE FIGURE

Egyptian, ca. 2500 B.C.

Limestone with traces of polychrome

63 × 33 in. (160 × 83.8 cm.)

Gift of Mrs. Charles M. Cooke, 1930 (2896)

This work is said to be one of over thirty reliefs retrieved from the tomb chapel of Ni'ankhnesut at Sakkara. Ni'ankhnesut, who lived during Dynasty VI in the reign of Pharaoh Teti (2323–2291 B.C.), was known by various titles, including count and overlord of Nekheb. The hieroglyphic inscription above the figure contains part of Ni'ankhnesut's name, indicating that the figure probably depicts Ni'ankhnesut.

Like its companion pieces, this work was carved in raised relief; the background, except for the inscription, was uniformly cut away to a depth of only a few millimeters. Although there is subtle modeling in the torso and appendages, and the figure was originally fully painted, it is the outline that makes the strongest effect. Indeed, Egyptian artists, throughout the Old and New Kingdoms, favored bold outlines in their compositions; one possible translation of the hieroglyph for painter is ''scribe of contours.''

The depiction of the figure is in keeping with the Egyptian convention of composite representation. This three-thousand-year-old formula portrays the human body in conceptual rather than prosaic terms: the head, torso, and appendages are shown in profile, but the eye and the shoulders are in their frontal aspect. The artist, representing the most characteristic aspect of each part of the body, thus composed a complete and ideal image that supplies all essential information about the figure. RAD

PINHEAD

Iranian, Luristan, ca. 8th–7th century B.C.

Bronze, h. 3¼ in. (8.3 cm.)

Gift of Mr. and Mrs. J. Scott B. Pratt III, 1973 (4205.1)

Luristan, a province in the central Zagros Mountains of western Iran, derives its name from the nomadic Lurs tribe. In the first half of the first millennium B.C., bronze-casters inhabiting this region created an enormous number of highly sophisticated small objects, which have been found over the last fifty years in large cemeteries typically located near small settlements. Probably made by the lost-wax method, the objects are primarily horse gear, weapons, and ornaments. The inhabitants of Luristan must have been accomplished horsemen if the number of horse bits and chariot fittings found is any indication. The objects are decorated with real and composite animals; often only a head or another part of an animal is used on a piece.

Numerous objects of adornment have been recovered, including buckles, bracelets, torques, and pins. Some of the pins may have been used as votive objects rather than for adornment. The Academy's pinhead is unusual in that the creatures that comprise it, a moufflon and two highly stylized lions, are typically found on harness rings. In this piece the moufflon, its legs tucked under, reclines above two lion heads in profile, which together create a frontal feline mask. The large cursive horns of the moufflon dominate the piece and give it a sense of movement. The bronze-caster squared off the moufflon's snout, making it appear bovine.

The lack of written records on Luristan bronzes and the small number of controlled excavations make it difficult to determine the significance of the animals portrayed and their relationships. Some creatures may have been used as apotropaic symbols, used to ward off evil. Generally, leonine creatures seem to have been considered destructive and evil, and moufflons beneficent and protective; to this day, moufflon horns are found over some house entrances in Iran. In this bronze, the dominant moufflon may be a protective device to subdue or neutralize evil, represented by the lion heads. RAD

BUST OF A WOMAN

Greek, 4th century B.C.

Terra cotta; 11 × 9¹/₂ in. (27.9 × 24.1 cm.)

Gift of Edith Porada and Hildegard Randolph in
memory of their mother, Catherine de Porada, 1985
(5347.1)

The dignified female bust depicted in this terra-cotta relief is probably
Demeter, the Greek goddess of agriculture. The goddess is shown with her
mantle draped over her head, its end laid over her shoulder. The relief was
purchased in 1895 by Carl Humann, a well-known archaeologist of Asia
Minor in the late nineteenth century, in Myrina, a site on the west coast of
Turkey between Izmir (formerly Smyrna) and Bergama (ancient Pergamon)
where Greeks dominated the population and where fragments of similar
terra cottas have been found.

Although the terra cotta was probably a votive relief for use in a sanctuary,
objects such as this were also placed in private homes or put into graves.
Such reliefs were often hung on walls, but the lack of suspension holes and its
rectangular shape suggest that the Academy relief was placed in a wall
niche, leaned against a wall, or laid in a grave.

The relief conveys the classic Greek style of the fourth century B.C.; the
triangular forehead, the deep eye sockets, the merging of eyebrow and super-
ciliary arch into a rounded form, and the fleshy, strongly curving lips are
characteristic. The earrings, composed of a disk and pendant, suggest the
fourth-century date and parallel those seen on terra-cotta heads dating from
late in the century in Sicily and Magna Graecia, the Greek colonies in south-
ern Italy. LM

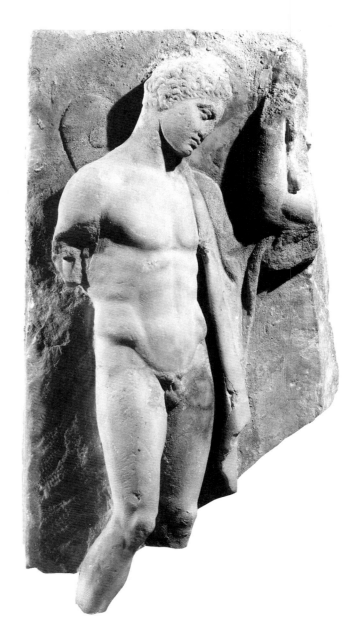

MALE FIGURE

Greek, 4th century B.C.

Marble; h. 16½ in. (41.9 cm.)

Gift of Mrs. Charles M. Cooke, 1932 (3610)

After the Peloponnesian War (431–404 B.C.), Greece was engulfed in political chaos. The fourth century B.C. was nevertheless a period of artistic innovation and experimentation. Although still within the general framework of the fifth-century classical tradition, this marble relief fragment dates from the fourth century. By this period, technical problems associated with depicting the nude body had been solved. The anonymous artist who carved the Academy relief rendered the youthful figure anatomically correct and concentrated on the quality and texture of the muscles and flesh. The sensuousness and the relaxed languor of the body resemble the work of the fourth-century master Praxiteles, whose sculptures are known for their attenuation and soft, almost feminine, grace.

Fourth-century Greek art is also known for portrayals of experiences that evoke pity and compassion, traits more fully explored later in Hellenistic art (323–31 B.C.). The languid body, tilted head, and downcast eyes of the Academy figure express the pathos of death. The figure most likely represents Hermes in his capacity as Psychopompus, Guide of Souls, at the moment he draws Eurydice away from her husband, Orpheus, the ruler of the Underworld, and back to Hades. (One variant of the myth tells how Eurydice, who had died from a snake bite, was permitted to spend one day with Orpheus, after which time Hermes led her back to the Underworld.) One of the distinguishing signs of Hermes, his broad-brimmed messenger's hat, is shown resting against Hermes' back. On the reverse side of the Academy fragment are depicted two pillows and a cover, suggesting that the subject of the entire piece was death-related or funerary in nature; in ancient Greece the bier was usually dressed as a bed, part of a traditional association between sleep and death. RAD

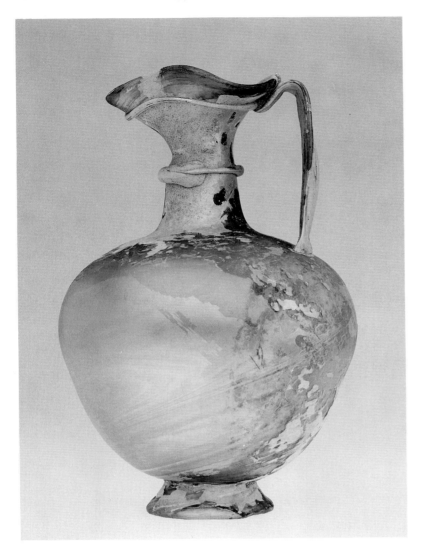

LARGE PITCHER (oenochoe)

Roman, Syro-Palestinian coast,
probably Sidon, 2nd–4th century
Blown glass; h. 9¾ in. (24.8 cm.)
The Kayyem Collection of Ancient Glass. Gift of Renee
Liddle in memory of Faiz Omar El Kayyem and Mrs.
Charles M. Cooke, 1965 (4174.5)

More than four thousand years ago, during the great Bronze Age civilizations of the eastern Mediterranean, sand, soda, and lime were first combined, melted, and fused to produce a viscous, malleable material, which was brittle but durable and esthetically exciting. Molded beads and amulets simulating precious stones were the initial objects designed in this first man-made synthetic. Ancient sources record the difficulty of maintaining proper conditions for such chemical fusion to occur; thus in its beginning glassmaking was considered to be a ritual, performed under royal and priestly supervision. Early glass forms closely followed those of metalwork, and with the decline of bronze cultures, glassmaking came to a standstill, but by the eighth century B.C. the Assyrians revived the old processes and developed additional molding and lathe-cutting techniques to produce luxury goods for wealthy households. The glass industry was revolutionized by the discovery, believed to have been made in Sidon or its environs in the first century B.C., that glass could be blown with human breath into a variety of desired shapes and sizes. The Roman penchant for labor-saving devices and mass-production soon made glassware as plentiful as ceramics, with a thriving market serving different peoples of all classes throughout the far-flung empire.

This oenochoe, or wine pitcher, is of clear blue-green glass. Its form embodies the graceful dignity of classical art: it has a full bulbous body; an applied, solid pad foot with slight tool marks; a high, well finished, neatly tucked reeded strap handle; and a tapering neck and trefoil spout ornamented with irregular glass threads. Through the ages the surface has weathered to a silvery patina and vivid iridescence that resembles amethyst, emerald, and sapphire jewels, a much-admired quality in ancient glass. SSD

MALE TORSO

Roman, after a Greek original, 1st century A.D.

Marble; h. 38 in. (96.5 cm.)

Gift of Mrs. Charles M. Cooke, 1932 (3603)

In the second century B.C. the Romans conquered mainland Greece and the kingdoms founded by the successors of Alexander the Great in Macedonia and Asia Minor, and thousands of Greek sculptures, paintings, and other objects were brought home to Rome by victorious generals. The plunder from Greek lands kindled in the Romans a love for beauty and for objects made of costly materials, and soon there was a great demand for more. Artists in Greece were commissioned to create these objects, but they could not keep up with the demand; before long, Greek artists were brought to Rome to work. By the middle or second half of the second century B.C., these artists began making copies of masterpieces of Greek sculpture, which were used to decorate open squares and public and private buildings in Rome.

This male torso is said to be one of several replicas of a Greek work of the Hermes-Richelieu type, named after a piece in the Louvre. This fragmentary figure may represent a type that was created in the mid-second century B.C. and used throughout the late republican and imperial periods. The type combined an idealized body of a Greek god or hero with the naturalistic head of a Roman man of distinction. In the Academy's torso a thick mantle rests on the left shoulder, continues down the back of the left arm, and may have wound around the forearm. This mantle may distinguish the figure as a Roman general or emperor. A broken end of a sword rests against a fold of the fabric on the upper left arm; the hilt was probably held in the left hand. The remaining part is decorated with a floral motif reminiscent of those found on swords held by emperors or generals in other sculptures.

Although Greeks of the classical period would have found unthinkable the prospect of combining the body of an Olympian deity or a mythological hero with the head of a contemporary personage, the Romans, always interested in aggrandizement and propaganda, saw no difficulty in the composite form. Because of the fragmentary condition of the work, it may never be possible to establish the identity of the first-century A.D. personage represented in the Academy piece, and indeed, the drill hole in what remains of the neck may indicate that over the years different heads were attached to the torso, a not uncommon practice. RAD

HEAD OF A SATYR

Roman, 2nd century

Marble; h. 8⅞ in. (22.5 cm.)

Gift of Daphne Damon in memory of Violet D. Putman, 1957 (2300.1)

The Romans highly prized the masterpieces of Greek sculpture, but because Greek works were scarce and difficult to transport, many well-to-do Romans formed collections of copies. Emperor Hadrian (r. 117–38), who placed copies of famous Greek works surrounding his pool at Tivoli, initiated one of the most active periods of classical reproduction. *Head of a Satyr* is a Hadrianic copy of a Greek type of the third century B.C. In early mythology, satyrs (sylvan deities representing the luxuriant forces of nature) were associated with Dionysus. Half-man, half-beast, mischievous and amorous, satyrs were often depicted chasing nymphs or reveling at drinking parties.

Late Roman writers confused these wood spirits with their own more gentle fauns, assigning them goat legs.

The smooth face (the tip of the nose is repaired) of the Academy's piece contrasts with the deeply cut curls and waves of the hair. None of the mischievous or bestial characteristics of a satyr—save the pointed ears—are portrayed. Instead, the head evokes an elegiac mood, reminiscent of the Hellenistic period. The eyes were drilled slightly, creating dark spots that closely resemble pupils, a technique introduced during the Hadrianic period. The drilled pupils symbolized the function of the eye as the organ of revelation, the window of the soul. RAD

ANIMALS HUNTING

Roman, Daphne (Antioch), Syria,
late 5th–early 6th century
Mosaic; 9 ft. 6 in. × 9 ft. 3 in. (2.9 × 2.82 m.)
Purchase, 1937 (4672)

Founded in 300 B.C., Antioch by the fourth century A.D. had become—with Rome, Constantinople, and Alexandria—one of the great metropolitan centers of the ancient world. The city was filled with large public buildings, houses, and villas, each with lavish painted wall and ceiling decoration and elaborate pavement designs of mosaic, naturally colored stone cut into cubes (tesserae) and set into designs by artisans working from a cartoon, or pattern guide. Most wall and ceiling paintings were destroyed by catastrophe and time, but the more durable mosaics survive as fine examples of late classical art and design.

The subject matter of the Antioch mosaics ranges from personifications of gods, allegories, and figures from classical mythology and literature to animals, scenes of sea life, still lifes, and purely geometric inventions. The Academy's mosaic is one of the largest panels depicting animals. Excavated at Daphne, once a summer resort outside Antioch, it formed the central panel of a larger floor design in a villa, probably a hunting lodge, which was destroyed in an earthquake in 526.

The composition of the scene is essentially square. A striding lion at the center is surrounded by scenes of ani-

mal combat in which a tigress and her cub pursue a stag and a doe, a lioness chases a pair of ibexes, a leopard attacks an ostrich, and a bull confronts a bear. Birds of various types, including a goose, parrot, quail, guinea fowl, and pheasant, are used as decorative space fillers. This series of vignettes would have been viewed one by one as a person approached from any direction and walked around or over the mosaic. The design also shows a modification of Greek and Roman traditions by Persian and Near Eastern influences in the substitution of a neutral ground for a naturalistic setting. The bits of stone in yellow, tan, red, pink, gray, and black blend in the viewer's eye, compensating for rough outlines.

The careful placement of tesserae to model musculature and the subtle juxtaposition of colors, which shift from dark to light, produce contrast and a tangible sense of contour, giving the animals solidity and vitality. The repetitive bits of stone establish a visual rhythm that emphasizes line and adds to the overall sense of movement. Even the neutral background, in which stones are laid in concentric half-circles, displays an activated surface that further delights the eye. JJ

European Art

QUEEN SEMIRAMIS WITH ATTENDANTS

Flemish, Tournai, ca. 1480

Wool and silk, tapestry weave

8 ft. 3 in. × 8 ft. 5 in. (2.52 × 2.56 m.)

Gift of the Charles M. and Anna C. Cooke

Trust, 1946 (325.1)

Mille-fleurs (thousand flowers) tapestries—in which the entire background is a dense mass of flowering plants—were popular in Flanders and France in the fifteenth and sixteenth centuries. This notable example, probably from a series of tapestries representing legendary heroines, shows Semiramis, queen of Assyria and Babylon, combing her hair in front of a mirror. According to legend, Semiramis, the daughter of a mortal and a goddess, was famous for her beauty and courage. At the end of her life she ascended into heaven in the shape of a dove.

The inscription at the top of the tapestry can be translated: "I was Semiramis, Queen of Babylon. I conquered barbarians, Indians, and Syrians. I went into the north and set my throne there and slew the king of the Ethiopians." LM

MASTER OF 1518

Flemish

The Adoration of the Magi, early 16th century

Oil on panel; 32 × 27⁵/₈ in. (81.3 × 70.2 cm.)

Purchase, Acquisition Fund, funds given in memory of Mrs. Richard A. Cooke, Alyce Hoogs, Wilhelmina Tenney, and Douglas Damon, the bequest of Alyce Hoogs, and contributions by the Charles and Anna C. Cooke Trust, Mrs. Robert P. Griffing, Jr., Robert Allerton, and John Gregg Allerton, 1963 (3103.1)

The fine arts flourished in Flanders at the end of the fifteenth century. Although many works of the period have survived the passage of time, the specific identity of artists responsible for them often remains obscure. A body of recognizable works, which includes this richly detailed biblical subject, is given to the hand of the Master of 1518, a date inscribed on his large retable in Lübeck. This panel is one of four or possibly five works depicting scenes from the early life of Christ, paintings which made up a now-disassembled altarpiece (two of the paintings are in the collection of the National Gallery, London, and another is at the Museum Mayer van den Bergh, Antwerp).

A popular subject at the time, the Adoration of the Magi derives from the biblical account (Matthew 2:1–12) of wise men who journeyed from the east to find the child born king of the Jews. Embellished over time, the story assumed symbolic and narrative details. With the star they followed to Bethlehem radiant in the sky and their entourage ascending to the distant city, the magi—including a Moor or African—are here depicted as kings, and their originally unspecified number has become three. According to a popular pictorial convention, they find the Christ Child in the ruins of a fine classical structure. Sprigs of young plants rising from the ancient stone symbolize the beginning of the new era signaled by his birth.

Like many of his contemporaries, the Master of 1518 was concerned with recreating the physical appearance of the natural world and here constructed a scene of high surface finish and invisible brushwork, rich with color, texture, and detail. The magis wear luxuriant costumes of exquisite brocade and other fabrics with elaborate gold and gemstone borders, reflecting the Flemish skill in the manufacture of beautiful textiles. In the distance, a charmingly fanciful recreation of Bethlehem joins Flemish architecture with an imaginary mountainous terrain. In this depiction of idealized features, courtly demeanor, and restrained emotion, the Master of 1518 created an image of symbol and splendor appropriate to the son of God receiving homage from all ages of man.　JS

AELBRECHT BOUTS

Flemish, ca. 1455/60–ca. 1549
The Holy Family, ca. 1520
Oil on panel; 28⁵⁄₁₆ × 22⁵⁄₈ in. (71.9 × 57.5 cm.)
Gift of the Honolulu Star-Bulletin in memory of
Frank C. Atherton, 1946 (379.1)

As the doctrine of the Immaculate Conception became part of the Christian liturgy during the late fifteenth century, devotion to St. Anne, Mary's mother, increased, and depictions of the Holy Family proliferated in northern Renaissance art. In Aelbrecht Bouts's *Holy Family* the infant stands in Mary's lap and reaches to take from St. Anne an apple, a symbol of original sin. With this simple gesture Bouts alludes to Christ's acceptance of his role as redeemer and his understanding that mankind will find salvation through his sacrifice. Quietly observing the infant's actions, the two women suggest with their tenderly serious expressions their recognition of the coming Passion of Christ. A concomitant interest in the genealogy of Christ led to depictions of additional family members such as Joseph, identified here by the budding rod, a reference to his divine selection as the husband of Mary. Mary's father, Joachim, or possibly a donor, appears at the right. Finally, two angels draw aside the canopy's curtains to reveal the dove symbolizing the Holy Ghost, the vehicle through which Mary divinely conceived Christ, hovering in a rainbow-hued aureole of light.

Working in the Flemish tradition of naturalism, Bouts created an image of strong color, rich texture, and minute detail. Bouts equally revealed an awareness of the compositional order and balance underlying Italian Renaissance painting in his positioning of the central figures. He reinforced the importance of Mary, Christ, St. Anne, and their meeting by presenting their monumental figures on an elevated, elegantly paved dais, where they sit on an architecturally impressive throne within the isolating embrace of a canopy. A sense of geometric symmetry in the arrangement of the figures and gestures recalls Italian rationalism and further enhances the seriousness of the moment. Although the product of an artist from Flanders, this painting bears witness to the assimilation of ideas from two sides of the Alps. The interweaving of northern colorism with southern intellectualism engenders an art powerful in symbolic content, jewellike in visual effect, and compelling in spirituality. JS

THE HARROWING OF HELL

English, 15th century

Alabaster with traces of polychrome and gold

20½ × 11⅜ in. (52 × 28.9 cm.)

Purchase, Robert Allerton and Prisanlee Funds and the
General Acquisition Fund, 1985 (5382.1)

The first record of an English alabaster carving dates from the mid-fourteenth century. A brisk trade in altarpieces and tomb sculpture soon developed, using alabaster from quarries around Nottingham and other English towns. After Henry VIII came to the throne, however, the Act of 1550 was passed banning the making of religious images, and the production of alabaster carvings soon ceased.

The subject of this relief is somewhat unusual in English alabaster carvings (only eight other panels representing the theme are known). It derives from the apocryphal Gospel of Nicodemus, retold in Voragine's *Golden Legend*, in which Christ is said to have descended into Limbo during his stay on earth after the Resurrection to rescue Old Testament personages.

Hell is symbolized by the wide-open mouth of Leviathan, the great fish-monster in the Book of Job, a pictorial device which has a long tradition in Christian iconography. The open mouth lined with teeth, with a curled snout above, makes a formidable hell-image, its fearsomeness somewhat mitigated by the two small devils above and below, who add an impish air. A large figure of Christ with a halo dominates the scene at the left; the seminude torso, crown of thorns, and cross-staff (the top part is missing) allude to the Crucifixion. Christ reaches to pull Adam out by the arm, while Eve, her hands held in prayer, stands behind ready to follow. Other figures representing the patriarchs and prophets of the Old Testament are also visible, awaiting salvation and an orderly exodus from the mouth of hell.

The alabaster's translucency and creamy white tones enhance the beauty of the panel, while traces of paint and gilding hint at its original colorful brilliance. Leviathan's mouth is lined with red, and the ground has a blue-green cover dotted with white flowers. Christ's halo has vestiges of red and gilt, the crown of thorns green. The panel would probably have been combined with others, perhaps illustrating scenes from Christ's life, to form an altarpiece, all encased in a carved wood frame that also would have been painted and gilded. The glittering visual effect of such a sculptural array would have been magnificently rich, inspiring awe and devotion in those who worshiped before it. JJ

VIRGIN AND CHILD

French, Bourbon-l'Archimbault, Allier region,
ca. 1510–30
Limestone; h. 57 in. (144.8 cm.)
Purchase, Robert Allerton Fund, 1956 (2254.1)

The cult of the Virgin Mary, popularized in the twelfth century, became by the beginning of the Gothic period an expression of devotion to Mary as the mother of Christ and the intercessor for sinners. As the centuries-long struggle to make the Christian faith supreme in Europe succeeded, the glory of the Roman Catholic church was embodied in the Virgin as Queen of Heaven, and as humanism gradually infused secular and religious culture, the Virgin reflected the ideals of feminine grace and purity of which courtly poets and troubadours sang.

All these qualities are embodied in the Virgin in this *Virgin and Child* from central France. The sacred and secular are balanced in this depiction of Mary as Queen of Heaven. Richly robed in a mantle with an embroidered hem and jeweled clasp over a dress with a tight bodice, and wearing a low crown (many of its points are missing) placed over a soft veil, which covers her long tresses, her garments bestow upon her a regal elegance that reflects the sophisticated taste and manners of the French court. The characteristics of dress and coiffure suggest the date of this sculpture. The figure's calm stance, normative proportions, and realistic costume represent the turn away from Gothic mannerisms toward Renaissance naturalism.

The Virgin's humanity is stressed through the earthly tenderness and intimacy of her relationship to the infant Christ. She stands firm and straight, solidly supporting the child in one arm, one hand with its long, straight, well-formed fingers steadying him by gently grasping his extended foot in a gesture that conveys a warmth of human feeling. Her gracious, placid face inclines slightly toward the child, and her delicate mouth shows a faint smile as she watches Christ playing with a goldfinch, a reference to the Passion, for in Christian legend a goldfinch plucked a thorn from Christ's crown and in so doing was stained with a drop of his blood, thereby acquiring the red spot on its breast.

Inviting quiet contemplation and communicating love, mercy, and joy, this sculpture embodies the serenity of the secure, well-ordered, God-centered late Gothic–early Renaissance world. JJ

JACOPO DI CIONE

Italian, act. 1365–98

Madonna and Child with Saints, 1391

Tempera and gold on panels; central panel:

53 ³/₄ × 27 in., side panels: 49 × 24 in.

(136.5 × 68.6 cm. and 124.5 × 61 cm.)

Gift of Mrs. Charles M. Cooke, 1928 (2834)

Italy during the fourteenth century was alive with artistic activity, and Florence was a thriving center enjoying economic expansion, political stability, and artistic achievement. Jacopo di Cione, a member of a Florentine family of artists that included his brothers Nardo and Andrea (called Orcagna), is credited with creating this panel painting, which once hung in the Church of San Lorenzo in Florence.

This is a devotional painting of the Virgin Mary and Christ enthroned, with Mary depicted as the Mother of God, a common theme in Christian art. Here Christ, although the size of a child, seems to embody the entire Trinity, a concept corroborated by the goldfinch, the symbol of his Passion, in his left hand, and the blessing gesture of his right hand. Generally recognized by their attributes, the figures on the side panels have traditionally been identified as St. Anthony, St. Catherine of Alexandria, St. John the Evangelist, and St. Gregory. Other research indicates that the images may depict St. Amata, St. Concordia, St. Andrea, and St. Marco Papa, whose relics are in San Lorenzo.

Artists of the late fourteenth century in Italy fell heir to the accepted practices of late Gothic art styles as well as to the innovations brought about by notable pre-Renaissance artists, such as Cimabue, Duccio, and Giotto. Giotto had successfully experimented with creating a convincing illusion of three-dimensional space on a flat surface. It is apparent that Jacopo was deeply influenced by Giotto; in the *Madonna and Child with Saints* Jacopo attempts to create perspective, particularly in the floor tiles in the central panel, the shading of the angels' robes, and the overlapping forms of the saints and the angels. One senses the volume of the bodies, the flow and fullness of the clothing, and a bold attempt to model the faces, in both the youthfulness of Mary and the agedness of Pope Gregory. This panel painting shows the lavish use of gold leaf so popular in the dark, candlelit churches of the time. Close scrutiny reveals hundreds of tiny brushstrokes built up to shape faces, clothing, and other elements. This work exemplifies the experiments and successes during a critical epoch in the history of Western painting. LLG

BARTOLOMMEO VIVARINI

Italian, ca. 1432–ca. 1499

Madonna and Child, ca. 1475

Tempera and gold on panel; 23$^7/_{16}$ × 16$^1/_8$ in.

(59.5 × 41 cm.)

Gift of Mrs. Charles M. Cooke, 1931 (3049)

Bartolommeo Vivarini's work belongs to a transitional phase of fifteenth-century Venetian art. He was a sensitive interpreter of a style that retained elements of the Byzantine and Gothic traditions and at the same time incorporated characteristics that looked toward new developments of the Italian Renaissance.

Vivarini was born into a family of painters from Murano, an island in the Venetian lagoon. After studying and then collaborating with his older brother Antonio, an artist whose work remained fundamentally linked with the International Gothic tradition but who introduced the earliest Renaissance elements into Venetian painting, Bartolommeo came under the influence of the Paduan school, especially the work of Andrea Mantegna.

In this painting, Vivarini monumentalizes the figures by enlarging them to fill the foreground, with only hints of background landscape. Within this compressed space he masterfully guides the eye first to the triangle formed by the opening of the Virgin's dark blue mantle, revealing the rich rose-red gown. Its crisp folds lead to her hands, held in a gesture of reverence, which lead to her full, round face; her gentle expression and downcast glance are directed to the sleeping child, the focal point of the work.

Bartolommeo Vivarini drew from and synthesized in his mature style various traditions evident in this *Madonna and Child*. The sleeping Christ Child in her lap is an archaic theme from Byzantine tradition, and the gold background and decorative, linear style are inherited from the Byzantine-Gothic icon tradition. The foreshortening of the Christ Child and his sculpturesque modeled form, the strong linear quality in the folds of the Virgin's garments and in her face and hands (where the line is sharp but softened by the color), the striving for a rational space, and the attention to realistic details all reveal an awareness of the innovations introduced by Mantegna and echo the principles of Renaissance art in Florence transmitted to Venice.

Despite these contemporary features, Vivarini's work always remained somewhat conservative. He seems never to have wholeheartedly accepted or absorbed the Renaissance discoveries or the interpretation of classical antiquity put forward by Mantegna and others; rather, he aimed for a balance between strongly accentuated linear drawing and rich, luminous color. At their best, his works, as in this painting, may not be revolutionary but are profoundly beautiful and moving. JJ

FRANCESCO GRANACCI

Italian, 1469–1543

Adoration of the Christ Child, ca. 1500

Tempera on panel; d. 34½ in. (87.6 cm.)

Gift of the Samuel H. Kress Foundation, 1961 (2987.1)

Francesco Granacci was trained in the Florentine workshop of the painter Domenico Ghirlandaio and later was engaged for several months as an assistant to Michelangelo (also an apprentice in the Ghirlandaio shop and Granacci's friend) in painting the frescoes of the Sistine Chapel ceiling.

Using the tondo (circular) format popular in the Renaissance for his composition, Granacci monumentalized the Holy Family by placing the figures in the foreground on a small rise against a background of receding vistas. The infant Christ lies on the edge of his mother's robe, which is spread out over a cushion of straw. Mary kneels above him with a tender, adoring gaze. She wears a brightly colored dress in contemporary Renaissance style; a delicately painted transparent veil covers her head. But the eye is drawn ultimately to her hands in an elegant gesture of prayer, the focal point of the painting.

At the left, Joseph is seemingly lost in contemplation of the newborn child. Granacci demonstrated loyalty to his own city of Florence by including on the right its patron saint, John the Baptist, who traditionally was not present at Christ's birth. Though still a child, St. John wears an animal skin and carries a cross-staff, his standard attributes. He looks intently at the Christ Child, who returns his gaze and gestures toward him, symbolizing the eventual connection between them.

In the middle ground is the stable, represented as a neoclassical ruin with sculpted capitals and reliefs. The receding beams of the rebuilt roof and the rows of columns are a purposeful demonstration of Granacci's mastery of Renaissance linear perspective.

At the left in the far distance an angel descends on a cloud in a halo of light, announcing the birth of Christ to shepherds, whose dogs meet the sight with startled wariness. In the distance on the right, through the stable columns, a fifteenth-century galleon appears, perhaps a reference to the source of Florentine wealth in trade. These mundane details contribute an anecdotal charm that is a foil for the sensitive and dignified solemnity of the Holy Family. JJ

CARLO CRIVELLI

Italian, ca. 1430–ca. 1495

An Apostle, 1470/75

Tempera and gold on panel

12¼ × 9 in. (31 × 22.9 cm.)

Gift of the Samuel H. Kress Foundation, 1961

(2979.1)

Carlo Crivelli, son of a Venetian painter, Jacopo Crivelli, and brother of the painter Vittore Crivelli, is mentioned in a document of 1457 as a master painter in Venice. His work shows the influence of such Venetians as Antonio Vivarini and the young Giovanni Bellini. Crivelli's master was Francesco Squarcione, the most famous painter in Padua in his time, who was also the master and foster father of Andrea Mantegna. In 1468 Crivelli signed an altarpiece for Massa Fermana in the Marches, a region in central Italy extending along the Adriatic. He spent the rest of his life in provincial towns in the Marches, where, isolated from more progressive art centers, he had considerable influence. His success was based on his admirable craftsmanship and much favored archaic style rooted in the Paduan school's background of late Gothic, Germanic, and International-Style influences.

The Academy's panel of an apostle was originally part of the predella of an altarpiece Crivelli painted for the Franciscan Observant Church (Frati Conventuali Riformati) in Montefiore dell'Aso near Ascoli. Around 1850, a number of panels from the altarpiece were still together in the collection of Pietro Vallati in Rome. Today they are scattered among several European, English, and American collections, among them the Musée Royaux des Beaux-Arts, Brussels; the National Gallery, London; the Metropolitan Museum of Art, New York; and the Detroit Institute of Arts.

The apostle's expressive, individualized face, gestures, and slender bony hands are typical of Crivelli's style. His conception of form was essentially Gothic with individual forms outlined by strong, bold lines. The crisp angular folds in the drapery increase the sense of tension and wiry energy in the figure, thought to represent Andrew, who was martyred by crucifixion. SW

PIERO DI COSIMO

Italian, 1462–1521

Saint John the Evangelist, 1504–1506

Oil on panel; 32⅝ × 23¼ in. (82.9 × 59.1 cm.)

Gift of the Samuel H. Kress Foundation, 1961 (2989.1)

Framed by a window, St. John the Evangelist gathers his robe with one hand, blesses a chalice with the other, and gazes serenely at a snake writhing across the lip of the cup. Instead of depicting the theme of St. John and the serpent in narrative form, Piero di Cosimo followed an early precedent and showed the author of the fourth gospel isolated with one of his attributes. According to legend, when St. John was in Ephesus, he was to drink from a chalice of poisoned wine as a test of the strength of his faith—two men had already done so and died. As Piero depicted, when St. John blessed the cup, the poison departed miraculously in the form of an asp. By placing the figure and the beautifully detailed still life of snake and chalice close to the picture plane, and by projecting their forms beyond the window frame, Piero charged this moment of wondrous purification with a heightened sense of immediacy.

Piero's career spanned the transitional years of the Renaissance when a revival of interest in classical antiquity and a search for naturalism came to fruition. Although Piero's early work is marked by a strong linearity and eccentricity of motif, he quickly adopted the innovations of Leonardo da Vinci. The massive bulk and drapery of the youthful apostle, enveloped in a palpable haze of light and shadow founded upon Leonardo's well-known chiaroscuro, dominate the picture surface. Leonardo's style is seen in Piero's naturalistic recording of the shape and details of St. John's hands, and in his accomplished treatment of the light playing across these complex forms. The long silken hair, idealized features, and serene expression refer again to the art of Leonardo, but here they assume a sentimentality not usually found in the master's art. That Piero had already spent half his career working with the traditions of the preceding century makes his embrace of these multiple innovations that much more remarkable.

Witnessing not only a rebirth of interest in classical antiquity, the Renaissance also encompassed a new respect for the dignity of man. Portraits and Christian themes built upon a knowledge of anatomy, perspective, chiaroscuro, and other tools of naturalism were among the primary manifestations of these beliefs. By focusing on the corporeality of St. John and the still life, the naturalism of his gesture and spiritual presence, Piero aligned himself at this late point in his career with Renaissance humanism. JS

FRANCESCO DE' ROSSI

called Francesco (or Cecchino) Salviati
Italian, 1510–63
Portrait of a Young Man, ca. 1540–50
Oil on panel; 23⅛ × 18¼ in. (58.7 × 46.4 cm.)
Gift of the Samuel H. Kress Foundation, 1961 (2981.1)

Called Salviati after his early patron Cardinal Salviati, Francesco de' Rossi was an accomplished master of the second phase of mannerism. He worked throughout Italy, spending time in Florence, Rome, Bologna, Venice, Parma, Mantua, and elsewhere fulfilling commissions for the papal court, the Duke of Tuscany, other important families of Italy, and Francis I of France as well. His frescoes adorn the Vatican, the Palazzo Vecchio in Florence, and the Farnese Palace in Rome. Salviati was also much in demand as a portraitist, and his striking likenesses are among his best works. As is true for many of his portraits, the identity of the subject in this painting is unknown.

Salviati came under the influence of mannerism, a style of painting that subordinated the naturalism, rationality, and balance of classicism and the Renaissance and valued instead an individual style and the artist's inner vision of idealized beauty. This likeness reflects an ascetic portrait type that Salviati developed toward the end of his career. The muted palette of harmonic black, gray, olive, and white tones establishes a mood of sobriety maintained by the attire of the sitter—the black garment adorned with black buttons and pleated sleeve finds its only bright accent in the carefully detailed collar embroidered in black and white with a tassel of twisted threads. The sitter studies the viewer with a side gaze and an expression that gives nothing away, his porcelainlike complexion devoid of human warmth. By placing his subject in front of a wall niche stripped of all ornament and centering him within its bare vertical jambs, Salviati intensified the unsparingly severe qualities of the portrait. In this way Salviati emphasized the young man's exquisitely refined elegance, a quality highly esteemed at the time.

As portraiture blossomed during the fifteenth and sixteenth centuries, Salviati aspired, like many of his contemporaries, to express the dignity of his sitters as individuals. To do this, he developed the direct and austere pictorial language apparent in this painting. More than many others at the time, Salviati transcended the self-conscious artifice of prestige portraiture with penetrating psychological insights. Here, the austere qualities of the image join with the particularized features of the young man and his aloof but direct gaze to infuse the portrait with a striking intensity of character. JS

GIOVANNI BATTISTA MORONI

Italian, ca. 1525–78
Portrait of a Man, 1553
Oil on canvas mounted on panel
41 1/8 × 32 3/8 in. (104.5 × 82.2 cm.)
Gift of the Samuel H. Kress Foundation, 1961 (2982.1)

During the fifteenth century, although portraiture developed into a legitimate genre, independent of images of donors included in religious paintings, few Italian artists specialized in likenesses. One of the first to do so in this age of humanism was Giovanni Battista Moroni, a sixteenth-century painter who frequented the relatively remote northern regions of Brescia and Bergamo. There, with a simple, direct style, he painted persons from all walks of life caught in ordinary moments. Moroni was so respected for his portraits that the Venetian master Titian is said to have referred sitters to him.

This portrait—one of the earliest dated Moroni portraits known—illustrates the transition from the artist's first stylized, mannerist-inspired works to his mature canvases. In this painting Moroni elongated the sitter's proportions according to artificial standards of physical beauty and gave the subject's right hand an elegance at odds with the naturalism of the other. Placing the sitter's upper body against a gray monochromatic background allowed the artist, by means of silhouette, to delight in the overly nervous contours of his figure.

Despite the adoption of such typical mannerist devices, however, Moroni did not attempt to ennoble the sitter, as did many of his contemporaries. For the most part, Moroni's patrons in these outlying cities differed greatly from the exalted members of the papal court and Italian aristocracy who sat for many of the other artists. Instead, his clientele consisted of tailors, soldiers, magistrates, and other professionals to whom the contrived qualities of mannerist painting might seem inappropriate. Perhaps with their more conservative interests in mind, Moroni developed his technique of understated naturalism, comfortable settings, individualized features, and sensitive candor. This man of letters gazes with uncomplicated dignity at the viewer.

During his career Moroni also treated religious subjects, creating altarpieces for churches in the area using a style considerably less sophisticated than that of his portraits. Perhaps, in a conscious assessment of his patrons, he may have reserved his archaic style for the more provincial religious audience and pleased his other clients with likenesses as accomplished in verism and sympathetic in characterization as this portrait. JS

ABRAHAM BLOEMAERT

Dutch, 1564–1651

Personages in Elaborate Dress, early 1590s

Ink and wash heightened with white on paper

12 × 8 in. (30.5 × 20.3 cm.)

Purchase, C. Montague Cooke, Jr., Fund, 1953 (13,262)

Early in his career, Utrecht artist Abraham Bloemaert came under the influence of the late mannerist style that had spread from Italy and dominated northern European painting at the end of the sixteenth century. This drawing, an excellent example from the mannerist phase of Bloemaert's development, probably dates from the period between 1591 to 1593, when Bloemaert was active in Amsterdam; there he became acquainted with the works of mannerist artists in Haarlem, especially those of Carel van Mander, Cornelis van Haarlem, and Hendrick Goltzius. The sinuous, elegantly contorted posture of the standing figure seen from the back, the exaggerated contrapposto of the stance, the elongated and well-developed body, the elegant, even foppish costume, as well as the ambiguous nature of the activities and relationships among the figures in the background are all hallmarks of the mannerist style. Bloemaert focused attention on this

figure by using a bold interplay of dark ink washes and prominent highlights in opaque white, which serve to accentuate its sculptural qualities. At the same time a vibrant visual rhythm is established, which courses up through the powerful legs and torso and ripples out through the plumes of the precariously perched hat.

Through this masterful work it is not difficult to see why Bloemaert had a significant influence on early seventeenth-century painters in Utrecht, many of whom achieved great distinction. Bloemaert's influence was further disseminated by his book *Fondamenten der Teecken-Konst* (Foundations of the Art of Drawing). Illustrated by Bloemaert's son Frederick with engravings after his father's drawings of figures in different poses, the work was used in the training of artists in the eighteenth and nineteenth centuries. The central figure in this drawing appears as no. 68 in this important manual. JJ

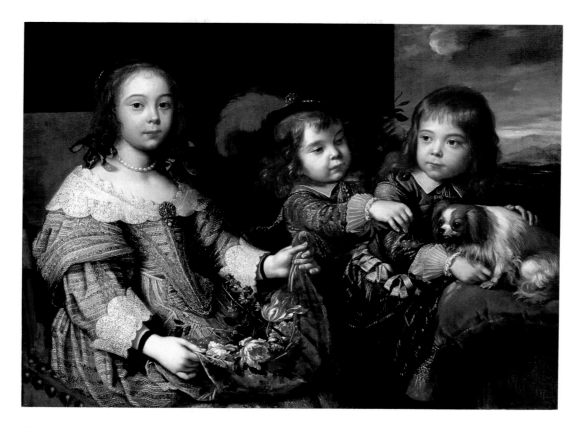

Until the middle of the seventeenth century, Italy was the center of the European art world. Although painting, sculpture, and other art forms flourished in other countries, it was Italy with its glorious heritage of classical antiquity and the Renaissance that most artists aspired to visit. One of many French artists who spent time there, Pierre Mignard worked in Rome from 1635 to 1657 as a highly respected portraitist. His fame rested upon the elaborately detailed likenesses of sitters from the papal court and other important families such as that of the duc de Bouillon.

This richly elaborated and finely finished painting has not always been recognized as an example of the courtly style of portraiture that Mignard practiced with great popularity first in Rome and later in Paris. The lack of a signature and historical documentation sparked much discussion concerning the artistry of the work well before it entered the Academy collection—earlier attributions included artists as diverse as the Dutchman Jan Baptist Weenix and the Italian Francesco Cittadini. A later drawing (Musée des Beaux-Arts d'Orléans) that reproduces the portrait, however, identifies its artist with the inscription "after Mignard" and refers to the subjects as the children of de Bouillon in another annotation. This nobleman, Frédéric-Maurice de la Tour d'Auvergne, was in Italy from

PIERRE MIGNARD

French, 1612–95

The Children of the Duc de Bouillon, 1647

Oil on canvas; 35 × 46¾ in. (88.9 × 118.7 cm.)

Purchase, Robert Allerton Fund, 1975 (4293.1)

1644 to 1650, a period concurrent with Mignard's lengthy residency there, and apparently commissioned this painting from his compatriot. An inscription on the canvas confirms where it was painted as well as its date: "Roma 1647 Junii Die V" (Rome, June 5, 1647).

The portrait is stylistically consistent with Mignard's other Italian subjects. Working in the cosmopolitan atmosphere of the papal court, he practiced an ostentatious and stately mode preferred at the time. The three young children appear as miniature adults in fashionable and elaborate attire rich in brocades, lace, and jewelry. The twelve-year-old girl appears with the standard attributes of women, fruits and flowers, symbols of fecundity and femininity. However, the protective gesture of one boy as he leans over his dog and the mischievousness of the second establish a mood of intimacy, creating an image of innocence and charm that led to the informality dominant in the portraiture of the following century. JS

THE RAPE OF A SABINE WOMAN

after a work by Giovanni Bologna, 1529–1608
Italian, ca. 1600–50
Bronze with dark brown lacquer over brown patina
h. 23 in. (58.4 cm.)
Purchase, gifts of Mrs. Philip E. Spalding, Mr. and Mrs.
Theodore A. Cooke, Mr. and Mrs. Walter Dillingham,
Robert Allerton, and Mrs. Charles M. Cooke, by
exchange, and with Academy funds, 1981 (4977.1)

Giovanni Bologna, called Giambologna, was the Italian name of Jean de Boulogne, a French sculptor who went to Italy about 1555 for further training and stayed to become the most important sculptor in Florence during the last quarter of the sixteenth century. Giambologna unveiled his colossal white marble version of this subject (today in the Loggia dei Lanzi, Florence), which had been commissioned by Francesco de' Medici, in January 1583. It represented a culmination not only of Giambologna's personal striving to create a sculpture that could be viewed satisfactorily from all sides but of the century-long efforts and ambitions of successive Renaissance sculptors to resolve harmoniously the problem of coordinating a group of figures into a single integrated action. Giambologna intended the group as a demonstration piece to proclaim his talents at composition and carving marble on a monumental scale.

The subject matter is drawn from ancient legend. The founders of Rome, searching for wives, resorted to a trick: inviting a neighboring people, the Sabines, to a festival, they suddenly fell upon them with arms, taking their women away by force. For Giambologna, however, the subject was secondary to his interest in solving formal artistic problems (in fact, the arbitrarily chosen title had to be made explicit by a bronze relief added to the pedestal constructed for the sculpture). In his arrangement of forms Giambologna placed a nude Roman male astride a vanquished Sabine man; the Roman turns and strains as he holds aloft a Sabine woman who cries out in anguish, her arms extending into space to complete the marvelous spiraling movement and energy that courses up through the figures.

The work was immediately acclaimed for its convincing clarity and seemingly effortless grace, and soon a demand arose for bronze reductions, which Giambologna's workshop provided both before and after his death. Although it is not known which artist created this cast, a particularly fine example, one authority has attributed it to Pietro Tacca (1580–1650), Giambologna's closest assistant at the end of his life. JJ

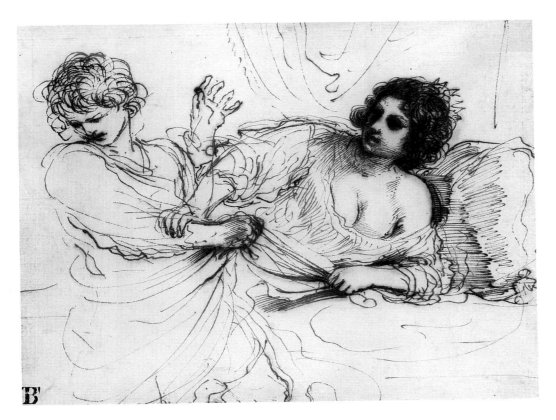

Giovanni Francesco Barbieri, better known by the nickname Il Guercino (the squint-eyed) because of his conspicuous habit of looking with his eyes partly open, was born in Cento in the duchy of Ferrara. Influenced by the painting manner of the Carracci brothers, especially Ludovico of nearby Bologna, Guercino's early works reflect the emerging baroque style and are dynamic and full of movement, characterized by a vibrant theatricality and painterly technique.

When the Bolognese Cardinal Alessandro Ludovisi was elected pope in 1621, Guercino was called to Rome; there he executed several commissions, including the famous *Aurora* ceiling fresco in the Casino Ludovisi. While in Rome, Guercino was influenced by the classicizing, tranquil manner of painting that prevailed there and by Guido Reni, the most influential artist in Bologna, who also worked in Rome on several occasions during the first decades of the seventeenth century. Guercino returned to Cento in 1623 and spent the remainder of his career there and in Bologna, where, upon Reni's death in 1642, he became the leading artist of the mid-seventeenth century.

As well-known for his beautiful drawings as his paintings, Guercino was a prolific draftsman and often made preparatory drawings to refine the final design of a painting. This drawing may be such a work, for it is related to a

GIOVANNI FRANCESCO BARBIERI

called Il Guercino

Italian, 1591–1666

Joseph and Potiphar's Wife, ca. 1649

Pen and brown ink on paper; 7³/₄ × 10³/₈ in.

(19.7 × 26.4 cm.)

Gift of Margaret Day Blake, 1954 (13,427)

painting (National Gallery of Art, Washington, D.C.) commissioned from Guercino in 1649 by Aurelio Zanoletti. The subject is from an episode in Genesis (39:1–23), in which Joseph, who had been sold to Potiphar, an officer of the pharaoh, came to be trusted and honored in Potiphar's household. But Potiphar's wife falsely accused Joseph of trying to violate her when her attempts to seduce him failed. The drawing depicts the dramatic moment when Joseph rejects her advances as he recoils from her enticing demeanor and aggressive grasp. Her left hand clutches his robe, which Joseph left behind in his flight and which Potiphar's wife later used as evidence against him. The emotional intensity of the scene is heightened by Guercino's agitated nervous line and by the dynamic play of light contrasted with the rich chiaroscuro reminiscent of Caravaggio. JJ

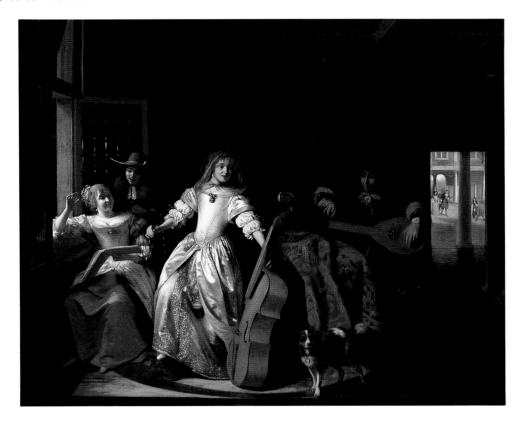

PIETER DE HOOCH

Dutch, 1629–84

A Musical Conversation, 1674

Oil on canvas; 38⅝ × 45¼ in. (98.1 × 114.9 cm.)

Purchase, 1971 (3798.1)

Until the seventeenth century, the Roman Catholic church and the aristocracy were the major patrons of European art, and their commissions led to the magnificent decoration of both churches and palaces. But, as the Low Countries of Europe merged at this time into the Republic of the United Netherlands—a successful mercantile nation of middle-class burghers—a new class of patrons emerged. Proud of Dutch achievements, they supported the growth of a new pictorial tradition that celebrated their lifestyle: landscapes, still lifes, portraits, and other everyday or genre subjects adorned their comfortable residences. A masterful technician and specialist in genre painting, Pieter de Hooch was influential in the development of domestic subjects.

In this painting two well-dressed young couples meet for an enjoyable musical interlude. One woman with a songbook sits under the affectionate gaze of her gallant; the other readies a cello, while the second man tunes another instrument. They are assembled in a spacious salon sumptuously decorated with floor tiles, pilasters, and other ornamental wood moldings, as well as with murals, a painting of Venus, and an oriental carpet.

De Hooch established a mood of refinement and tranquility not by subject alone; an acute observer of tenebrous light, he suffused the scene with a glowing radiance that enters from the open side window, illuminates the small gathering, and glints off various details. De Hooch's keen eye for surface appearance was fundamental to his mastery of textures such as the satiny sheen of the women's garments. An appreciation of the compositional value of geometric floor tiles and wall moldings underlies the quiet order of the scene. Peace, harmony, and elegance reign supreme in this depiction of a genteel diversion deemed highly appropriate for portrayals of the leisured class.

Refined musical subjects were popular in seventeenth-century Dutch painting. Valuing such scenes as reflections of their own sophistication, the Dutch also often assigned a variety of metaphorical meanings to genre themes. Concerts generally referred to harmony in family groups and among friends or intimate young couples. In this case, under the watchful eye of Venus, the classical goddess of love, the two couples prepare to commune through music. JS

NICOLAS DE LARGILLIÈRE

French, 1656–1746

JEAN-BAPTISTE BLIN DE FONTENAY

French, 1653–1715

Hélène Lambert de Thorigny, ca. 1695–1700
Oil on canvas; 63 × 45 in. (160 × 114.3 cm.)
Purchase, 1969 (3577.1)

During the seventeenth and eighteenth centuries the fine arts of France fell within the purview of the Royal Academy of Painting and Sculpture. This government-sponsored organization sanctioned a hierarchy of subjects that valued portraiture second only to history painting. An artist whose career spanned the reigns of Louis XIV and Louis XV, and whose work illustrates the transition from the dignified grandeur of baroque art to the informal charm of the rococo, Nicolas de Largillière became one of the most popular portraitists in France by the turn of the eighteenth century. French and English royalty sat for likenesses, as did leading members of the *haute bourgeoisie* such as Hélène Lambert de Thorigny, the wife of a financier of Normandy. Relying on an established tradition of studio assistance and collaboration, the popular Largillière completed some 1,500 paintings during his career. This portrait is believed to be the joint work of Largillière, painter of the figure, and Jean-Baptiste Blin de Fontenay, a flower specialist.

A masterful technician and brilliant colorist, Largillière portrayed Madame de Thorigny finely attired and framed by a garland of flowers into which she prepares to insert a final sprig of blossoms. She is assisted by an exotic servant wearing a turban, earring, and slave collar, who holds a basket of flowers and helps support the garland. Largillière returned to this particular theme of sitter, flower garland, and exotic servant several times during his career.

By emphasizing the classically grand setting, Largillière also suggested the importance of the woman's social position; the heavy swag of drapery reinforces this effect. Although such elaboration of the sitter's wealth and station was central to seventeenth-century baroque taste, this portrait also reveals a lighthearted charm that aligns the artist with the spirit of the rococo. The repetition of curving forms energizes the likeness, as does the momentum established by Madame de Thorigny's uplifted arms and eyes, her appealingly tilted visage, and even the counterclockwise movement of the flowers. Only her gaze remains at rest, and as it directly engages the attention of the viewer, we are invited into the scene to enjoy the moment's enchantment. JS

CHEST OF DRAWERS

German, ca. 1725

Walnut and oak with walnut and fruitwood veneers

and inlay; gilt-bronze mounts; 31¼ × 44¼ × 25 in.

(79.4 × 112.4 × 63.5 cm.)

Gift of Mr. and Mrs. Bradley Geist, 1963 (3170.1)

Seventeenth-century Europe was marked by a consolidation of political and economic power that led to a period of relative stability and unparalleled prosperity in which the arts flourished. The demands of a rising middle class caused a significant increase in the production of all decorative arts, especially furniture, as the newly affluent consumers sought furnishings with a broader range of artistic and technical quality.

The tendency toward more elaborate and visually imposing furniture culminated in the baroque style, characterized by exuberant and lavish ornamentation. In general, an effort was made to break away from the outdated rectangular shapes of the Renaissance and to give furniture a more sculptural character.

This chest of drawers illustrates many characteristics of the late baroque style in furniture as it developed in Germany in the late seventeenth and early eighteenth centuries. Most prominent is the concentration on form and mass, seen in the undulating facade of this chest, which is symmetrically, almost mathematically, organized in a series of flat, concave, and convex surfaces that emphasize the sculptural and spatial aspects of the piece. The subtle visual mobility of the chest's front silhouette is boldly restated in the molding of the edge of the top and the face of the stand in which the case sits, elevated on sturdy but graceful bracket feet, which give a certain lightness to the massive form.

Baroque taste filtered into Germany from France, Italy, and the Netherlands. The revocation of the Edict of Nantes in 1685 caused many highly skilled Protestant craftsmen to escape religious persecution by fleeing France for Germany, Holland, and England, thereby disseminating French techniques and designs. French influence in this chest is readily seen in the finely cast and chased gilt-bronze handles and backplates that prominently feature the mask of a woman with an elaborate headdress. Dutch taste is reflected in the sumptuous use of veneers and marquetry. The pattern of elongated rectangles on the drawer fronts, which emphasizes the horizontality of the form, contrasts with the swirling vertical grains of the veneers and combines with the wavelike geometry of the facade to keep the eye in constant motion. Thus, a piece of furniture with an everyday function becomes as well an object of visual delight. JJ

SHEPHERD

German, Meissen, ca. 1750–60

Hard-paste porcelain with overglaze enamels and gold

h. 10½ in. (26.7 cm.)

Gift of Margaret Carroll Gray, 1980 (4876.1)

After Marco Polo returned to Italy from his sojourn in Central Asia and China in the fifteenth century, Europeans became intrigued by exotic Asian cultures. They were especially interested in Asian porcelains, which from time to time found their way into the hands of European collectors via merchants and traders. Rare in Europe, these porcelains were highly prized; their steep prices were an inducement to imitation, and for centuries Europeans competed to discover the secret of making porcelain.

The closest European equivalent to Chinese porcelain was discovered in 1708–1709 by Johann Friedrich Böttger, an alchemist working under the patronage of Augustus the Strong, elector of Saxony and king of Poland, who had a passion for Asian porcelains and amassed a collection of 20,000 Chinese and Japanese pieces. In 1710 Augustus established a factory at Meissen, a town a few miles from Dresden, which began producing the white, translucent, vitrified material referred to as hard-paste porcelain for Augustus's use and for sale.

This superbly modeled and painted figure suggests an attribution to Johann Joachim Kändler, who became chief modeler at Meissen in 1733, or at least to one of the gifted modelers who assisted him. One of the first to recognize the sculptural possibilities of porcelain, Kändler created figures and animals which at the time seemed to defy the innate laws of the new material in their minute detail and rhythmic vitality.

Meissen figures and groups—with themes ranging from theatrical characters to mythological and allegorical subjects—often served as table decorations, replacing earlier ones of colored wax or sugar. This figure depicts a gentleman "disguised" as a shepherd of sophisticated mien. The richness of his dress and his pose of mannered elegance reflect the practice of some eighteenth-century aristocrats, who amused themselves by playacting at the bucolic lives of peasants. The skill of the Meissen artists appears in the delicacy of the sculpted details and in the exquisite, painstaking delineation in enamel of each hair of the scalp and eyebrows. Equal attention is devoted to the sheep, capturing the texture of its woolly coat and giving the animal a wary but engaging demeanor. JJ

COVERED SOUP TUREEN AND STAND

French, Vincennes, ca. 1750
Soft-paste porcelain with overglaze enamel decoration
and gold; d. (stand) 8⅝ in. (21.9 cm.)
Gift of Mrs. Christian H. Aall, 1987 (5623.1)

Interest in porcelain in eighteenth-century Europe was fiercely competitive, and German success at producing porcelain at Meissen and other factories stimulated the French to try their hand at it.

Before 1768 French factories, with the exception of those in Strasbourg, produced only soft-paste porcelain made from a mixture of powdered glass and clay. Soft-paste porcelain is characterized by a soft, warm surface translucency in contrast to the colder, glittering white of Meissen, an effect shown to advantage in this elegant tureen and stand (écuelle) from Vincennes.

A porcelain factory was set up in 1738 at the Vincennes château near Paris as a private undertaking by the brothers Orry de Vignoury and Orry de Fulvy. At first unsuccessful, after 1740 the Vincennes factory began producing substantial, saleable porcelain. Administered by Orry de Fulvy's valet (the sculptor Charles Adam), in 1745 the factory obtained exclusive rights from Louis XV to "manufacture porcelain in France in the manner of Saxony [Meissen] . . . painted and gilt with human figures . . . so as

to stop consumers in this realm from sending their money to foreign countries. . . ." This royal act was remarkable in that the Vincennes factory, as yet incapable of producing gilt decoration, was still experimenting to develop a suitable range of colored enamels. Nevertheless, within two years a royal order was issued forbidding the manufacture of porcelain anywhere else in France and giving Vincennes a monopoly in the production of colored and gilded porcelain. In 1753 the factory was designated "la Manufacture royale de porcelaine"; and in 1756 it was moved to Sèvres, with the king as sole proprietor from 1759 on.

This superb tureen illustrates the mastery that was quickly gained at Vincennes in the molding and sculpting of porcelain and its decoration with enamels and gold. A shallow bowl with entwined branch handles sits in a saucerlike stand with scalloped edges; on the bowl rests a low, domed cover, all edged and deftly highlighted with gilding and delicately painted in puce monochrome (en camaieu), with rustic scenes framed below in crossed fronds and separated by bouquets of flowers. The focal point is the handle of the cover, which is sculpted as a delightful still life incorporating a fish, shell, seaweed, turnip, and mushroom, perhaps hinting at the delicate flavors of the tureen's intended contents. This playfully and exquisitely adorned curvilinear form epitomizes rococo taste in mid-eighteenth-century France. JJ

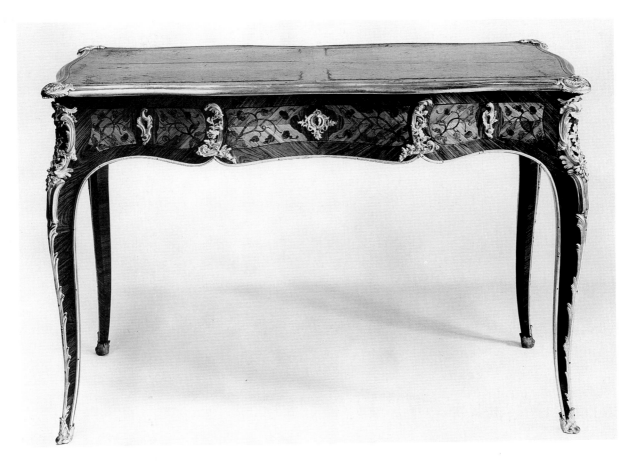

The new taste that flourished during the reign of Louis XV (1715–74) came to be called rococo, a name derived from the French word *rocaille*, meaning rockery or rock grottoes. The rococo style took some of its characteristic motifs from the grottoes that were fashionable features in many French gardens, as well as from natural forms such as shells and plants. The hallmark of rococo design was the use of the curved line, the swelling, whirling, interlacing contour that the eighteenth-century English artist William Hogarth aptly called "the line of beauty."

This writing table exemplifies the French rococo style in furniture. Of modest, even delicate proportions, its form embodies continuous rhythms, for there is not one straight line to be found in it—every surface bulges and recedes, turns and flows. The table stands on gracefully supple cabriole legs, each carved with five facets to make it seem even more slender. The surfaces of the oak frame are sheathed in veneers and marquetry of exotic imported woods. The richly patterned grains of the veneers and the variegated warm brown tones of the marquetry, consisting of foliate motifs set in cartouches on all sides, provide an effective background for the gilt-bronze mounts. Every projecting edge in the table is trimmed with narrow gilt-

WRITING TABLE

French, Paris, ca. 1750
Attributed to Bernard II van Risen Burgh (1700–65/66)
Oak frame veneered with tulipwood and kingwood marquetry; gilt-bronze mounts; green leather; 31 1/2 × 47 × 23 1/2 in. (80 × 119.4 × 59.7 cm.)
Purchase, 1969 (3579.1)

bronze strips intended to hold the veneer in place and protect the most vulnerable points, but which also serve to define and enhance the smooth, flowing lines of the piece. The feet, upper parts of the legs, drawer fronts, and corners of the tabletop are boldly accented with sculptural gilt-bronze mounts abstracted from foliate forms, superbly cast and chased.

Though no mark is apparent, this table presents stylistic features generally associated with the work of Bernard II van Risen Burgh, who came from a family of Dutch cabinetmakers established in Paris in the early eighteenth century. He became a master himself before 1730, producing some of the finest furniture of the mid-eighteenth century. JJ

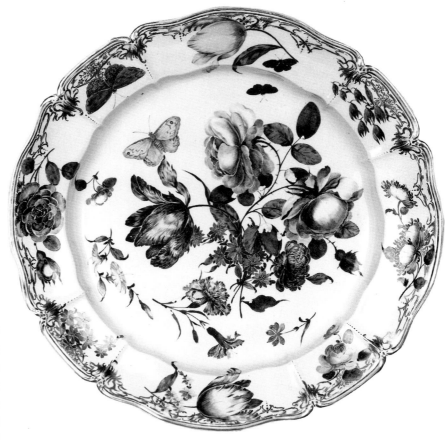

PLATE

German, Nymphenburg, ca. 1760–65
Painted decoration attributed to
Joseph Zächenberger, 1732–1802
Hard-paste porcelain with overglaze enamels
and gold; diam. 13⅛ in. (33.3 cm.)
Gift of Mrs. Harrison Cooke, 1986 (5459.1)

Nymphenburg in Bavaria was one of the great German porcelain centers of the eighteenth century. Attempts to produce hard-paste porcelain were made there as early as 1729 but without success. Interest was revived in 1747 under the patronage of the elector of Bavaria, Maximilian III Joseph, who had married the granddaughter of Augustus the Strong of Saxony, patron of the Meissen factory. In 1753 J. J. Ringler, a peripatetic arcanist who possessed the secret of making porcelain and made a career of selling his talents to several porcelain factories, was engaged as manager at Nymphenburg. Ringler is given credit for developing the finest hard-paste material in Europe—flawless in texture, perfectly white, and without the harsh coldness of its rivals. Although Ringler remained at Nymphenburg for only four years, until 1757, his methods were acquired by J. P. R. Hartl, who succeeded him as manager.

Concurrent with technical mastery of the porcelain body at Nymphenburg came an important development in the art of decorating. Before 1756 much of the blank por-

celain was sent out to be painted, but in that year Andreas Ettner, a talented decorator from Vienna, arrived at the factory, and thereafter Nymphenburg pieces became noted for their elaborate floral decoration in a full and brilliant palette of colors painted by in-house artisans trained in Ettner's style and methods.

The Nymphenburg factory was at the height of its artistic power and prosperity when this large plate was made. It formed part of a large table service commissioned by the elector of Bavaria and was used at court banquets in Munich. Molded with a gently scalloped rim articulated by four pairs of ribs, the plate's surface is intricately gilded and painted with lush masses of flowers interspersed with exotic butterflies. The decoration for this service has been attributed to Joseph Zächenberger, who was trained in flower painting by his father and apprenticed under Joseph Ruffin in Munich until 1760, when he became the chief flower painter and teacher at Nymphenburg. This plate superbly illustrates the artistic finesse and exuberant opulence of German rococo taste. JJ

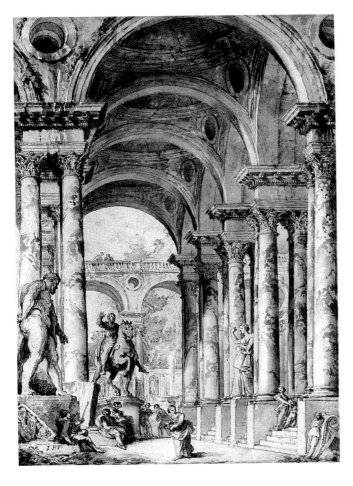

GIOVANNI PAOLO PANINI

Italian, 1691–1765

*Capriccio with Marcus Aurelius and
the Farnese Hercules*, ca. 1750

Ink and watercolor on paper

14 × 9½ in. (35.6 × 24.1 cm.)

Purchase, Robert Allerton Fund, 1965 (15,107)

Born in Piacenza, Giovanni Paolo Panini arrived in Rome in 1711 and began his career by painting fantasy scenes of ancient ruins. In the 1720s he began to paint *vedute esatte* (genuine views of ruins) of the Roman Forum and the Palatine. In an elaboration of this popular genre, Panini invented the *capriccio* or *veduta ideata* (capricious or imaginary view), in which he arbitrarily combined and juxtaposed famous monuments of ancient Rome according to his fancy. These visual compendiums of ancient sculpture and architecture were designed to appeal to Europeans taking the Grand Tour who wanted mementos of their visits to Rome. Panini's elaborately conceived paintings and drawings, functioning as rather embellished equivalents of today's picture postcard or souvenir snapshot, satisfied the traveler's appetite for the scenic and also evoked the classical past, a subject much in vogue at the time among intellectuals, artists, and poets. A strong demand for his works among an international European clientele made Panini the most celebrated and influential of the Italian eighteenth-century view painters.

In this highly finished watercolor, which was intended to be a complete and independent work rather than a study for a painting, Panini included two of the best-known ancient sculptures in Rome, the Farnese Hercules and the equestrian statue of the Roman emperor Marcus Aurelius. These monumental works were not located near each other in Panini's day, but he put them together for increased aesthetic effect in a grand, imaginary architectural setting with rows of columns and arched, domed vaults, a scene that evokes one of the great baths or other public buildings of ancient Rome. Panini enlivened the scene with the casual activity of several figures, who, dwarfed by the architectural forms and empty space, seem to symbolize the inconsequence of man in relation to the scope of history and the power of nature.

While Panini had an enthusiastic following throughout Europe, he enjoyed special favor in France (he was married to the sister of Nicholas Vleughels, director of the French Academy in Rome). This watercolor once was part of the famous collection of Pierre-Jean Mariette, one of the foremost art connoisseurs in eighteenth-century Paris. JJ

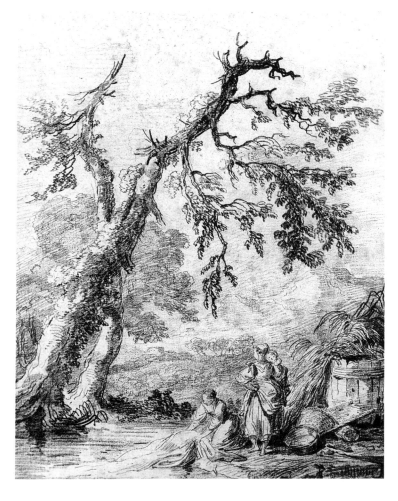

HUBERT ROBERT

French, 1733–1808

Landscape with Washerwomen, ca. 1770

Red chalk on paper; 16⅝ × 12½ in. (42.2 × 31.8 cm.)

Purchase, C. Montague Cooke, Jr., Fund, 1964 (15,090)

Born in Paris, Hubert Robert studied drawing with the sculptor Michel-Ange Slodtz and in 1754 traveled to Rome with the comte de Stainville (later duc de Choiseul), the French ambassador, for whom Robert's father was a valet. Through the count's intercession, Robert received permission to attend the French Academy in Rome, where he studied under Giovanni Paolo Panini and was powerfully influenced by Panini's style of depicting fanciful landscapes and ruins. Robert remained in Rome for eleven years and sketched the Italian landscape in all its variety, from ancient ruins to palace gardens. After returning from Rome in 1765, Robert became interested in garden design in addition to his successful career as a painter of decorative landscapes. By the 1770s, when it was fashionable to reject the highly formalized gardens of the past, he was much in demand to create gardens in the new naturalistic manner filled with picturesque rustic effects.

This drawing, executed in the artist's favored medium of red chalk, was probably done sometime between 1765,

when Robert returned to France from Italy, and 1778, when his appointment as designer of Louis XVI's gardens led to a decrease in his production of drawings. Unlike Robert's sophisticated arrangements of architectural elements and classical ruins, this landscape is a simple country scene in which two washerwomen, one holding a small child, occupy themselves at the edge of a stream or pond. Their tubs and baskets make an informal still life at the right; in the distance is a mountainous vista. The pictorial space is dominated by tall overlapping trees spreading across the sheet from the left. Robert's versatile use of chalk is demonstrated in fine looping strokes and tight sawtooth lines used to render the foliage, in contrast with the long, parallel hatched strokes that delineate the background. In counterpoint to the sturdy young laundresses, the tops of the trees are broken and dead, perhaps from lightning or a storm, a discordant and slightly ominous note that hints at the power of nature and the transience of living things and lends a proto-romantic aura to this otherwise harmonious vignette. JJ

Terra-cotta sculpture was much in vogue during the eighteenth century in France, and the sculptor Claude Michel, known as Clodion, was perhaps the most famous European artist working in this medium.

Clodion, born to a family of sculptors, first studied with his uncle, Lambert Sigisbert Adam, and then under Jean-Baptiste Pigalle, the leading mid-century rococo sculptor in France. When he was only twenty-one, Clodion, a prodigious talent, won the Prix de Rome, an honor that entitled him to study in Rome. He remained in Italy for ten years, where he developed a repertoire of subjects from classical sources which he used throughout his life— mythological figures, putti, nymphs, and satyrs. Terra cotta became his favorite medium, and the malleability of the clay showed his remarkable gifts as a modeler. Although he executed a few large commissions, Clodion was best known for his small-scale figures and groups. He was swamped by the demands of private patrons for these intimate, sensual, and sensitive works, which, as his earliest biographer records, were "bought by amateurs even before they were finished." Among his clients was Empress Catherine II of Russia, who attempted without success to attract Clodion to her court. Clodion instead returned to France in 1771 and to the patronage of the court of Louis XVI and Marie Antoinette. Clodion's style radiated the hedonism and elegance of the period and brought the lively spirit of the rococo to its ultimate sculptural refinement.

This terra cotta is from Clodion's mature period. The dynamic, vivacious composition and the meticulous detail and immediacy of the modeling—especially in the drapery, hair, and foliage—exemplify the culmination of Clodion's talents. The lightness and frivolity of the two figures are rococo in taste, but there is also a suggestion, particularly in the bacchante's drapery, of neoclassical influence, which was just beginning to emerge in the mid to late eighteenth century with the rediscovery and excavation of Pompeii and Herculaneum.

The French Revolution, which destroyed royal and aristocratic patronage and brought a complete change of taste, ruined Clodion, and he died in poverty and obscurity.

JJ

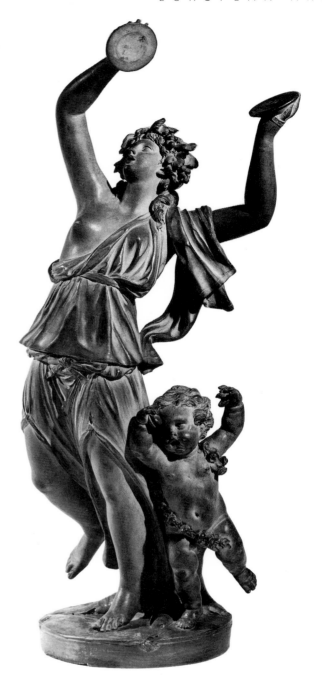

CLAUDE MICHEL

called Clodion

French, 1738–1814

Dancing Bacchante with Amour, 1785

Terra cotta; h. 19 in. (48.3 cm.)

Purchase, Academy Volunteers Fund, 1981 (4944.1)

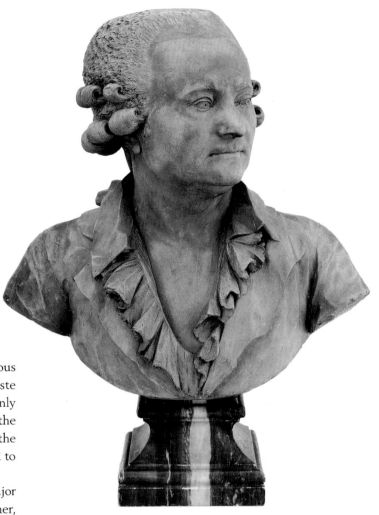

AUGUSTIN PAJOU

French, 1730–1809

Bust of a Man, ca. 1792–94

Terra cotta on marble socle; h. 19½ in. (49.5 cm.)

Gift of Mrs. Frank A. Hecht, 1985 (5359.1)

Born in Paris, Augustin Pajou was artistically precocious and began to study at age fourteen under Jean-Baptiste Lemoyne, the primary court sculptor to Louis XV. Only four years later Pajou won first prize for sculpture at the Royal Academy's school, entitling him to a place at the French Academy in Rome, where he studied from 1752 to 1756.

On his return from Italy, Pajou achieved the first major success of his official career with a bust of his teacher, Lemoyne, exhibited at the Salon in 1759. From that year until 1802, Pajou exhibited regularly at the annual Salons. Patronized by both Louis XV and Louis XVI, he received numerous royal commissions, among them his grandest achievement—the decoration of the opera house at Versailles. In addition, Pajou served as the chief sculptor to Madame du Barry, the mistress of Louis XV. One of the few leading sculptors whose career survived the Revolution, Pajou produced a considerable body of work in his long career, ranging from monumental sculpture and portrait busts to small-scale decorative pieces.

This work is characteristic of the less grandiose, more personal portraits of Pajou's later years. Though not dated, it can be compared to other busts he executed from 1792 to 1794 in Montpellier in southern France, where Pajou and many wealthy and intellectual individuals had taken refuge from the upheavals of the Revolution and the Terror in Paris.

Pajou presents the subject, whose identity is not known, in an informal aspect fashionable in the late eighteenth century. The extraordinary control and careful calculation displayed in the arrangement of the garments and the crisp spontaneous working of the details of the shirt collar and wig demonstrate Pajou's genius in the pliable medium of terra cotta, which he preferred to marble. Yet these details remain appropriately subordinated to the central focus of the work—the subject's face. Pajou suggests his keen understanding of the sitter in his frank and straightforward description of the facial features and in his sensitive examination of the sitter's inner feelings. Although his demeanor is nonchalant and dignified, the subject's face is marked with a slight sense of melancholy, a wistful reflection, perhaps, upon the turbulent times in which he lived, when one order and way of life was being violently replaced by another. JJ

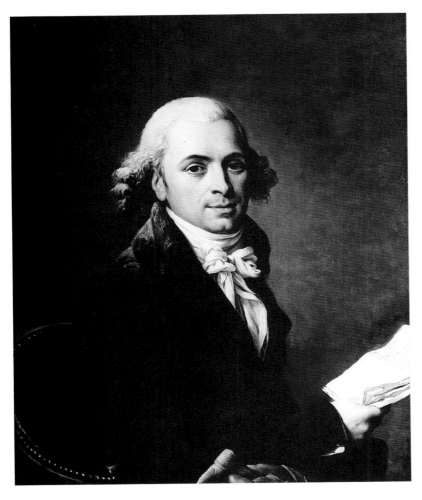

ADÉLAÏDE LABILLE-GUIARD

French, 1749–1803
Portrait of Monsieur Meunier, 1798
Oil on canvas; 29 × 23½ in. (73.7 × 59.7 cm.)
Purchase, 1962 (3067.1)

Born in Paris, Adélaïde Labille was the daughter of a fashionable haberdasher. At the age of twenty, her life changed drastically when her mother and two sisters died, and she married Louis Nicolas Guiard. The ill-suited couple separated legally within ten years, and Labille-Guiard began the pursuit of her art career. She had studied first with François Élie Vincent, a respected miniaturist; then with the better-known pastelist Maurice Quentin de la Tour; and finally, with Vincent's son, François-André, who had been her childhood friend. In 1800, when divorce was legalized, he became her second husband.

Labille-Guiard initially showed her work at the Academy of Saint Luke. Membership in the more prestigious Royal Academy was restricted to a quota of four women. In 1783 two of these positions opened. Labille-Guiard was proposed for one, Elizabeth Vigée-Lebrun for the other. Queen Marie Antoinette personally intervened for Vigée-Lebrun, but Labille-Guiard insisted upon being judged by open balloting. Much has been made of the contrasts and rivalry between these two meritorious portraitists, but both enjoyed commissions from their peers in artistic circles, as well as royal patronage. Labille-Guiard served "Mesdames de France," the maiden aunts of Louis XVI, who were bastions of monarchial dignity, while the more mercurial and dashing Vigée-Lebrun was favored by the younger faction associated with Marie Antoinette.

After the Revolution, Vigée-Lebrun fled France. Labille-Guiard adapted to the more austere egalitarian style popularized by Jacques-Louis David. Among her finest works is this portrait of a citizen now known only as Monsieur Meunier. The soberly dressed sitter holds annotated papers that indicate he is a writer, counsel, or statesman. His intelligent and appealing face conveys the duality of reason and emotion that so fascinated the eighteenth-century Enlightenment. Analytical detachment and profound feelings are revealed in his hazel eyes, humor and sensuality by the modeling of his mouth. Social distance between sitter and viewer is breached by Meunier's closeness to the picture plane and by his casual disregard for the hair powder that dusts his collar. SSD

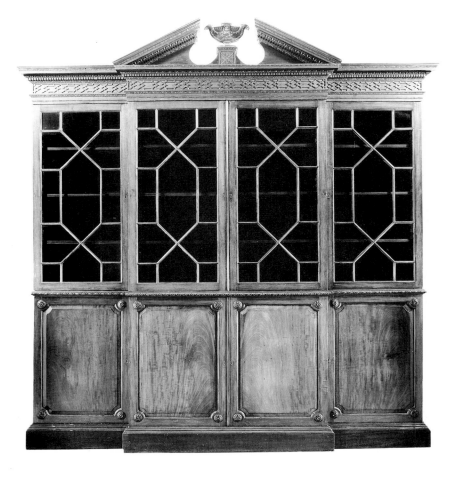

BREAKFRONT BOOKCASE

English, ca. 1750–80

Mahogany; 9 ft. 2 in. × 8 ft. 6 in. (2.81 × 2.59 m.)

Gift of Mr. and Mrs. A. M. Adler, 1976 (4417.1)

The publishing of furniture designs was popular in England during the eighteenth century, but no one was as influential in the development of the decorative arts of the time as Thomas Chippendale. The first of three editions of his book, *The Gentleman and Cabinet-maker's Director*, appeared in 1754, presenting its subscribers—noblemen as well as cabinetmakers and carvers—with a compendium of patterns for almost every type of furniture design. In this first comprehensive catalogue of interior decoration, Chippendale illustrated furniture styles that were not so much his original conceptions as a compilation of existing English and continental styles both historical and exotic in nature. Chippendale's workshop and other contemporary cabinetmakers carefully copied the patterns in their furniture or created pieces derived from one or multiple diagrams; this bookcase by an unknown maker combines Chippendale variations on neo-Palladianism and an orientalizing effect popular at the time.

Neo-Palladianism appeared in England in the early seventeenth century and again in revival form a hundred years later. The work of Andrea Palladio, an Italian Renaissance architect well known for his understanding of classical principles and vocabulary, formed the basis of the English interpretations. Although Palladio never designed furniture, cabinetmakers created pieces deemed appropriate for Palladian revival–style interiors; Chippendale's patterns are late manifestations of the interest in the Italian artist.

This bookcase is architecturally conceived in its massiveness and design; it follows the precedent of Palladian classicism with its four-part construction, projecting central sections or breakfront, elaborate dentil and egg-and-dart cornice moldings, and broken pediment anchored by an urn. At this time New World mahogany, popular because of its strength, rich color, and beautiful graining, replaced walnut. Here, perfectly matched figured panels enrich the lower cabinets.

The prevailing interest in the exotic and picturesque, particularly Chinese-derived motifs, appears in Chippendale's *Director* and also in the application of fretwork patterns to the cornices and glazed doors of this bookcase. The precision and regular repetition of the fretwork pattern enliven the quiet formality of the bookcase as its dignified proportion and balanced geometry generate a sense of grandeur suitable to the spacious library setting for which it was created. JS

SIR THOMAS LAWRENCE

English, 1769–1830

Portrait of George Blackshaw, ca. 1817–20

Oil on canvas; 30 × 25 in. (76.2 × 63.5 cm.)

Gift of Mr. and Mrs. Jeremiah Milbank, 1949 (880.1)

Born in Bristol, Sir Thomas Lawrence early manifested a gift for drawing, especially a precocious ability to catch a likeness. Essentially self-taught, Lawrence attracted attention by executing small portraits in pastel for "eminent personages" in Oxford, Weymouth, and finally Bath, where his family settled in 1780. By the time of his adolescence, it was apparent that Lawrence possessed true talent; in 1787 he went to London, studying at the Royal Academy for three months and exhibiting his first oil portrait there the following year. In 1789, at the age of twenty, Lawrence received an extraordinary honor, a commission to paint Queen Charlotte, and from that point he was assured of a brilliant career. In 1792 he succeeded Sir Joshua Reynolds as Painter to the King. He was knighted in 1815 and in 1820 was elected president of the Royal Academy.

Following in the tradition of the great school of British portraiture developed by Joshua Reynolds and Thomas Gainsborough, Lawrence became the preeminent portrait painter in London during the early nineteenth century, his dazzling, romantic style the epitome of glamour during the late Georgian period. A list of Lawrence's portraits is tantamount to an index of the most powerful, socially prominent, and sophisticated figures of his time.

Among the portraits Lawrence painted during his forty-year career is this painting of George Blackshaw, about whom little is known except that he was called Captain Blackshaw and thus may have had a military career. Despite its demonstration of Lawrence's technical virtuosity with paint and his talent as a subtle colorist, this portrait is not one of the artist's flattering productions for aristocratic tastes. Modest in size and with barely any indication of setting, the work is a remarkably straightforward, intimate characterization, intently focused on the personality of the sitter. Blackshaw is represented for what he was, a model of the confident, well-appointed gentleman of his day.

The importance of modish appearance is reflected in Blackshaw's attire (his brother-in-law was the society dandy and fashion arbiter George "Beau" Brummel). He wears a tailored cloth coat of sober dark-green color trimmed with black braid and fur. In dramatic contrast is the impeccable whiteness of the high starched collar of his shirt. The delicate modeling, harmonious colors, richly differentiated textures, and golden highlights of this stylish characterization convey the luxurious comfort and unquestioned security of George Blackshaw's world.

JJ

JOHN WEBBER

English, 1750?–93

View of Otapia Bay in Otaheite, 1787

Oil on canvas; 23 × 31 in. (58.4 × 78.7 cm.)

Gift of Richard A. Cooke and Theodore A. Cooke,

1935 (4268)

The official draftsman for Captain James Cook on his third voyage to the Pacific, John Webber recorded in plein-air sketches their various discoveries of exotic customs, lands, and events. On his return to London in 1780, he worked his sketches into finished drawings and paintings and supervised their engraving for the official voyage account published four years later. Throughout the remainder of his career, Webber continued to create and regularly exhibit paintings from the voyage.

Here Tahitian natives gaze and gesture toward the thatched structures across the river and the lush vegetation of the surrounding mountains, encouraging the viewer to experience the topography, flora, and ethnology so delightfully strange and appealing to eighteenth-century Europeans. The popularity of works such as this attested to the European fascination with the land and people of the South Seas.

With such landscapes Webber satisfied two masters—

the call for naturalistic precision and the evocation of place. The eighteenth century was a period of exploration and discovery, and integral to these investigations of the world were visual records made by artists like Webber. Based on a drawing (now at the British Museum, London) believed to have been made at the site where the expedition spent ten days in 1777, *View of Otapia Bay* accurately records the profile of the Tautira Mountains at what is presently Cook Anchorage on the southeast coast of Tahiti.

When reports of the South Pacific reached Europe, the public became fascinated with a land and lifestyle that was deemed to be an earthly paradise. Popular accounts of Cook's expeditions went into print, the public eagerly collected objects brought back from the three voyages, and numerous pantomimes were performed to general acclaim. Webber and other artists also exhibited and sold depictions of what they had seen. This work is one of several versions of the site by Webber—at least two other canvases and three additional watercolors of similar views have been identified.

In this painting Webber created an objective rather than popular and fanciful rendering of the tropical paradise. Yet, with its quiet accord of man and nature, the picturesque landscape and pleasing color harmonies soften the clinical detachment of his scientific perspective. JS

FURNISHING FABRIC

Probably English, ca. 1785
Cotton, plain weave, with copperplate-printed design in
sepia (perhaps originally purple or black)
50 × 27¼ in. (127 × 69.9 cm.)
Gift of Mrs. George R. Carter, 1935 (4169)

Polynesian scenes began to appear in the decorative arts, especially on printed wallpapers and fabrics such as this example, which shows four vignettes separated by a delicate tracery of fanciful leaf and flower forms. The anonymous designer took his figural compositions from engravings after drawings by Sydney Parkinson, William Hodges, and John Webber, the artists who accompanied Cook on his first, second, and third voyages respectively. Each scene is a pastiche of elements taken from several sources. Individual figures, groups of figures, and landscape elements from different engravings are sometimes combined with curious trees and plants, which have their source in the artist's imagination. Authenticity gave way to the designer's whim, for one scene shows a Maori boat from New Zealand in front of a landscape from Huahine in the Society Islands. LM

The publication of the journals of Captain James Cook and other accounts of Cook's voyages in the Pacific between 1768 and 1779 coincided with and influenced the late eighteenth-century European taste for the exotic.

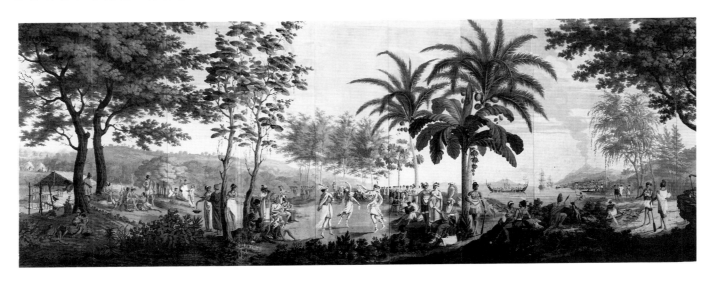

LES SAUVAGES DE LA MER PACIFIQUE

French, ca. 1804–1806

Designed by Jean-Gabriel Charvet, 1750–1829

Printed by Joseph Dufour, 1742–1827

Block-printed on paper; 20 panels,

each approx. 77 × 21 in. (195.6 × 53.3 cm.)

Gift of Mrs. Charles M. Cooke, 1928 (2692)

Accompanying the three volumes of Cook's expeditions published in 1784 was a separate folio atlas containing engravings of landscapes, portraits, and artifacts recorded by shipboard artists during the voyages. This visual documentation provided the imagery that was later translated into picturesque decorations such as this set of scenic wallpapers.

In about 1804, in an effort to satisfy a growing demand for the exotic, the French printer Joseph Dufour, collaborating with a designer, Jean-Gabriel Charvet, commemorated Cook's explorations with this set of wallpapers depicting in continuous narrative various scenes and incidents from Cook's voyages. Since machine-made paper was not yet commercially available, these panels were made by joining small handmade sheets of paper to form long rolls, which were then cut to the desired length. A layer of light-blue water-based pigment was brushed on the panels to serve as a ground for subsequent printing and also as the sky tone in unprinted areas. Designs for each color were carved on separate blocks, and as many as sixty blocks might be required to print a single panel.

In a descriptive pamphlet accompanying his scenic paper, the idealistic Dufour stressed its edifying and informative aspects, expressing the hope that the wallpaper would serve an educational purpose as well as a decorative one, "creating by means of new comparisons a community of taste and enjoyment." He also provided historical notes for each sheet, discussing the discovery of each locale and identifying the depicted incidents. However, the papers are anything but geographically, botanically, or historically accurate. Charvet freely interpreted details of the dancers' costume in panels 5 and 6 (shown here), modeling them after French fashions of the early Napoleonic period. In panels 8 and 9 (also shown), Charvet set a depiction of Captain Cook's death in Hawaii against an erupting, cone-shaped volcano that resembles Vesuvius more than Mauna Kea or Mauna Loa.

Although Dufour realized almost immediate popular success with *Les sauvages de la mer pacifique* in England and America, sets of these wallpapers are rare today. This is one of only four known complete sets and several partial ones that survive. JJ

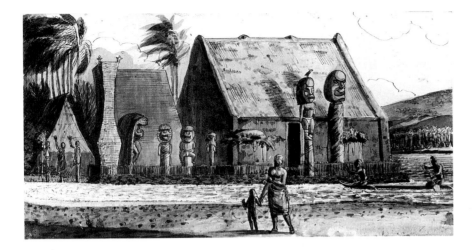

LOUIS CHORIS

Russian, 1795–1828

Temple of the King in Kailua Bay, 1816

Watercolor on paper; 6⅝ × 12 in. (16.8 × 30.5 cm.)

Gift of the Honolulu Art Society, 1944 (12,160)

Kamehameha, King of the Sandwich Islands, 1816

Watercolor on paper; 5 × 3½ in. (12.7 × 8.9 cm.)

Gift of the Honolulu Art Society, 1944 (12,162)

A Russian of German descent, Louis Choris was raised and educated in Kharkov in southern Russia. As a youngster, he displayed exceptional artistic talent, and at twenty years of age he was accepted as an artist aboard the sailing ship *Rurick*, commanded by Captain Otto Von Kotzebue, which visited Hawaii in 1816 and 1817. During these visits Choris created a series of sketches of Hawaiians and their activities, architecture, and objects. On November 24, 1816, Kotzebue and the crew visited Kamehameha the Great at Kailua, Kona, Hawaii, at which time the king brought the party, including Choris, to his personal temple, Ahuena Heiau, dedicated to the god Lono.

The first watercolor depicts the temple and several persons outside the fence. Dominating the scene, the temple area is composed of buildings and carved wooden images wrapped with Hawaiian barkcloth (*kapa*). Most of the images display features common in extant wooden carvings. The second image from the right is described as depicting the god Koleamoku in an account of the temple by John Papa Ii, a nineteenth-century Hawaiian politician and social commentator. The image wore a helmet upon which perched a *kolea*, or golden plover. This is one of the rare instances in which a carved image depicted by a foreign artist can be associated with the name of a specific Hawaiian deity. On the left, the figures with raised arms may represent a kind of temple image composed of several parts and similar in construction to the articulated puppets used in certain hula performances. There appear to be two small images with cursive outlines atop the tower (*'anu'u*) on the left.

During the seven hours that the party spent with Kamehameha that day, Choris painted several small likenesses of the king. The powerful portrait illustrated here shows the king in what appears to be a black *kapa* mantle. The mantle was possibly painted over some sort of European clothing. Another portrait of Kamehameha by Choris, also in the Academy collection, depicts the king wearing a European shirt and red vest. RAD

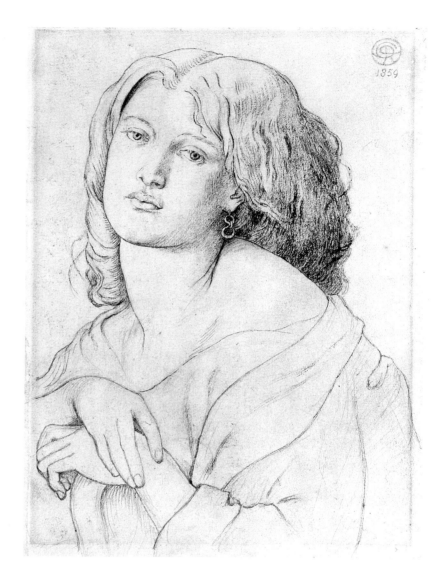

DANTE GABRIEL ROSSETTI

English, 1828–82

Fanny Cornforth, 1859

Graphite on paper; 11⅝ × 8¼ in. (29.5 × 21 cm.)

Gift in memory of Fritz Hart by his friends, 1949

(12,656)

Dissatisfied with the programs of the Royal Academy schools, Dante Gabriel Rossetti joined William Holman Hunt and John Everett Millais in 1848 to form the Pre-Raphaelite Brotherhood, an initially secret society devoted to the ideals expressed in art before Raphael. To these men, contemporary art seemed facile, banal, and lacking sufficient reference to nature. They hoped to resurrect what they perceived to be at the heart of fifteenth-century Italian art—realism joined with "direct and serious and heartfelt" subjects. A poet, steeped in the literature of Shakespeare, Dante, Scott, and Byron, Rossetti often dwelled upon themes derived from a romanticized view of the Middle Ages that allowed him to deify women and their spiritual purity or subsume himself in their sexual allure. Since Rossetti used very few women as his models—those he did were associated with him and the Brotherhood either by marriage or liaison—the faces of

his wife and other women close to him recur throughout his work. One such model was his mistress Fanny Cornforth. They met in 1853, and from then until the end of his career, Rossetti sketched and painted her full-lipped beauty. With its fluid contours, delicate shading, and silvery effect, this drawing illustrates Rossetti's exquisite linear technique. The model's long, plump neck, heavy mass of hair, and full lips form the basis of Rossetti's concept of idealized beauty. However, as subdued as she seems in this moment of introspection, her heavy-lidded eyes, languid pose, and back-tilted head reveal a potent sexuality that pervades Rossetti's representations of women. The provocative and voluptuous sensuality of Fanny Cornforth served Rossetti well; he often used his mistress as the model for images of fallen women and femmes fatales.
JS

EUGÈNE DELACROIX

French, 1798–1863
The Justice of Trajan, 1858
Oil on canvas; 25 × 20¾ in. (63.5 × 52.7 cm.)
Purchase, 1941 (4954)

Following the political and social changes of the French Revolution and the regime of Napoleon, the French questioned many premises of the eighteenth-century Enlightenment. No longer did a faith in reason and intellect seem to guarantee a peaceful and prosperous future. Instead, a new appreciation for the inner life of the individual arose, influencing the literature and fine arts of the period. Perhaps more than any other French artist, Eugène Delacroix led the shift to a more emotionally charged art. Replacing the austere and rational style of the neoclassicists with energy and passion, he addressed a variety of subjects including biblical topics, portraiture, and scenes of battle, North Africa, and the Near East, as well as incidents derived from medieval, Renaissance, and classical history. This work, a small replica of a painting he exhibited in the Paris Salon of 1841, is one such example.

Derived from the tenth canto of Dante's *Purgatorio*, the painting depicts a scene in which a grief-stricken woman meets the emperor Trajan leading his legions to war. She implores him to avenge the death of her son. The impatient Trajan assures her that he will resolve the matter on his return, but she calls upon an ancient law that allows her to demand the immediate attention of the emperor. Swayed by her plea, Trajan promises prompt retribution. Although derived from classical antiquity, the story also appears in Christian legend and was lauded for its moral illustrating the humbling of the proud.

Delacroix depicted the drama inherent in the woman's confrontation with Trajan in a free and energetic style. Close to the picture plane and compressed within the confines of the canvas, carefully orchestrated gesturing figures such as the mother, Trajan, and the rearing white charger activate the small canvas. The dramatic lighting of the figures and triumphal arch contributes to the painting's dynamic mood of excitement and drama, as does the striking compositional structure of multiple diagonal axes. Forms are rendered with rapid brushwork and broken color, a style that led early critics to accuse Delacroix of painting with a drunken broom. The artist's technique generates a vivid immediacy, which transcends the static rationality of neoclassicism, and achieves a new level of pictorial drama influential in the development of later nineteenth-century painting. JS

JEAN-BAPTISTE CARPEAUX

French, 1827–75

Portrait of a Young Chinese Man, ca. 1872

Bronze; h. 12½ in. (31.8 cm.)

Purchase, Academy Volunteers Fund, 1979 (4750.1)

Jean-Baptiste Carpeaux was the most important sculptor of the Second Empire in mid-nineteenth-century France. His best-known work, both during his lifetime and today, is the large figural group *The Dance* (Musée d'Orsay, Paris), which originally decorated the facade of the Paris Opera. Although Carpeaux is not as well known as Auguste Rodin, who is credited with opening the way to modernist sculpture, it is difficult to conceive of the achievements of Rodin without those of Carpeaux. Indeed, Rodin recognized the sculpture of Carpeaux as one of the major influences on his own work. Today Carpeaux is considered an important figure in the transition to modernism—an opponent of academic classicism who revived the spirited traditions of French sculpture of the eighteenth century and pointed the way to new freedoms in sculpture of the late nineteenth and early twentieth centuries.

Portrait of a Young Chinese Man is an example of Carpeaux's work at its finest. It is derived from the artist's careful ethnographic studies for the figure representing Asia, which he incorporated in his large decorative commission *The Four Parts of the World*, the centerpiece of a fountain for the Luxembourg Gardens in Paris. Ironically, Carpeaux used a young man as his model but in the final work grafted the head onto a nude female body; apparently he could not find a Chinese female model willing to pose for him.

This sculpture admirably demonstrates Carpeaux's ability to translate observations from life into an artwork of inner vitality and strength. He turned the head to the right, animating the composition and requiring the viewer to move around the work to take in the young man's gaze. Attention to details of the costume and hairstyle, especially the beautifully articulated braid winding down the back, and subtle variations in patination add to the work's powerful realism and striking visual impact, which are far removed from the lifelessness of the work of many of Carpeaux's conservative academic contemporaries.

JJ

AUGUSTE RODIN

French, 1840–1917

The Age of Bronze, 1875–77 (reduction ca. 1890s)

Bronze; h. 25 1/2 in. (64.8 cm.)

Acquired through gifts of Mrs. Philip E. Spalding and
Mary Cooke Dillingham, 1970 (3703.1)

Auguste Rodin brought to his work an appreciation of his European heritage as well as a progessiveness that influenced the development of twentieth-century art. Often considered the father of modern sculpture, Rodin, who was trained in the French figurative tradition, had a profound faith in man's centrality to the ideals of truth and beauty. Rodin's keen understanding of anatomy and sensitivity to man's inner life enabled him to create works of compelling naturalism and psychological expression.

When Rodin contemplated returning to Paris after spending the years of the Franco-Prussian War in Belgium, his considerations probably included an official entrance into Parisian art circles. Perhaps hoping to make his mark at the Salon, Rodin began his first major full-figure statue, now known as *The Age of Bronze*. He examined his model from numerous perspectives and, working in clay, linked a multitude of profile contours into a unified image of remarkable fluidity, grace, and naturalism. He also conveyed the vibrancy of human flesh; his constant manipulation of the clay and his mastery of subtle modulation resulted in the palpable illusion of muscle, sinew, and bone.

Rodin submitted the work, with the title *The Vanquished*, for exhibition in Brussels in 1877. Rodin's selection of a male nude with allegorical associations of the recent French defeat by the Prussians fell well within the traditions of French sculpture. But instead of acclaim, the statue earned him instant notoriety. Its acutely observed anatomy did not conform to the idealized proportions sanctioned by French critics—Rodin was accused of creating the figure by using casts taken from the model. Its enigmatic gestures also confused a public accustomed to conventional representations with standardized poses, costumes, and attributes.

Nonetheless, Rodin sent the plaster cast to the Paris Salon, where it met with equal incredulity despite a title change to *The Age of Bronze*. Rodin probably hoped that this reference to an era considered to be a time of injustice and violence would have meaning to a nation still recovering from its defeat at war. Again, the imprecise content and unimproved anatomy of the sculpture condemned it. Rodin's forthright naturalism in the balanced contrapposto and supple modeling of the figure, as well as the ambiguity underlying its gesture, pose, and psychological self-absorption, catapulted this sculpture beyond Salon-based formulas. Rodin's evocation of humanity in *The Age of Bronze* prefigured the twentieth century's preoccupation with the mysteries of man's inner life. JS

GUSTAVE COURBET

French, 1819–77

The Torrent, ca. 1872–73

Oil on canvas; 23¼ × 28½ in. (59.1 × 72.4 cm.)

Purchase, gifts of Mrs. Philip E. Spalding, Mrs. Clyde Doran, Renee Halbedl, Mr. and Mrs. Aaron Marcus, Mr. and Mrs. Alfred J. Ostheimer, by exchange; and with funds given in memory of William Hyde Rice, 1981

(4946.1)

Courbet was a major figure in realism, a mid-nineteenth-century movement that constituted a reaction against both the classical tradition and the literary conceptions of romanticism. As the nineteenth-century critic René Huyghe commented, "Realism decreed that the task of art should be the faithful representation of nature and that nature itself must remain simple and straight-forward . . . it was not to be ennobled, transfigured or disguised, and it must always stay close to the basic realities." Courbet summed up his attitude by declaring that he did not paint angels because he had never observed any. But Courbet's painting is not as objective as such a pronouncement might imply. Although Courbet stated that he wanted to translate the customs, ideas, and look of his own time into pictures, he added that he wanted to do so according to his own understanding of them. While he referred directly to the world around him for inspiration, he interpreted what he saw rather than simply transcribing it.

Courbet's monumental compositions of rough peasants and ordinary persons earned him a reputation for being a socialist and brought him sharp criticism, and his often arrogant and egotistical public demeanor made him a controversial personality. But Courbet also loved nature. When asked how he set about making such beautiful landscapes, he responded, "I am moved." Sensing the palpability of matter, and left in untroubled communion with nature, by using his own raw material—color—Courbet created a sumptuous vision of the world.

A fine example of Courbet's vision and technique, *The Torrent* was probably painted in Switzerland, where Courbet went into self-imposed exile following the Franco-Prussian War. The work depicts a fast-running stream and in the distance its source, a waterfall cascading through a cut in the cliffs. The paint is thickly and vigorously applied, expressive in its varied textures—scumbled and layered in the rocks where Courbet used the flat of a palette knife to apply it, loose and delicate in the foliage where he flicked on pigment with the knife's tip. Affinities with impressionism, for which he in large measure prepared the way, can be seen in Courbet's interest in light effects and the tonal contrasts among the slabs of rock in the warm sun, the turbulence of the cool water, and the deep shadows of the rock crevices and dense, spongy foliage. JJ

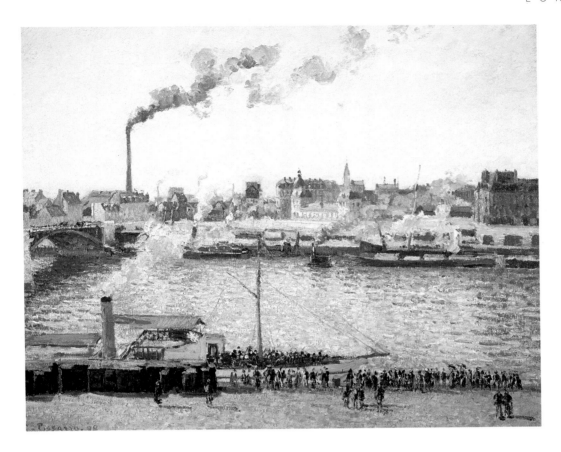

Often called the father of impressionism, Camille Pissarro was the only artist to show his paintings in all eight impressionist exhibitions held in Paris from 1874 to 1886. Pissarro was an adviser and friend of many of the younger impressionists, including Claude Monet and Pierre-Auguste Renoir, and postimpressionists such as Paul Cézanne, Paul Gauguin, and Vincent van Gogh. For most of his artistic life, Pissarro depicted peaceful rural scenes in which he sought to unify color to create an overall harmony or accord. Pissarro did not dissolve his subjects into semiabstract patterns of brushstrokes, as did Monet and others; instead he retained a certain formal solidity.

In the last decade of his life, Pissarro turned to the rapidly expanding urban centers of France for subject matter. From July to October 1898, he stayed in Rouen on the Seine River and painted nineteen canvases. *View of Rouen* is from this series. The painting was most likely executed from a window in the Hôtel de l'Angleterre (Pissarro's decision to paint indoors was partly because of a recurrent eye infection he had suffered since 1889). Two years before painting *View of Rouen*, Pissarro had stayed in the same hotel, where he painted *The Great Bridge, Rouen* (1896, Museum of Art, Carnegie Institute, Pittsburgh), the same bridge (Pont Boieldieu) as that in *View of*

CAMILLE PISSARRO

French, b. West Indies, 1830–1903
View of Rouen, 1898
Oil on canvas; 25 × 31 ¼ in. (63.5 × 79.4 cm.)
Gift of Mrs. Charles M. Cooke, 1934 (4110)

Rouen. Although in the Academy painting the view is slightly farther upstream, the towering chimney of the main gasworks and the windblown puffs of smoke are prominent in both paintings; the slanted glass roof of the Gare d'Orléans in front of the gasworks can be distinguished in each.

In *View of Rouen*, Pissarro captures a moment in the spectacle of urban life. The salmon-colored quay in the foreground is populated with observers and passersby. Aboard the ship, the people crowding the deck are painted in strokes similar to those used for the figures on land. Large cargo ships are moored on the far side of the glistening Seine; impressive buildings line the street that parallels the wharf. The entire work is created with thickly applied strokes of paint that capture the light, causing the surface of the painting itself to shimmer.
RAD

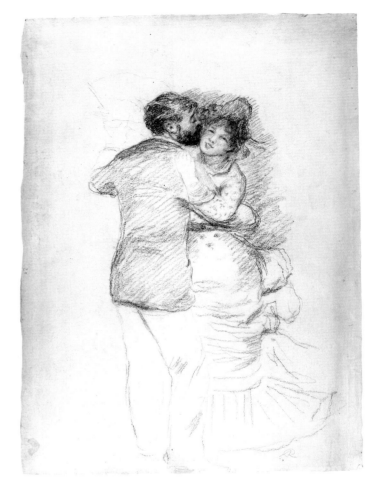

PIERRE-AUGUSTE RENOIR

French, 1841–1919

Dance in the Country, 1883

Carbon pencil on paper

19¼ × 13⅝ in. (48.9 × 34.6 cm.)

Purchase, 1937 (10,955)

The impressionist artist Pierre-Auguste Renoir, committed to the representation of contemporary French life, generally depicted beautiful women and the social pleasures of the time. The models for this drawing are generally believed to be Renoir's wife and frequent subject, Aline-Victorine Charigot, and his friend Paul Lhôte. By showing the dancers closely embracing and dancing, Renoir captured their delight in each other and their joy in the moment.

As an impressionist, Renoir was also concerned with capturing on canvas the ever-changing quality of light on the varied surfaces of the physical world. He attempted to document light's fleeting effects in a rapid and direct painting technique in which drawing played a minor role. Renoir, in his quest to portray the instantaneous, dismissed as too time-consuming the development of a subject through numerous sketches; furthermore, the impressionists believed that contours considered fundamental to drawing did not exist in a light-filled nature. Consequently, sheets such as this by Renoir are relatively rare.

In the early 1880s, however, Renoir began to question impressionism and his own ability to record light and nature. In spontaneously applying pigments to the canvas as he examined light and not substance, he came to feel that he had forgotten how to paint and draw. A trip to Italy and the study of Renaissance art inspired him to exercise a new discipline in his work through drawing, thereby regaining his mastery of the basics of painting.

This sheet, one of several preparatory works on paper for the oil painting *Dance in the Country* (1883, Musée d'Orsay, Paris), represents Renoir's experiments in working out a final composition. The drawing demonstrates how Renoir, by emphasizing contours and shading, ultimately grounded his paintings in a more concise definition of form. A few faint outlines describe the legs of the figures and the placement of their upraised hands and fan; firm strokes delineate the figures and their faces, and strong parallel strokes of modeling give them volume. By choosing carbon pencil on paper to investigate mass and detail, Renoir rediscovered the substance of nature that his interest in light had obscured. JS

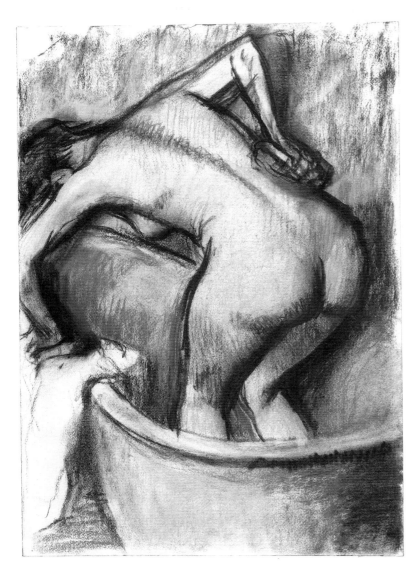

EDGAR DEGAS

French, 1834–1917

The Bath: Woman Sponging Her Back, ca. 1887

Pastel on paper; 20¾ × 14⅛ in. (52.7 × 35.9 cm.)

Gift of Mr. and Mrs. Henry B. Clark, Jr., 1979 (17,400)

The primary concern of Edgar Degas's art was the human figure, and he examined its many nuances and possibilities in his series of nudes. In these works Degas endeavored to depict the female form from a new point of view. Instead of showing undressed models in formal attitudes chosen by the artist, Degas set up tubs and basins in his studio and asked his models to go through the ordinary movements of their baths and personal care. Thus he could observe them in unstudied, natural attitudes and from unexpected angles that revealed new possibilities in composition.

In this pastel the bather bends forward, supporting herself with one arm placed firmly on the rim of the tub. Our eyes are carried up the arm, down the spine and buttocks, and to the legs in one bold, sweeping movement. Yet the emphasis is not so much on the muscular tensions as on the solid form of the woman's body, fully and roundly delineated. The rubbed and deliberately smudged colored pastels—red-brown for the hair, yellow highlights on the flesh, soft blues in the background—and the hatching strokes defining the body's contours produce a luminous and textured surface. One can even see Degas's ideas changing as he corrected the position of the arms. This pastel is an intimate and spontaneous response to something observed—dynamic, alive, momentary, yet stable—reflecting Degas's own belief: "Drawing is not form, it is a way of seeing form." JJ

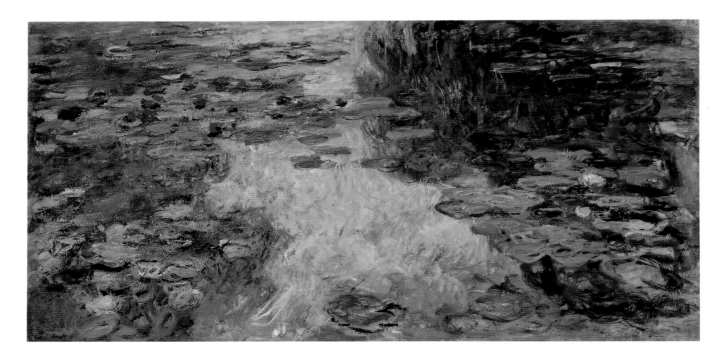

CLAUDE MONET

French, 1840–1926

Water Lilies, 1917/19

Oil on canvas; 3 ft. 3¼ in. × 6 ft. 7 in. (1 × 2 m.)

Purchased in memory of Robert Allerton, 1966 (3385.1)

In 1883 Claude Monet rented a simple country house in Giverny, a small village in the rich valley of the Seine River about forty miles west of Paris. The artist spent over half of his creative life at the Giverny house, which he bought in 1890 and around which he planted a garden that eventually covered four acres. Monet had a passion for water, and in 1893 he acquired a meadow across from his garden in which lay a pond with wild water lilies. He redesigned the pond, enlarged it several times, and diverted a branch of the Epte River to replenish its waters. It became a source of artistic inspiration to him for over thirty years.

As with other impressionists, Claude Monet pursued the fleeting moment for its own sake, trying to capture in paint the ever-changing moods of nature. Monet used the word "instantaneity" to describe what he was trying to achieve, and, more than any other subject, his lily pond provided him with a motif at once fixed and in flux, specific and universal.

The Academy's *Water Lilies* belongs to the last of three series of paintings depicting the fugitive, fleeting play of light on the artist's beloved pond. Disregarding the restrictions and limitations of the picture frame, Monet painted the illusion of a shimmering horizontal surface on a vertical one, creating visual tension. The viewer stands as if at the edge of the pond and sees the lily pads and water recede at the top of the painting. The next moment the entire painting snaps up and becomes a decorative frieze of closely keyed colors and flickering light. The brushwork adds to the feeling of ambiguity, as loose scrawls are placed next to tightly knit strokes; lily pads dissolve into strokes of pure green, which coalesce into pads. The canvas ground can be seen through the thin brushwork of the water and the waving grasses beneath. In some areas there is a layering effect as the paint is scumbled; in others, the surface, because of the thick impasto, is extremely granular.

Although inspired by nature and careful observation of it, Monet's late monumental canvases were the result of formal considerations and long hours of work in his specially constructed, large studio (in a 1954 photograph of Monet's smaller studio in the house at Giverny the Academy's *Water Lilies* hangs on a wall above a couch). Monet's last "Water Lilies" series is a precursor of mid-twentieth-century painting, as well as a final evocative statement of impressionism. RAD

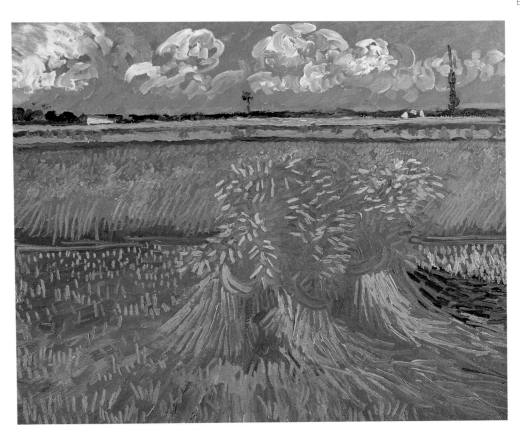

After the particularly hard winter of 1887–88, Vincent van Gogh traveled to the south of France, hoping the sun and warmth would restore his failing health. From February 20, 1888, to May 8, 1889, he lived in Arles, a small town on the Rhône River. In less than fifteen months, the artist created about one hundred drawings and watercolors and two hundred paintings, a prolific flowering of creative genius unequaled by any nineteenth-century artist. Although prodigious, this production was carefully planned and focused. As van Gogh explained in his letters, he divided his work into a series of thematic paintings. The Academy's *Wheat Field* belongs to the "Harvest" series, ten paintings executed in the last half of June 1888.

Unlike other works in this series, which display dramatic perspectives accented with diagonals, this painting is constructed in distinct horizontal bands that lead the eye from the sheaves and stubble in the foreground to the rows of wheat in the middle ground, to the trees and buildings on the horizon line, and finally to the sky. Only the seemingly swaying sheaves in the foreground and the two distant trees disrupt the separate, brightly colored planes.

"Everywhere now there is old gold, bronze, copper, one might say, and this with the green azure of the sky

VINCENT VAN GOGH

Dutch, 1853–90
Wheat Field, 1888
Oil on canvas; 21¾ × 26¼ in. (55.2 × 66.7 cm.)
Gift of Mrs. Richard A. Cooke and family in memory of
Richard A. Cooke, 1946 (377.1)

blanched with heat," van Gogh wrote of the fields around Arles in June. To accentuate what he termed the high yellow note, van Gogh used a complementary violet, setting up a vivid pulsating interplay in the lower half of *Wheat Field*. To create a deliberate abstraction of form, he used slashing strokes, dots, and whorls to compose the elements of the painting. This abstraction can be seen in two van Gogh drawings (Staatliche Museen, Berlin, and private collection, Switzerland) based on *Wheat Field*.

During his summer in Arles, van Gogh evolved his mature style and left behind the dominating and restricting influences he had felt in Paris. His relieflike impasto, accentuated brushwork, and lightness of tones were breakthroughs. Van Gogh's construction of form by discrete emotion-charged strokes and his expressive use of color—to suggest more than the appearance of reality—introduced important elements into modern art. RAD

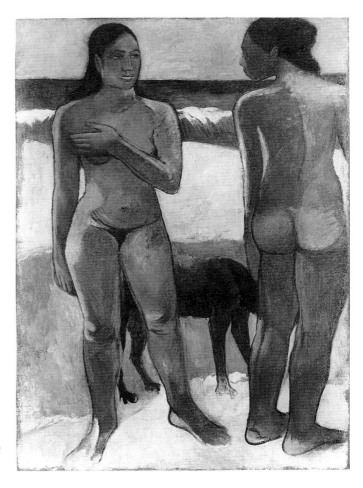

PAUL GAUGUIN

French, 1848–1903

Two Nudes on a Tahitian Beach, 1891/94

Oil on canvas; 35³/₄ × 25¹/₂ in. (90.8 × 64.8 cm.)

Gift of Mrs. Charles M. Cooke, 1933 (3901)

Paul Gauguin's decision to move from France to Tahiti in 1891 involved complex familial, economic, philosophical, and artistic reasons; primary was Gauguin's desire for freedom from the material motivations and values of European life. He envisioned Tahiti as an innocent paradise, much as Rousseau conceived it, where man lived intimately with a benevolent nature and where an artist's work would flow freely. Indeed, Gauguin's first stay in Tahiti, from June 1891 to June 1893, was one of the most productive periods of his life. During this period or shortly after his return to Paris, he painted *Two Nudes on a Tahitian Beach*.

Gauguin often compared the relationship of colors to musical harmony. In *Two Nudes* he created a counterpoint of color with intense blues and bright oranges and pinks. The two brown figures, simplified and monumental, dominate the picture plane. The body of the dog is used as a visual link; to the left of the forward-facing figure can be seen the traces of the initial rendering of one of the dog's hind legs, painted over in blue when the artist decided to center the animal between the women, thus anchoring the composition.

Other pentimenti can also be seen: a tall tree on the extreme left, and in the center a canoe with a figure, possibly the artist. Gauguin probably revised the painting at least twice, distilling the subject and simplifying the

forms. He emphasized the essentials with the kind of bold expressive lines he had learned from Japanese prints and art nouveau. Brilliant colors, forms stripped of detail, strong outlines, as well as the denial of illusionary space and the rejection of naturalistic shading—all lending an overall decorative quality—are key elements in *Two Nudes* as well as in numerous other paintings from Gauguin's first Tahitian visit. Although Gauguin was considerably influenced by the tropical vegetation, people, and culture of Tahiti, all these aspects of form and color had earlier been explored by the artist in the late 1880s in the Breton village of Pont-Aven, where Émile Bernard and Gauguin formed the symbolist group.

Gauguin did not find the paradise he had hoped for in Tahiti; long before his arrival, Tahiti had seen an influx of Europeans, and Papeete was dominated by French colonials. Nevertheless, the subject matter Gauguin found in the South Seas, combined with his genius for expression, enriched and enlivened his art for the remainder of his life. RAD

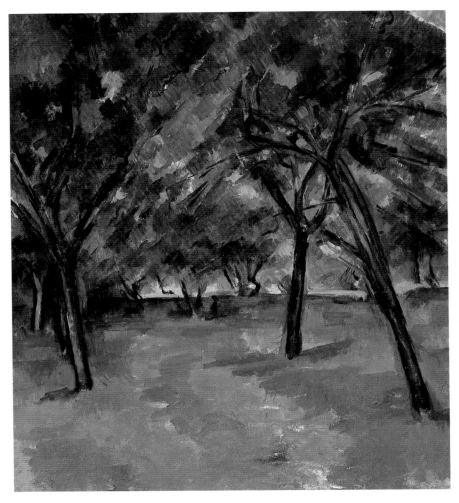

PAUL CÉZANNE

French, 1839–1906

Un Clos (A Close), ca. 1890

Oil on canvas; 24¼ × 20½ in. (61.6 × 52.1 cm.)

Purchase, Robert Allerton Fund and donations

from Mr. and Mrs. Henry B. Clark, Jr., and

Academy friends, 1980 (4845.1)

"Painters must devote themselves entirely to the study of nature and try to produce pictures which will be an education," Paul Cézanne wrote shortly before his death. *Un Clos*, painted at the beginning of his important last period, exemplifies Cézanne's approach to nature: a desire to delve beyond its external appearance and express its essential order and stability. In this work he recorded his sensations of the dense canopy of a grove of trees. Carefully ordering his forms, Cézanne built them into a structural unity through the use of a limited number of colors—green, blue, violet, with occasional flickering touches of ochre and tan—interwoven in the shimmering mass of parallel brushstrokes that depict the foliage and masterfully hold together the cross-directional accents of tree trunks and branches. Cézanne drew with color rather than line, creating movement and depth as colors recede or advance. Here, the viewer is drawn by a path into the vibrant green meadow between the foreground trees, through the cool, shaded grove to the line of warm accents that suggest brilliant sunlight shining in a clearing beyond. Above, patches of sky are visible in the foliage, the remarkable bright blue triangle in the upper right subtly opening up the composition. There the eye connects with a tree branch, which leads to the magnificent tangle of branches that demonstrates the dynamics of Cézanne's composition—thrusts and counterthrusts, curves and countercurves, a network of opposing and interlocking triangles, all enmeshed by a vigorous, agitated brushwork that sets up rhythms almost akin to musical sensations. Just above is a stroke of crimson red, a visual spark that ignites the painting's color harmonies. Imbued with sensitivity, perception, and technical mastery, *Un Clos* brings the viewer in contact with the artist's inner spirit, providing inspiration as well as instruction. JJ

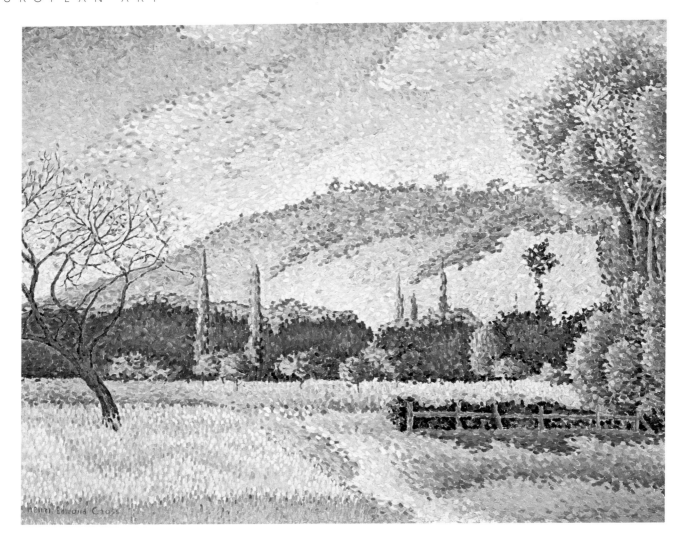

HENRI-EDMOND CROSS

French, 1856–1910

Landscape, ca. 1896/99

Oil on canvas; 25¾ × 32 in. (65.4 × 81.3 cm.)

Purchase, 1974 (4225.1)

Henri-Edmond Cross (born Delacroix, he changed his name to an English equivalent) and Paul Signac were followers of Georges Seurat, who, in response to impressionism, formulated a scientific theory of painting called neo-impressionism. Under Seurat's intellectual leadership, the neo-impressionists attempted to solidify form, which had been disintegrated by the impressionists, by dividing it into its basic components (divisionism) and applying color in dots or dabs of uniform size (pointillism). This formula tended to reduce objects to geometric shapes and to emphasize their silhouettes.

Known for his rectangular brushstrokes and high-value colors, Cross used pastel yellows, blues, pinks, and greens in the Academy's *Landscape*, which probably depicts a scene in the south of France. The horizontal pattern created by the field, dark forest, sloping mountain, and sky combines with the soft colors to give the work a strong decorative feeling. Indeed, Cross and some of the other neo-impressionists were precursors of fauvism, the first artistic revolution of the twentieth century. In the summer of 1904 Henri Matisse worked with Cross and Signac in the south of France. This contact probably led to the explosion of pure color and the overall decorative sense that marked the fauve movement. RAD

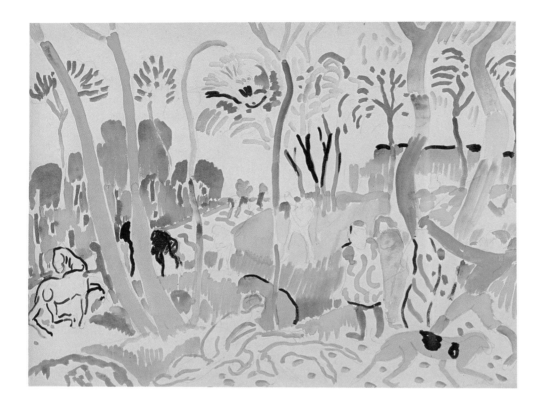

André Derain's *The Enchanted Forest* is a classic example of fauvism, which received its name from the comment of a critic, who, in reviewing the 1905 Salon d'Automne in Paris, likened Derain and his colleagues (Henri Matisse, Maurice Vlaminck, Raoul Dufy, and others) to *fauves* (wild beasts) for their aggressive color and technique.

Fauvism, a short-lived (1905–1907) but influential movement, sprang from a desire for renewal in painting among artists seeking a form of pictorial representation other than impressionism, which emphasized landscape, natural phenomena, and observation. The fauve painters rejected objective representation and naturalism, taking a new approach to space and color in which nature was regarded not as the subject of art but as a realm in which the artist's emotions and imagination could be released. The works of Vincent van Gogh and Paul Gauguin, with their forceful brushwork and emotional use of pure colors, were strong influences on Derain and the other fauve painters. They went further, however, and deliberately exaggerated those features of a subject which struck them. Later Derain explained: "Fauvism was our ordeal by fire.... [Photography] may have influenced our reaction against anything resembling a snapshot of life. No matter how far we moved away from things, in order to observe them and transpose them at our leisure, it was never far enough.... It was a fine idea ... to free the picture from all the imitative and conventional contact."

ANDRÉ DERAIN

French, 1880–1954

The Enchanted Forest, ca. 1904–1905

Graphite and watercolor on paper: 19 1/2 × 25 1/2 in. (49.5 × 64.8 cm.)

Gift of John Gregg Allerton, 1984 (18,983)

This watercolor illustrates Derain's fauve style. The landscape is not an observed one, not an interpretation of reality, but an imaginary one, filled with fantasy, magic, and emotion. The clashing colors are arbitrary and unnatural, refusing to fuse into harmonious, descriptive tonalities. The application of the watercolor pigments in a frenzy of bold, flat, broken strokes against areas of untouched paper establishes a mosaic-like pattern that enhances a sense of movement.

Fauvism opened the way to abstraction; however, the fauve artists themselves rejected this direction. By 1907 Derain had turned to Paul Cézanne in the desire to control his passion and adopt a "more cautious attitude." Derain's later work became more classical and conservative and never equaled his fauve-period works in strength, invention, and color. JJ

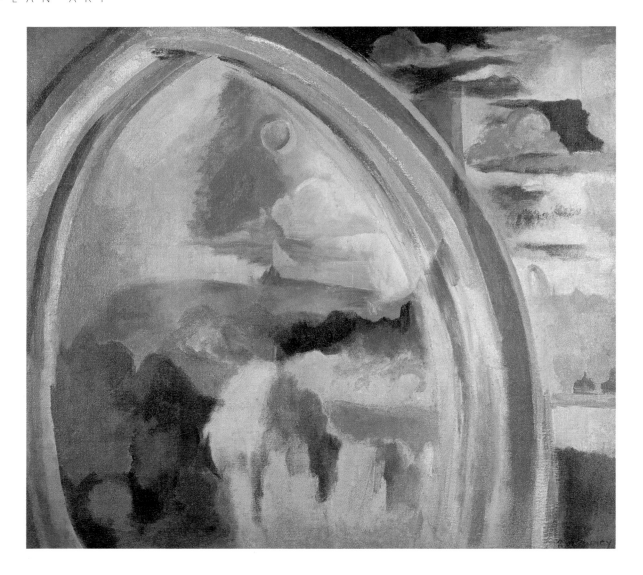

ROBERT DELAUNAY

French, 1885–1941

Rainbow, 1913

Oil on canvas

34⁹/₁₆ × 39⁵/₁₆ in. (87.8 × 99.9 cm.)

Purchase, 1966 (3417.1)

Although he exhibited with the cubists at the Salon des Indépendants in 1911 in Paris, Robert Delaunay had reservations about the almost monochromatic palette used in analytical cubism. What he had learned about the effects of color from the impressionists gave rise to the movement called orphic cubism (Guillaume Apollinaire coined the term in 1913 to describe painting that was more esoteric or oracular than that of the cubists). Delaunay, believing that color should take precedence over form, used the spectrum to create what he termed the law of simultaneous contrasts. His paintings are bright and imaginative, composed of broad planes and pure color.

Between 1910 and 1913 Delaunay painted a series depicting the city of Paris, especially the area around the Eiffel Tower. In *Rainbow* the artist placed a prismatic rainbow between the viewer and a cityscape alive with colorful trees; a hot air balloon rises above the hill of Montmartre, crowned by the Cathedral of Sacré Coeur. To the right, the Eiffel Tower is partially lost behind the rainbow; next to it, a loosely scrawled arc represents a ferris wheel. Delaunay's free and expressive color greatly influenced Vassily Kandinsky and other later pure abstract artists. RAD

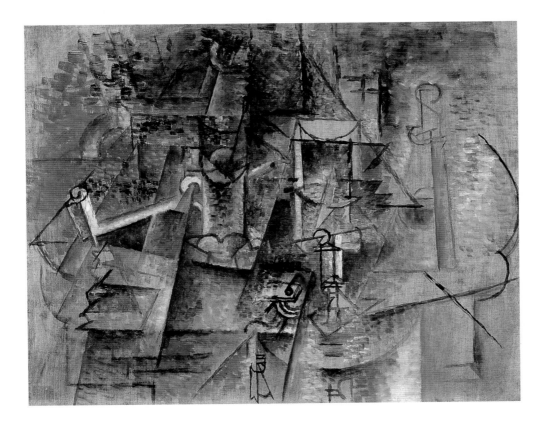

Between 1907, the year of his revolutionary work *Les Demoiselles d'Avignon*, and 1916, Pablo Picasso worked on solutions to the problems inherent in cubism. Cubism's cofounders, Picasso and Georges Braque, were concerned not only with the two-dimensional depiction of the three-dimensional aspects of reality but also with the constant flux and change of appearance and perception. In the second phase of cubism, analytical cubism (1909–12), the two artists sought to simultaneously portray multiple aspects of objects they had visually broken down and then reconstituted. Works from this period, a watershed in the history of modern art, have an austere linear quality and a lofty beauty.

In early July, 1911, Picasso left Paris and traveled south to the small town of Céret in the French Pyrénées. In August Braque joined him, and the two worked closely for about three weeks. *Fan, Pipe and Glass* is one of the paintings from Picasso's stay at Céret, though it may have been completed or reworked when he returned to Paris in September. To the left in the painting, a white clay pipe appears to hover above a folded fan resting on a table. Two reassembled glasses in the center lend their curves to the composition, while to the right are schematic references to stringed instruments. These objects or similar ones appear in different combinations and in different configurations in other paintings done at Céret. As in those works,

PABLO PICASSO

Spanish, 1881–1973

Fan, Pipe and Glass, 1911

Oil on canvas; 16½ × 20¾ in. (41.9 × 52.7 cm.)

Purchase, Academy Fund and gift of the Friends of the Academy, by exchange, 1969 (3576.1)

Picasso applied the pigment on this canvas in the facetlike strokes reminiscent of the technique, but not the vibrant colors, of the neo-impressionists. Picasso used sober colors, mostly muted browns and grays, black, and white.

As signs of reality, the objects—though difficult at first to recognize—play an important role in the complex dynamics of the painting. Picasso used a grid of slanting and vertical lines that not only created abstract shapes and intricate patterns but also determined the placement of the concrete objects and linked them compositionally. Picasso erected this grid in a pyramidal design, which helped to integrate the foreground spatially with the background.

At Céret, in paintings like *Fan, Pipe and Glass*, Picasso explored a new space filled with ambiguity. He succeeded in balancing signs of external reality—inanimate objects—with a new spatial structure, and in doing so, altered the course of Western art. RAD

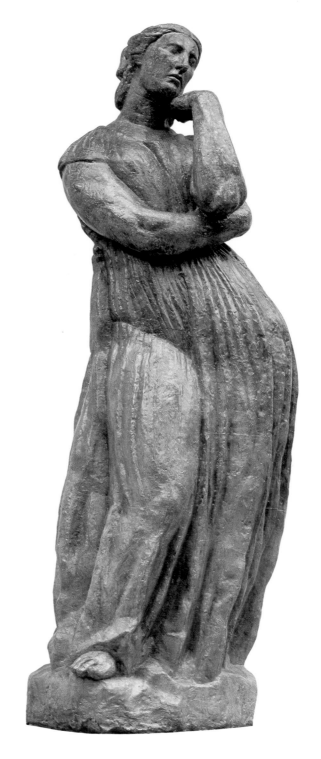

ÉMILE-ANTOINE BOURDELLE

French, 1861–1929

La Grande Penelope, 1912 (cast 1956)

Bronze; h. 96 in. (243.8 cm.)

Gift in memory of Mrs. Richard A. Cooke

by her children, 1965 (3334.1)

Referred to as "the beacon of the future" by Auguste Rodin, Émile-Antoine Bourdelle brought sculptural realism into the twentieth century. Unlike many of his contemporaries, such as Jean Arp and Constantin Brancusi, who perceived the natural world in terms of smooth biomorphic forms, Bourdelle exaggerated surfaces and built up multiple volumes, reveling in the physical presence of the human figure. Themes of allegory, history, and classical mythology provided Bourdelle with the larger-than-life subjects for which he is so well known. He created a constellation of works that depict Adam, Heracles the Archer (a fine cast of which is in the Academy's collection), dying centaurs, and portraits of artists, composers, and sculptors; represented here is Penelope, the virtuous wife of Odysseus. Left in Ithaca, Penelope patiently waited for her husband to return from Troy; finally, after twenty years, her steadfast faithfulness was rewarded. Preoccupied with the theme of Penelope from as early as 1906, Bourdelle created an extensive series of drawings and clay and wax models based on Cleopatre Sevastos, a Greek sculptress who later became his wife. *La Grande Penelope* dates from 1912 and represents the culmination of one of the major efforts of his career.

As is true for much of his other sculpture, Bourdelle found inspiration for the depiction of this figure in the art of antiquity. He drew upon the traditions of classical sculpture and painting for the "S" curve of her posture, muselike stance, and regular features. Ignoring the idealized proportions of these precedents, however, Bourdelle monumentalized Penelope through massively enlarged dimensions. With the gentle rhythms of her swaying figure and serene expression as she leans her head on an upraised hand, Penelope embodies the heroic quality of timeless endurance. JS

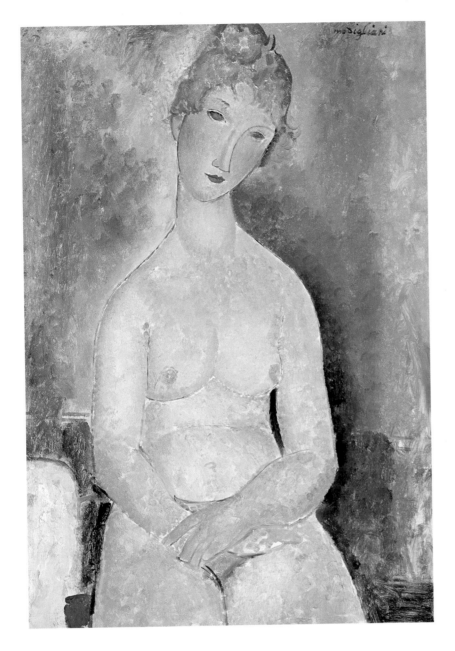

AMEDEO MODIGLIANI

Italian, 1884–1920

Seated Nude, ca. 1918

Oil on canvas; 39½ × 25½ in. (100.3 × 64.8 cm.)

Gift of Mrs. Carter Galt, 1960 (2895.1)

Born of a distinguished family of Sephardic Jews in Livorno, Amedeo Modigliani received his early art training in Venice. In 1906 he moved to Paris, where he spent the remainder of his life, which was cut short at thirty-five by tuberculosis. Handsome and talented, Modigliani was the epitome of the Parisian bohemian artist. During the first quarter of the twentieth century, his paintings of nudes were controversial. Indeed, in 1917 Modigliani's only solo exhibition, composed of a series of nudes, was closed on its opening day on grounds of indecency; the exhibition was held in Galerie Berthe Weill, unfortunately situated opposite a police station. Despite spending most of his artistic life in France, Modigliani remained first and foremost an Italian artist, influenced by Sienese trecento painters, Renaissance masters, and the mannerists.

Between 1917 and 1919 Modigliani painted a half-dozen Botticelli-like nudes, of which the Academy's painting is one. The artist chose a delicate peach color for the sitter's flesh and a light burnt orange for shadows. The flaming red hair completes this catalogue of warm colors, accentuated by the cool painterly background. The configuration of the torso, facial features (especially the eyes), and hair indicates that this may be the same model seen in the artist's *Le Nu blond* painted in 1917 (private collection). RAD

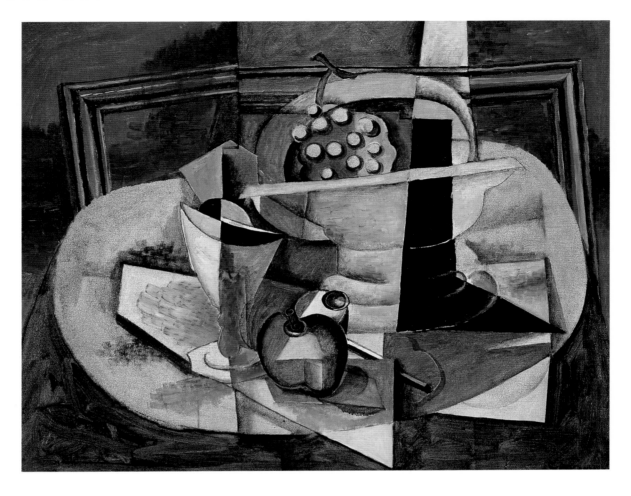

GEORGES BRAQUE

French, 1882–1963

The Apple, 1929

Oil on canvas; 19¼ × 25¼ in. (48.9 × 64.1 cm.)

Gift of the Friends of the Academy, 1941 (4952)

After service in World War I and a long convalescence, Georges Braque resumed painting in the summer of 1917. He attempted to pick up where he had left off with synthetic cubism, a movement that had reintroduced color, tactile qualities, and simplified shapes into cubism. Over the years Braque's continuous efforts to find alternate solutions in his compositions led him to a personal style well known for its perfect balance and harmony between design and color.

Braque was primarily a still-life painter, heir to the great French still-life tradition that included Jean-Baptiste-Siméon Chardin and Paul Cézanne. Braque infused this tradition with a new pictorial language he had developed out of cubism, creating small-scale paintings with humble themes. *The Apple* is typical of his work in the 1920s and early 1930s. An apple, pipe, glass, and bowl of grapes rest precariously on the dramatically tilted tabletop. Covered with an emerald-green cloth that conceals the lower portion, the table appears to be a *guéridon* (round table supported by a columnlike base that ends in a tripod), a favorite subject of Braque during this period. Braque believed that color and form could function independently, as in this painting: the browns, grays, and blacks extend beyond the outlines of the objects and acquire a life of their own. The faceting of the objects into multiple points of view offers an understanding of the full volume of each object. RAD

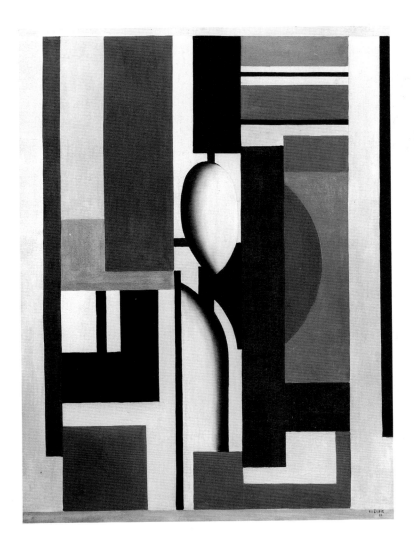

FERNAND LÉGER

French, 1881–1955

Abstraction, 1926

Oil on canvas; 51 1/4 × 36 1/2 in. (130 × 92.7 cm.)

Gift of Robert Allerton through the Friends of the

Academy, 1945 (311.1)

The son of a Normandy farmer, Fernand Léger moved in 1900 to Paris, where he experimented with various painting styles. Strongly influenced by cubism, he became friends with Amédée Ozenfant and Le Corbusier, the founders of purism. The purists had great confidence in the modern machine. Léger incorporated elements from machinery such as pistons, cylinders, and cogged wheels into his compositions, often meshing them with robotlike human figures. Striving to purge his work of all but the most elemental forms, Léger created a personal idiom known for its precision, lack of sentimentality, and mastery of spatial paradox.

Abstraction is one of the few truly nonrepresentational paintings in Léger's oeuvre. For this painting, the artist borrowed from his own works, abstracting and enlarging part of a 1924 mural, *Élément Mécanique* (Kunsthaus, Zurich). *Élément Mécanique* in turn was an enlarge-

ment of a 1922 painting (Louis Carré Collection, Paris). Léger's murals, which are actually easel paintings, were composed with reference to architecture and, specifically, a real or imaginary white wall. The artist used flat planes to reinforce the flatness of the wall. In *Abstraction*, black, blue, gray, and orange-red rectangles overlap, seemingly retreating and advancing. This evocative sense of space, which is found in other works by Léger during this period and seems to deny their essential flatness, is accented in *Abstraction* by the white ovoid and the curved shape below. Because of the cursive lines and their shading, the viewer's eye is led around them and into the ambiguous space created by the colored rectangles and white background. The only personal touch in this meticulous composition is Léger's signature and the date placed in the lower right corner. RAD

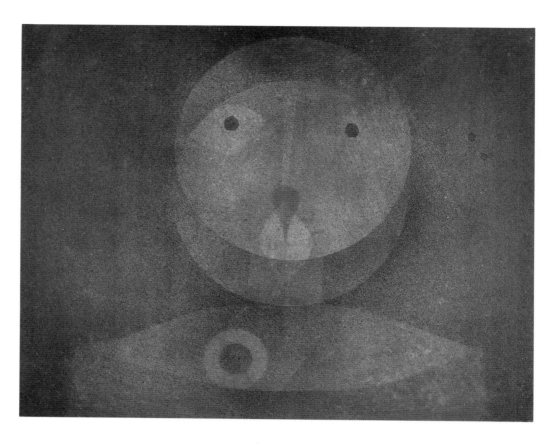

PAUL KLEE

Swiss, 1879–1940

Pierrot Lunaire, 1924

Watercolor on paper; 12 × 14¾ in. (30.5 × 37.5 cm.)

Gift of Geraldine P. and Henry B. Clark, Jr., on the

occasion of their 40th wedding anniversary, 1982

(18,459)

Paul Klee, born in Switzerland, worked in Germany and is considered a seminal figure of German expressionism, one of the important movements in the development of modern art in the early 1900s. Klee differed from other German expressionist artists, however, in his fusing of cubist and other abstract theories into an extraordinarily personal art of fantasy and mystery that was at once closely associated with natural experience and concerned with experiences beyond those in the perceptible world. Klee drew simultaneously from many sources and levels of experience—from nature study and intuition, from reality and dream—creating a complex, metaphorical imagery that is often difficult to interpret and understand. His unique, half-hidden world reveals itself in stages.

At times Klee's art plumbs the secret depths of the human soul and opens its mysteries; Klee's friend Will Grohmann wrote, " . . . his art is not only a picture of our world but also a diagnosis of its problems." *Pierrot Lunaire* refers to a song cycle for recitation with piano, flute, clarinet, violin, and cello composed by Arnold Schönberg in 1912. In this work, Klee uncovers the dark, self-destructive forces in man, interpreting the clown Pierrot as an anguished, alienated martyr. Klee followed the text of several of the songs in creating his image, likening Pierrot's head to the large orb of the moon, a recurring image in the song cycle. Klee depicts Pierrot's heart in his breast, and two more hearts appear faintly above each shoulder, as if insignias of his quest for love. In the position of Pierrot's mouth, Klee placed a light-colored ellipse with an inverted red-brown droplet that probably refers to the eleventh song in the cycle, "Red Mass," in which Pierrot climbs on an altar and tears out his own heart as the host for a gruesome communion. In Schönberg's composition, and reiterated in Klee's watercolor, Pierrot's surreal martyrdom elevates the tragic-clown theme to an analogy of the fate of art and the artist. Klee, who was interested in music and an admirer of Schönberg's work, gives his song cycle a powerful visual form in this remarkable watercolor. JJ

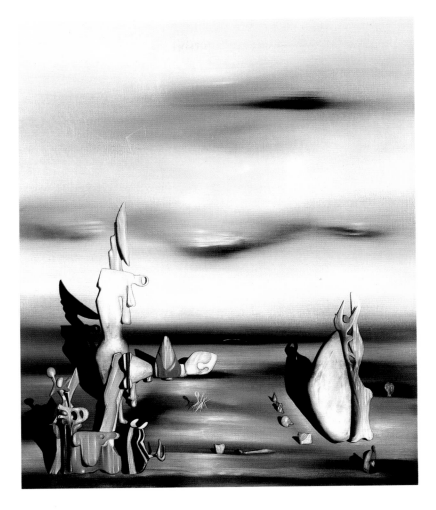

YVES TANGUY

French, 1900–55

The Long Rain, 1942

Oil on canvas; 39 × 32 in. (99.1 × 81.3 cm.)

Gift of the Friends of the Academy, 1943 (262.1)

Yves Tanguy's family originated in Locronon, Brittany, and during his childhood Tanguy spent his vacations there. The region is known for its spectacular megalithic sites, and its haunting menhirs and dolmens made a strong impression on the young boy. Although he denied it late in life, the stones may have been the source of some of the forms Tanguy used in his paintings.

In 1920 Tanguy was called for military service and stationed at Lunéville, where he met the surrealist poet Jacques Prévert. After being discharged in 1922, Tanguy joined Prévert in Paris and there began sketching in the cafés, soon attracting the attention of Maurice de Vlaminck. Tanguy was unsure of his future in art until, in 1923, he happened to be on a bus that passed the Paul Guillaume Gallery, where, in the window Giorgio de Chirico's *The Child's Brain* was displayed. Tanguy got off the bus, studied the painting, and decided then and there that he would devote himself to oil painting. Without receiving any formal training, Tanguy started painting, and by 1925 he had joined the surrealists. In 1939 the artist traveled to America, eventually settling in Woodbury, Connecticut; he became an American citizen in 1948.

The Long Rain is typical of Tanguy's paintings of the early 1940s. Applying his paint in layers of thin glazes, a traditional technique, the artist created the cool blue atmosphere that pervades *The Long Rain*. Stretching to the distant horizon, a bleak plain is populated by strangely colored and striped abstract forms. The large form on the left has some anthropomorphic qualities, but, like the others, it is primarily an odd composite of organic and mineral attributes. The harsh, hard-edged shadows cast by the disquieting forms lead a life of their own, disregarding any distorting effects of the plain or clouded sky. The painting can be interpreted as a macabre dreamscape, or possibly an extraterrestrial landscape; either way, *The Long Rain* is a mildly disturbing image. Of all the surrealists, Tanguy made the fewest references to the everyday world of the five senses, thus creating works that plumb the depths of the imagination and subconscious mind.

RAD

ERNST BARLACH

German, 1870–1938

Russian Lovers, modeled 1908, cast 1909–13

Glazed porcelain; 7½ × 13¾ in. (19.1 × 34.9 cm.)

Purchase, funds from the Robert F. Lange

Foundation, 1986 (5523.1)

Ernst Barlach was one of the great German sculptors of the twentieth century. Although linked with the German expressionist artists who were his contemporaries, his work differs significantly from theirs in that it sprang from Barlach's desire to express universal dignity and feeling rather than his own emotions.

On finishing his training in sculpture at Hamburg, Dresden, and Paris, Barlach devoted himself to writing and making drawings and small ceramic works before taking up a post at a school of ceramics in the Westerwald, a position he held from 1904 to 1905. A trip to Warsaw, Kiev, and Kharkov in 1906 kindled his artistic sensibilities, and he emerged as a sculptor. During his travels through rural Russia, Barlach found himself confronted with peasants whose humanity had not been corrupted or destroyed by society. The simplicity and the nobility of their existence were to him a revelation, and upon his return to Germany he began a series of small-scale clay sculptures of Russian peasants and beggars which expressed this spiritual integrity and power.

The simplified, rounded forms of *Russian Lovers*, cast in porcelain at the Schwarzburg Workshop for Porcelain Art, illustrate Barlach's new, mature style. The two peasants are conceived in broadly handled, almost geometric masses and seem to meld into the base, symbolizing their bond with the earth. Their garments are plain, and their features are not particularized, as Barlach avoided details and allowed all to flow together to emphasize the essential harmony of this courting couple. JJ

WILHELM LEHMBRUCK

German, 1881–1919

Head of a Thinker, 1918

Cast stone; h. 25 in. (63.5 cm.)

Purchase, 1973 (4135.1)

Born into a Rhineland mining family, Wilhelm Lehmbruck showed early artistic promise and at age fourteen enrolled in the School of Arts and Crafts in Düsseldorf. Trained in the academic tradition, Lehmbruck won numerous awards and enjoyed early success. In 1905 he became interested in the subject matter and technique of Auguste Rodin, and after moving to Paris in 1910, he discovered the classicism of Aristide Maillol. Although influenced by other artists, such as the Belgian symbolist sculptor George Minne, Lehmbruck developed his own distinctive style, marked by attenuated proportions, unconventional poses, and evocative moods. With the outbreak of World War I in 1914, Lehmbruck was forced to return to Germany and eventually settled in Berlin. There he served as a nurse in a military hospital and witnessed enormous suffering. Except for a brief retreat in Switzerland, he remained in Germany for the few remaining years of his life.

Rodin's death in 1917 may have inspired Lehmbruck to take up motifs used by the master, something Lehmbruck had briefly done before. The title of the Academy's piece and its delicate impressionistic surface recall Rodin's famous sculpture *The Thinker*, but the similarities end there. Instead of the muscular full figure of Rodin's work, Lehmbruck's *Thinker* is fragmentary. The amputated arms end in ragged edges; a disconnected single clenched fist is held tightly to the chest. The prominent forehead, deep-set eyes, and downturned mouth lend the head a brooding expression. The piece evokes a sense of anxiety and doom. In 1918, when he completed this work, Lehmbruck was in poor health and subject to bouts of depression. Autobiographical notes of torment may be in Lehmbruck's *Thinker*, for a year later the artist committed suicide. RAD

HENRI MATISSE

French, 1869–1954

Annelies, White Tulips, and Anemones, 1944

Oil on canvas; 23⅞ × 28¾ in. (60.6 × 73 cm.)

Gift of the Friends of the Academy, 1946 (376.1)

After settling in Nice in 1921, Henri Matisse created in his paintings a private world of calm, repose, grace, and ease, domesticating the sensual and decorative pastoral themes that had informed much of his earlier work. He worked with a succession of favorite models to depict a world inhabited almost entirely by women. "My models," he once said, "are the principal theme in my work. I depend entirely on my model, whom I observe at liberty, and I decide on the pose that best suits her nature."

This painting, a prime example of these intimate themes, dates from 1944, when the artist was seventy-five years old. In the early 1940s Matisse's life had been disturbed by a series of events which no doubt interfered with his normally prodigious creativity. He was still recuperating from a serious operation in early 1941, which had left him weakened and often confined to bed. In March 1943 the Allies began bombing near Nice, and Matisse was advised to move to Vence. Although forced to leave his comfortable environment and drained of energy, Matisse nevertheless arranged a convenient working space in his bedroom. Marguette Bouvier, who visited Matisse at Vence in October 1944, mentioned that Matisse hung paintings on which he was working on the wall facing his bed. On the day of her visit, there were seven paintings on the wall, in the center a portrait of a girl seated at a table between two bouquets of flowers—*Annelies, White Tulips, and Anemones.*

The model, Annelies, a young local girl whom Matisse took as a student, gazes intently from between the flowers, looking up from a book she has been reading. The flowers' delicate lavender and creamy whites are luminous against the dark table covering and background, in which Matisse scratched patterns with the end of his brush.

The sober colors of the work, compared to the more brilliant hues for which Matisse is famous, perhaps hint at disturbing events in Matisse's life: in spring, 1944, his wife and daughter, who had been working for the French Resistance, were taken prisoner by the Nazis. Madame Matisse spent time in prison, and their daughter was tortured by the Gestapo. This painting, as well as the others from this period, betrays no sign of the turmoil of the war-torn world nor of the disruption and anxiety it caused in Matisse's life. One sees only the artist's ongoing pursuit to create a world of beauty. JJ

HENRY MOORE

English, 1898–1986
Working Model for Stone Memorial, 1961–71
Bronze; 22 × 23 × 24 in. (55.9 × 58.4 × 61 cm.)
Gift of Henry B. Clark, Jr., 1977 (4501.1)

Study for "Family Group", 1944
Ink, wax crayon, and watercolor on paper;
4³⁄₈ × 7 in. (11.1 × 17.8 cm.)
Gift of Mrs. Philip E. Spalding, 1947 (12,558)

Like many artists of this century, Henry Moore spent his early career discarding traditional conventions and seeking new ways to understand the reality of form and shape. He sought, as he said, "to react to form in life, in the human figure, and in past sculpture." Moore found inspiration in the primitive and archaic sculpture from various world cultures that he saw on frequent visits to the British Museum and in natural forms such as bones, pebbles, and shells. Deeply committed to making these forms his own by discovering in personal terms their underlying meanings, Moore mined a rich vein of universal experience buried in our collective subconscious memory.

Working Model for Stone Memorial illustrates the classic, mature result of Moore's artistic search. Dense, compact, heavy, concerned with mass and volume, the work is a biomorphic abstraction with smooth, taut contours that evoke bone pushing out against flesh; its rasp-roughened surface, like a weatherworn stone, is seemingly etched with the marks of age and external forces.

Moore's affirmation of natural, vital forces is perhaps most explicit in his many works that deal with the human figure. This figurative drawing is from a large group of sketches that led to a series of bronze sculptures, each titled *Family Group*, completed between 1946 and 1949.

During World War II, Moore spent considerable time discreetly observing and drawing civilians who took refuge in London's subway stations. As he watched families and friends communally waiting out bombing raids, he filled his notebooks with poignant images that were pitiful yet heroic. In the Academy's drawing, one child is held protectively between his father's legs while a younger child is shown in the arms of his parents. Moore later likened this gesture to a knot in which the arms come together and are tied by the child, a metaphor expressing the deep experience of family closeness and continuity. JJ

 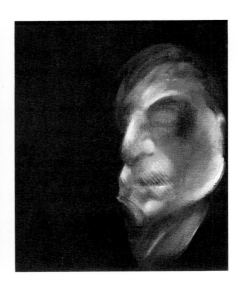

FRANCIS BACON

English, b. 1909

Three Studies for a Self-Portrait, 1983

Oil on canvas; each: 14 × 12 in. (35.6 × 30.5 cm.)

Gift of Mr. and Mrs. Henry B. Clark, Jr., 1983 (5165.1)

Conventional concepts of the terms beautiful and ugly help little in coming to terms with Francis Bacon's art. Motivated by a fierce thirst for reality, Bacon makes the important distinction that realism in art must not be confused with the simple desire to give a translation, in convincing terms, of objective existing phenomena. He once defined realism as "an attempt to capture the appearance together with the cluster of sensations that the appearance arouses in me. I would like to make images which reflect all kinds of things that I instinctively feel about my own species, and I would like, in my arbitrary way, to bring one nearer to the actual human being." Bacon's concentration on the "brutality of fact," his deliberate deforming and distorting of forms—half magic, half menace—is the method he uses to achieve this desire.

Among Bacon's most immediate and compelling works are close-up intimate portraits, small single paintings, diptychs, and triptychs, each canvas fourteen by twelve inches; the subject always a close friend or himself. This work is part of a series of self-portrait studies that provides a remarkable record of Bacon's penetrating vision. The triptych format recalls medieval and Renaissance altarpieces, in which the side panels amplify the narrative or subject stated in the center panel. Bacon, who conceptualizes his images in threes, uses the triptych to enfold the viewer, believing that the repetition of images can induce a trancelike state. In one frontal and two three-quarter or profile views, Bacon records the salient data of his features, but he alters these natural forms, blurring, even obliterating them by dragging a dry brush or rubbing a rag over the surface of the wet paint. The bony substructure and flesh seem to merge and become fluxes or whorls of matter.

In describing his method of working, Bacon emphasizes the importance of allowing chance to come into play. He always works directly on the canvas with rarely anything more in mind than an image and a state of feeling as his point of departure. For him the act of painting is a series of discoveries, and "non-rational" marks or accidents—a drip of paint, a slip of the hand, the way pigment moves—constantly suggest to him new ways in which a work can go forward.

Although Bacon declares he has no message to deliver, no hidden symbolic meanings, his works evoke a sense of the ephemeral nature of human existence. JJ

American Art

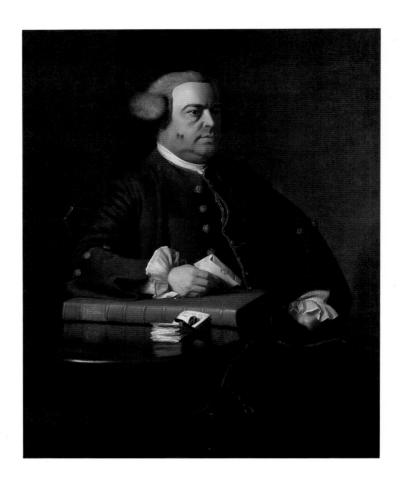

JOHN SINGLETON COPLEY

American, 1738–1815

Nathaniel Allen, 1763

Oil on canvas; 50 × 40 in. (127 × 101.6 cm.)

Purchase, Frank C. Atherton Memorial Fund, 1976

(4376.1)

Massachusetts painter John Singleton Copley, a self-taught artist, became the leading portraitist of Boston, indeed of the American colonies, during the last half of the eighteenth century. This portrait is an outstanding example of the skills Copley developed early in his career—precise naturalism, carefully controlled color and light, and evocation of the sitter's character and social station—and represents the standard of excellence against which much colonial American portraiture is measured.

Nathaniel Allen (1718–78) typifies Copley's colonial patrons. A successful merchant with interests in shipping and the fishing industry, Allen served as a justice of the peace and representative of the Great and General Court and Assembly. As a Congregationalist and moderate Whig, Allen was a respected citizen of Gloucester, Massachusetts.

Through careful drawing, controlled brushwork, and close attention to the play of bright light and deep shadow, Copley demonstrated his technical mastery. Not only did he detail the appearance of the sitter, down to the two hairy moles on his cheek, Copley particularized Allen's business attributes, precisely rendering the ledger and its accompanying stack of documents. Thus, with likenesses of unflinching naturalism, were sitters rewarded for the hours of posing such intense scrutiny required.

Copley recorded more than the physical appearance of his patrons, however, as here the suggestion of position and achievement plays an important role. Allen's massive bulk fills the picture surface, its triangular format lending monumentality and stability to his bearing, the sober color scheme reinforcing his serious mien. Gesture and posture contribute further to Allen's general sense of prosperity—he sits comfortably, fist planted firmly on hip, and seems to consider the letter in hand. Allen is depicted as confident, capable, and in control of his affairs; his contribution to the success of the new social experiment in America is clearly implied.

The colonists did not view Copley's emphasis upon worldly achievements with prejudice; his position as Boston's leading portraitist demonstrates that he presented his sitters the way they wished to be seen. In fact, the colonists' belief that their material well-being was a sign of heavenly favor provided justification for Copley's style of portraiture. JS

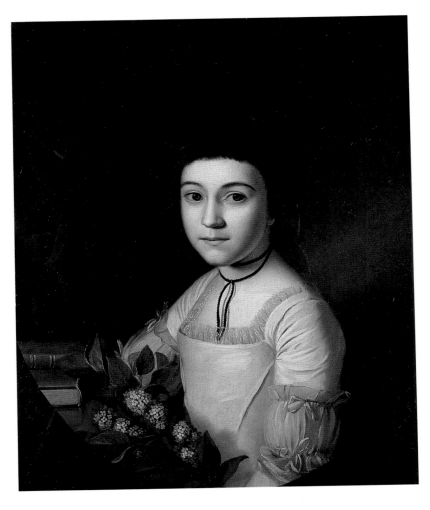

CHARLES WILLSON PEALE

American, 1741–1827

Henrietta Maria Bordley, 1773

Oil on canvas; 23⅝ × 19 in. (60 × 48.3 cm.)

Purchase, Robert Allerton Fund and Academy Fund,

1972 (4082.1)

A saddler, soldier, clock and watchmaker, an inventor, naturalist, writer, museum proprietor, and founder of a family dynasty of artists, Charles Willson Peale personified the spirit of eighteenth-century enlightenment. Believing that artistic ability was not the result of innate genius but diligent application, Peale took up the brush as a young man inspired to improve upon the achievements of the first artists whose work he had viewed. Although a painter of varied themes, he specialized in portraiture and made likenesses of America's leading soldiers and statesmen. Peale found early support for his interest in the arts from friends and benefactors in his native area, the tidewater colony of Maryland. John Beale Bordley, a prominent lawyer and agriculturalist of Wye Island, and longtime associate of Peale's family, led the subscription taken up in 1766 to send the aspiring artist to study in London, where he met Benjamin West. Peale painted numerous portraits of Bordley family members, including this one of Henrietta Maria, Bordley's eldest daughter. It dates from her school years in Philadelphia, where Peale often made working trips before moving there in 1776.

Peale painted many portraits of children, but the formality of this work stands somewhat outside of Peale's typical treatment. Generally his paintings depict childhood as a formative period of growth and development that prepared the young for the responsibilities of adulthood. Peale's portraits often suggest this new-found respect for the innocence and purity of youth with allusions to familial intimacy, informality, and affection. However, this portrait of a ten-year-old girl, away at school learning the polish and skills expected of a young lady, harks back to the earlier practice of presenting children as miniature adults. Comfortable in her elegant dress, graceful and erect, self-composed and confident, Henrietta demonstrates her feminine graces. The swag of drapery in the background, with its association of wealth and grandeur, complements the sitter's achievements, as do her attributes—the books and flowers. The two volumes on the table may refer to her education, just as the lilacs, the first flowers of spring, symbolize youth and fecundity. As Peale once assured Bordley from Philadelphia, ''Henrietta looks charmingly well.'' JS

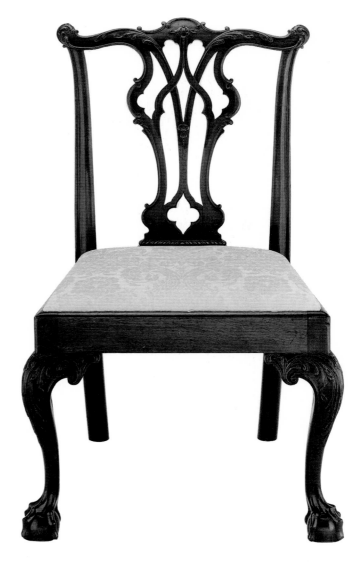

SIDE CHAIR

American, Philadelphia, ca. 1760–80

Mahogany; 37½ × 21½ × 17½ in.

(95.3 × 54.6 × 44.5 cm.)

Purchase, 1971 (3747.1)

During America's colonial period, as both population and personal wealth increased, a market for decorative arts developed. In general, the colonies looked to Great Britain for cultural guidance, and European fashions dominated American decorative arts. The inspiration provided by furniture pattern books published by major British designers was integral to the stylistic development of these art forms. Although few pieces of furniture can be attributed with certainty to Thomas Chippendale, his ideas, as published in *The Gentleman and Cabinet-maker's Director*, were instrumental in shaping British and American taste in furniture design. It first appeared in 1754 in England, with copies entering the American colonies shortly thereafter.

One of a pair in the Academy's collection, this chair, possibly by Philadelphia cabinetmaker Benjamin Randolph (active 1760–82), offers a particularly fine reflection of America's appreciation of Chippendale's designs. Adapted from a pattern joining rococo and Gothic motifs, the chair back and cabriole legs are enriched with carved acanthus leaves and other natural forms derived from French precedent; these are gracefully balanced with the pointed arch, tracery elements, and quatrefoil shape associated with medieval French architecture. The interlaced elements of the Gothic splat, visually lightened by raised

ornamentation, merge, separate, and curve harmoniously, each part smoothly integrated with the other. The disparate elements of the chair back coalesce into a unified whole as the topmost piercings continue into the crest rail and the acanthus leaves sweep upward from the splat, maintaining their sinuous movement across it. Even the gentle curve of the stiles and their subtle narrowing contribute to the chair's organic and measured rhythms.

Although specific patterns and combinations deriving from Chippendale and other furniture designers did not appear exclusively in one colony or another, elaborate surface carving and splat patterns such as this enjoyed particular popularity in Philadelphia, an important center of taste and design during the third quarter of the eighteenth century. The Academy's side chairs surely represent the highest level of achievement reached during the golden age of Philadelphia furniture manufacture. JS

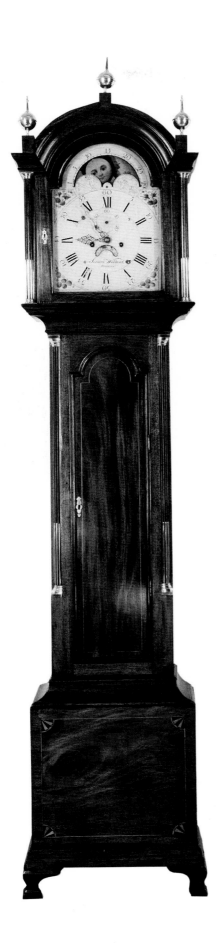

TALL CLOCK

American, 1790–1800

Movement by Simon Willard (1753–1848),

Roxbury, Massachusetts

Mahogany case with light wood inlays and brass fittings

h. 7 ft. 9½ in. (2.37 m.)

Gift of Mary Ann Burgess McCrea in memory of

Stanley Barrows McCrea, 1981 (4993.1)

Tall clocks were first produced in Europe in the latter part of the seventeenth century, and the form was probably introduced into America not long afterward. This type of clock was developed to protect the movement from dust and damage as well as to conceal the weights and pendulum.

The maker of the clock's movement, Simon Willard, was among the best clockmakers of the American Federal period. Born in Grafton, Massachusetts, he set himself up in business in Roxbury in the late 1770s. Willard had a genius for his trade; he possessed a natural mechanical ability, an inventive mind, and meticulous work habits. His clock mechanisms were fashioned by hand with absolute precision; that the eight-day movement of the Academy's clock works as well today as when it was made attests Willard's remarkable skill and his high standard of workmanship.

The beauty and precision of Willard's clock movement is entirely concealed from the viewer by the case, which, as was customary with the wooden cases of such clocks, was made not by Willard but by a professional cabinet-maker (whose identity is not known). The fine proportions and the straightforward design give the case elegance and distinction.

Such clocks frequently convey much information in addition to the time. The Academy's clock has a movable register above its face which shows the phase of the moon; maps of the world, divided into two hemispheres, appear below it. A dial below the "XII" tells the seconds, and a curved slot beneath the center boss reveals the day of the month. Painted dials, like the wooden cases, were made by other tradesmen. The clock's dial, decorated with delicate sprays of roses and strawberries, bears a backplate stamped "Wilson," the name of a manufacturer in Birmingham, England. JJ

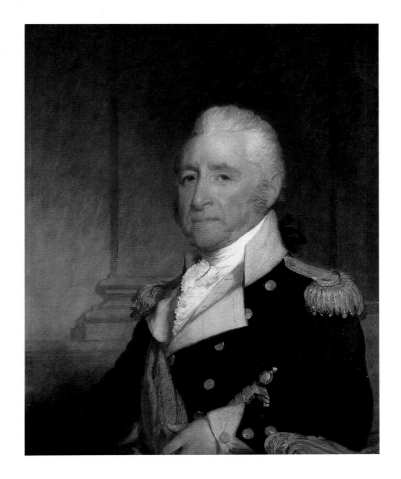

GILBERT STUART

American, 1755–1828

Governor John Brooks, ca. 1820

Oil on canvas; 32 × 26 in. (81.3 × 66 cm.)

Gift of Mrs. Edward T. Harrison in memory
of her husband, 1965 (3370.1)

Highly praised for his ability to infuse his likenesses with vibrancy and naturalism, Gilbert Stuart was the preeminent portraitist of Federal America. Immediately popular upon his return in 1792 from five years of study in the London studio of Benjamin West, Stuart recorded the visages of presidents, politicians, military officers, businessmen, foreign dignitaries, and leaders of society alike. Commissions were constant as he followed the route of the nation's changing capital cities—New York, Philadelphia, and Washington—and finally settled in Boston.

Professionally respected, politically recognized, and socially responsible, John Brooks (1752–1825) was typical of Stuart's sitters. A native of Massachusetts, Brooks stood in loyal support to George Washington during the Revolutionary War, ultimately rising to the rank of colonel. In 1816 he became governor of Massachusetts, a position he retained for several terms.

Employing stylistic principles popular in England at the time, Stuart recorded with keen understanding the character of his subject. Brooks sits comfortably erect in uniform, hand on his sword's hilt, and meets the eye of the viewer. His confident posture and straightforward glance give the image a sense of command and bearing, and Stuart's inclusion of standard props of grand manner portraiture—the loosely sketched pilaster and high-style empire gilt chair—lends additional stature to the sitter.

Unlike many contemporary American portraitists who produced likenesses of high polish and fine detail, Stuart introduced the fluid handling of pigment and luminous color harmonies learned from the study of eighteenth-century British portraiture. Forsaking a reliance upon preliminary studies, Stuart approached the canvas directly, building forms by deftly applying pigments of rich and varied shades. In addition to animating the canvas surface, Stuart's facile control of brush and color also tangibly evokes the textures of the physical world—opalescent flesh, gleaming gold, transparent lace, and soft hair. Stuart further enlivened the likeness with his skilled handling of the chromatic brilliance of the sitter's uniform and the modulated, warmly toned atmosphere that envelops the background. Stuart infused this likeness of Governor John Brooks with a vitality and presence that match the immediacy and approachability suggested by the sitter's direct gaze and forthright positioning. JS

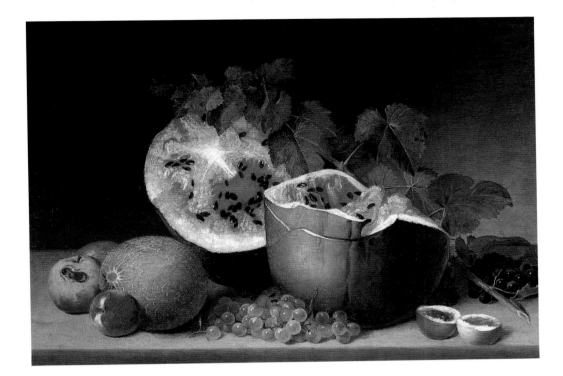

JAMES PEALE

American, 1749–1831
Still Life, ca. 1824
Oil on panel; 26½ × 18 in. (67.3 × 45.7 cm.)
Gift of Mrs. Edward T. Harrison, 1967 (3497.1)

Painting in Philadelphia at the turn of the nineteenth century, James Peale took lessons in watercolor and oil from his older brother, Charles Willson Peale, and became an active member of the Peale dynasty of artists. Primarily a miniaturist, James turned to still-life subjects during the 1820s, as his failing eyesight must have made it difficult to maintain his exacting work. James and his nephew, Raphaelle Peale, are now recognized as the founders of the American still-life tradition.

This panel typifies the artist's frontal grouping of fruits on a shallow tabletop. Close to the picture plane and monumental in size, a broken watermelon, cut and uncut peaches, two varieties of grapes, and what seem to be an apple and cantaloupe rest upon a smooth surface. The fruit is strongly illuminated from the left, their clearly lit forms silhouetted against a darkened background; some shadowed grapes and leaves are heightened by their appearance against a lighted section of wall. With careful attention to the suggestion of mass, volume, light, and rich textures, Peale imbued these forms with a convincing physicality. Such a tempting wealth of fruits, considered delicacies in the early Federal period, may reflect a pride in the prosperity and agricultural promise of the youthful America.

Although the traditional European hierarchy of subjects placed still life in a position of minor respect—it was believed that painting such an artificial arrangement of objects was more a product of imitation than of learning and creativity—the selectivity and choice demanded of the artist in his still-life subjects displayed to best advantage his control of formal considerations. Aligned along the tabletop, the objects conform to the classic shape of an isosceles triangle; the stability of their placement finds further geometric reinforcement in the emphatic horizontal axes of the table edges. Peale accented the rhythm of the rounded forms, closely juxtaposing the repeated irregular shapes of the leaves. Peale's palette, bright and clear, centers on the complementary relationship of red and green. Line, color, and design here coalesce into a masterful composition of compelling monumentality and presence.

Marred by cracks, overripeness, and worm holes, these fruits suggest the inexorable passage of time. Traditional allusions to the transience of earthly pleasures, they may also represent the personal musings of an aging artist, reflecting on the brevity of life and his own inescapable mortality. JS

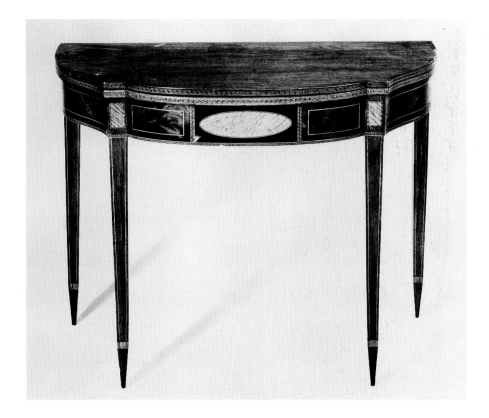

ELISHA TUCKER

American, Boston, act. 1809–27

Card Table, ca. 1810

Mahogany with rosewood and satinwood veneers,
and dark- and light-wood stringing and inlays

28¼ × 35½ × 16¾ in. (71.7 × 90.2 × 42.6 cm.)

Gift of Mrs. Edward T. Harrison in memory of her
mother, Lamora Sauvinet Gary, 1971 (3819.1)

At the turn of the nineteenth century Americans generally continued to view Great Britain as a leader in cultural matters including style in costume, interior design, and decorative arts. Card tables—relatively new furniture forms created to accommodate the needs of increased leisure-time activities—demonstrate the American adaptation of the patterns published by British furniture designers such as George Hepplewhite. Following the lead set in Hepplewhite's *Cabinet-Maker and Upholsterer's Guide* of 1788, Elisha Tucker replaced the robust sculptural qualities, organic motifs, curvilinear movement, and cabriole legs of the Chippendale period with lighter, more linear and geometric forms. Of delicate proportions and precise contour, the Academy's square card table, with half-serpentine ends and elliptical front, rests upon slender, tapering legs. Tucker accented the crisp geometry of the card table with fine veneer and inlay work. Oval and rectangular panels of shimmering satinwood appear on the table and legs just as a fine Grecian key pattern runs along the tabletop edge; intricate inlays of contrasting woods form decorative borders and outline related rectilinear shapes. An elegant example of Federal-period furniture, this card table is one of the rare Boston pieces that retains its maker's label.

Hepplewhite's designs reflect the interest in classical antiquity prevalent in Europe after the discovery of Pompeii, Herculaneum, and the ancient sites of Dalmatia. By adopting geometric balance, elegant linear patterns, and classical motifs in their furniture, Americans demonstrated more than just blind allegiance to European taste and prototype. As news concerning the sites of antiquity reached the United States, Americans recognized certain similarities between their democracy and the Roman republic. In their search to find emblems to symbolize their deeds and aspirations, they readily found classical style and form an appropriate archetype. Thus, Federal-period furniture such as this card table seems to reflect the mood of the nation, embodying the sense of patriotism so strongly held by Americans at the beginning of the nineteenth century. JS

WILLIAM GUY WALL

Irish, 1792–after 1864 (act. U.S. 1818–36 and 1856–62)
Cauterskill Falls on the Catskill Mountains, Taken from under the Cavern, 1826–27
Oil on canvas; 37 × 47 in. (94 × 119.4 cm.)
Gift of the Mared Foundation, 1969 (3583.1)

The nineteenth century was a period of increased leisure time, recreation, and travel in the United States. Summer trips became fashionable, and the interests of the traveler fueled a developing market for painted and printed images of scenic views. Americans took new pride in the beauty of their nation, and landscape subjects joined portraiture as a favored theme in painting. Topographic in their approach, artists depicted the picturesque side of nature, where man and wilderness met, often rendering views of natural landmarks. Kaaterskill Falls rivaled Niagara Falls and the Natural Bridge of Virginia as one of the most popular themes of the time. William Guy Wall's *Cauterskill Falls*, exhibited to popular acclaim in 1827 at the second annual exhibition of the National Academy of Design, is an early example of the developing genre.

Located in Greene County, New York, and renowned for a semicircular gallery behind its flowing water, Kaaterskill Falls figured in the itineraries of tourists and artists alike. In this painting, Wall positioned the viewer in the back of the cavern looking out, the curving rock roof framing a magnificent wilderness vista. The immense scale of this natural amphitheater and the receding expanse of forested mountains dwarf a group of tourists as they explore the area. Luminous in color, fresh in brushwork, and benign in mood, the painting reflects the scenic qualities for which Kaaterskill Falls was so admired.

Later in the century American landscapists became increasingly concerned with capturing the sublimity of their country's awe-inspiring vistas and evoking the meditative state encouraged by its more serene aspects. Wall's work, however, developed out of an earlier topographic tradition that found its basis in straightforward representation. With a direct approach, neither romanticized nor idealized, Wall commemorated a development seminal to America's self-perception: eager tourists investigating a picturesque natural landmark and experiencing the beauty of their native land. JS

THOMAS SULLY

American, 1783–1872

Elizabeth McEuen Smith, 1823

Oil on canvas; 30 × 25 in. (76.2 × 63.5 cm.)

Purchase, Robert Allerton and Prisanlee Funds and

with funds derived from the bequest of

Katherine M. Jenks, 1985 (5442.1)

Portraiture remained the primary subject of American artists well into the nineteenth century, and after the death of Gilbert Stuart, Thomas Sully became the premier portraitist in Philadelphia. Traveling often to the major metropolitan areas, he was among the most sought-after painters of likenesses on the eastern seaboard. He rendered more than two thousand portraits, including likenesses of American presidents, statesmen, military officers, famous actors and actresses, successful businessmen and other professionals, prominent members of society, and even royalty.

Little is known regarding Elizabeth McEuen Smith, the sitter depicted in this work. Sully recorded in a detailed log of his paintings that one of Elizabeth's sisters commissioned the canvas; he further noted that it was begun on November 24, 1823, and completed twenty-six days later. That Sully at the same time painted Elizabeth's sisters, Mary and Emily McEuen, in a double portrait (Ganz Collection, Los Angeles) suggests that the young women may have intended the works as gifts for each other.

Painted in mid-career, when Sully's talent was at its peak, this portrait reflects the casual grace, exquisite color harmony, sensual paint handling, and figural idealization for which the artist is known. Comfortably seated, her hand gracefully placed at her chin, Elizabeth engages the viewer's attention with her direct gaze. Her oval face, softly curved eyebrows, unblemished complexion, slender neck, and gently sloping shoulders are idealized in accordance with contemporary standards of feminine beauty. Sully complemented his sitter's delicate loveliness with the sensitive handling of translucent shadows and the masterful consonance of cool blue, glowing copper, deep red, and porcelain white tones. The facile handling of creamy pigment belies further the skill underlying the artless charm of his portraits. Ultimately, however, it is Sully's luminous treatment of the eyes that is central to the serene beauty of Elizabeth McEuen Smith; as one nineteenth-century critic commented, "Nobody ever painted more beautiful eyes." JS

FREDERIC EDWIN CHURCH

American, 1826–1900

The Andes of Ecuador, ca. 1855

Oil on canvas; 14½ × 21 in. (36.8 × 53.3 cm.)

Purchase, Robert Allerton and Prisanlee Funds

and gifts of Mrs. Wallace Alexander and Renee Halbedl

by exchange, 1987 (5622.1)

Perhaps more than any other American artist of the mid-nineteenth century, Frederic E. Church popularized landscape paintings of epic proportion and cosmic meaning; he approached his subjects with the observant eye of a naturalist and the transcendent vision of a prophet. Church mastered his craft while studying as the only pupil of Thomas Cole, the leading light of the Hudson River school, and learned from him to rely on sketches made directly from nature in the production of his finished studio works.

Looking beyond New England and the Hudson River Valley for his subjects, Church visited the far corners of the globe, trekking to Labrador, the Near East, and Central and South America, drawing the land before him. The studies that resulted became the foundation of enormous exhibition pieces such as the 1855 *The Andes of Ecuador* (Reynolda House Museum, Winston-Salem, North Carolina). The Academy's painting, possibly a reduced replica, more probably a preliminary study, is closely related to the larger work, which was at the time Church's most ambitious painting.

Remote and primordial, South America was a land most Americans would never see; Church's detailed landscapes offered vicarious adventure to the armchair traveler. *The Andes of Ecuador* stems from Church's first trip (1853) to the southern hemisphere, where he advanced through the wilderness of Colombia and Ecuador, incessantly recording the dramatic landscape around him. Fascinated by the natural sciences, he depicted with technical virtuosity and a keen eye for detail a magnificent vista of immense breadth and depth. But Church combined more than technical brilliance and scientific detail with natural grandeur. Like many artists of the period, he viewed nature as a mirror of divine truth capable of inspiring intense spiritualism. To many Americans the sun represented a profound manifestation of the divine, and in this work it shines on a panorama that includes a few peasants, little corrupted by civilization and at home in these vast and distant reaches of equatorial mountains, jungle, water, and sky. This source of all life envelops within its glowing radiance the harmony of man and nature at its most elemental. Church's vision is one of hope, well-being, and contentment. *The Andes of Ecuador* is, indeed, the statement of an inveterate optimist. JS

THOMAS MORAN

American, 1837–1926

Grand Canyon of the Yellowstone, Wyoming, 1904

Oil on canvas; 30 × 60½ in. (76.2 × 153.7 cm.)

Gift of Bank of Hawaii, 1970 (3701.1)

With his spectacular landscapes depicting the wild and sublime character of the frontier territories, Thomas Moran helped shape the late nineteenth-century perception of the American West. A veteran of several western survey expeditions and trips of his own, Moran drew on his firsthand experiences of the region to paint natural phenomena as awesome as Yosemite, Yellowstone, and the Grand Canyon of the Colorado. It was with the purchase of Moran's *The Grand Canyon of the Yellowstone* (U.S. Department of the Interior, Washington, D.C.), of which this is a later variant, that the U.S. Congress marked its decision in 1872 to preserve the Yellowstone region as America's first national park.

Moran once commented that the memory of Yellowstone's "stupendous and remarkable manifestations of nature's forces" would remain with him forever; indeed he returned to the subject numerous times. The Academy's work is one of several variations of a view across the canyon to the lower falls of the Yellowstone River. Moran placed the viewer on the canyon's rim; the opposite side rises high on the picture plane, the 1,000-foot-deep chasm drops steeply down. The vast canyon appears in a panoramic format of awe-inspiring breadth and depth; trees and rock outcroppings in the foreground provide a sense of scale that reconfirms the grand dimensions of the gorge. As Moran depicted the ever-changing play of light on the canyon walls and craggy rock formations, he revealed the earth's glowing coloristic richness, the "beautiful tints" that the artist supposedly said were "beyond the reach of human art." Finally, in the center distance, all but enshrouded in the mists that they produce, appear the lower falls that are responsible for shaping this natural wonder.

Although Moran executed numerous detailed drawings and sketches on the spot and relied on them in the creation of works such as this, his paintings are not dryly topographical. He combined his keen eye for detail with a profound appreciation of nature's beauty and its spiritually uplifting effect. Through careful orchestration of deep space, varied atmospheric effects, striking color, and rich textures, Moran transcended mere transcription to exalt the sublimity of the wondrous site. In an age when the transcontinental railroad was spelling the demise of America's primeval wilderness, *Grand Canyon of the Yellowstone* stands at the end of an indigenous landscape tradition in which the beauty and majesty of the land stood for the truth and future of the American nation. JS

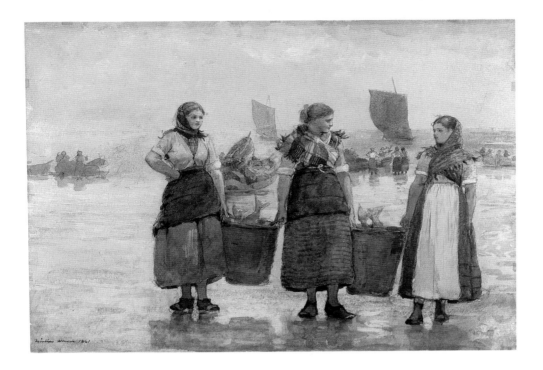

One of America's best-known artists, Winslow Homer is often considered the father of American watercolor painting. Although he practiced the technique as early as the 1870s, Homer's twenty-month sojourn in England in 1881–82, during which he used watercolor almost exclusively, represents a milestone in his mastery of the medium. *Fisherwomen, Cullercoats* dates from early in his stay in Great Britain and reflects his command of the technique.

The small village of Cullercoats, Homer's base of operation in England, overlooks the North Sea. Its high cliffs, rough seas, gray skies, and sturdy fisherfolk may well have reminded Homer of a favorite haunt on the northeast coast of America—Gloucester, Massachusetts. To make a living in this unforgiving environment, the men fished at night, and in the morning the women divided the catch for street-side sale in nearby towns. Generally more interested in the activities of the women, Homer here depicted three young fishmongers carrying fish-filled baskets away from the water. In the distance, other women assist the men in beaching the flat-bottomed cobles.

Unlike many of his contemporaries who used watercolor to create a highly controlled, finely detailed image, Homer understood its inherent fluidity and freshness. After sketching in pencil the basic composition of *Fisherwomen, Cullercoats*, Homer built up the scene with overlapping or adjacent transparent washes. Typical of his handling, Homer treated the watercolor with additive and

WINSLOW HOMER

American, 1836–1910
Fisherwomen, Cullercoats, 1881
Graphite and watercolor on paper
13 1/2 × 19 3/8 in. (34.3 × 49.2 cm.)
Purchase, 1964 (15,091)

subtractive processes. As he brushed new pigments onto dry patches of color, he created details such as the horizontal tucks in the women's skirts. His control of a reductive technique appears where, in order to further modulate the sand in front of the women, he lifted off pigment by dampening the area and working it with a dry brush. By such manipulations Homer created a freshness and luminosity in this scene of women, shore, and sky.

During the second half of the nineteenth century, marine subjects found a place in the popular arts, and works such as *Fisherwomen, Cullercoats* indicate Homer's association with the genre. For him, the endurance and courage needed to survive the harsh environment of the fishing village symbolized a life lived close to nature. The Academy's work celebrates the strength of the fisherwomen with a compositional arrangement that metaphorically and literally links their forms to each other and to their livelihood. In their acceptance of such a rigorous life Homer discovered what he perceived to be a nobler and purer human condition. JS

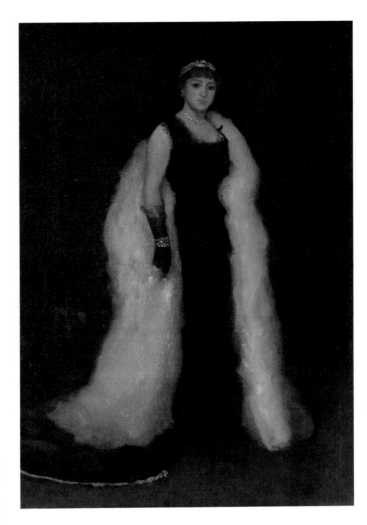

JAMES McNEILL WHISTLER

American, 1834–1903

Arrangement in Black No. 5: Lady Meux, 1881

Oil on canvas; 76 1/2 × 51 1/4 in. (194.3 × 130.2 cm.)

Purchase, Acquisition Fund, funds from public

solicitation, Memorial Fund, and Robert Allerton Fund,

1967 (3490.1)

An elegant dandy, acerbic aesthete, and outspoken proponent of modern art, James McNeill Whistler was not only one of America's more notorious expatriates but one of the most accomplished portraitists of his time. Committing himself professionally to art in Europe in 1855, he worked primarily in London. After a two-year sojourn in Venice, where he made etchings, pastels, and small-scale oils, Whistler returned to London in 1881, probably hoping for a major commission that would bring him back into the public eye. His opportunity came with this portrait of Valerie Susie Meux (ca. 1856–1910).

A well-known British social figure—she had a menagerie of exotic animals at her country residence and purchased London's original Temple Bar for the estate's adornment—Mrs. Meux (later Lady Meux) commissioned three portraits from Whistler. On completion of the first, *Arrangement in Black No. 5*, Whistler reportedly displayed the work in his studio for Edward VII (then Prince of Wales) and Princess Alexandra as well as for the press. Commended by the royal couple, the portrait inspired high praise in numerous reviews. One critic was so impressed with the elegance of Mrs. Meux's figure and dress that he likened her to Venus, the classical goddess of beauty. It was this first portrait that Whistler chose to exhibit in the 1882 Paris Salon, where it was enthusiastically received by the public and favorably commented upon by Edgar Degas.

Always relying on actual subjects, Whistler nonetheless argued for the legitimacy of artistic freedom and released his work from the strict illusionism of more traditional portraiture. In this likeness of Mrs. Meux he created a sensuous tonal statement of rich blacks and whites accented by red lips and auburn hair; the elegant contours of the fur as it flows onto the floor from her sloping shoulders and the sinuous lines of her provocatively bared arm contribute to the portrait's seductive harmony. Expressing more than the physical presence of the sitter, Whistler delighted in the concordance of line, color, and design that in paint suggests the harmonic properties of music. Whistler recognized the similar creative roles of musician and artist in orchestrating the chords, tones, and rhythms of sight and sound. He even adopted musical terms in the titles of his paintings, as in this elegant and sensual portrait of Mrs. Meux. JS

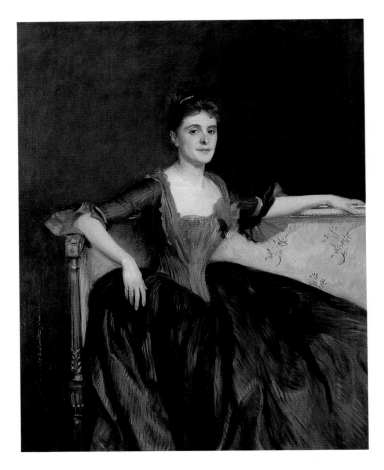

JOHN SINGER SARGENT

American, 1856–1925

Mrs. Thomas Lincoln Manson, Jr., ca. 1890

Oil on canvas; 56 × 44¼ in. (142.4 × 112.4 cm.)

Purchase, 1969 (3584.1)

The product of a cosmopolitan European upbringing, at home in the urbane and wealthy circles of European and American society, a precocious student of painting, John Singer Sargent was the most sought-after portraitist in the Anglo-American world at the turn into the twentieth century. Although Sargent initially studied art and established himself as a society portraitist in Paris, he settled permanently in 1886 in England, where he built his reputation practicing a sophisticated technique characterized by fluid brushwork, exquisite color harmonies, and self-conscious style. Two successful painting trips to the United States—the first from 1887 to 1888, the second from 1889 to 1890—confirmed his position as the leading society portraitist of his day.

This portrait stems from Sargent's second sojourn in America when, for almost a year, he lived on New York's Madison Avenue in the residence of Mr. and Mrs. Thomas Lincoln Manson, Jr. According to tradition, Sargent painted this likeness as a gift for his hosts in appreciation of their hospitality. Mrs. Manson, wearing an elegant gown, a jeweled comb in her hair, and flashing rings on her right hand, exemplifies the standard of high fashion Sargent set for his society portraits. Positioned on a Louis XVI sofa, her luminous form emerges from the penumbral background. The harmonious tonal relationship of iridescent silk, translucent flesh tones, pastel upholstery, and surrounding shadows testifies to Sargent's exquisite sense of color. Drawing with facile strokes of multihued pigment and manipulating his brush with verve and fluency, Sargent captured the confidence and sense of station central to the self-image of the rich. Indeed, with the studied informality of Mrs. Manson's pose and the naturalism with which she assumes the comforts of her class, this portrait responds to the taste of the time. A masterful technician, Sargent celebrated Mrs. Manson's social rank; he showed the sitter in command of an elite world of wealth and privilege.

Although Sargent's emphasis on elegance and stylishness answered his sitter's social needs, his portraits often reflect as well an appreciation of human individuality. His friendship with the sitter allowed him to portray an especially forceful sense of character, her direct gaze suggesting a psychological resonance unexpected in society portraiture. JS

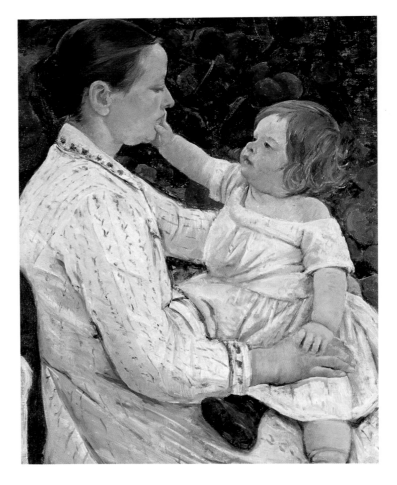

MARY CASSATT

American, 1844–1926

The Child's Caress, ca. 1891

Oil on canvas; 25½ × 19¾ in. (64.8 × 50.2 cm.)

Gift in memory of Wilhelmina Tenney by a group of
her friends, 1953 (1845.1)

Leaving the comforts and prosperous security of her upper-class family in Philadelphia, Mary Cassatt settled in Paris in 1874, determined upon a career in art. A work she exhibited in the annual Paris Salon attracted the attention of Edgar Degas and led to a lifelong friendship between the always respectable Cassatt and the often intractable Frenchman. Cassatt ignored the traditional conservatism of academic art circles, preferring the modernity of subject and approach practiced by Degas and his impressionist associates. Like her mentor she ascribed to the belief that art should be of its time.

Rarely turning to the landscape subjects favored by many impressionists, Cassatt focused on contemporary humanity. Perhaps because of an actual partiality or perhaps because of limiting social restrictions, Cassatt generally depicted women at their daily tasks. Her subjects read, do handiwork, or, as in *The Child's Caress*, tend children, here, in front of a fruit tree. Although an independent composition, this painting relates to a mural commission Cassatt received for the 1893 World's Columbian Exposition in Chicago. The mural, entitled *Modern Woman* (now lost), included depictions of women and children picking apples.

In American and European art of the time, women typically appeared idealized in beauty, often caught in moments of languid dreaminess or artistic reverie. Cassatt recognized the contributions of women to society, and, with the objectivity favored by Degas and other impressionists, she sensitively delineated their lives and activities. By ignoring the standard conventions of beauty and appearance, Cassatt defined the somewhat homely features of her models and their informal dress. Her uncanny ability to catch a naturalness of gesture leads to a spontaneity of physical and emotional interaction as, unselfconscious and unaware of the viewer, the sitters in *The Child's Caress* gaze at and touch each other. Their hands, eyes, and bodies meet in a powerfully direct and unsentimental statement about the bonding of woman and child. With such an unaffected representation, Cassatt celebrated modern life and women's participation in it. JS

JOHN LA FARGE

American, 1835–1910

Kilauea, Looking at Cone of Crater, 1890

Watercolor on paper; 4⁵/₁₆ × 9³/₄ in. (11 × 24.8 cm.)

Gift of Admiral and Mrs. Henry S. Persons, 1988

(20,108)

Traveling with the American historian and essayist Henry Adams, John La Farge visited the Hawaiian Islands, Samoa, Tahiti, and Fiji from 1890 to 1891. He had recently completed several design projects and sought spiritual renewal in the exotic embrace of the Pacific. The travelers spent the month of September 1890 exploring the islands of Oahu and Hawaii, their first landfall.

Disappointed by Western influence on the native lifestyle, La Farge turned to the landscape for subject matter, executing several watercolors of the varied scenery. The two men rode on horseback around Hawaii, and the artist spent several days painting its ever-changing volcanic aspects. They trekked into Halemaumau crater, hoping to observe the fiery movement of molten rock, and watched the transient effect of light, color, steam, and atmosphere from the Volcano House, their rim-side hotel. *Kilauea, Looking at Cone of Crater* is a watercolor sketch La Farge executed on the spot, recording the vista to which he awoke on his first morning at Kilauea, one of the world's largest active volcanoes.

La Farge was one of the foremost American watercolorists of the period, and he relied almost exclusively on the medium during his travels in the Pacific. Indeed, the freshness and spontaneity of watercolors are qualities well suited to the representation of atmospheric ephemera. In this work La Farge first applied delicate veils of pigment to define the basic placement of sky, crater, and grass. Testing his colors on the paper's margin, he then sensitively applied additional washes of subtly different tones. In this way he suggested the delicate pink and lavender tints of early morning, the dark shadows of the crater's cone and floor, and the meeting of clouds and vapor. La Farge inscribed the sheet in pencil: "Kilauea, 10 A.M., Sept. 15. Looking at Cone of Crater, Southward—Cloud over Mauna Loa."

Since the eighteenth century, many European and American artists had been fascinated by volcanoes. Unlike painters such as Frederic E. Church, who were enthralled by their awesome powers, La Farge was moved by the unearthly mixture of rising fumes, changing light, and vapors. In this work he sensitively captured their luminosity and fleeting effects as seen from the crater's rim.

JS

MAURICE BRAZIL PRENDERGAST

American, 1858–1924

Afternoon, Pincian Hill, 1898

Graphite and watercolor on paper

15⅛ × 10⅝ in. (38.4 × 27 cm.)

Gift of Mrs. Philip E. Spalding, 1940 (11,653)

A social ritual of life in Rome in the nineteenth century was a late afternoon promenade on the fashionable Pincian Hill. Pedestrians and carriage riders, foreigners and natives, seminarians, liveried servants, and beggars alike crowded the Pincio to the strains of military band music, hoping to see and be seen. Maurice Prendergast vividly captured in three watercolors and one monotype the sparkle and vibrancy of this favored activity. In this version, coachmen thread their horse-drawn carriages among nursemaids, prams, and well-dressed strollers, all partaking of the afternoon's delights.

Prendergast was an early advocate of modern art and has often been called America's first postimpressionist. A painter, watercolorist, and master of monotypes, Prendergast spent most of his career in Boston. He made several trips to Europe, however, spending time in Italy and executing watercolors such as this, which resulted from his second journey abroad (1898–99). Although reality was the basis of much of his work—Prendergast generally depicted moments of leisure and recreation—its truthful depiction was not the artist's primary motivation. Pren-

dergast was one of the first Americans to respond to the formal elements of art, allowing them to become the main focus of his paintings and prints.

In *Afternoon, Pincian Hill*, the close-up view of figures, trees, and brick walls truncated by the paper's edge stresses the two-dimensionality of the scene. The hillside subject deemphasizes spatial recession, and on this flat surface, structured by vertical, horizontal, and diagonal axes, Prendergast reduced the components of the scene to bright spots of colored washes, their placement accented by flashes of white paper. As contrasting shapes and tones play across the surface of the sheet, a decorative, tapestry-like effect of cheerful hue, sparkling light, and rich texturing results. The watercolor stands not as a detailed record of a specific event but, because of Prendergast's mastery of the expressive potential of color and form, as an imaginative and artful image evocative of the gay pleasures of a promenade on the Pincio. Prendergast's respect for the expressiveness of the formal elements of art not only leads to a beguilingly idyllic world but also presages much of twentieth-century art. JS

Painter, sculptor, photographer, and teacher, Thomas Eakins was perhaps the finest American figure painter of the nineteenth century. He based his art on a thorough knowledge of anatomy and a sensitive penetration of the human psyche. Eakins created images, such as *William Rush and His Model*, compelling in their unvarnished honesty, objective naturalism, and moving portrayal of mankind.

A realist dedicated to recording the world around him, Eakins found few occasions to incorporate nude subjects drawn from contemporary contexts. William Rush and his model, however, is a historical subject that justifies the use of the female nude and is a theme Eakins depicted four times during his career, initially as early as 1877. William Rush (1756–1833) was a celebrated sculptor and ship-carver who in 1809 received a commission from the city of Philadelphia to create a statue commemorating the new Schuylkill River waterworks. In allegorical reference to the Schuylkill, Rush carved a nude woman holding aloft a bittern, a river bird. In the first canvas of the series (Philadelphia Museum of Art), Eakins fully illustrated the theme—Rush is in his studio carving the figure and bird while, under the protective eye of a chaperone, a nude woman poses on a modeling platform. The Academy work eliminates the studio setting, the statue, and the attendant

THOMAS EAKINS

American, 1844–1916
William Rush and His Model, 1907–08
Oil on canvas; 35 1/2 × 47 1/2 in. (90.2 × 120.7 cm.)
Gift of the Friends of the Academy, 1947 (548.1)

figure. Rush stands behind a ship's scroll and hands down his model; she, eyes downcast, is careful of her footing.

Eakins neither idealized nor sentimentalized the figures in *William Rush and His Model*. With graciousness, the sculptor assists the woman; strongly modeled and convincingly plastic, she descends the two steps, unashamed of her sexuality. Eakins here merged gesture, movement, and expression, establishing a wholeness of body and soul that suggests a broader statement about human dignity. The painting provides a summation of Eakins's work, interests, and attitudes toward art. The meeting of Rush and his model encapsulates Eakins's belief that artistic creativity is inspired by the human figure, the fundamental basis of beauty. It is generally believed that the features and proportions of the sculptor are those of Eakins himself. JS

CHILDE HASSAM

American, 1859–1935

Isles of Shoals—Broad Cove, 1911

Oil on canvas; 34½ × 36 in. (87.6 × 91.4 cm.)

Purchase, Academy funds and gifts of Mrs. Robert P.

Griffing, Jr., and Renee Halbedl, 1964 (3194.1)

Childe Hassam, after working as an artist in Boston and developing a style notable for its city subjects and subdued color harmonies, spent three years in Paris (1886–89) during the period critical to public acceptance of French impressionism. The impressionists' interest in light and its effects appealed to Hassam, and he adopted the brilliant chromaticism and broken brushwork central to the style.

Hassam's mastery of bright color, active paint manipulation, and sparkling light effects is perhaps best exemplified in a series of canvases devoted to the Isles of Shoals, a group of islands located off the Maine and New Hampshire coastline. Hassam spent many summers there between 1890 and 1915 and, over the years, depicted numerous times the elemental meeting of land, sea, and sky. Typical of the series, Hassam utilized in *Isles of Shoals—Broad Cove* an oblique view from above and, abandoning the fascination of his French predecessors in treating different times of day under different weather conditions, chose to paint during the midday calm. Covering the canvas in some sections, allowing the primed canvas to appear in others, Hassam rapidly applied his paints with the multihued and textured brushwork tech-

nique learned in Paris. Short, parallel, horizontal dashes of blue pigment of varying hue and intensity contrast with juxtaposed patches of vertical brushstrokes and warmer brown tonalities. The overhead sunlight reveals the vivid blue of the clear ocean and glints off the moving water as it picks out each cobble on the beach and reveals the configuration of the rocky outcropping.

Even though representational, *Isles of Shoals* bears witness to Hassam's manipulation of brush, pigment, color, and composition for an independent decorative end. The almost-square proportion of the canvas and the scene's high horizon unnaturally restrict the breadth of this panorama while suppressing the three-dimensional qualities of the view. On the flat picture plane the stylized and dashing application of paint creates an insistent surface pattern enriched by Hassam's choice of a near complementary palette of vibrant blue and glowing orange, rust, cream, and brown tonalities. By matching such vibrant style and luminous subject matter, Hassam created an image of nature at her most brilliant; he referred to the impressionism of his time yet also looked forward to the artistic freedom of the future. JS

CHARLES BURCHFIELD

American, 1893–1967

Ghost Plants, 1916

Graphite and watercolor on paper

20 × 14 in. (50.8 × 35.6 cm.)

Purchase, 1983 (18,675)

Unlike his artistic contemporaries John Marin, Arthur Dove, and Charles Demuth, who traveled to Europe and were involved with the American artistic avant-garde, Charles Burchfield never went abroad and was content to spend his entire life in Ohio and western New York. Burchfield drew his inspiration almost entirely from the scenes around him—the world of nature. His powerful, evocative images set forth his responses to this infinite private world of fact and fantasy and establish him as one of the great visual poets and celebrants of nature and the American landscape.

Ghost Plants, one of the finest and best-known works from Burchfield's early career, was done on September 21, 1916, only a few months after he had graduated from the Cleveland School of Art and just a few days before he left for New York on a scholarship to study at the National Academy of Design, from which he dropped out after one day. In 1915 Burchfield had begun to paint seriously out-of-doors, writing in his journal, "I hereby dedicate my life and soul to the study of nature." He quickly evolved a flat, calligraphic, almost posterlike style that lent itself to the fanciful, dreamlike interpretations of natural phenomena he favored. Burchfield started his paintings by outlining the design in pencil, then filling in colors. This technique is evident in *Ghost Plants* in the handling of foreground elements, but the background is executed with a more spontaneous, direct application of pure color.

Ghost Plants also shows Burchfield altering his decorative approach to achieve more romantic ends. Among the personal innovations he began to employ was the double image, the use of easily recognizable natural objects that also resemble something else—often something sinister and foreboding. In *Ghost Plants* the spaces between the leaves of the cornstalks are eyes, and the stalks themselves skeletal figures, dancing in attendance on the ominous figure of a dead sunflower silhouetted against the cavelike shadow of a bush. Trees tower darkly overhead, their spiky branches discouraging passage, and a gaping hole of sky intimates the infinite expanse of the universe yet denies escape from the macabre, claustrophobic world below. Combining a fantasy of color and pattern with an innocent, childlike apprehension, Burchfield's work resonates with an intuitive, sensory, emotional, and intellectual intensity that gives it a haunting mystery and irresistible magic. JJ

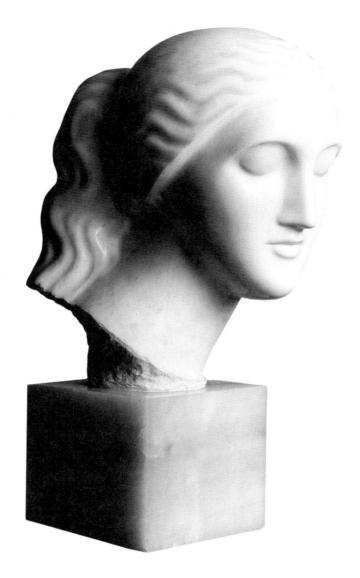

ELIE NADELMAN

American, b. Poland, 1882–1946

Ideal Head, ca. 1910

Polished marble; h. 13½ in. (34.3 cm.)

Gift of Mr. and Mrs. Walter F. Dillingham, 1964 (3264.1)

Escaping the turmoil of Europe at the beginning of World War I, Elie Nadelman moved to New York and, with his elegant figural works, became a leader in modern American sculpture. Unlike many of his contemporaries who chose the route of abstraction, Nadelman always maintained a basis in the figurative traditions of the past. An avid collector of American folk art and familiar with sculpture as diverse as that of Auguste Rodin and Clodion, he was also interested in the prehistoric cave art of France, the drawings of Aubrey Beardsley, and the paintings of Georges Seurat. Although he felt that he was as important as Pablo Picasso to the development of cubism, Nadelman is perhaps best known today for his stylized figures and heads, which reflect a profound appreciation of the beauty of classical and Renaissance sculpture.

This work, one in a series of classical heads begun in 1909, reflects Nadelman's interest in antique art in its material—white marble—and in the idealized proportions of the oval face and graceful coiffure. Nonetheless, the woman's overly stylized hair and features mark the sculpture with a decidedly modern character. Formal considerations, the balance and relationship of line and mass, were primary to Nadelman's sculptural work. In fact, at the time of this series, Nadelman indicated his commitment to these concerns by frequently labeling his work with titles such as *Research in Volume* and *Accord of Forms*.

In *Ideal Head* Nadelman eliminated surface detail from the highly polished stone and concentrated on the geometry of the face's rounded volumes. Elegant and fluid in profile, the swelling movement from one volume and surface to another is subtle and smooth. Nadelman remarked in an article published in *Camera Work* (October 1910), "I employ no other line than the curve, which possesses freshness and force. I compose these curves so as to bring them in accord or opposition to one another. In that way I obtain the life of form, i.e., harmony." Although a formal serenity and cool detachment underlie the classical sense of repose embodied by this woman's face and closed eyes, Nadelman's keen interest in the abstract rhythm of line and volume identifies him as a modernist. JS

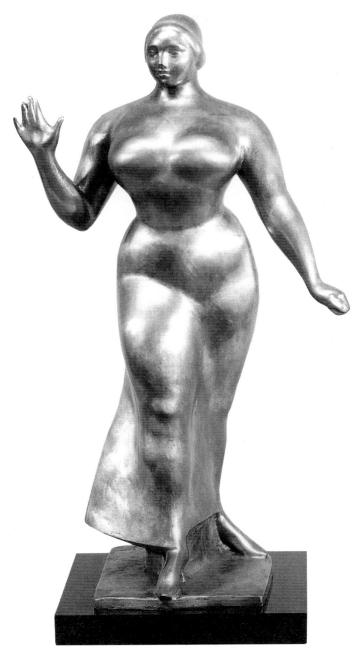

GASTON LACHAISE

American, 1882–1935

Walking Woman, 1922

Polished bronze; h. 19½ in. (49.6 cm.)

Gift of Mrs. Philip E. Spalding, 1941 (4956)

inspiration and model, including the Academy's bronze *Walking Woman*.

Although Isabel Lachaise was a striking, full-bosomed woman with generous proportions, she was not the weighty giantess Lachaise depicted in his sculptures. Instead of making literal or idealized portraits of Isabel, Lachaise translated her essence in his female figures, lingering over anatomical forms with concern and reverence, yet transcending the superficial and the temporal to create an archetypal form that personified his vision of the female principle. As the painter Marsden Hartley, a contemporary of Lachaise, wrote, "He saw the entire universe in the form of [a] woman."

In *Walking Woman*, Lachaise achieved a classic equilibrium between form and surface. The figure strides forward, proud and erect, her sexuality expressed through distortion of form and powerful modeling. Body and drapery become simplified swelling masses, and curves unify under the ankle-length dress, which clothes the form like a membrane. Despite its relatively small size this sculpture has a powerful and monumental presence, exuding an almost primordial sense of potency and mystery—the ancient earth mother reincarnated in modern guise. JJ

The critic Lincoln Kirstein wrote in 1935 that Gaston Lachaise was an "interpreter of maturity . . . concerned with forms which have completed their growth, achieved their prime; forms, as he would say, in the glory of their fulfillment. . . . His subject matter is the glorification, revivification and amplification of the human body, its articulate structure clothed in flesh. He was an idol maker." Lachaise's wife, Isabel, was certainly his idol, for her image appears in the vast majority of his work as

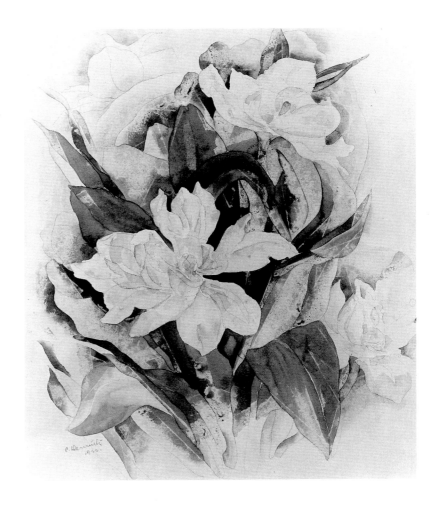

CHARLES DEMUTH

American, 1883–1935

Flower Study (Parrot Tulips?), 1922

Graphite and watercolor on paper

13½ × 11¾ in. (34.2 × 29.8 cm.)

Gift of Robert Allerton, 1950 (12,826)

Watercolor was practiced with consummate artistry by several American painters during the first quarter of the twentieth century. Primary among this group was Charles Demuth, who joined a respect for naturalism with the formal concerns, new modes of representation, and expressionist directions found in contemporary European painting. Demuth treated subjects ranging from America's industrial landscape and scenes of vaudeville to unpublished illustrations of American and European literature and still lifes. It is with his still lifes that Demuth, in his preferred watercolor medium, integrated European modernism and the American taste for realism with exquisite delicacy and practiced fluidity.

Still lifes in general and floral subjects in particular recur throughout Demuth's work, finding their inspiration in Demuth family life. His mother tended a lush Victorian garden during the childhood and adult years he spent with her in his rural Pennsylvania hometown, and floral still lifes by female relatives adorned the house interior. The blossoms that appear in *Flower Study (Parrot Tulips?)* may well have come from his mother's carefully tended flower beds. Freely sketched on the sheet, Demuth's supple pencil contours describe the shapes of petals and leaves. Sensitively applied colors and wash loosely conform to the underlying graphite design; a tinge of yellow is barely perceptible at the blossoms' center, and a flush of pink and mauve cross the delicate petals.

At home in Paris and in the avant-garde circles of the American art scene, Demuth also took inspiration from the spatial explorations characteristic of so much contemporary art. Probably using a masking or lift-off technique, Demuth exposed in narrow and crossed lines the white paper beneath the watercolor pigments, creating an irregular pattern superimposed on the leaves. The faceted forms suggested by such a process contribute to the formal structure of the still life; they reflect Demuth's interest in the compositional manipulations of Paul Cézanne and the cubism of Pablo Picasso. Merging tradition and modernism, Demuth's floral watercolors represent an art of diaphanous washes, exquisite color, animate draftsmanship, and fastidious technique. JS

ARTHUR DOVE

American, 1880–1946

The Brothers #1, 1941

Oil on canvas; 20 × 28 in. (50.8 × 71.1 cm.)

Gift of the Friends of the Academy, 1947 (450.1)

In the artistic ferment of the early twentieth century, painters reevaluated Western visual traditions and searched for new means of pictorial expression. Arthur Dove was key to the development of modernism in American art and pioneered abstraction in the United States. Creating nonrepresentational pastels and paintings as early as 1910, he was the first American to publicly exhibit such revolutionary images. Alfred Stieglitz, a friend as well as the most important promoter of avant-garde art of the time, displayed Dove's work in 1912 at 291, his New York gallery devoted to contemporary art. Dove's exhibition caused a sensation in American art circles and thrust him to the forefront of the modernist movement. Abstractions derived from natural sources preoccupied Dove throughout his career, and some of his most powerful statements date from the last years of his life, among them *The Brothers #1*.

Choosing not to live in New York City, Dove preferred small, often rural, communities in the state. His final home was on the shore of a Long Island Sound tidal pond, which provided the source for most of his late abstractions, including *The Brothers*. A view of a Catholic monastery across the pond appealed to Dove, and he returned several times to the motif of two gabled structures juxtaposed between water, sky, and hills. He executed a series of ten watercolors and three oil paintings, of which this is the earliest oil.

Dove felt a spiritual affinity with nature, and through the liberated use of line, color, and form, he strove to capture the spirit of a place. These formal elements acted as intermediaries through which Dove expressed a scene and his perception of it. Dove's representations of the monastery illustrate various experiments as he searched for the pictorial equivalent of his private vision.

In *The Brothers #1* Dove simplified the view, removing it from nature and creating a unified surface design. He placed the abstracted structures between a sliver of sky and the gently stylized blue waves of Long Island Sound, and between the jagged edge of the trees at the water's edge and the mass of the textured hillside beyond. The subject is reduced to geometric planes of unmodeled hue, and shading of the shapes is limited to suggest only the shallowest relief. Flat diamond, square, triangular, and sinuously curved areas of color fit together in a network of crisply defined forms. Centered and symmetrically arranged, they suggest a sense of balance and equilibrium, qualities that seem appropriate to the subject, a cloistered center of monastic contemplation.　JS

STUART DAVIS

American, 1894–1964

Pad #1, 1946

Oil on canvas; 9⅞ × 12¾ in. (25.1 × 32.4 cm.)

Gift of the Friends of the Academy, 1948 (650.1)

The 1913 New York International Exhibition of Modern Art—more familiarly known as the Armory Show—introduced to many American artists the modernist developments of late nineteenth- and early twentieth-century European art. A participant in the exhibition, Stuart Davis was among the many American painters impressed by what they saw; he commented that the show was the "single greatest influence I have experienced in my work." Davis left high school to study with Robert Henri, and so began his career in the realist tradition of the Ashcan school, adopting the urban subject, objective approach, and broad brush of his master. Exposure to the paintings of artists such as Henri, Pablo Picasso, and Henri Matisse, however, marked a turning point in his development. As exemplified in *Pad #1*, Davis ultimately captured the vitality of contemporary life by joining a keen interest in popular American culture with the liberated color of fauvism and the innovative treatment of structure and composition of cubism.

Pad #1 is the first in a series of jazz-inspired paintings that preoccupied Davis during the last five years of the 1940s. Long interested in contemporary music, he enjoyed the syncopated and rhythmic energies of jazz improvisations. Davis's use of the term "pad" in the title—jargon inspired by jazz for a personal world or emotional state—suggests his attempt to create paintings that visually encapsulate the nature of the musical form. Abandoning the naturalism of his early urban subjects, Davis explored instead the expressive potential of brightly colored, sharply defined, simple abstract shapes. Concentric and individual geometric planes, broad parallel, crossed, and angled lines, as well as repetitive yet differently patterned dots—all reminiscent of his interest in fauvism and cubism—energize the surface of *Pad #1*. Davis's use of richly textured pigment and strong color contrasts, juxtaposing brilliant pink, blue, orange, and green, intensifies the bold and seemingly spontaneous all-over design of the image. The forthright graphic statement made by block letters spelling out "PAD" plays a dual role in the work; not only does it define the contemporary jazz/popular culture subject of the painting, it merges with the flat and abstract nature of the composition and contributes to its visual dynamism. Although small in size, this work thus demonstrates Davis's synthesis of the modernist principles of European art with the spirit of American music and culture. JS

The art of Morris Graves is best seen in the context of Asian as well as Western thought and artistic tradition. From childhood Graves was exposed to elements of Asian culture that filtered into his native Pacific Northwest, especially through Asian immigrants who settled there. More direct contact came when Graves traveled to Asia in 1928 and 1930. By 1935 he had developed an interest in Zen Buddhism, which offered him a refreshing new view of the world, and throughout the late 1930s and early 1940s Graves increasingly incorporated influences from Asian culture into his work.

In 1946 Graves received a Guggenheim Fellowship to travel to Japan, where he intended to help with the post-war recovery effort. Although he did not have a visa to enter Japan, Graves sailed to Hawaii in early 1947, confident that permission would soon be forthcoming. His efforts were to no avail. During his stay in Hawaii, Graves often visited the Honolulu Academy of Arts, where his study of the Asian art collection became a partial substitute for his failed trip. He immersed himself in particular in the museum's assemblage of ancient Chinese

MORRIS GRAVES

American, b. 1910

Shang Owl, ca. 1947

Gouache on paper; 15 × 19⅝ in. (38.1 × 49.8 cm.)

Gift of John Young in memory of Mrs. Theodore A. Cooke, 1970 (15,501)

bronzes and began to create a series of paintings and drawings based on these ritual objects.

Shang Owl belongs to this body of work in which Graves transformed the shapes and decoration of Shang and Chou vessels, including the abstract *t'ao-t'ieh* (animal mask) design, into fantastic creatures. In *Shang Owl* he combines ancient Chinese bronze decorative motifs with a bird form. Throughout his career, birds of all kinds have held a compelling fascination for Graves, who has used them as symbols of solitude, human traits, his own state of mind, and above all spiritual transcendence. In *Shang Owl* it is as if an ancient vessel is reanimating itself, gradually reviving to meditate, in Graves's words, "upon its vital origin, its spiritually illuminated past." JJ

HANS HOFMANN

American, b. Germany, 1880–1966

Fragrance, 1956

Oil on canvas; 60 × 48 in. (152.4 × 121.9 cm.)

Purchase, 1968 (3529.1)

Hans Hofmann was born in Weissenberg, Germany, and studied art in Munich and later in Paris. In 1915 Hofmann founded his first art school in Munich, and in the early 1930s he taught at the University of California, Berkeley. By 1932 he had settled permanently in America, and in 1934 he opened the Hans Hofmann School of Fine Arts in New York. A theoretician, teacher, and painter, Hofmann went on to become one of the leading proponents of American abstract art, especially abstract expressionism.

Nature was the starting point for Hofmann's creative ideas. His paintings are interpretations of sensations and objects experienced in nature, three-dimensional reality transformed into two-dimensional patterns of high-keyed colors. *Fragrance* was painted in 1956, a time when the artist was working out a method of applying rectangularly shaped dabs of paint in heavy impasto. Bright blues, reds, oranges, and yellows seem drawn, as if by a magnet, to the center of the canvas, each interacting to create an explosive surface vitality. This vitality is reinforced by the illusion of advancing and receding planes, brought about by the properties of the colors and the shape, size, and placement of the brushstrokes. RAD

In the 1940s the Baltimore artist Morris Louis was creating abstract paintings and collages strongly influenced by cubism. Toward the end of the decade he kept a close eye on the work of Jackson Pollock, and in April 1953 Louis visited New York, where he saw the latest Pollocks and also the work of Helen Frankenthaler. As a result of this trip, Louis began laying unstretched and unprimed canvases on the floor and pouring on thin washes of paint. Over the next eight years, he evolved a distinctly personal approach to abstract expressionism, painting numerous large canvases that were lyrical, even mystical, in mood.

Turning belongs stylistically to a group of paintings done between 1954 and 1959, and more specifically to a 1958 series titled *Veils*. In *Turning*, the expansive horizontal space is dominated by a single imposing form. The form is composed of plumes of rich earth colors, which were stained one over the other, wet on wet, and were absorbed by the warp and weft of the raw canvas. Dark reds, pale olives, and moss greens flow upwards, warmed by an underlying incandescent red-orange. The layered, or laminated, effect of the washes creates a puzzling three-dimensional quality that seems to shift before the viewer's eye. As were other pioneers of his generation, Morris Louis was interested in "all-over" painting (later called "field" painting), which emphasized the actual picture plane and the validity of paint itself.

RAD

MORRIS LOUIS

American, 1912–62

Turning, 1958

Acrylic on canvas; 94¼ × 178¼ in. (239.4 × 452.8 cm.)

Purchase, Acquisition Fund and Academy Volunteers Fund, 1971 (3997.1)

ROBERT RAUSCHENBERG

American, b. 1925

Trophy V (For Jasper Johns), 1962

Oil, collage, and found objects on canvas

78 × 72 in. (198.1 × 182.9 cm.)

Gift of Mr. and Mrs. Frederick R. Weisman

in honor of James W. Foster, 1971 (4022.1)

In the 1950s Robert Rauschenberg was one of the leading proponents of the idea that painting should not be categorized as a purely two-dimensional art form. He helped break the traditional boundaries between sculpture and painting by creating works that joined both, a form he called "combines." *Trophy V* is an example of a Rauschenberg combine, composed of freely painted areas and three-dimensional objects either attached to or set into the canvas. By selecting such banal objects from contemporary life as a cardboard box and a window screen, Rauschenberg—much as Marcel Duchamp did earlier—demonstrates that ordinary entities are worthy of aesthetic consideration. Rauschenberg's return to recognizable subjects made him a transitional link, along with Jasper Johns, between the abstract expressionists and the pop artists.

The title of this piece is a tribute to Rauschenberg's friend, and elements in the canvas allude to the work of Johns. The manner in which the box was "painted out," the variety of gray tones, and the small stenciled map of America on the left are each witty references to the paintings of Jasper Johns. RAD

An artist known for his figurative themes, Alex Katz helped revitalize portraiture as a legitimate subject in an age when the internal probings of an artist were more highly valued than acknowledgment of the external world. Initially intending to become a commercial artist, Katz redirected his career to painting the comforts of middle-class life—social gatherings, outdoor activities, family groupings—and to recording likenesses of the people around him. No individual has preoccupied Katz so much or provided such constant inspiration as his wife, Ada. Over the last thirty years he has celebrated her classic beauty more than eighty times.

Katz has repeatedly stated that his portraits are void of any meaning and empty of all content; he describes his art as one of style and surface. For instance, as he joins the larger-than-life scale of this portrait—one of a series of similarly sized paintings begun in the early 1960s—with a close-up focus and abrupt compositional truncations, he carries the figurative subject beyond traditional naturalism; he focuses on the painting's abstract properties. Utilizing a flat linear style of arbitrary shading, subtle palette, reduced detail, and smooth, impersonal paint application, Katz investigated the interrelationship of the formal elements of his craft. The play of oval and triangular forms within this off-center composition, the rhythms of curved and angular planes, and the interaction of multiple surface patterns dominate the work.

The noncommunicative gaze of Ada stresses the depersonalized quality of the portrait. Since there is no direct contact with the subject by which the viewer might enter the scene, the likeness seems to deny any underlying psychological meaning. As the oversize proportions infuse Ada with an iconic monumentality, they seem to reinforce her calculated aloofness from the viewer and Katz's recognition of the deliberate social posturing of the American middle class. In this portrait, Ada's self-conscious demeanor matches the pointedness of Katz's formal manipulations, and together they comment on the artifice of life and art. JS

ALEX KATZ

American, b. 1927
Ada with Black Scarf, 1966
Oil on canvas; 72 × 48 in. (182.9 × 121.9 cm.)
Purchase, Shidler Family Foundation Fund, Robert Allerton and Prisanlee Funds, 1986 (5452.1)

DAVID SMITH

American, 1906–65

Hirebecca, 1961

Welded and painted steel, h. 82¼ in. (208.9 cm.)

Purchase, 1972 (4092.1)

Born in Decatur, Indiana, David Smith went to New York in 1926, and for six years studied painting at the Art Students League. He aligned himself with the ideas of the American abstract painters but, in time, concentrated on sculpture. He went on to become one of America's most forceful and imaginative sculptors.

As are many of Smith's works, *Hirebecca* is constructed of pieces of steel welded together to make a geometric composition. Supported by a stanchion ending in a four-pronged foot, a large ring encircles rectangles of different sizes, set at different angles. The major views are from the front and back; side views minimize the dominant ring.

Besides the tightly formed configuration and the subtle allusion to the human figure, *Hirebecca* is distinguished by its strong color. Never one to separate sculpture and painting, Smith applied the colors in a painterly fashion, thick in some areas, thin in others, creating a sense of surface texture.

A small plaque welded onto one of the rectangles carries the name of the artist, the date of the sculpture, and the title, which was formed by adding a casual salutation to the name of Smith's daughter, Rebecca. RAD

Dissatisfied with conventional, naturalistic approaches to their medium, twentieth-century sculptors joined their painter compatriots in a search for new pictorial means appropriate to their modern age. Sculptors and painters alike eliminated objective reality from their work and not only explored the realm of abstraction but also delved into man's subconscious state. A seminal figure in the development of such modernist sculpture, Isamu Noguchi merged these two trends in monoliths such as *Red Untitled*.

A master of direct carving, Noguchi in this sculpture took a massive piece of red travertine—a veined, porous stone infused with pockets of transparent crystals—and, through manipulation of shape and surface, turned it into a sophisticated study of oppositions. The elongated oval balances opposing areas of fine and rough-hewn surfaces as well as projection and recession; the shape creates a sense of circulation, suggesting perhaps even the cycle of growth, decay, and regeneration. Noguchi enriched the conception of this work by treating the other side identically except in reverse. Smooth areas are backed with more highly textured surfaces, and convex formations are matched by concave. With its compositional configuration, variations of pale mottled pink color, and surface texture—whether an area Noguchi worked or a natural lacuna—*Red Untitled* is seductively tactile and invites the human touch.

More than a dialogue of stylistic dichotomies, however, the work also embodies Noguchi's dual cultural heritage—American and Japanese. A response to contemporary Western artistic developments with an emphasis on abstract form, *Red Untitled* also demonstrates Noguchi's profound respect for stone and its embodiment of emotional power. Well versed in the philosophy of Zen, Noguchi perceived rock as the reflection of universal truths of life, time, and durability, and through a feeling for the nature of his materials, he worked to reveal their essence. Part of a series of megaliths started during the 1960s, the Academy's work stands self-contained in its symmetry yet approachable with its formal and tactile oppositions. It suggests an ancient stone rune infused with spiritual force, a prehistoric monument whose secrets about nature and reality are discoverable through time and contemplation. Primitive yet sophisticated, organic yet geometric, simplistic yet empowered, *Red Untitled* appeals to hand and mind alike. JS

ISAMU NOGUCHI

American, 1904–88

Red Untitled, 1965–66

Red Persian travertine; 64½ × 23⅝ × 22¾ in. (163.8 × 60 × 57.8 cm.)

Gift of Geraldine P. Clark, 1977 (4502.1)

LOUISE NEVELSON

American, 1899–1988

Black Zag X, 1969

Black painted wood and formica

39⅝ × 38 in. (100.7 × 96.5 cm.)

Gift of the estate of Clare Boothe Luce, 1988 (5719.1)

Abstraction and assemblage (the integration of disparate objects into a unique work of art) have played a key role in the development of modern art and find important expression in the work of Louise Nevelson. Influenced by cubism, surrealism, abstraction, and abstract expressionism, Nevelson arrived at her mature style during the 1950s. Although she worked in a variety of materials, ranging from plexiglas to metal and stone, assemblages such as *Black Zag X*, composed of found or manufactured wood pieces, comprise her most noted works.

Basic to Nevelson's sculpture is the stacked arrangement of multiple wood boxes and crates with smooth or textured geometric wood forms set in the rectangular enclosures. Nevelson preferred a monochromatic palette and typically painted her monumental wall pieces and freestanding objects black. Although a minimal sense of depth and a structural emphasis on geometric planes betray an interest in cubism, the lack of a central focus and her intuitive sense of placement suggest an affinity with the tenets of abstract expressionism.

During the 1960s Nevelson created the *Zags*—a series of moderately scaled wall reliefs. Working with a number of black box units, Nevelson created composite arrangements with irregular outlines, which are framed in black formica. Earlier efforts depended upon a collection of found wood objects, but by this time Nevelson had begun to use crates manufactured to her specification and premade wood pieces. In fact, the regularly contoured and smoothly surfaced geometric shapes that fill the *Zag* box units were often commercially available children's blocks.

In *Black Zag X* Nevelson has composed within a selection of boxes numerous truncated cones, hollowed rectangular blocks, and other larger geometric wood cutouts; the various forms repeat rhythmically or, when in juxtaposition, define contrasting patterns. Using multiple layers of forms in relief enveloped by black monochrome, Nevelson created within the work a dialogue of opposing concepts. As she considered the exchange of positive and negative space, mass and volume, and the standardization of identical forms and individuality of placement, she made an abstract statement of balance and harmony.

JS

CHRISTOPHER WILMARTH

American, 1943–87

Clearing #2 of Nine Clearings for a Standing Man, 1973
(glass remade 1986)

Etched glass, steel sheet, and wire cable

6 ft. 7½ in. × 5 ft. (2.02 × 1.52 m.)

Gift of Mr. and Mrs. Barney A. Ebsworth, 1986 (5501.1)

Influenced by the confluence of abstraction and minimalism in American contemporary art, Christopher Wilmarth is known for his evocative sculptures of steel and etched glass. Fascinated by the ability of etched glass to catch and hold light through its color and frosted translucency, Wilmarth initially joined the material with wood. A 1971 collaboration with American sculptor Mark di Suvero, who constructed a steel framework for their work, encouraged Wilmarth to abandon wood for steel. During the early and mid-1970s he created glass, steel, and steel-wire pieces of various scale and orientation. In addition to small wall pieces, hanging reliefs, and large freestanding constructions, Wilmarth used these architectural materials in works such as *Clearing #2*, which rest on the floor yet are attached to the wall.

In 1973 he began *Nine Clearings for a Standing Man.* In each work of this ambitious series he placed a large sheet of metal, bent subtly along one or two vertical or horizontal axes, behind a piece of lightly etched glass of similar dimensions. Using screws or steel cables of wire rope,

Wilmarth attached the two layers to the wall, against which they were closely aligned. As technologically modern as his materials are, Wilmarth suggested that the architectural quality of his work is secondary to the experience of light they create. In these constructions he regulated the luminosity of the piece by varying the space between the glass and steel. In this sculpture, the steel bends slightly along a horizontal axis toward the wall, admitting light behind the upper portion of the glass; thus Wilmarth divided it visually into two sections, the top lighter, the bottom darker. Seen from the front, the sculpture's shape, tonal quality, and linear accent—the steel cable that punctuates the surface of the glass serves a structural and graphic role—lend a distinctly pictorial effect to the work. As the viewer moves or the illumination changes, however, the coloristic character alters. The sculpture suggests the poetry of light or, as Wilmarth once called it, the quality of indirect light found under trees. JS

243

ROBERT MANGOLD

American, b. 1937

A Rectangle and a Circle within Square, 1975

Acrylic and crayon on canvas; 4 × 4 ft. (1.22 × 1.22 m.)

Gift of Mr. and Mrs. Edward H. Nakamura, 1984

(5235.1)

When looking at a painting by Robert Mangold, the viewer sees a painted surface divided by lines. Excluded are any concerns with space, movement, emotional content, process, painterliness, or references to anything other than the physical painting itself. This sparseness lets the viewer concentrate on only the most essential elements: the relationships of forms drawn on the surface to the exterior shape of the work. Mangold sums up his approach: "The idea is always relatively simple. If the idea were too complicated or clever, it might be interesting on its own and take precedence over the actual piece. The idea and the piece should be the same."

Mangold's "ideas" are usually subtle geometric relationships, as in the Academy's painting, which deals with the placement of a circle and a rectangle within a square. Since the arrangement of these shapes can be worked out in several ways, Mangold often builds a group of works around variations that are thematically related but not interdependent. In each of his works of the 1970s Mangold used a single, neutral color, applied with a roller to avoid expressive brushwork. The flatness, evenness, and nearly matte, slightly thick opacity of the ground, combined with its neutrality—being neither dark nor light, bright nor dull—enhance the unity of surface, line, and shape in his paintings.

Although Mangold's methods suppress connotative or expressive meaning and deemphasize his role as creator, he establishes a dynamic tension that gives his works intellectual and visual power. In the Academy's painting this is accomplished by his opposition of irregularity within symmetry. The circle is inscribed exactly within the square, just touching the canvas edge on all four sides. The sense of balance and stasis this conveys is countered by the rectangle, which touches the edge at only three points, piercing or overlapping the circle's boundary. The eye would like to see the rectangle contained within the circle, so strong is our natural desire for balance, but the brain perceives the geometric impossibility of this even as it appraises the notion that it is somehow being deceived. Inviting introspection and contemplation, Mangold is not only challenging and questioning the way we perceive and understand, but gracefully manipulating forms to new ends. JJ

Born in Portland, Oregon, Richard Diebenkorn has spent most of his artistic life in California. His first works were strongly influenced by abstract expressionism (he knew Mark Rothko and Clyfford Still), but in the 1950s Diebenkorn became one of the most famous members of what later became known as the California figurative school. In 1967 Diebenkorn returned to abstraction, beginning a series of large canvases titled *Ocean Park* (a section of Santa Monica, California) to which this work belongs. *Ocean Park #78* presents in abstract format a vast space animated by subtle shifts of light and a sense of depth that belies the flat planes. Diagonal lines cut across the surface, accenting the dominant verticals and horizontals. These features, as well as the high horizon line and the pale blue register above it, suggest a landscape. Indeed, the artist has a stated temperamental inclination toward landscape painting.

In *Ocean Park #78* Diebenkorn celebrates the process of creation by showing the many alterations that took place. Layers of thinly washed paint, applied by brushing, staining, scrubbing, and dripping, expose the history of the piece. Diebenkorn's emphasis on the literalness of the flat painted surface and his references to landscape space help create a subtle tension that informs the entire painting. RAD

RICHARD DIEBENKORN

American, b. 1922

Ocean Park #78, 1975

Oil on canvas; 6 ft. 11½ in. × 6 ft. 3 in. (2.12 × 1.91 m.)

Purchase, funds provided by a grant from the

National Endowment for the Arts and matching funds,

1975 (4346.1)

PETER VOULKOS

American, b. 1924

Untitled, 1980

Glazed wood-fired stoneware and porcelain

diam. 23 in. (58.4 cm.)

Purchase, Memorial Fund and funds from

the Persis Corporation, 1981 (4948.1)

Beginning with the Renaissance, when artists became increasingly self-conscious about themselves as creators and their work as fine art, distinctions developed between the fine artist and the craftsman. These boundaries have been broken in the twentieth century, and the innovative and experimental ceramic work of Peter Voulkos has been instrumental in the reevaluation of the artificial separation of artist and craftsman. A traditionally trained ceramist creating functional forms, Voulkos began to approach his wheel-thrown pieces in radical ways during the 1950s. Voulkos started with a conventional shape— such as this low, broad platter—aggressively bending, puncturing, and scoring its body. He embedded porcelain bits into the stoneware, encouraged the coloristic irregularities that occurred as glazes pooled or flowed during wood-firing, and appreciated the heavy texturing produced by falling ash. Voulkos's vigorous, almost gestural manipulation of the clay and his reliance on accidental effects in such powerful crude forms are reminiscent of action painting and abstract expressionism. As he explored the expressive potential of clay, he overturned the longstanding division between art and craft, linking ceramics with the aesthetic concerns of painting and sculpture.　JS

WAYNE HIGBY

American, b. 1943

Landscape Bowl; Deep Mesa, ca. 1984–85

Glazed and raku-fired earthenware

11 1/2 × 19 × 16 1/8 in. (29 × 48.2 × 41 cm.)

Gift of Louise Guard, 1985 (5365.1)

Wayne Higby also has challenged the traditional barriers between ceramics and other art forms, working his clay in search of new expressive ends. With its large and deep wheel-thrown bowl, compressed into an ovoid form and tapered to a beveled foot, *Deep Mesa* illustrates a shape recurrent in Higby's work. When viewed from the side, the initially abstract pattern of glazing, both inside and out, aligns into an imaginary vista of mesa, sky, depth, and space. In creating this landscape imagery, Higby recalls the earthen source of clay by suggesting the arid coarseness of a desert with the craquelure of the white glaze and marks on the clay body. Higby respected the integrity of the traditional bowl form, yet he used its decoration to explore a new illusionism, manipulating its round shape and surface patterning to mimic pictorial traditions that evoke the third dimension.　JS

PAUL WONNER

American, b. 1920

Dutch Still Life in the Studio, 1981–82

Acrylic and pencil on canvas; 6 × 6 ft. (1.83 × 1.83 m.)

Gift of Laila and Thurston Twigg-Smith, 1985 (5401.1)

Paul Wonner first came to prominence in the late 1950s as part of a group of San Francisco Bay Area artists that included Richard Diebenkorn, Elmer Bischoff, and David Park, all of whom shared an interest in figurative or representational painting but also were influenced by the expressive brush-work and action-painting process of abstract expressionism. Throughout the 1960s and early 1970s, Wonner's paintings became simpler, and the painting surfaces calmer. As he left painting in oil and began increasingly to use pencil, gouache, and acrylic, Wonner turned away from a broad handling of pigment, which deemphasized details, toward a tighter, more controlled touch that allowed him to develop further his skill at rendering a likeness of reality.

In the late 1970s Wonner began painting monumental still lifes that reflect his interest and pleasure in seventeenth-century Dutch still-life paintings. Although seemingly simple in their visual and formal presentation, these works, such as the Academy's painting, establish ambiguous concepts of reality and appearance. Wonner's distinctive method is to first divide a painting horizontally into a background and a plane representing a floor or tabletop. Within this stark setting he assembles objects selected from his surroundings, painting them one by one, working out the composition as he proceeds. Strongly lit from one side, the objects cast bold shadows, but objects and shadows usually do not overlap and are positioned so that each leads the eye to the next. In these "landscapes of objects" Wonner creates a personal dialogue with the elements of his everyday world, exploring the realms of both emotion and intellect. JJ

ALICE NEEL

American, 1900–84

Marisol, 1981

Oil on canvas; 42 × 25 in. (106.6 × 63.5 cm.)

Purchase, gifts of Clare Boothe Luce and Mr. and Mrs. Howard Wise, by exchange; Prisanlee and Robert Allerton Funds, 1988 (5717.1)

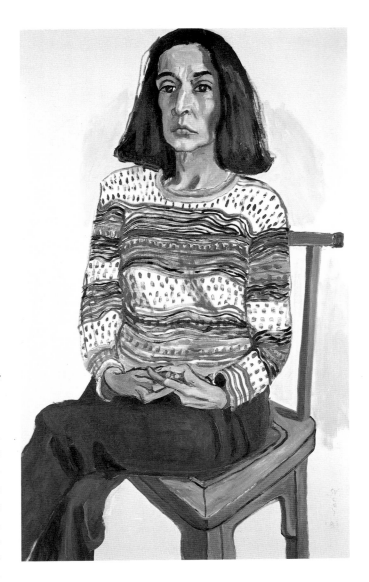

In an age when realism was condemned by those interested in abstraction or the gestural emotionalism of abstract expressionism, Alice Neel was a realist who devoted herself to portraiture for over half a century. Depicting the faces and figures of people around her, Neel considered herself a collector of souls, the chronicler of the "neurotic, the mad, and the miserable" who make up what she called the human comedy. To record fully the complexities of contemporary humanity, she painted not those who wanted to commission likenesses—and could therefore maintain some control over her work—but those who, in crossing her path, caught her attention, whether they were friends, family, children in her Harlem neighborhood, people she noticed on the street, or colleagues such as the Brazilian sculptor Marisol (b. 1930).

Neel usually allowed her sitters to select what they wanted to wear and to situate themselves as they liked on the furniture in her New York studio. Marisol, wearing slacks and a brightly patterned sweater, perches on a straight-backed Chinese chair. Forsaking the tradition of preliminary drawing and studies, Neel worked directly on the canvas, first sketching the figure with aquamarine pigment, which remains apparent as contours outlining the sitter's hands, figure, hair, and chair.

Not one to flatter or sentimentalize her subjects, Neel responded intuitively to the sitter and painted what she saw and perceived. Abandoning the traditional elements of strict naturalism, Neel distorted and manipulated the relationship of shape, line, color, perspective, and light, creating direct and uncompromising portraits. Seated slightly askew with awkwardly crossed legs, the figure's tenseness and torsion are reinforced by the strained entanglement of the long bony fingers in her lap and the agitated design of the sweater. The strongly featured face, averted gaze, and bluntly cut hair also suggest the intensity of this artistic personality, who, placed close to the picture plane, demands the attention of the viewer. The cockeyed perspective of the truncated, two-legged chair is similarly disturbing, as is the elimination of a background context. Nonjudgmental yet deeply expressive, Neel's portrait of Marisol is one within a corpus of penetrating characterizations, which, taken in its entirety, reveals the complexities of contemporary life. JS

Art of the Pacific, the Americas,

and Africa

Feather cloaks and capes were symbols of power and rank in the Polynesian areas of Hawaii, Tahiti, and New Zealand. Red feathers were symbolic of gods and chiefs. Because of their scarcity in Hawaii, yellow feathers also came to be prized, and garments made from them could be worn only by the highest ranking individuals. In the nineteenth century Hawaiians still called their magnificent cloaks and capes, regardless of color, 'ahu'ula (red-shoulder garments). To create these garments, thousands of tiny feathers were tied to a foundation of net made from the softened bark of olonā (Touchardi latifolia). Women cleaned, sorted, and grouped the feathers; men tied bundles of about twelve feathers to the netting using olonā thread, attaching successive rows of feathers to hide the quills of the row below.

The Academy's cape (3306.1) is made from the yellow and black feathers of the 'o'o (Moho nobilis) and the red feathers of the 'i'iwi (Vestiaria coccinea). A large crescent with a double concave curve on the upper edge, which forms a point in the center, dominates the yellow background of this cape. The neck and front edges are decorated with short bars in alternating black, yellow, and red. Two red triangles act as half motifs on either side; when the cape is tied in the front, the designs are brought together to form crescents. Two red hearts below the black crescent are not traditional design motifs, and they appear on no other Hawaiian garment. The hearts clearly date the piece to the post–European contact period and may have been inspired by playing cards used by sailors and other voyagers who came to Hawaii in the late eighteenth and early nineteenth centuries.

The owl feather cape (4994.1) is the only one of its kind in existence. The short-eared owl (Asia flammeus) lived throughout the islands from sea level to 8,000 feet and above. Important beings in Hawaiian mythology, owls were worshiped as family protectors ('aumakua). The net foundation of the owl cape is made of two-ply olonā fiber. Brown feathers accented with white form a band at the neck and in the center of the cape. Carefully arranged, variegated bands of dark brown, light brown, and white feathers make up the rest of the cape (the garment may have been trimmed). The names of six Hawaiian priests (kahuna) have been associated with this cape; the earliest, High Priest Holae, reportedly lived before the time of Kamehameha the Great. RAD

CAPE ('ahu'ula)
American, Hawaii, late 18th–early 19th century
Feathers tied on netting
16¼ (neck to edge) × 31 in. (41.3 × 78.7 cm.)
Gift of Mrs. Andrew I. McKee, 1964 (3306.1)

CAPE ('ahu'ula)
American, Hawaii, 18th century
Owl feathers tied on netting
15 (neck to edge) × 36 in. (38.1 × 91.4 cm.)
Gift of Mr. and Mrs. Alfred J. Ostheimer, 1981 (4994.1)

STICK IMAGE (akua ka'ai)

American, Hawaii, late 18th–early 19th century

Wood; h. 9 in., overall 22 in. (22.9, 55.9 cm.)

Purchase, 1962 (3075.1)

At traditional Hawaiian temples (*heiau*), wooden images were prominently displayed and carefully supervised by the priesthood. In less formal settings, images of family or personal gods who functioned as protective spirits helped direct the lives of Hawaiians from birth to death. In all instances the gods had to be summoned into the images through prayer and offerings before the images were "activated."

This fine stick image is carved in the so-called Kona style, exhibiting characteristics associated with the Kona coast area of the island of Hawaii, as seen between the late 1700s and the early 1800s, when European tools were introduced. (Kona style is a provisional working term since only a dozen or so images can be stylistically linked, although the characteristics are unmistakable.) The stance, which has been likened to that of a wrestler or dancer, and the tensed muscles lend the figure an aggressive power. The oversize head and headdress comprise over one-half the height of the figure. The lozenge-shaped eyes follow the gentle curve of the lower edge of the headdress. Below the extended nostrils, the horizontal figure-eight-shaped mouth and the slightly jutting jaw make a defiant statement. The adz marks were not obliterated in the finishing and polishing of the piece and suggest the use of metal tools.

Akua ka'ai are images with props. (*Ka'ai* [sash, bind] probably refers to the barkcloth wrapped around a figure of a god [*akua*] in preparation for ceremonies.) The props were used for securing the images upright into the ground or the thatched wall of a building. During one ceremony, the *kauila nui* celebration, *akua ka'ai* were held aloft while affixed to banner-decorated spears.

This figure is from Hale-o-Keawe at Pu'uhonua o Honaunau (present-day City of Refuge National Historic Park, Kona, Hawaii), which housed the deified remains of the High Chief Keawe and his line, from which Kamehameha the Great was descended. Hale-o-Keawe was visited in 1825 by a large party headed by Lord Byron, captain of the HMS *Blonde*, which had been dispatched to Hawaii with the bodies of King Kamehameha II and his wife, Kamamalu, who had died of measles in London in 1824. Andrew Bloxam, a naturalist on the *Blonde*, recounted that the party saw wooden figures protruding from the sides of the building. Having been given permission to remove "curiosities," the captain and his crew took away numerous objects. This stick figure was removed by Midshipman Joseph N. Knowles, according to a twentieth-century account. RAD

STICK IMAGE (akua ka'ai)

American, Hawaii, Oahu, late 18th–early 19th century

Wood; h. 24½ in., overall 32½ in. (62.2, 82.6 cm.)

Purchase, 1945 (351.1)

Six months after the death of Kamehameha the Great in May 1819, the system of restrictions (*kapu*) vital to Hawaiian religion and traditional society was overthrown. This was accomplished when the new king, Liholiho, broke the "eating" *kapu* by participating at a feast with the female chiefs, an act encouraged by the regent, Kaahumanu. The breaking of the *kapu* marked the beginning of a cultural and religious revolution in Hawaii. Countless wooden images representing Hawaiian gods were burned or thrown into marshlands. Today, there are less than two hundred images extant. Many Hawaiians did not abandon their old faith, however, and some figures were hidden in caves to be worshiped and for burial purposes.

This large stick image, with barkcloth (*kapa*) bound around the waist, was found in a burial cave in Waimea Valley, Oahu. The figure itself is one of the largest in the category. Blocklike feet and thick legs support the attenuated torso. The phallus is a rare indication of sex in such stick images. Dividing lines at the ankles, knees, breast, and neck are crisply delineated. Resting on a long columnar neck, the imposing head is crowned by a comblike crest, now partially damaged. Bulging eyes extend out from the surface of the face. The protruding mouth is accentuated by the dramatically curved jaw, reminiscent of the shape of the carved whale-tooth pendant (*lei niho palaoa*) worn by royalty.

Akua ka'ai were used in ceremonies associated with the construction of war temples, carried into battle, and displayed at childbirth. These relatively small, easily transported stick images may also have been used during personal worship; others may have represented protective or family gods (*'aumakua*). RAD

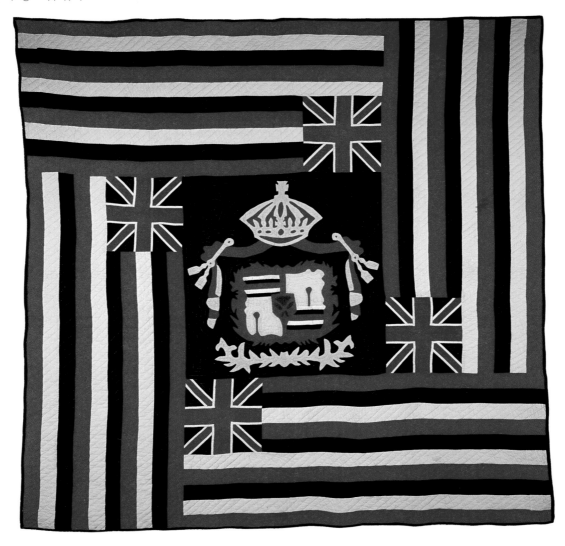

BED COVER

American, Hawaii, Waimea, before 1918
Cotton, plain weave, with cotton appliqués, quilted
7 ft. 6 in. × 7 ft. 6½ in. (2.29 × 2.3 m.)
Gift of Mrs. Richard A. Cooke, 1927 (2590)

This quilt pattern is called K'u Hae Aloha (My Beloved Flag) and shows four Hawaiian flags in red, white, and blue, which form a wide border around the Hawaiian royal coat of arms in the center on a dark blue ground. At the end of the Hawaiian monarchy, many Hawaiians feared that they would not again be permitted to fly the emblem of their kingdom and turned to the quilt as a means of perpetuating the flag and coat of arms. This popular pattern appears in several versions, at least twelve of which have survived in Hawaii in public and private collections. The main differences among them are in the presentation of the coat of arms and other elements in the central panel; also, two have four pairs of Hawaiian flags on crossed staffs rather than the wide border of four flags. Another pattern inspired by this type of quilt has a border of four American flags with the American eagle emblem in the center. LM

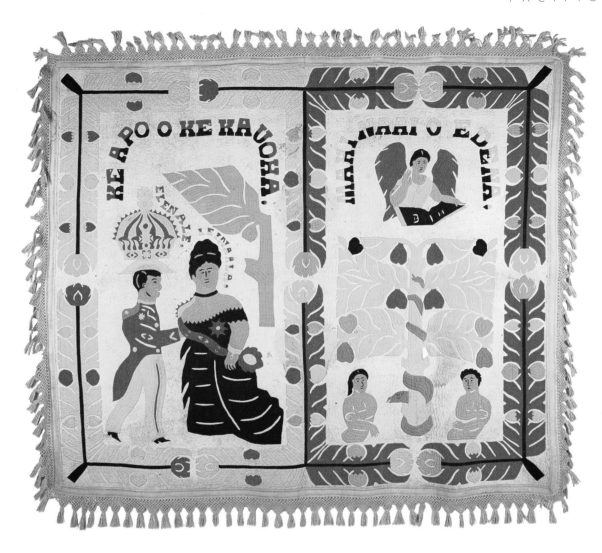

This bed cover is one of the most unusual and striking of all Hawaiian quilts. The pattern, called Na Kihapai Nani Lua 'Ole O Edena a Me Elenale (The Beautiful Unequaled Gardens of Eden and of Elenale), shows Adam and Eve seated beneath a tree around which the devil, in the form of a serpent, is entwined. Above the tree an angel holds an open book under the legend "Mahina'ai O Edena" (Garden of Eden). On the left side, two figures in royal court dress and regalia stand beneath the branch of a tree under the legend "Ke Apo O Ke Kauoha" (The Embrace of a Commandment). The man, with a large Hawaiian crown above his head, is identified as Elenale, and the woman as Leinaala, the principal characters in a Hawaiian romantic story popular in the late nineteenth century. The beautiful Leinaala, held captive by a witch in Manoa Valley, was rescued by Elenale, who took her to live in his exquisite garden. The anonymous maker of this quilt has made an analogy between the Garden of Eden and that of Elenale, and has likened Elenale's love for Leinaala to the first love of Adam for Eve. Elenale and Leinaala are portrayed as Hawaiian royalty; the figures were copied from photographs or lithographs. A full-length view of Queen Emma (1836–85) can be identified as the source for the figure of Leinaala. LM

BED COVER

American, Hawaii, before 1918

Cotton, plain weave, with cotton appliqués, quilted and with knotted fringe; 6 ft. 6½ in. × (without fringe) 7 ft. 8 in. (1.99 × 2.34 m.)

Gift of Mrs. Charles M. Cooke, 1929 (2828)

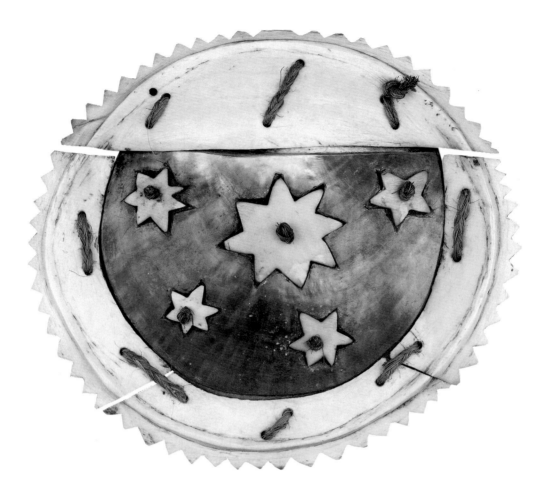

BREAST ORNAMENT (civa)

Fijian, 18th century

Whale ivory, pearl shell, sennit

7 × 7½ in. (17.8 × 19 cm.)

Gift of Grossman-Moody, Ltd., 1947 (440.1)

Fijian culture reflects a mixture of Polynesian and Melanesian traits; its arts are clearly Polynesian in concept, style, and technique. Utilitarian and decorative objects made for chiefs and commoners display the inherent beauty of the natural materials from which they are made. Of all the chiefly paraphernalia, the large shell, whalebone, and whale-ivory breast ornaments show the most accomplished craftsmanship. Worn by high-ranking persons in battle or at major ceremonies, some breast ornaments combine the splendor of shell and the warmth of ivory.

This piece is composed of a large ground and polished pearl shell, surrounded by four plates of split sperm-whale ivory, which are held together by sennit laced through drill holes. A sennit cord attached at the top of the piece was used to suspend it from the neck. The periphery of the ornament is decorated with a sawtooth pattern; ridges carved on each plate connect to create a circular raised border. The pearl shell is inlaid with a central star and four smaller stars of ivory, also held in place by knots of sennit. The inlay work is similar to that on the heads and ends of clubs. Other motifs on similar Fijian breast ornaments include circles, lozenges, and stylized birds and are reminiscent of birds and animals in Tongan decoration. RAD

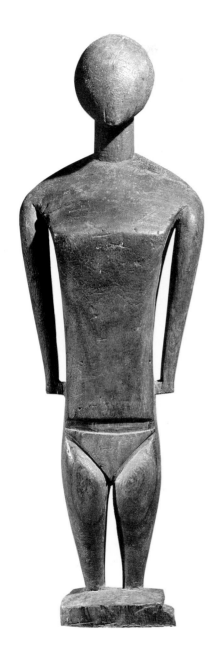

FIGURE

Eastern Caroline Islands, Nukuoro
early to mid-19th century
Wood; h. 15%/16 in. (39.5 cm.)
Museum exchange, 1943 (4752)

kept in a community religious building (*amalau*), are the most highly stylized and geometric of all Oceanic anthropomorphic sculptures. Essential parts of the body are interpreted as formal elements: ovoids, triangles, cylinders. The proportions, clearly displayed in the Academy's piece, were rigidly applied to all figures. The pointed egg-shaped head rests at an angle on the columnar neck. The face of this figure is smooth, but other examples have abbreviated facial features. From the broad shoulders, spindly arms hang down and terminate in strutlike hands resting on the hips. Where the sloping chest meets the rectangular plane of the midsection, a crisply defined ridge is indicated. Deeply incised bands accentuate the pubic triangle. In profile, the exaggeration and stylization of the buttock is evident. The legs taper to the supporting block (on some images the block is incised to indicate toes and feet). The smooth, unadorned surface and the superb craftsmanship of this piece are reminiscent of Mangarevan sculpture and other Polynesian works. However, its austere abstraction lends the piece an elegance and sophistication unique to Nukuoro.

Probably fewer than twenty Nukuoro images are extant; they range in size from about fifteen inches to over seven feet. The Academy's figure was acquired by the Reverend E. T. Doane, an American missionary stationed in Ponape, who sent it to the American Board of Commissioners for Foreign Missions in Boston. Doane had visited Nukuoro aboard the ship *Star* in 1874 and may have acquired the piece at that time. RAD

Within the broad areas of Melanesia and Micronesia are islands inhabited by people who exhibit Polynesian physical and cultural traits. This figure was made on one of these Polynesian "outliers," Nukuoro, an atoll of four hundred acres with forty islets to its north, east, and south, situated in the Eastern Caroline Islands of Micronesia. Micronesian mats, fabrics, and ceremonial bowls, decorated with nonrepresentational designs are well known, but figurative sculpture is rare. The remarkable sculpture of Nukuoro underscores its Polynesian connection.

Nukuoro religious images (*tino* or *dinonga eidu*), representing either primeval gods or deified ancestors and often

FIGURE

New Zealand, North Island, Maori
late 18th–19th century
Wood; h. 10¾ in. (27.3 cm.)
Gift of Henry B. Clark, Jr., 1989 (5805.1)

In the tenth and eleventh centuries, New Zealand was set-tled by ancestors of the Polynesian people who now com-pose the various Maori groups. Maori art created over the last thousand years can be divided into two broad phases. The archaic, when form was stressed over decoration, began with the settlement era and continued on North Island until about 1500 and on South Island until the nine-teenth century. The classic phase—noted for its strong curvilinear surface decoration—began about 1500 and existed until recent times.

Maori carvers sculpted in whalebone, ivory, and jade but are best known for their works in wood. Not only were small utilitarian and ceremonial objects carved of wood but major constructions were decorated with elaborate wooden images. The three most important sculptural vehicles were the canoe (*waka*), the meeting house (*whare whakairo*), and the storehouse (*pataka*). Storehouses pro-tected food and valuables while adding to the prestige of the chiefs, and ranged in size from small, boxlike struc-tures elevated on posts to large buildings. Their facades were sometimes fitted with sculpture, often including carved anthropomorphic finials (*tekoteko*). This piece is most likely a finial figure from the apex of the barge-boards (*maihi*, or facing boards on the gable) of a small storehouse. The bottom of the piece shows signs that it was broken away, and the figure may have stood upon another figure or a mask, a common configuration.

This piece is an excellent example of an ancestor figure of the classic style associated with the east coast of North Island and may have been created in northern Auckland. The figure displays characteristics common to Maori fig-ural sculpture: oversize head, round hypnotic eyes, out-thrust tongue, three-finger hands, indication of sex, and bent-knee stance. Two birdlike profile figures (*manaia*)

are carved on the back of the head at the top. A large *manaia* head runs down the back of the head and abuts a separate piece of wood attached to the figure. Lashed on with split *kiekie* vine (*Freycinetia banksii*), the unusual addition supports the figure, although its initial purpose is unknown.

In the Maori view, land, human beings, and natural and man-made objects, indeed most things, were imbued with a power called *mana*. Religious objects were by their very nature filled with *mana* and protected by strict laws (*tapu*). This figure and others like it were not considered inanimate art objects but were sanctified ancestral images charged with immanent power. As such they were seen as intermediaries between the visible and invisible worlds. RAD

The Sulu Archipelago lies between Mindanao and Borneo, bridging the Sulu and Sulawesi sea basins. Because of its location, Sulu for centuries served as an important cultural center for maritime trade. Perhaps reflecting the cosmopolitan atmosphere of the area, woven textiles of the Sulu Archipelago are highly sophisticated in their designs and techniques. Sulu's colorful headcloths, shawls, and skirts made of imported silk are particularly known for their intricate patterns and brilliant color combinations. This example of a silk tube skirt is painstakingly woven on a simple backstrap loom using a fine tapestry technique. The result is a brocadelike geometric design in delightful purple, pink, orange, and pale green. The design motifs of the skirt, especially the triangles at the borders, are reminiscent of Indonesian batik or Indian *patora* patterns, which indeed may have influenced Sulu weaving designs. This type of skirt is worn by either men or women on festive occasions. RB

TUBE SKIRT

Philippine Islands, Sulu, 20th century

Silk, tapestry weave; 41 × 32 in. (104 × 81.3 cm.)

Gift of Mrs. W. Thomas Davis, 1989 (5882.1)

MALE ANCESTOR FIGURE

Papua New Guinean, Lower Sepik, 19th century

Wood, shell, sennit, raffia, and human hair

h. 23⅝ in. (60 cm.)

Purchase, Academy Volunteers Fund, 1983 (5105.1)

New Guinea, the second-largest island in the world, is home to more than seven hundred culturally distinct groups. The Sepik River, which meanders for over seven hundred miles, is a unifying element for many of the northern groups. The people living along or near the river have created some of the most extraordinary art in all of Oceania. Ornately decorated utilitarian objects, musical instruments such as flutes and drums, elaborate wooden masks with appended materials, and freestanding ancestor figures—ranging in size from a few inches high to over six feet—are some of the best-known objects from the Sepik region. Ancestor worship is a dominant force, and many works of art are used in complex religious rituals.

The Academy's male ancestor figure, probably from the Lower Sepik, is carved in a strong frontal pose. The slight tilt of the torso to the figure's left relieves somewhat the rigidity inherent in such a presentation. The "stooped shoulder" impression the piece gives is aided by the large ovoid head resting directly on the upper chest. A conical headpiece is composed of sennit, raffia, and human hair. Although the adz marks are apparent and certain parts, such as the blocklike feet and hands, are summarily rendered, the piece is extremely descriptive, with many anatomical details clearly articulated. The ankles, kneecaps, phallus, and elbows are accurately, even sensitively, carved. The flange encircling the face would have appeared as a lifelike beard when sennit or other fiber was threaded through the drill holes. Tiny shells inlaid in the huge orbits give vivacity to the eyes. The frontal suture divides the prominent forehead and meets the narrow ridge of the nose. The tip of the nose has been distended because of the pierced nasal septum, and there are two holes over each nostril, probably meant for ornaments. The concern for naturalism can be seen on the outer arms,

where long segmented scars are carved in relief. Scarification patterns on images probably derive from practices common during certain initiation rites, in which the body is repeatedly incised and the wounds rubbed with oil to produce large raised scars.

Ancestor figures are associated with exclusively male spirit houses. Ritual objects such as figures and masks are stored in spirit houses where initiation, funeral, and head-hunting ceremonies begin and end. The presence of such sacred objects in the spirit house is believed to aid adult males in their communion with the powerful spirit world. RAD

Sepik art has a relatively homogeneous character in part because of the inter-tribal communications along the Sepik River. Numerous distinct regional styles nevertheless exist; that of the Iatmul group has been well known and admired for many years. The Iatmul, the largest group along the river, live in the Middle Sepik district, which consists of lowland rain forests between the interior and the coastal mountain ranges. Iatmul ceremonial houses are the grandest on the island, and their rituals involve a wealth of masks and figures made of wood or basketry. Iatmul household objects are decorated in the same careful manner as sacred objects, reinforcing the belief that the super-natural is a constant presence in everyday life.

The Iatmul, like other Sepik and certain Southeast Asian groups, chew a mixture of powdered lime, betel nut, and leaves, which creates a distinctive red juice and produces a stimulant and narcotic effect. Lime containers with elaborate finials were presented to Iatmul boys by their maternal uncles upon passing initiation rites into adulthood.

This Iatmul wood stopper is an ornament carved as a seal for a long bam-boo lime container. The stopper exhibits the expressive, curvilinear form typical of the best of New Guinean art. Parts of the bird's body are seemingly disassembled, interpreted as pure shapes, and then reassembled to create rhythmical cursive patterns. The curves of the wings are balanced by the opposing curves of the body. Although the piece is thin and was meant to be viewed from either side, the careful through-carving lends the bird a bold sculptural quality. The beak, shell-inlaid eyes, and conical hat are finely detailed. The bird's hat suggests totemic symbolism. Totemism, the claim that specific clans share legendary relationships or kinship with specific ani-mals, plays an important role in the religion of the Sepik region. RAD

STOPPER FOR LIME CONTAINER

Papua New Guinean, Middle Sepik, Iatmul
probably 19th century
Wood, paint, shells, and fiber cordage
h. 16½ in. (41.9 cm.)
Gift of Mrs. Philip E. Spalding, 1936 (4196)

MASK

American, Alaska, Eskimo, ca. 1880
Wood; 9 1/2 × 8 in. (24.1 × 20.3 cm.)
Gift of Irma Fulwider, 1946 (367.1)

MASK

American, Alaska, Eskimo, 20th century
Wood with beads; 7 1/2 × 3 5/8 in. (19.1 × 9.2 cm.)
Gift of Mrs. W. Thomas Davis, 1989 (5864.1)

Eskimo groups live in the challenging environments of Greenland and the extreme northwestern parts of Canada and Alaska. According to traditional Eskimo religion and mythology, all living things and all natural and man-made objects possess a spirit, or *inua*, in different forms. The Eskimo shaman acts as a conduit between the spirit and the three-dimensional world during ritual performance, reenacting dreams or visions of the spirit world. He uses wooden carved objects such as staffs, figures, and masks, which are based on the shaman's vision and carved either by the shaman himself or by another man according to his instructions. The most imaginative and artistically rendered masks come from the Yupik-speaking Eskimo of the lower section of the Canadian and Alaskan range, bordering on the Bering Sea.

Masks such as these are said to represent the *inua* of animals. The larger mask comes from the Kuskokwim River region and is said to represent a seal. Upright ears are carved in low relief on a panel rising behind the round head. The swirling grain of the wood matches the carved forms on the mask, especially around the eyes and the nose, although the piece originally may have been painted. Shallow incisions were made for the mouth and nostrils; the eye holes were drilled. The smaller mask has tiny beads for eyes and a string of beads of the same size for the bow-shaped mouth. A small drill hole on either side of the mask just below the eye was most likely threaded with a thong that held the mask to the head. The erect ears and long snout rendered as one continuous element indicate that the spirit represented might be a wolf, fox, or wolverine. Bering Sea Eskimo masks are meant to be understood within a complex ensemble involving dance, song, and testimony. Eskimo carvers were encouraged to reinterpret the myriad symbols and forms found in their religion. This practice, and the theatrical setting in which the masks were viewed, makes secure identification difficult, but imbues the works with unusual artistic strength and creates an impressive diversity. RAD

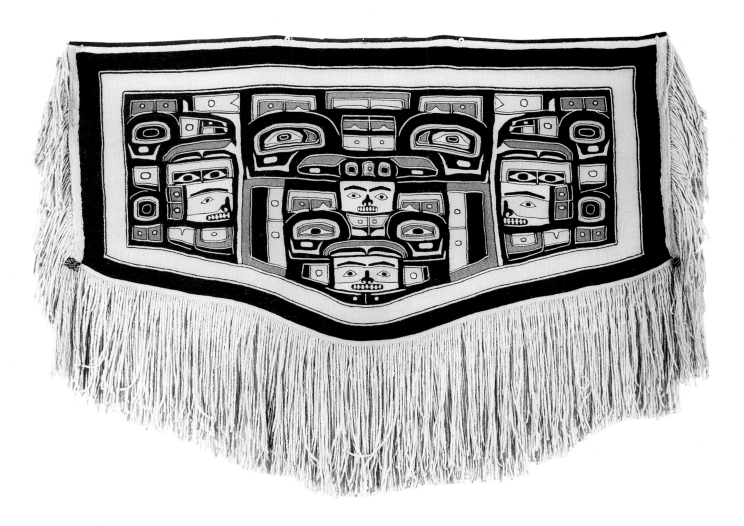

Textiles such as this are commonly termed Chilkat blankets after the sub-group in the Tlingit group that specializes in weaving them. They were worn as ceremonial robes or capes by persons of rank, and in local terminology were referred to as "dancing blankets." The long unfringed edge passed over the shoulders and tied around the neck, the narrower edges falling at the sides and the central section across the back. The full costume included a sleeveless shirt, apron, and leggings, which were all made in the same way and ornamented with related motifs. The traditional patterns of these blankets are all similar in form and show highly stylized totemic animals. This blanket shows a raven in frontal view in the center and in profile to either side. Small masks representing bear heads are also incorporated into the design. The master patterns for these blankets were painted on boards by men of the group and showed the central section and one side in outline only. The weavers, always women, carried the placement of the traditional colors—black, white, yellow, and green or turquoise—in their memories. Most of these blankets were woven of goat's wool over a base of shredded cedar bark; however, no cedar bark was used in this example. RB

BLANKET

American, Alaska, Tlingit, late 19th–early 20th century

Wool, twill tapestry twining, with warp fringe at

bottom and applied fringe at sides

49 (with fringe) × 64 in. (124.5 × 162.6 cm.)

Purchase, 1935 (4183)

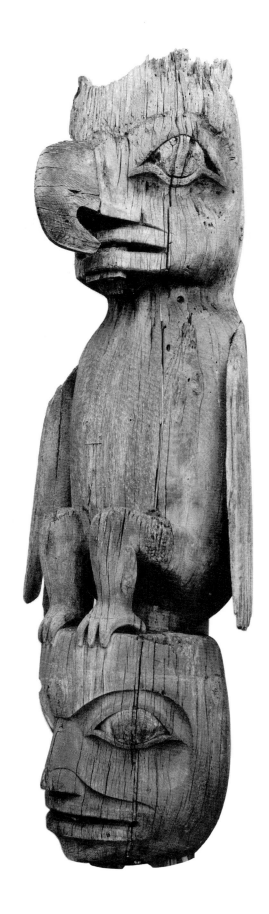

TOTEM POLE (detail)

American, Alaska, Prince of Wales Island,

Tlingit, ca. 1900

Redwood with traces of pigment

h. 24 ft. 9 in. (7.54 m.)

Gift of Vincent and Mary Grant Price, 1981 (4975.1)

Universally recognized as symbols of Northwest Coast Indians, totem poles were erected in front of the houses of persons of distinction. These carved wooden pillars were typically installed at the time of potlatches. This example (only the upper one-third is illustrated) came from Tuxican, the chief town of the Henya, a Tlingit group. A hawklike bird is poised at the top of the pole. The area around the irises of its large expressive eyes has been cut back and painted white. The curved portion of the beak and the slablike wings displaying individual feathers were carved separately and then attached to the poles. The bird sits, resting its talons on the head of an anthropomorphic figure. Crisply carved, the head of the figure retains some yellow and ochre paint around the eyes and red on the lips. On the bottom two-thirds of the pole, this figure stands atop a bear and holds a long fish in front of its torso.

In mythological times, ancestors of kinship groups had encounters with or became animal beings. The groups later claimed these animal beings as their totemic symbols or, more properly, crests. Members of groups do not consider themselves to be hawks, for instance, or to possess hawk characteristics. When a Northwest Coast Indian says he is a hawk, he is declaring his membership in a kinship group that has a legendary relationship with a hawk.

When a totem pole was commissioned, the owner instructed the artist on how many and which crests should be depicted. Each totem, depicting hidden meanings and visual puns, often became a statement about the owner's membership in a group. In order to interpret the Academy totem pole, or any piece, viewers have to know what the owner and the carver, who had a certain degree of artistic license, intended the piece to mean. Little of this information has come down to us over the years; thus, scholars can only conjecture about the meaning of crests.
RAD

RAVEN RATTLE

Canadian, British Columbia, Queen Charlotte Islands,
Haida, mid-19th century

Wood; I. 13¼ in. (33.7 cm.)

Gift of Mrs. Theodore A. Cooke, 1946 (384.1)

Across North America, native Americans have traditionally included rattles in their elaborate ceremonies; Northwest Coast rattles exceed all others in their variety and complexity. Used as accompaniment for dances extolling social rank and by shamans to heal persons or to contact spirit helpers, Northwest Coast rattles imply the presence of supernatural powers. The distinctive sound of rattles is believed to act as a channel to the spiritual realm. Said to have been invented by the carvers of the Nass River people, the Nishga, raven rattles were produced by several different groups as far south as the Kwa'kiutl area during the nineteenth century. The majority of these rattles depict Raven, or Yahl, a mythological being who figures prominently in Northwest Coast creation stories. A few rattles depict other birds.

This rattle reveals an intricate tableau from the natural and supernatural worlds. In its oversize bill the raven holds a small, round red object, which may represent the daylight or possibly the fire that Yahl carried in his bill. A creature with the head of a bear or wearing a bear mask reclines on the raven's back. The body of the bear figure was apparently broken off and replaced with crudely fashioned appendages, although the feet are original. The tongue of the bear figure arches up and is grasped in the bill of a large bird head, which rests on the wings of the raven. The long-beaked bird resembles the kingfisher, and its jutting crest feathers act as the raven's tail. The raven's underside is decorated in fine, low relief with the face of

what appears to be a hawk. The downturned beak of the creature is grasped in the mouth of a tiny frog that crouches below. The frog and the bear figure are found on only a few Northwest rattles, all of which are of the highest quality.

Another unusual aspect of this rattle is its composition from a single piece of wood. The solid handle merges into the globular body, which has been split all around under the wings and displays no joinery. Behind the kingfisher's head is a hole, now plugged, which may have been used to introduce sound-producing pebbles or shot. Generally, the exchange or joining of tongues, or tongues and beaks (which occurs twice on the Academy piece), is believed to symbolize communication or possibly a transfer of power. Although most authorities today believe that raven rattles were used by Northwest shamans, native informants told researchers at the turn of the century that the rattles were used by chiefs during dances. A chiefly dancer would hold a raven rattle down and to the side with its belly up, for, it was said, if the rattle were held upright, the raven might fly away. RAD

FEMALE FIGURE

Ecuadorian, Jama-Coaque, ca. 300 B.C.–A.D. 300
Terra cotta with traces of pigment; h. 22 in. (55.9 cm.)
Purchase, 1973 (4185.1)

Interest in ancient Ecuador and its culture increased dramatically when radiocarbon dating indicated that Ecuador may have been the location of the first settlements in South America. Pottery remains from Valdivia, Guayas province, including small effigies of nude females, are the oldest found in South America, possibly dating to 3200 B.C. The Chorrera culture (ca. 1200–300 B.C.) produced a great variety of ceramic effigy vessels and figures, including "backbending" acrobats and vessels in the shapes of squash, pineapples, monkeys, jaguars, and dogs. Stylistic similarities between Chorrera vessels and those from Colima, Mexico, indicate strong trade ties, and like their Chorrera predecessors, the Jama-Coaque people must have maintained these ties, since their realistic and softly rounded figures are strikingly similar to West Mexican examples. This piece, unusually large and in the full Jama-Coaque style, was probably excavated from the site of San Ysidro on the north coast of Ecuador, an area where the Jama-Coaque culture flourished during the Regional Development period (ca. 500 B.C.–A.D. 500).

Numerous objects found in the excavations, such as spindle whorls and flat and cylindrical stamps, suggest a widespread and active Jama-Coaque textile industry. Ceramic figures depicted in elaborate clothing also lend credence to this supposition. This figure is bedecked with a dramatic horned and winged headdress, earrings, a long skirt, a large nose plug, a wedge-shaped lip plug, necklace, and bracelets. The bony superstructure of the face is exquisitely modeled, and the protruding, semicircular eyes and hawklike nose are clearly emphasized. The cupped hands may have held cylindrical objects or one long object. The shoulders and legs were burnished, and substantial traces of pale green and yellow-orange paint remain on the headdress. A secular interpretation of this piece and others like it would suggest that they represent important members of Jama-Coaque society. However, it is possible that Jama-Coaque figures functioned as sacred objects used in funerary rites and perhaps signify important mythological beings. RAD

MASK

Mexican, Olmec, ca. 500–400 B.C.

Jade; 6³/₄ × 6 in. (17.1 × 15.2 cm.)

Purchase, 1973 (4175.1)

The humid forests and swamps of the modern Mexican states of Veracruz and Tabasco were home to one of Central America's first civilizations, the Olmec. In the tropical habitat that borders the Gulf of Mexico, the Olmecs flourished from about 1500 to 400 B.C., developing their distinctive art forms: large architectural centers, colossal stone sculptures, impressive stelae, and exquisite hard-stone figurines and masks. The "people of the land of rubber," as the Olmecs were known to the Aztecs, carved gigantic monolithic heads—one weighs over sixty tons—and it was these that caught the attention of archaeologists.

This mask is one of more than twenty-five life-size jade masks and one thousand celts found in a burial site at Las Choapas, Arroyo (or Rio) Pesquero, Veracruz, near the Tabasco border. Stylistic similarities are found between the Las Choapas jades and those from the important Olmec ceremonial center of Las Venta in Tabasco. Jade masks originally had a high polish, but some masks, such as the Academy's piece, were burned in ancient times and thus have acquired a matte finish. This pale green mask has tinges of brown patina around the eyes and on the ears and lips. The puffy area under the eyes, the round cheeks, full lips, rounded teeth, and overall subtle modeling of the facial planes are characteristics of Olmec masks. The irises of the eyes, the nostrils, and mouth have been pierced (there are drill holes in the corners of the mouth). Ear plugs or other ornaments, possibly of perishable materials, may have fit into small surface holes in the earlobes. Large holes are found below each ear and on the top edge of the mask, which may have been placed upon the face of the deceased. These holes were perhaps threaded with cord to secure the mask. Many aspects of Olmec religion and symbolism remain shrouded in mystery, making interpretation of objects such as these jade masks problematic.
RAD

DOG EFFIGY WITH HUMAN MASK

Mexican, Colima, ca. 300 B.C.–A.D. 500
Terra cotta; 9 × (length) 15 in. (22.9 × 38.1 cm.)
Purchase, Academy Volunteers Fund, 1973 (4173.1)

The shaft-tombs of Colima, Jalisco, and Nayarit on the Pacific coast of Mexico have yielded an impressive variety of hand-modeled clay mortuary figures. The large, polished red-ware figures from the small state of Colima are especially well known for their realistic portrayals of wild and domesticated animals. Deer, turtles, sharks, ducks, parrots, and especially dogs are part of a large menagerie charmingly described by Colima artists.

One of the first-published (1888) shaft-tomb figures from West Mexico was a Colima dog with a human mask almost identical to the Academy's piece. Similar extant sculptures have smaller masks covering only the nose of the dog. The Academy's dog has a corpulent body supported by stocky legs and a large head cleverly balanced by a spoutlike tail. Detail is created by modeling, for example in the subtly indicated spine and the erect ears, and by some incision on the eyes and ears of the mask. The coloring of the piece is mottled, the result of the buff clay being covered with red slip, which in turn is flecked with black because of reduction firing. The piece was also burnished. Many Colima dog effigies have pierced ears (in the Academy's example only the ears of the mask are pierced), suggesting that they may have worn earrings or other ornaments of perishable materials. Today the Huichol Indians of West Mexico occasionally thread a cotton string or a small weaving as a talisman through holes they pierce in their dogs' ears.

The dog represented in Colima sculpture is apparently a *tepescuintli* or *techichi*, a special breed of hairless canine that was raised for food by the Maya, Aztecs, and other Mesoamerican groups. The ancient inhabitants of Colima may also have consumed the meat of this animal, perhaps at feasts or sacrificial rituals. The ubiquity of the dog effigies in tombs may indicate that they were not only important companions for their dead masters but also a source of nourishment in the next life. They also may have represented guides to the underworld or totemic animals (a concept found also in North and Middle American mythology). A totemic relationship between the dog and a man or clan might be indicated, since the mask transforms the wearer into the being whose likeness he wears.
RAD

DOUBLE-FIGURE WHISTLE

Mexican, Maya, Jaina, ca. 700

Terra cotta with traces of pigment; 10½ × 5¾ in.
(26.7 × 14.6 cm.)

Purchase, 1973 (4184.1)

The Mayan civilization flourished from about 300 to 900 on the Yucatan Peninsula in an area covering five modern countries: Mexico, Guatemala, Belize, and the northwest corners of Honduras and El Salvador. Among the best-known and most appealing of Mayan art forms are figurines from the tiny island of Jaina, a ceremonial and burial center in the Gulf of Mexico just off the coast of Campeche, Mexico. Excavation of its more than one thousand tombs has yielded realistically rendered polychrome figurines, depicting single and double standing or seated figures, often bedecked with elaborate coiffures, headdresses, capes, and jewelry, holding shields or other objects.

In this Jaina terra cotta, two young figures, male and female, are of the same height and therefore of equal importance, the female's imposing headdress notwithstanding. The headdress, her circular earplugs, bracelets, and necklace are signs of elite status; her facial scarification, long nose, flattened forehead, and haircut are Mayan distinctions of beauty. The male figure appears to be speaking to the female, his head turned toward her. His left arm rests gently on her shoulders, and he possesses the same aristocratic air as she. Attention to details of jewelry and facial features is evident in the male figure (the jewelry is added by appliqué technique; the mustache and beard, minutely incised). Elongated torsos and reduced proportions of the legs give both figures a weighty dignity.

Jaina clay tomb figures were made by mold, by hand, or by a combination of both techniques. Detailing was added by appliqué, and the buff clay was painted, often with Mayan blue, traces of which can be seen here. Most of the figures were apparently used as rattles or whistles, possibly in funeral processions. This piece has a perfectly shaped whistle hole at the bottom. The extraordinary detail in the costumes and jewelry on this piece and others like it may indicate that the artists were attempting to reproduce as accurately as possible actual clothing worn by Mayan aristocrats. Be that as it may, the figures might represent supernatural beings, symbolizing astronomical or cosmic concepts. Although identification of Jaina figures as deities remains problematic, it is clear that these figures, numerous and carefully rendered, were important grave objects. RAD

MALE FIGURE

Mexican, Huastec, ca. 11th–12th century

Sandstone; h. 69 in. (175.3 cm.)

Gift/Purchase from Mary Grant Price, 1984 (5257.1)

The Huastec hold a unique place in Mesoamerican history because of their unbroken cultural development from the early preclassic period to the time of the Spanish Conquest, a period of 2,500 years. Isolated in the far northeastern corner of Mesoamerica, in a region within the modern states of San Luis Potasi, Tamaulipas, and Veracruz, the Huastec absorbed influences from the south but were not radically altered by them. The outpost of the Huastec, who sprang from Mayan roots, was in the valley of the Rio Panuco, to the west of the gulf port of Tampico in Veracruz. Although they spoke a Mayan language, the Huastec developed their own art style and are known for handsome solid ceramic figurines and monumental stone sculptures. The sculptures, carved from single slabs of sandstone, display a severe hieratic style. The shape of the figures, male and female deities, are adapted to the block-like qualities inherent in layered sandstone. Although generally more sensitive, Huastec sculpture shows an affinity to Toltec sculpture.

This standing male figure is from northern Veracruz and dates from the postclassic period. On its back, a flat panel in low relief connects the headdress to the torso. The thin sculpture was clearly meant to be viewed from the front. Behind the head and conical hat is a large, half-round device, possibly representing a fanlike paper construction. The face is rendered in sensitive low relief; the ears support oversize, pendant ear ornaments that end in hooks. The arms are flexed, and the hands have drill holes meant to hold cylindrical objects. The figure wears a long-sleeved shirt and a minimally defined skirt and apron. Large, blocklike feet, with toes and ankles portrayed, rest on a rough-hewn base. The overall effect is one of dignity and solemnity.

The conical hat and hooked ear ornaments suggest that this figure represents the god Quetzalcoatl, possibly in his wind-god manifestation, Ehecatl.　　RAD

270

An artist who turned his back on the works of Pablo Picasso, Georges Braque, and other friends of the European avant-garde, Diego Rivera devoted the mature part of his career to powerful depictions of his Mexican compatriots. Completing mural commissions and easel paintings alike, Rivera is arguably the best-known painter of his country in the twentieth century.

As a student aware of the general discontent brewing in Mexico and the need for reform, Rivera searched for an effective means of communicating his social concerns. His discovery of early Italian Renaissance murals marked a pivotal point in his career as he recognized in them a painting type that was legible to all and appropriate for complex iconographic statements. Rivera took Mexico as his subject—the strength of her people confronting their social, political, and economic history—and joined to it what he had learned in Italy about style, technique, and content. Although his major commissions were generally for government-sponsored murals, Rivera also executed a prodigious number of easel paintings, a fine example of which is the *Flower Seller*. Here, a young Mexican woman quietly nurses her child as she sits behind the array of varied flowers she waits to sell.

The *Flower Seller* demonstrates Rivera's brilliant sense of design and a grandeur of conception illustrative of his mature style. The artist concentrated on the geometric

DIEGO RIVERA

Mexican, 1886–1957

Flower Seller, 1926

Oil on canvas; 36 × 43¾ in. (91.4 × 111.1 cm.)

Gift of Mr. and Mrs. Philip E. Spalding, 1932 (49.1)

essence of the image; crisp in contour and bright in hue, the contrasting rounded and angular forms completely fill the work, creating a symmetrical composition of balance and order. Rivera's placement of these basic shapes close to the picture plane and the use of a dense screen of leaves to obscure a larger spatial context also stress the two-dimensional surface of the canvas and contribute much to the painting's bold compositional patterning. As flat, simple forms of strong color take on a significance independent of the physical world they describe, Rivera generated a decorative abstract design of remarkable visual impact.

The serene and thoughtful expression on the young mother's face suggests a resigned acceptance of life's lot. Grave and dignified, the woman nursing her infant assumes iconic proportions reminiscent of earlier European depictions of the Virgin Mary and Christ Child. Rivera's sympathetic respect and affection for the Mexican people, humanistic concern for the dignity of the individual, and still-potent social realism demonstrate his easel work at its best. JS

EFFIGY VESSEL

Costa Rican, Late Period IV, ca. 200–500

Terra cotta with design in black and white pigments

h. 18½ in. (47 cm.)

Purchase, 1975 (4291.1)

Created on the Nicoya Peninsula in northwest Costa Rica, the Academy's impressive painted effigy vessel is of a type known as Tola Trichrome, which has modeled and appliquéd forms and black-and-white decoration on a zoned red slip. Human/animal beings or humans costumed as bats or alligators are common subjects of Costa Rican ceramics, especially in Tola Trichrome works. The Academy's piece represents an alligator with human traits. The iconography and large size of this vessel and other similar vessels suggest that they once held substances, possibly liquids, which may have been used in rites in which mythological beings were important. These rites may have been part of shamanistic practices involving the transformation of humans and animals.

This globular vessel is supported by two hollow legs in front and a hollow conical tail in the back. The male genitalia are carefully rendered below a register of decoration that covers the body of the vessel. The decoration, executed in black accented with white outlines and dots, depicts highly conventionalized and geometric alligator motifs. The motifs were evidently applied in a kind of resist technique. Initially painted in wax, the motifs left negative patterns after firing, which were then filled with paint. The black-and-white decoration makes a pleasing contrast with the warm red slip. Scrawny arms and tiny hands in raised relief hug the body of the vessel, with the right hand holding what appears to be a black rattle. On the neck of the vessel, a riveting humanoid face stares out defiantly. The mouth with teeth bared, the sharply upturned nose, and the buttonlike, hypnotic eyes give the face a grim aspect. Except for the black eyes, the face was covered with white paint. The appliquéd pellets above and on either side of the face symbolize the alligator. The flaring mouth of the vessel acts as the terminating design element for the figure. RAD

The Bena Lulua (Men of Lulua), who live in the environs of Luluabourg and along the Lulua River in Zaire (formerly Republic of Congo), migrated to the region between 1885 and 1890. Although the Bena Lulua were once under the sway of the Baluba (the largest complex of culturally related tribes in Zaire), their art retained a distinctive and much-admired character. The Bena Lulua produced refined masks and small images, but their most striking works were figures of chiefs and women (sixteen inches and larger), all said to have been carved before their migration. Known as *lupfingu*, these images probably represent ancestor guardians, although some may have been protective or helpful fetishes.

No better balance between form and surface decoration in African art can be found than that displayed in Bena Lulua sculptures. The serene, graceful elegance of the anatomy is accented by elaborate scarification patterns, which at times cover the entire figure. The marks are apparently an exaggeration of scarification practices that had died out.

The Academy's Bena Lulua figure is a classic example of its kind and ranks as a masterpiece of Congolese sculpture. The figure of a pregnant woman with hands on the sides of her abdomen is of a type possibly used in a fertility cult known as *tshibola*, whose primary purpose was to encourage children who had died prematurely to return to life. The figure has the typical bulbous head, a long neck, slim torso, and oversize feet. The most articulated part, the head, is covered at the top back with a pointed skullcap or headdress, which is slightly damaged. The delicately modeled eyes, nose, and lips are harmoniously disposed. A raised scarification design covers the chin and flares up the cheeks, ending in spirals, and the riot of intricate patterning continues down the neck and onto the chest, contrasting vividly with the shiny surface of the torso and muscular arms. The vibrant sheen on many Bena Lulua works is a result of rubbing with oil and *tukula* (powder made from the dust of camwood, believed to possess magical powers).

The focal point of the piece is the pendulous abdomen with fine concentric circles accentuating its globular form. The legs are long with cursive outlines; blocklike feet anchor the work and balance the oversize head. Although stylized and geometricized, the figure's anatomy conveys an admirable fidelity to nature. RAD

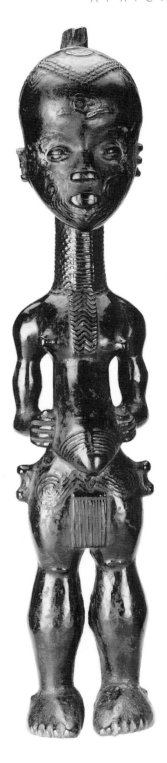

FEMALE FIGURE

African, Zaire, Bena Lulua, 19th century

Wood with traces of *tukula* pigment

h. 19¾ in. (50.2 cm.)

Promised gift of Mr. and Mrs. Richard Rogers (L30,778)

ANTELOPE MASK

African, Ivory Coast, Guro, 19th–20th century
Wood with brass; 16 1/2 × 4 5/8 in. (41.9 × 11.7 cm.)
Purchase, Academy Volunteers Fund, 1983 (5104)

The Guro people of the Ivory Coast are artistically related to the larger Baule tribe and are especially admired for their ingenious figurative heddle pulleys and refined dance masks. This Guro mask may be a precursor of the Zamle Society antelope masks from the Zuenola district. Antelope masks are typically polychromed, and the features resemble the hyena and crocodile as well as the antelope. Zamle masks and the Academy's Guro mask were worn vertically on the face; however, in the former the dancer peered through the eye slits, whereas in the latter the dancer looked through the holes in the bowl-shaped base. The eyes are brass plates, nailed to the mask, with dentate designs on the bottom. The squared-off mouth, lined with two rows of small teeth, appear more canine than antelopelike. The long narrow nose meets a decorative ridge that runs up over the head and ends at the central horn. The three horns, decorated with carved rings on two-thirds of their length, taper upward impressively. Holes in the badly worn base were probably used to suspend fibrous material, such as raffia, which helped conceal the dancer. Undoubtedly the complete mask, costume, and dance created a lively interplay of form and motion. RAD

MALE ANCESTOR FIGURE

African, Guinea-Bissau, Bijugo, 20th century
Wood with *tukula* pigment; h. 19 in. (48.3 cm.)
Purchase, 1973 (4166.1)

From Angola and Zaire across the breadth of West Africa, a myriad of figure-carving traditions exists, with some tribes known for their naturalism, others for their austere abstraction. The art of the matriarchal Bijugo people, who inhabit the Bassagos Islands at the extreme western edge of Africa, reveals a subtle blend of both naturalism and abstraction. The number and variety of extant seated and standing ancestor figures indicate their wide use and importance in Bijugo society.

This male ancestor Bijugo figure is seated upon a low stool that rises from a circular base. The figure, with hands clasping the knees and head facing forward, exudes a monumental dignity. The inherent stiffness of the pose is eased somewhat by the inward slant of the legs and feet and the slight backward tilt of the head. The appendages are smoothly and sensitively modeled, with the fingers tapered gently and the thumbs convincingly splayed. The genitalia and umbilicus are carefully rendered, as is the modulation of the upper chest. The flat-topped shoulders, characteristic of Bijugo figural sculpture, create a distinct base for the columnar neck and the proud head. The beard and hair (or cap) are carved in low relief and painted black, setting them off from the rest of the piece, which is painted in red *tukula* pigment. Protruding bushy eyebrows cast dark shadows over the minimally defined eyes.
RAD

FEMALE FIGURE

African, Nigeria, Yoruba, early 20th century
Wood with paint; h. 39 in., overall 49¾ in.
(99, 126.4 cm.)
Purchase, 1973 (4296.1)

The eleven million Yoruba, the most numerous and prolific producers of art of all the peoples of West Africa, are divided into about twenty subgroups, traditionally autonomous kingdoms distributed throughout southwestern Nigeria, parts of the neighboring Republic of Benin, Togo, and Ghana. Predominantly hard-working farmers, traders, and craftsmen, the Yoruba are heirs to an extraordinary classical tradition dating to the Ife Kingdom (ca. 850–1700), renowned for its life-size terra-cotta and bronze heads and figures that display an idealized naturalism. Today the Yoruba have a firm sense of their historical continuity; Ife is their holy city and site of over four hundred religious cults organized around the vast Yoruba pantheon of gods, or *orisha*.

This Yoruba figure is a rare depiction of a royal devotee of Oshun, the most important female deity, who is praised as goddess of beneficent waters to aid childbirth and to cure smallpox and other dreaded diseases. Oshun is also known as an *orisha* of whiteness. During the goddess's annual festival, priestesses dressed in white wrappers with beaded panels collect water from the Oshun River, and food, prayers, and dances are offered.

Calm and impassive, the figure is shown kneeling, a position that in a West African context suggests a relationship to a higher force. Although in size and some detail reminiscent of a caryatid house post, the figure was probably used as a pedestal for displaying ritual paraphernalia. Decorated on the front with a small head or mask, the support for such objects is the slightly concave, bowl-shaped structure with a beveled edge atop the conical hairstyle or headpiece. The two carved necklaces of large coral beads are symbols of chieftaincy (female chiefs are currently found in some Yoruba towns). The royal devotee holds a ritual rattle in one hand and a staff with a bird on top in the other.

This figure displays a subtle integration of the parts of the body, and a sensitive handling of their swelling surfaces. The oversize head is replete with striking facial features: heavy-lidded eyes, broad nose with nostrils equal in width to the mouth, and everted lips. On both head and torso, the sculpted forms are accentuated by white scarification stripes and dots, which contrast stunningly with the brilliant blue at the top. Without concealing the dynamic design qualities of the piece, the Yoruba artist has created an eloquent statement of humanism and dignity. RAD

Index